FRAME, GLASS, VERSE

FRAME, GLASS, VERSE

The Technology of Poetic Invention
in the English Renaissance

RAYNA KALAS

CORNELL UNIVERSITY PRESS
Ithaca & London

This book has been published with the aid of a grant from the Hull Memorial Publication Fund of Cornell University.

First published 2007 by Cornell University Press
First paperback printing 2018

Printed in the United States of America

Library of Congress Cataloging-in-Publication Data
Kalas, Rayna, 1968–
 Frame, glass, verse : technology of poetic invention in the English Renaissance / Rayna Kalas.
 p. cm.
 Includes bibliographical references and index.
 ISBN 978-0-8014-4541-5 (cloth : alk. paper)
 ISBN 978-1-5017-3088-7 (pbk. : alk. paper)
 1. English poetry—Early modern, 1500–1700—History and criticism.
2. Frame-stories—History and criticism. 3. Poetics—History—
16th century. 4. Mirrors in literature. 5. Invention (Rhetoric).
6. Renaissance—England. I. Title.
 PR535.F7K35 2007
 821'.309—dc22

For Barbara Jean Nelson,
who taught me to see through things
and to see them

Contents

Preface

Traditional thinking, and the common-sense habits it left behind after fading out philosophically, demand a frame of reference in which all things have their place. Not too much importance is attached to the intelligibility of the frame—it may even be laid down in dogmatic axioms—if only each reflection can be localized, and if unframed thoughts are kept out. But a cognition that is to bear fruit will throw itself to the objects *à fond perdu*. The vertigo this causes is an *index veri*; the shock of inconclusiveness, the negative as which it cannot help appearing in the frame-covered, never-changing realm, is true for untruth only.

—Theodor W. Adorno, *Negative Dialectics*

This book is interested in poetry's ability to make visible things that might otherwise remain unseen: such things as time, systems of social rank, the physical properties of matter, the processes of the imagination. Some of these things are unseen because intangible. Others are solid material things, things that are a part of everyday reality, but are overlooked precisely because they are familiar, inherent, or routinized. Poetic language brings things to light: it makes the opaque transparent, to use a contemporary idiom. This book is interested in *how* figurative language achieves such disclosure. I cannot say, strictly speaking, that this is my interest, because such disclosures belong to the history of poetics. In the case of Renaissance poetry, the interest in how poetry reveals things gets expressed in figures of framing and images of glass. Framing and glass reveal a crucial aspect of Renaissance poetic imagery: its character as a material practice and a technical craft.

"All verse is but a frame of wordes."[1] The quotation comes from Samuel Daniel's 1603 *Defence of Ryme*, though it might have been taken from any one of the poetic manuals of the late sixteenth and early seventeenth centuries. The word *frame* is ubiquitous in the poetic tracts, where it consistently refers to the organization of language, but never to a picture frame. This book began with my asking what it meant for language, and verse in particular, to have been "framed" in this older sense, before the word became so closely identified with the picture frame. Reading the word in context, I was able to glean that *frame* meant "framework," "embodiment," or "orchestration," and that, as a verb, *frame* meant "to make," "to shape." Further reading, both within and beyond the poetic tracts, revealed that *frame* did not strictly refer to the design or planning of a thing but to its presence as matter: to its manifestation within a temporal, or worldly, reality. A frame almost always indicated some condition of its making or "tempering"; I realized, therefore, that to abstract out of those examples a concept of the sixteenth-century frame would be inapt. Cognition, to borrow Adorno's formulation, would have to "throw itself to the objects." I began then to study the framing of language in relation to another quintessentially tempered material substance, the substance of glass. Glassmakers and poets alike took common particles that were abundantly at hand—grains of sand or words—and rendered that selfsame matter into a glittering surface. And because glass contains in its solid state some of the physical characteristics or "temperament" of the liquid phase in which it is formed and fashioned, it seems to have exemplified for poets what it meant to make or temper language as figurative verse. When I recognized that *frame* referred to both the material craft and the immanence of matter, I understood that the use of *frame* in the poetic tracts signaled not merely a different referent but a different practice of signification.

Because the modern frame obscures earlier meanings of *frame* (so thoroughgoing is the identification of framing with the picture frame, and so prevalent is the use of *frame* as a modern metaphor of intellection) it seems that one would have to hold it in abeyance in order to recover the sixteenth-century idiom of framing. And yet, this book could not have been written without a modern concept of the frame. The word *frame* only stands out in those sixteenth-century manuals when it is read against a contemporary lexicon of framing to which it does not conform. And it is precisely because the pictorial logic of the modern frame gets used to delimit everything from a point of view to the domain of aesthetic judgment, and from the protocols of scientific inquiry to the parameters of reason, that its absence from an earlier idiom is especially notable. It is the salience of the modern frame that prompts the question of what is meant by an earlier "frame of words." The modern frame has

not only superseded an older idiom of framing, it has also conditioned the apprehension of what might have preceded it. And in the modern system of the arts, I would contend, poetry has been framed as an aesthetic.

If the frame as a quadrilateral enclosure is a modern phenomenon, and so too is the entire aesthetic and pictorial logic that has accrued to that apparatus, then in the absence of that pictorial and aesthetic logic, the very character of poetic language must have been different. To restitute what sixteenth-century framing might once have been, however, is as much a project of disclosing the modern separation of reason from judgment, of thought from praxis, and of formal from sensory perception, as it is a project of historical recovery. In that respect, the interests of this book are not only those of Renaissance poesy but also those of contemporary discourse. My aim is to render visible both the special orchestration of language that framing once named and the pictorial logic of the modern frame. And my method is guided by the premise that this earlier form of framing stands in distinction, but not in opposition, to the modern frame. To stand in opposition to the modern frame is precisely to be framed by its logic. And the early modern framing of language, though it shares none of the abstract logic of the modern quadrilateral frame, does share something of that very frame's practical and liminal character. The central claim of the book, then, is that a predominant strain of poetic language and theory in the English Renaissance recognized poesy as *techne* rather than aesthetics, and figurative language as framed or tempered matter, rather than verbalized concepts.

That the apparatus of the modern frame has structured what we do and do not see does not mean that it has itself been visible. Although the frame was pivotal to Kant's categorization of the painting as a beautiful object, because Kant also deemed the frame to be adjunct to the work of art, its conceptual role within aesthetics went unquestioned for many years.[2] Artists themselves playfully manipulated the appearance and function of frames in their work throughout the nineteenth and twentieth centuries. Even so, scholarly and curatorial information about frames was minimal until the mid-twentieth century.[3] Apart from a few specialized studies, frames do not appear to have held much interest as a subject in their own right. Henry Heydenryk's 1963 *The Art and History of Frames: An Inquiry into the Enhancement of Paintings* is one of the earliest treatments of framing as a topic of general interest.[4] And it was not until the 1969 publication of Meyer Schapiro's signal article on the semiotics of the frame that the conceptual and philosophical significance of framing began to be recognized.[5] In the next few decades, intellectual and practical interest in the frame took hold in critical theory, art history, and curatorial practice.[6]

By the last quarter of the twentieth century, frames and framing had been translated out of aesthetics and into epistemology. In the 1990s, virtually everything was being framed in academic book titles: there were books framing "Authority," "Blackness," and "Feminism," others framing "Culture" and "Feeling"; "History," "Science," "the Falklands War," and "Anna Karenina" were all subjects of "Framing," as were "the Margins" and "Marginality" itself—these are just a few.[7] Some of these books imitated the instrumental role of the frame in offsetting the value, unity, or integrity of the object framed; some critiqued the derogation of the frame as contingent, contextual, and solicitous of the interests of the viewing subject; some simply exposed the seeming neutrality of the frame without emulating either its valorizing function or its marginal status. Taken together, these titles corroborate the rhetorical and conceptual power of framing, regardless of whether the individual book sought to borrow or to supplant that authority. What these books make visible, in one way or another, is a semiotics (or, as some would say, ideology) of framing, as borrowed out of aesthetics. Taken together, they attest to the fact that we frame not only works of art but also ideas, discourses, and cultures. And in every case, they articulate framing as a form of analysis.

By the sheer variety of their subjects, these titles implicitly state that anything can be framed; that to study something is, perforce, to frame it. We frame our objects of analysis, imagining that our discourse is the "framing" that offsets it. And having acknowledged that, it is considered a mark of honesty, and rightly so, to say how the object has been framed, and according to which subjective interests. In this view, discourse is an instrument of the scholar's reason and analysis, and, as such, "framing" very effectively pinpoints how language has been and can be used as a tool in the service of specific aesthetic, social, or economic interests. This framing of discourse is less effective, however, in describing how thinking is produced by language, or the process by which language shapes the interests of its readers, speakers, and writers toward an object or an interest held in common with others. Especially in scholarly writing about language and poetics, where academic discourse shares with its subject matter the medium of language, the presumption that one stands apart as a subject from one's object of study does not necessarily make sense in any practical or experiential way. It makes sense only where subject and object are held apart, rather than conjoined, by an intervening frame. When I demurred, at the beginning of this preface, that the interests of this book are not strictly my own, I did so not to be disingenuous or coy, but rather to indicate that those interests are shaped by reading and by writing about poetic language.

Sixteenth-century writers treated language as something in and of the created world rather than something invented by an individual speaker or writer. Not only did Renaissance writers treat the word as a thing, they also granted

that temporal and worldly effects are wrought in and through language. The efficacy of language was generally attributed to divine agency. And although the rediscovery of classical texts and the development of vernacular writing revealed the contingency and mobility of language in historical time, perceptions about language in history were often articulated in terms of a Christian teleology. Even so, it has been tempting to speculate, in the course of writing this book, about how else to imagine agency in poetic language, and about why it is not easier to do so. Why is it such an anathema at present to apprehend poetry as a kind of technology rather than as a kind of aesthetic experience? And why has it been so difficult to imagine that figurative language might play a direct and active role in historical change? Although these questions exceed the scope of this book, they do help to indicate its orientation. And because both questions are responses to two of the more commanding influences on this book—Martin Heidegger's "The Question Concerning Technology" and Michel Foucault's *The Order of Things* respectively—they provide a kind of deep background to the more localized questions that I pose about the relationship between poetry and history. In his essay, Heidegger makes a philosophical and historical distinction between two modes of revealing: *poiesis*, which is a bringing forth, and "enframing," which is the essence of modern technology. That distinction is comparable to the one that Foucault draws between literature, which animates the contiguity of language and the world, and the signifying function of language, which has meaning as a system of ordering. Both distinctions, Heidegger's and Foucault's, resonate with the contrast I have drawn between the framing of poesy and the quadrilateral frame. This present engagement with Renaissance framing helps to bear out a language of framing that is at least adumbrated, if not explicitly stated, in both texts and will, I hope, suggest how the framing or tempering of poesy might yet be a useful way of thinking through the craft of language.

"There once was a time when it was not technology alone that bore the name of *techne*," writes Heidegger, "when the bringing forth of the true into the beautiful was also called *techne*," when "the *poiesis* of the fine arts was also called *techne*."[8] The essence of modern technology, by contrast, is a mode of revealing that interferes with *poiesis* as a mode of revealing: it is a "challenging-forth into ordering" (24). It is not anything technological but rather the *essence* of modern technology that represents a threat. And yet the essence of modern technology is also highly ambiguous. It contains within itself an historical alternative, which is also a philosophical alternative, in the same way that the etymology of the word *technology* contains within itself the root *techne*. Heidegger's original term for the essence of modern technology, "Ge-stell," is translated to English as "enframing." And though the translation has been disputed, the etymology of *frame*, which both explicates Heidegger's argument

and extends it, is an argument in favor of this translation.[9] "Enframing" contains within it *frame*, which, as I suggested above, once indicated the shaping or tempering of matter and the crafting of poetic language. These older uses of *frame* are evocative of the historical and philosophical alternative that Heidegger recalls as a time when techne also referred to the arts of the mind and the fine arts. Heidegger is ultimately concerned with restoring technology, in the sense of *techne*, to the fine arts: with reconstituting the fine arts as poietic, rather than mimetic or aesthetic. The etymology of *frame* has the further effect of animating the relationship between techne and poiesis for the arts of language, for poetry. Properly speaking, there is no language of framing in Heidegger's essay. Yet the felicitous translation "enframing" has the perhaps unintended effect of revealing that the instrumental reason Heidegger associates with the essence of modern technology—an association that resonates in the current denotations of *frame* as conceptual thought—also blocks the relationship between technology and poetry. To read this essay through the language of framing brings forth the possibility of realizing poetry as a kind of technology and of recognizing technology in a way that admits the presence of poetry within it.

Writing in *The Order of Things* about the natural sciences, rather than technology, Foucault describes systems of classification that evoke something of the "challenging-forth into ordering" out of which, according to Heidegger, the extreme dominance of the subject-object relation is predetermined.[10] Heidegger says of the term he uses to describe the essence of technology that, in its ordinary use, *Gestell* is some kind of apparatus. Foucault suggests that, during the Classical period, language as a system of naming and classification appears in a space that has opened up in representation: a "non-temporal rectangle" (131), a *tabula* or grid that "defines a periphery rather than providing an interior figure" (119).[11] Foucault calls this the "quadrilateral of language" (115). And the rectangle, as the armature or apparatus of representation, recurs in different versions throughout Foucault's work. It is expressed in the binary logic of signification, in which the sign is said to be a map or picture of the thing it represents; it appears as the "quadrilateral of language"; it appears as a frame that organizes point of view and makes possible the visual sovereignty of the modern subject as both the subject who sees and the object of knowledge; it distinguishes all these thresholds of modernity from the circular forms of the Renaissance; and it distinguishes Foucault's own archaeological methodology as one that cordons off spaces of knowledge and establishes the propinquity of things as on a table or grid. Refusing to make causal connections between one period in history and the next, Foucault looks back at history as a series of thresholds, or conditions of possibility. His book might be described as a system of comparative frames, emblematically represented in his analysis of Diego

Velázquez's *Las Meninas*: a consideration of the layers of history that are visible not as worldviews but only as outlines or frameworks of the kinds of discourse they make possible.

In Foucault's work, literature is marginalized, figuratively speaking, by these rectangles of knowledge, these *tabulae* of scientific and quasi-scientific discourses that establish the relationship between words and things. Literature becomes a "counter-discourse" (44) to them. The appearance, in the seventeenth and eighteenth centuries, of language as an arrangement of signs that "have value only as discourse" and that serve as a system for naming, ordering, and demonstrating dissolved "the peculiar existence and ancient solidity of language as thing inscribed in the fabric of the world" (49). The appearance of "literature" as such "manifests the reappearance of the living being of language": "Throughout the nineteenth century literature achieved autonomous existence and separated itself from all other language . . . by finding its way back from the representative or signifying function of language to this raw being that had been forgotten since the sixteenth century" (49–50). Literary language, for Foucault, recaptures that lost unity of language and the world—but it is not merely a form of nostalgia. Literary language has power as a counter-discourse; it reveals things with an immediacy that the representational language of scientific discourse militates against. It is even at the margins of Foucault's own work. Literature—like the passage from Jorge Luis Borges that begins the preface of his book—has the capacity to shatter "all the familiar landmarks of . . . thought" (xv).

Borges's Chinese encyclopedia, in its shattering of landmarks of thought, is emblematic of what it means to observe a radically different knowledge system across a historical rupture: emblematic, therefore, of the kind of apprehension that distinguishes Foucault's historical method from a history of ideas. Borges's encyclopedia reveals in ironic form the systems of classification that Foucault will describe. The passage from Borges makes something happen, by Foucault's own admission, in his thinking. And in a text that is so careful to avoid any explanation of how or why thought dissolves one set of forms and assumes another set of forms, it is notable that literary language seems to make things happen in the register of the imagination. Perhaps even more notable in this respect is Foucault's short analysis of *Don Quixote*, which he situates not only at the edges of official culture but also at the boundary between historical periods. It is not simply that *Don Quixote* marks a place of rupture in Foucault's account; it seems to articulate the change. The book's narrative adventures "form the boundary" that marks the end of one *episteme* and the beginning of another. Is *Don Quixote* able to articulate a historical boundary in this way because of its place in history, because the "living being of language" is not yet sundered from its signifying function? Or does this special class of language

that we call poetic, literary, or figurative have a relation to history that cannot necessarily be classed as ideality, that was never fully yoked to the history of ideas that modern subjects have imagined in their own image? Foucault does not say. That literature plays such an ambiguous role in this early part of his text—that it has the ability to make things happen in the imagination, and that it can be present in the fabric of the world, not as an image of "man" in history but as a marker of epistemic change—suggests that poetic language has an agency in *The Order of Things* that Foucault is unwilling to attribute to epistemological thought and discourse.

I offer these speculations about Foucault as a way of pointing back, not so much to the ordered unity of words and things that he ascribes to the sixteenth century, but to what Foucault refers to as the "the living being of language." For a great many English writers of the sixteenth century, the principal question was not how words relate to things, but how the crafting of language related to the crafting of things. Because words and things were of this world and mutable in time, the work of the imagination—the imagination itself being a worldly instrument of sensory perception—was comparable to any other artisanal skill. If words were things, that meant they were subject to all the alterations of artifice and invention, and subject as well to the constant change and mutability that characterizes all of material reality in the created world. In this way, sixteenth-century poesy and discourse convey not simply a system of resemblances but a temporal language: a medium marked by constant flux and by a sense of its own making, becoming, and bringing forth. In its materiality or temporality, and as both techne and poiesis, the framing or tempering of poesy in the sixteenth century enacted material changes in signification. This framing of language suggests a model of poetic agency in history. And by focusing on the craft of poesy, it may be possible to explain historical changes in the field of language and literature during the early modern period without constructing a world picture or privileging an idealized notion of the spirit of the age.

Acknowledgments

Although this book was written over the course of more years than I care to admit and more relocations than I care to remember, the influences that it absorbed along the way—in Philadelphia, Portland, Washington, D.C., London, and Ithaca—have made the book what it is. Countless people spoke with me about the project, and in virtually every case those exchanges spurred me to make the book more gracious and intelligible. It is from smart interlocutors of all kinds that this book has gathered its strength of conviction about language as a collective intelligence.

Margreta de Grazia saw the book at its sketchiest beginnings and in the years since has given it time, energy, and more than a few turns of phrase. For her tireless scrutiny, her nimble thinking, and her thoughtfulness as a friend and a scholar, I am immensely grateful. Peter Stallybrass has helped to shape the work of this book with both pragmatic suggestions and generous wit. Many other teachers and friends from my years in Philadelphia contributed as well: Maureen Quilligan, Rebecca Bushnell, Phyllis Rackin, Juliette Cherbuliez, Jane Penner, Suzanne Verderber, Lynn Festa, Liza Yukins, Julie Crawford, and Rhonda Frederick. Crystal Bartolovich has been a true comrade. I thank the members of the University of Pennsylvania's medieval and Renaissance seminar for inviting me back to present portions of the book. And to the still-anonymous person who left *The Invention of Infinity* in my mailbox, I am grateful for the mystery.

Juliet Fleming reflected the book back to me at several critical moments, in ways that allowed me to see where it was headed. She, as well as Gregor Kalas, Jonathan Grossman, Bill Sherman, and Tyler Smith passed along to me crucial

references and materials. Richard Strier and Daryl Gless returned me to texts that became central to the book. Many more friends have provided feedback and companionship: Anne-Lise Francois, Brent Edwards, Sabine Haenni, Anne McClanan, Mary Pat Brady, Kate McCullough, Rachel Weil, and Alan Stewart. Elisabeth Ceppi deserves a special note of thanks; she has been a gracious reader and an unstinting friend.

I received a year of support for the research and writing of this book in the form of a long-term fellowship at the Folger Shakespeare Library funded by the National Endowment for the Humanities. Portland State University gave me additional support during my year of leave. My year at the Folger was invaluable, and I am especially grateful to Georgianna Ziegler for her guidance. I also thank the reading room staff, especially Camille Seerattan for her keen eye and genuine friendship, and fellow readers David Hawkes, Garrett Sullivan, Valerie Wayne, and Susan Zimmerman. I had the good fortune that year of participating in the "Language and Visuality" seminar of the Folger Institute organized by Leonard Barkan and Nigel Smith. I thank them, and the other members of the seminar, especially Sean Keilen, Jen Waldron, and Will West.

A generous leave from Cornell helped me to finish the book. And my colleagues at Cornell have been a terrific source of support. I wish to thank Tim Murray, Walter Cohen, Barbara Correll, Laura Brown, Andy Galloway, Molly Hite, Doug Mao, and the members of the "Culture and Value" Mellon faculty seminar for their advice and comments on the manuscript. Scott McMillin was my official mentor at Cornell until his death in March of 2006; he was also a treasured friend. The book was made better by the rare combination of qualities that he brought to his intellectual work: a sharp critical acumen and a generous open mind. In a very bittersweet way, he became my principal imaginary audience in the final stages of writing. And I am grateful for the memory of this truly admirable colleague.

Jonathan Crewe and an anonymous reader for Cornell University Press made tremendously useful suggestions, as did John Ackerman, who has surpassed my expectations of what a good editor is. My outstanding research assistants, Ramesh Mallipeddi and Janice Ho, as well as Katy Meigs and Ange Romeo-Hall at the Press, paid careful attention to the proofs.

This book is dedicated to my mother, Barbara Jean Nelson, who inspires me with her brave determination and insight. My family has been a source of strength, comfort, and true intellectual companionship. For that, I extend my deepest appreciation to Andrea Kalas, Ronald Grant, Gregor Kalas, Justine Kalas Reeves, Jay Reeves, John W. Kalas, Mary Kalas, Robert Braddock, Sarah Braddock, and Nathaniel Braddock.

No other person has given more to this project than Jeremy Braddock: he has generated more excitement about it, given it more sustained attention, and worked harder than anyone else to free its sentences from "nightmares of sub-ordination." Above all, I am grateful for the intangible influence he has had on the book by letting there be a dream life in its making.

The Renaissance and Its Period Frames

English Renaissance writers were attuned to words as matter, whether as marks on a page or as the utterance of sound. Recent scholarship has begun to explore the philosophical and rhetorical implications of language as matter.[1] And yet what this materiality of language may have meant for Renaissance poetry, language that is by its nature figurative and imaginative, seems more elusive.[2] If words are matter, can the same be said for the poetic image and the poetic conceit? In this book I examine signal metaphors of Renaissance poetics—the frame, the mirror, the window, and the glass lens—as those objects were transformed by material innovation, proposing that the craft of poetic invention, or poesy, was a technology in its own right.

I use the word technology—emphasizing its etymology, *techne*, the conjoining of manual skill and creative invention—not to dampen but to accentuate the imaginative affect of figurative language in the Renaissance. During the modern era, artistry and technology have often been placed in opposition to one another, but in the Renaissance, when the word *art* had not yet been inflected by modern aesthetics, there was no such opposition to be drawn. Art was inseparable from the "misteries" and skills associated with a given artisanal craft. Precisely because words were matter, and because poets were understood to labor at a craft, poesy was an art in the earlier sense. Taking into account the techne of poesy makes it possible to recognize poetic language as an instrument of figuration that partakes of worldly reality rather than as an artifact or concept that reflects reality by observing the mimetic conventions of pictorial representation.[3] In short, by distancing Renaissance poetry from its modern reception as an aesthetic object, this book seeks to restore poesy to its earlier use as a technology and a form of making.

English Renaissance poets and poetic theorists attended to words as matter in order to answer the charge that poetry builds only castles in the air. English Protestant writers especially had to negotiate concerns about the "phantasticall," and potentially idolatrous, character of poetic language. On the one hand, poetry had to be free of any kind of excessive ornamentation that would lead to the overvaluation of its material nature, but on the other hand it had to remain grounded in worldly reality, so as not to conjure frivolous or fanciful imaginings that might be mistaken for transcendent truths. Because words were matter, and language was fallen, Protestants, generally speaking, deemphasized the materiality of the letter. The material letter itself had to be free of decoration—some opposed even rubrication—lest it be invested with special significance. But whereas Protestants began increasingly to emphasize a conceptual register in language, they also sought to ensure that the inventions of the human mind would not be confused with the pure ideality of divine truth. Thus, the materiality of the letter had to be played down as a simple index of divine and spiritual truths: as matter that leads to contemplation. But the materiality of the imagination had to be played up, as a way of acknowledging its difference from, and its humble refusal to confuse itself with, divine ideality. The imagination, like the material word, was neither to be denigrated nor exalted; it was to be recognized, plainly and simply, as material and temporal matter.

Instead of understanding the poetic imagination as pure fancy, many writers expressed the idea that poesy was a visual instrument, an optic like the eye, rather than a series of pictures conjured up by words. This, in part, accounts for the importance of lenses, mirrors, and windowpanes as metaphors for poesy: glass demonstrated how poesy could be visual, without being pictorial. In itself, the visual imagination was neither idolatrous nor even necessarily phantastical, but a visceral instrument of reason. Yet the imagination was always at risk of becoming idolatrous by mistaking an image in the mind for truth itself, or, alternately, by fixating on sensory perceptions as ends unto themselves, rather than physical ephemera that serve the faculty of reason. Renaissance writers acknowledged that a poem inhabits the imagination as surely as it is written on the page or as it is passed through the lips. To the extent that the imagination produced fantasies, these were to be recognized as corporeal means to a truer apprehension, and not as forms of ideality in themselves. Whereas for modern readers the imaginative register of the poem is a form of ideality, for Renaissance readers who understood the imagination to be a kind of visceral platform of sensory processing from which the higher function of the intellect draws its reason, the imagination testified to the physical embodiment of mind.[4] Like the word seen on a page or a sound that is heard, the poetic image or conceit leaves an impression on the imagination, which is itself of this world; the imagination is created matter, not spiritual essence.

The modern separation of thought from things, and of ideality from materiality, does not map seamlessly onto the Renaissance; a less anachronistic separation would be that of the eternal from the worldly, the spiritual from the temporal. And to say that words are material attests not only to the "thingness" of words but also to their variability in time, their temporality. This means, on the one hand, that language followed the course of all other God-given matter that had been set into motion in time by divine fiat. But it also means, on the other hand, that language was subject to material craft and innovation like all other matter. In the Renaissance, the poetic conceit distinguished itself as a thing in motion, against the pretense of eternal stasis or fixity of idea that is staged by an iconic or pictorial image. The novelty of the poetic conceit as a thing in motion and in time belonged not to the wit or ingenuity of a given writer but to the technical craft of poesy; and this novelty helped to situate poesy within a fluctuating hierarchy of trades and professions.

Two other innovations in particular shaped the relationship between technical and figurative invention in the Renaissance: the emergence of the frame as an apparatus that is separable from the painted image and the development of perfectly clear glass, also called *cristallo*. This is not simply to say that poets took note of these novelties in glass and framing and featured them in their poetry, though they did. Rather, framing and glassmaking were correlative to poesy because all three were distinctively imaginative techniques of craft practice—different from other crafts in that all three intimated an unusual interface between the divine immanence in matter and the novelty of technical invention. Because the word was both Logos and matter, because at the Creation God framed the universe of matter and the crystalline spheres of the heavens, because all of matter was a mirror of the divine idea, innovations in framing, glassmaking, and poesy were perceived uniquely to mingle matter and meaning, the finite and the infinite, the natural and the artificial, the word and the image. Poetic language revealed its relationship to framing and glassmaking not by intimating that the three media were united by a logical principle or universal spirit but by announcing their affinity as a novel set of material, technical, and visual practices. Used as metaphors, frames and glass did not link the word to an imaginary picture so much as they demonstrated the integration of visual technologies with figurative invention, and of techne with poiesis. The interchange among framing, glazing, and versification was material, in both senses of the word, to the unique status of poetry as a technology after texts and images had begun to be translated out of a sacred and iconic context and before they were fully translated into an aesthetic and representational one.

These older forms—of poesy, of framing, of transparency—tend to be overlooked by modern aesthetics and epistemology, which use a quadrilateral concept of the frame to mark off both the art object and the subjective ingenuity

of the artist. The alienable quadrilateral frame was a Renaissance invention. But the *idea* of the frame as a conceptual structure that demarcates the work of art is a product of eighteenth-century aesthetics. In the nineteenth century, objects, concepts, and even historical periods were construed as pictures in the perception of the thinking subject. And by the twentieth century framing was widely recognized as a metaphor of cognition. As a result of its subsequent history, the material innovation of the alienable quadrilateral frame has looked to some like a nascent form of modern subjective consciousness and an index of instrumental reason. Any understanding of the alienable frame as a Renaissance invention must differentiate it from its modern conceptual counterparts. But an apprehension of the technology of Renaissance framing must also do more than simply differentiate the modern concept from the early modern artifact or it will fall prey to the assumption that complex modern concepts derive from simple material facts. The alienable frame emerged out of a practice of framing as making or poiesis that was not limited to the fabrication of picture frames alone. It is in this broader context of framing as making that we may begin to understand innovations in framing as technical innovations: neither strictly material nor principally aesthetic or theoretical.

Before the emergence of the alienable frame, when most frames were continuous with the surface of the painting, there was a material continuity between the frame and the painted image. The fabrication of the picture frame would have revealed that the painted panel with its engaged frame was a "tempered" image, in that it mingled ground pigment with egg, gilt with wood. In its mixture of "simples," it seemed to recall, if not to embody, the divine tempering of spirit with matter, essence with substance. In iconic devotional images, once the wood had been tempered with gilt, the image ceased to be material and was instead recognized as an incarnation of divinity—its particular mingling of substances recalling the human frame itself as a mingling of bone with flesh and blood, and a mingling of spirit with substance. With linear perspective, painting on canvas, and the trade in art, however, the function of the frame shifted: instead of merging with the design, the frame now contained and ornamented it. Frames became alienable, interchangeable, and more uniform in shape; the frame became a principle of design for the work of art. Over the centuries this modern quadrilateral frame would come to structure ideas of art (picture frame), history (world picture), and even the very idea of context and contingency (frame of reference).

Rather than squaring off a view of the Renaissance—as one might a world picture or an object of study—I propose to "frame" the English Renaissance according to an older sense of the word *frame*. Remembering that the word *frame* was first used in the context of language and only later in reference to images, I take my cues principally from poetic language, the

medium that has most clearly defined the Renaissance in England. Though my claims are geared mostly to the English Renaissance, it is not my intention to isolate those claims from broader claims about the continental Renaissance. On the contrary, my hope is that the particular example of the Renaissance in England will modify perceptions of the Renaissance that derive largely from the example of the visual arts in Italy, not by supplanting those perceptions but by adjusting them. My aim is to reinvigorate a sense that the temporality of the Renaissance accommodated the poetic sensibility that certain universals or general principles abide in particularities, and thus that the particularities of English poetry can and should inform our overall sense of the Renaissance.

I continue to use the period designation Renaissance, albeit not exclusively, in this book. I do so not to conserve an aesthetic view of the period, but to sustain nonetheless an emphasis on imaginative practice, and to bring technology under the rubric of imaginative practice. I use Renaissance also to avoid the teleological implications of early modern, for one of my underlying claims is that the work of the imagination is historically material, but not necessarily as an instrument of progress. The term Renaissance connotes novelty, but only as the rebirth of what is old: English Renaissance writers spoke of the present in relation to the past as much as the future. They spoke of temporal change as both recurrence and novelty. And the capacity to apprehend time by turning forward to the future while also turning backward to the past is one of the distinctive techniques of poetic conceits and tropes. That temporal imagination is codified in older meanings of *frame* just as it is writ large in a notion of the Renaissance as both backward-looking and forward-facing. Though it was specifically an English phenomenon to name the poetic conceit "a frame of words," I would argue that the Renaissance frame, even as a material apparatus, was inflected with this *poietic* sensibility, just as the modern frame would later come to be inflected by a visual concept. As the following pages will show, this modern aesthetically oriented mode of "picturing" has eclipsed the role of the poetic—and the *poietic*—in the Renaissance and its frames.

The Material Frame and the Concept of Art

Have you ever considered in the early history of painting how important also is the history of the frame maker? It is a matter, I assure you, needing the very best consideration. For the frame was made before the picture. The painted window is much, but the aperture it fills was thought of before it. The fresco by Giotto is much, but the vault it adorns was planned first. Who thought of these—who built?[5]

The quotation is from a lecture by John Ruskin on Italian Renaissance engraving and its relation to other arts. In this suggestive aside, Ruskin converts the frame from an afterthought to a first principle. Ordinarily an auxiliary and ornamental enclosure, here the frame is the preparative groundwork for the painting: the niche prepared for a fresco, or the panel prepared for an application of pigment. "The frame was made before the picture," Ruskin remarks, referring to the fact that frame and panel together—whether an elaborate altarpiece or a simple wooden surface with a contiguous raised border—were once prepared prior to the painting of the image. To understand the history of painting, Ruskin urges, one must imagine not only the "painted window" but also the "aperture" that it fills. "The painted window is much," he grants, Giotto's artistic genius is much, but the precedence of the frame calls into question the system of value that has privileged the painted window over the crafted structure that supports and surrounds it. For Ruskin, the ingenuity of the frame maker and the craftsman are of no less value than the ingenuity of the painter.[6]

Searching back past the "painted window" to the "aperture it fills," Ruskin hoped to demonstrate a more fundamental and inclusive principle of unity among arts and crafts. The work of the frame maker is comparable to that of the artist, in Ruskin's view, because the frame is not only "built" but also "thought." The painter conceives of the "painted window": the framer, its aperture. "And in pointing out to you this fact," he goes on to say, "I may once and for all prove the essential unity of the arts, and show you how impossible it is to understand one without reference to the other." Because framing physically joins different media—painting with sculpture, and both of these with architecture, for instance—the revelation of framing as an art reveals the unity of all arts. And yet what proves the artfulness of the frame is the framer's *conception*: the concept of the aperture rather than the crafted artifact. To identify a principle of unity among the arts, Ruskin levels the hierarchy of painting over craft. But his valorization of the frame inadvertently reveals the extent to which the framed painting has defined the very idea of the *work of art*.

The aesthetic judgment of painting is predicated on a frame that functions as an aperture: as something that is largely insignificant as a thing unto itself but that is critical in setting apart what is viewed through it. Aesthetics disavows the material frame, deeming it extrinsic to the beautiful object, even as it relies on a concept of the frame as that which distinguishes and delimits the concept of the beautiful. Aesthetics, it might be said, gives the idea of the work of art its conceptual frame. By imagining that the essence of painting and all the arts can be glimpsed through the history of framing, Ruskin reproduces at a conceptual level the aesthetic function of the modern frame: the whole history of framing works, in Ruskin's account, as a conceptual frame for the idea of the aesthetic, albeit a more inclusive aesthetic that embraces both artists and craftsmen.

Though Ruskin imagined that the early frame is an "aperture" through which it is possible to see the "essential unity of the arts," this view of the frame turns out to be a prolepsis of its modern form.

The concept of the aperture has little to do with the earlier frames to which Ruskin refers. When the frame was made before the painting, it provided the foundational material support for the painting rather than its conceptual demarcation. An engaged frame, or a panel prepared with a border prior to painting, was a table rather than an aperture; and the raised border may well have been more important as a hand rest for the painter than as a means of demarcating the image.[7] An altarpiece frame, though it might have been made separately from the painted panels it housed, was an architectonic edifice rather than an aperture: it located painted images in adjacency to one another and within the space of the church. And it is difficult to conceive of the vault of a church, even one expressly designed to house a painting by Giotto, as first and foremost an aperture. In this "early history of painting" the frame was not yet an aperture. It was only as painting was divorced from the production of frames, and as painters worked at producing the illusion of space within the painted image itself, that the notion emerged of the frame as an aperture, through which one might see a painted scene as through a window.

Ruskin was right to point out that the material frame had been dismissed by modern aesthetics as merely an ancillary structure. And he was also right to note that the modern deprecation of the material frame belies its abstract function. But his assumption that the aperture function is a universal feature of all framing and bordering, rather than a particular configuration of the frame brought about by the history of aesthetics, draws on the same set of aesthetic principles that he appears to question. What Ruskin ultimately redeems is not the earlier craft of framing so much as the often-ignored conceptual function of the frame within modern aesthetics.

Ruskin's account nevertheless contains several salient observations about early frames: that the frame precedes the work of art, that framing was once comparable in value to painting, and that framing appears to link disparate artisanal practices rather than marking them off as distinct. What Ruskin's account also reveals is how difficult it is even to speak of early frames as if they were a special class of objects: Is a niche or a vault an *object*? The idea of the painting as a *work of art* has promulgated a concept of quadrilateral framing that is at once analogous to the material frame and yet entirely abstracted from the thing itself. This polarization of concept and artifact is belied by actual frames and by the actual practice of framing. And thus the history of framing cannot be accurately understood, or even fully accessed, as a subcategory of painting. The bordering of paintings once belonged to an artisanal form of making that did not necessarily divide what is "thought" from what is "built," or

concepts from things. And it was this kind of making that, in English, was called framing.

In England, framing had a rich conceptual, lexical, and material history quite independent of painting, before it became associated with pictorial enclosure. In the sixteenth century, framing referred to the immanence of a being or a thing: its internal orchestration rather than its external demarcation. Framing described a thing *in potentia* coming into presence as matter. To frame something was to index a thing in its becoming, instead of its discreteness or completion. In modern aesthetics, the frame is either an extrinsic ornament or a governing abstraction. But earlier forms of framing expressed an integration of matter and meaning that is at variance with modern distinctions of ideality from materiality: earlier forms of framing indicated an inclination in worldly substance toward its inherent design.

Framing once implied poiesis, and in sixteenth-century discourse, everything from timber to manners to language could be framed. To imagine that framing is a universal concept, though, would be to misapprehend the character of this earlier mode of framing. All acts of framing were shaped and determined by the materials framed—for this reason Renaissance framing is more aptly described as a technology than as an idea or a concept. A reference to vocational work in Thomas Wilson's 1560 *Arte of Rhetorique* shows framing to be a way of crafting something in accordance with an ideal standard, but an ideal standard that is realized only through the manipulation of matter: "By an order we devise, we learne, and we frame our doings to good purpose: the carpenter hath his square, his rule and his plummet, the tailor his meet yard and his measure, the mason his former and his plaine, and every one accordyng to his callyng frameth thynges thereafter."[8] The artisan frames "thynges" using the instruments of his craft.[9] And yet the worker's "doings" are also framed "to good purpose" when done "by an order." Framing is compared here to devising, but also to learning. Framing is not strictly a devising of intellectual mastery over an object but a learning that accedes to the technical arts of a professional trade and, ultimately, to one's place in the social order. The craftsperson's instrumental relation to matter conforms to technical protocols of proper craftsmanship and to the social and religious order of vocation or "callyng." Though "we devise . . . and . . . frame our doings," those doings are also circumscribed within a larger order that "frameth things thereafter." And framing also indicates that the artisan experiences "his calling" in the practice of a given craft as much as in some abstract, divine summons. The "order" of God's presence in the world may be manifest in natural and social hierarchies, but it is also manifest in the character of human activity. To frame one's doings by a divine order is to use properly the instruments of one's calling, instruments that are, in turn, appropriate to the materials shaped by that given craft.

Wilson's use of the word *frame* to describe the common "good purpose" among myriad trade practices has an odd resonance with Ruskin's intuition that framing might prove the "essential unity of the arts." By "arts," however, Ruskin means the fine arts of sculpture, painting, and engraving, whereas Wilson refers to the "artes" or "misteries" of guild practice. In the nineteenth century, framing belongs to aesthetics, in the sixteenth it belongs to poiesis. Ruskin looks to "prove once and for all the essential unity of the arts" that the framer, before all other artists, first "thought" and then "built." In Wilson's *Arte of Rhetoricke*, there is no "framing" of thought without the matter of words: framing reveals what is already inherent in matter, as well as its purpose.[10] Framing derives not from the premeditated design of the framer but from the multiplicity of human making. Ruskin's project, in the face of an increasingly specialized system of the fine arts in the nineteenth century, was to look back to the early history of painting in order to find at its origins an essential unity among the arts. But what he reveals instead is the epistemology of the frame in modern aesthetics.

The Art and Science of the World Picture

The period distinction "Renaissance," which was first developed in the nineteenth century to name a flourishing of fine arts and letters, reveals the aestheticism of early nineteenth-century periodization: periods can be differentiated on the basis of their artistic styles.[11] Ruskin's interest in craft separates his work from this tacit aestheticism in nineteenth-century histories of painting. And yet he uses history to "frame" the idea of the aesthetic. In this way, Ruskin's work is representative of a different kind of aestheticism in nineteenth-century writing about history: a philosophical aestheticism that, for its part, involves a kind of tacit framing. In the framing of history, aesthetic criteria shape not simply the objects but also the methodology of periodization. History itself becomes a picture and the role of historiography is to discover what the picture represents: this tacit framing in historiography gets expressed as a search for the origin of thought or the spirit of an age in a given civilization.

It was Jacob Burckhardt who first suggested, in his 1860 book *The Civilization of the Renaissance in Italy*, that the distinguishing feature of the Renaissance was not to be found in its works of arts but in the *idea* of the work of art. During the Renaissance, Burckhardt explains, "a new fact appears in history—the state as the outcome of reflection and calculation, the state as a work of art."[12] By his account, the work of art found expression in every aspect of civil society in Renaissance Italy. So deeply did the work of art saturate the structure of knowledge and culture that even the perspectivism of the historian is an index

of that "unavoidable" shaping influence that keeps subsequent generations thinking in pictures, however various and diverse those pictures may be:

> To each eye, perhaps, the outlines of a given civilization present a different picture. And in treating of a civilization which is the mother of our own, and whose influence is still at work among us, it is unavoidable that the individual judgment and feeling should tell every moment both on the reader and on the writer.[13]

Burckhardt acknowledges that historiography is an act of representation governed in part by the appearance of the object and in part by the "judgment and feeling" of the onlooker. Although he warrants that there might be as many pictures of the Renaissance as there are eyes to view, his rhetoric reveals that this plurality of views derives from the perspectival logic of the work of art. The influence of that logic, which has its origins in the Renaissance, is still at work in the nineteenth century, not least of all in the methods of the historian. Their differences notwithstanding, Burckhardt, like Ruskin, is interested in seeking out, at its origins, the idea of the work of art. The very notion that a past civilization presents itself in outline to the viewer suggests the tacit framing in Burckhardt's history.

Burckhardt's method offers not only a picture of the past but also a perspective on historical process. He frames a picture of the Renaissance as the moment in time in which the work of art appears as a fact in history. Yet he also frames a diachronic process that links the Renaissance with the nineteenth century, and that time frame holds a picture of the birth of the modern individual. "It is the most serious difficulty of the history of civilization," Burckhardt writes, "that a great intellectual process must be broken up into single, and often into what seem to be arbitrary, categories, in order to be in any way intelligible."[14] His study of the civilization of the Renaissance in Italy is parceled into a series of perspectives or parts: "The State of the Work of Art," "The Development of the Individual," "The Revival of Antiquity," "The Discovery of the World and of Man," "Society and Festivals," and "Morality and Religion." In these perspectives are glimmerings of a "great intellectual process" that Burckhardt summarizes in this way:

> An *objective* treatment and consideration of the state and all the things of this world became possible. The *subjective* side at the same time asserted itself with corresponding emphasis; man became a spiritual *individual*, and recognized himself as such.[15]

Burckhardt is careful to avoid any one authoritative claim about this civilization in history, a reaction, perhaps, to the universalizing Christianity of Hegel's

historical teleology, which, designating the Reformation as the beginning of modernity, charts a singular spirit working itself out in history.[16] Perspectivism allows Burckhardt to acknowledge the particularity of subjective judgment in this picture of the Renaissance, a particularity that applies not only to his own worldview as an individual historian but also to the particular worldview of the modern individual as a categorical vantage point in history.

This perspectival logic of the work of art, as Burckhardt himself recognized, conditions not only the "subjective side" of the modern individual but the possibility of an "objective treatment" as well. And indeed, a move toward scientific objectivity in humanistic study appears to have been the flip side of this artful perspectivism. Burckhardt's near contemporary Wilhelm Dilthey sought to systematize the human sciences and clear them of the prejudicial assumption that they are tainted by the vagaries of subjective judgment and opinion. In order that the human sciences might rival the natural sciences, Dilthey transformed the experience of viewing history as a picture into a philosophy of the worldview or Weltanschauung. The visual logic that for Burckhardt links the outlines of a given civilization to subjective judgment is a historical phenomenon: it has its origins in the Renaissance and is "still at work" in modernity. In Dilthey's work, that visual logic is an essential structure of thought. The "world picture" and the "I think" of self-consciousness are mutually constitutive: "The self is there for us only because it is distinguished from the external world. The latter, in turn, is there only because it is delimited from the self."[17] The world picture becomes the analytic of the human sciences.

So effectively did Dilthey achieve an abstraction of the world picture that it became a generalized methodology of historical inquiry, a paradigm that could be mapped onto any period. Though it is no longer fashionable to speak of historical periods as world pictures, the influence of this method of cultural analysis and periodization has a legacy in our habits of framing time. Burckhardt had imagined that he was both inside and outside of the picture, seeing its outlines, but at the same time feeling its influence. Dilthey endeavored to codify and legitimate humanistic judgment, although by objectifying this contingent way of practicing history as an epistemological method, he also erased aesthetic and subjective judgment from historical inquiry. Thus, where the Renaissance had once been shaped by an aesthetic criterion—namely, the idea of the work of art and the subjective response to it—periodization would now be shaped, and often invisibly so, by an analytical criterion: the world picture as the objective visual logic of the human sciences. At its inception, Dilthey's "world view" was meant to be a procedure for picturing society in its various constitutive parts, like Burckhardt's partial perspectives on a "great intellectual process," rather than one singular vision of a given civilization. In practice, however, the world picture was deployed as a method for precisely such a singular

vision. The objective analysis of thought and epistemology is the flip side of a world picture that produces subjective judgment of character, style, and culture. But in the shift toward objective analysis, the world picture became not only a way of creating pictures *of* a given culture in history but also a way of trying to imagine the worldview pictured *by* a given culture in history.

By the twentieth century, the idea of the world picture had come to be used in just this way: as a means of imagining the thought of another culture in history. In *The Elizabethan World Picture*, for example, E. M. W. Tillyard set about to counteract the work of those "scientifically minded intellectuals" whom he thought had falsely modernized the Elizabethan era as a secular period "in which religious enthusiasm was sufficiently dormant to allow the new humanism to shape out literature."[18] Instead of overemphasizing the secular and humanist strains of the Elizabethan period, Tillyard's world picture downplays the literary and promises an objective view of the Elizabethan "habit of mind." He argues that a "general medieval picture of the world survived in outline into the Elizabethan age" and that the Elizabethan "world picture was ruled by a general conception of order." His evidence for the endurance of this medieval system of order in the Elizabethan era is the "collective mind of the people." The "I think" of this world picture refers not to the historian but to the historical actor. And by using the world picture to reveal the "collective mind" of a people, Tillyard also reveals that he has transformed the model of the "world picture" from a system for creating multiple, individuated perspectives to a universalized principle. The analytic of the world picture has been so sufficiently absorbed as an epistemological method that Tillyard can presume that there is an "I think" and a "world picture" for every subject in history, even a collective subject. Tillyard wants to restore the nonscientific and nonprogressive sensibility of the Renaissance, but his method reveals the extent to which his approach is governed by a mind-set of scientific objectivity. The past is represented here not by an individual who sees but by a subject who thinks. Perceiving a period's "outlines"—which for Burckhardt linked his own subjective judgment to the character of the period he was observing—has become, by the time Tillyard was writing, a universal method for perceiving the "collective mind" of any people in history.[19] By the middle of the twentieth century, the world picture had become so normative a model of historiography that it no longer appeared to have a "subjective side."

The propensity to think in pictures is not a cognitive fact but a phenomenon of modern consciousness.[20] The implication in Tillyard is that for every people, there is a mind-set and the job of the historian is to conjure up its picture. But, as Heidegger explains in his essay, "The Age of the World Picture," "The world picture does not change from an earlier medieval one into a modern one, but rather, the fact that the world becomes picture at all is what

distinguishes the essence of the modern age."[21] Heidegger's essay places the analytic of the world picture back into history, arguing that the distinction that enables us to think of periods as pictures—the distinction between a *subjectum* and "the representedness of that which is"—is itself a feature of modernity. Like Burckhardt, who recognized that subjective judgment was not simply a facet of his own personal perspective but also a facet of the philosophical condition of the modern subject in history, Heidegger reveals that a world picture is not simply an objective form of knowledge but our modern form of knowledge. But unlike Burckhardt, who identified this relation in aesthetic terms— as a relation between the idea of the work of art and the subjective judgment of the modern individual—Heidegger identifies this relation in epistemological terms, as a relation between the world picture and the Cartesian subject. Like Burckhardt, Heidegger defines modernity as a break from the medieval past, and what signals that break is that the world becomes picture and the subject is differentiated from the object or the "representedness of that which is." But whereas for Burckhardt modernity begins with the Renaissance, for Heidegger it begins with Descartes.

How did modernity come to reconfigure itself in this curious way? And what happens to the Renaissance in the wake of that reconfiguration? Margreta de Grazia has explained that our understanding of modernity is bedeviled by an elision of two meanings of the word *modern*: modern as a period marker and modern as a deictic function that points to the present as the now. And one of the characteristic features of the modern era, she goes on to say, is a subject that repeatedly defines its position as new.[22] The modern subject, thus, redefines the new according to *its own* place in the new. Whereas the modern individual once defined itself through an aesthetic relation to the idea of the work of art, the modern subject now defines itself through an epistemological relation to the idea of the world as picture. We perpetuate the tradition, begun in the nineteenth century, of characterizing the historical past from the subjective position of our own perceived relation to that past, even as we have redefined the terms of that relation. Recent criticism has gotten around the problem that the Renaissance no longer appears to bear any relation to this new definition of the modern subject by using the term "early modern" in the place of Renaissance.[23] The use of "early modern" allows literary critics to adopt the latest definition of modernity, while also preserving the tradition that has traced the origins of the now to the period that used to be called the Renaissance.[24]

The picture has changed from that nineteenth-century view of the Renaissance as the origin of the modern individual whose subjective judgment is conditioned by the ideas of the fine arts and the humanities. The twentieth-century view, which has held sway even up to the present, is one that places an emphasis on the early modern period as the origin of a modern subject whose

objectivity is conditioned by the protocols of modern science. But whereas the picture has changed, both views are still conditioned by the idea of the world as picture. Both, in the final analysis, are framed by an outlook variously defined as "modern." The periodization of the fifteenth and sixteenth centuries as "early modern," with modern newly defined as the historical process of, for instance, global capitalism or colonialism, appears to be an objective form of history rather than one that seeks to glimpse in history a "great intellectual process." But these approaches also seek the beginning of the now in the past. And yet, the solution is not as simple as seeing the earlier period as different from our own. As the example of Tillyard shows, to define the period as "pre-modern" rather than "early modern" does not ensure that one is not imposing onto the period a modern frame of thought.

Scholars no longer explicitly try to produce world pictures. Still, the habit of framing history according to the concepts of the modern subject has held fast. And the result is a Renaissance that is either of us or not of us, either subject or object, either the beginnings of modern "man" or an anterior other, either "early modern" or the final waning of the middle ages, either identity or difference. The result, in any of these cases, is a Renaissance that is not really defined according to its own features as a period in its own right. Even a work like Michel Foucault's *The Order of Things*, which explicitly rejects any intention of producing a world picture, frames the Renaissance in counterpoint to a modern subject that is post-Cartesian. Foucault wants to disclose an archaeology of knowledge rather than, to borrow Burckhardt's phrase, the "great intellectual process" of the modern subject. He traces the conditions of possibility for the visual sovereignty of the modern subject in history's sedimented layers all the way back to the Classical period. Foucault pinpoints the early seventeenth century as a rupture between two periods that also constitutes the earliest threshold of modernity. After that rupture, a binary logic of representation defines the epistemology of the natural sciences, in contrast to the previous *episteme*, which he titles "The Prose of the World" and identifies with the end of the Renaissance.[25] His description of an episteme in the sixteenth century ordered by similitude and resemblance seems more a description of a prolonged medieval episteme than a discretely Renaissance one. Despite his conscious avoidance of imagining a world picture, Foucault's description of "The Prose of the World" is not so different, in the end, from the description of an enduring medieval order that Tillyard offers in *The Elizabethan World Picture*.[26] To be fair, Foucault does not claim to represent the "collective mind" of the Renaissance. Instead of picturing thought, he frames knowledge. But the result is one that renders static the unique relationship of language to temporality in the Renaissance. Foucault's Renaissance is a fixed order of resemblance and correspondence, in which there is a unity of words and things and

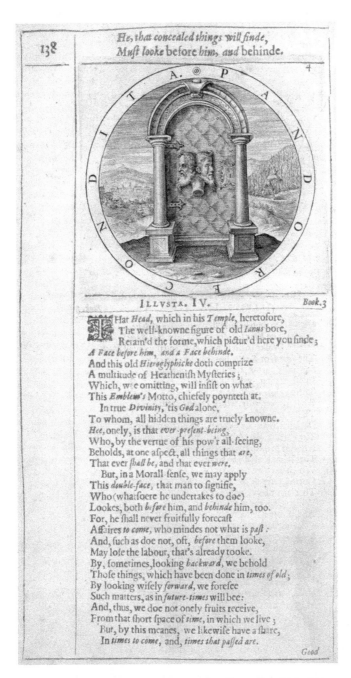

He, that concealed things will finde,
Must looke before him, and behinde.

ILLVSTR. IV. Book.3

That *Head*, which in his *Temple*, heretofore,
The well-knowne figure of old *Ianus* bore,
Retain'd the forme, which pictur'd here you finde;
A Face before him, and a Face behinde,
And this old *Hieroglyphicke* doth comprize
A multitude of Heathenish Myfteries;
Which, wee omitting, will infift on what
This *Emblem's* Motto, chiefely poynteth at.
 In true *Divinity*, 'tis *God* alone,
To whom, all hidden things are truely knowne.
Hee, onely, is that *ever-prefent-being*,
Who, by the vertue of his pow'r all-feeing,
Beholds, at one afpect, all things that *are*,
That ever *fhall be*, and that ever *were*,
 But, in a Morall-fenfe, we may apply
This *double-face*, that man to fignifie,
Who (whatfoere he undertakes to doe)
Lookes, both *before* him, and *behinde* him, too.
For, he fhall never fruitfully forecaft
Affaires *to come*, who mindes not what is *paft* :
And, fuch as doe not, oft, *before* them looke,
May lofe the labour, that's already tooke.
By, fometimes, looking *backward*, we behold
Thofe things, which have been done in *times of old*;
By looking wifely *forward*, we forefee
Such matters, as in *future-times* will bee:
And, thus, we doe not onely fruits receive,
From that fhort fpace of *time*, in which we live ;
But, by this meanes, we likewife have a fhare,
In *times to come*, and, *times that paffed are*.

Good

Figure 1. George Wither, *A Collection of Emblemes* (London, 1634),
138. Courtesy of the Division of Rare and Manuscripts Collection,
Cornell University Library.

"a profound kinship between language and the world." It is a Renaissance still tacitly framed by its nonmodernity.

Modern subjective consciousness, in various guises, has led to the framing and reframing of the Renaissance as its origin and, occasionally, as its objective other. Perhaps framing still has such a hold on our habits of thinking that this is unavoidable. But it seems that we should at least try to begin framing the Renaissance not from the outside in, but from the inside out: not as the Renaissance has been framed by the protocols of an aesthetic teleology that begins modernity with Renaissance works of art, nor as it has been framed by the protocols of an instrumental reason that begins modernity with early modern science, nor even as it has been framed by the protocols of historical consciousness that begins modernity with the Reformation, but in accordance with its own discursive expression of framing as making, tempering, and crafting.[27] To frame the period from the inside out means not to cordon it off but to notice its joints, mixtures, and temperings. Framing from the inside out would look to the relationship between those features of "rebirth" and "reform" that are sometimes kept separate in our period definitions of the Renaissance, while also recognizing that the European Renaissance was diversified by history and geography. To "frame" the Renaissance in this way would be to acknowledge that the Renaissance is as much a rhetoric as it is a picture. And framing from the inside out would involve looking both backward to the past and forward to the future, Janus-like, as was the habit in so many poetic and visual Renaissance exempla.

The Framing of History

Foucault's characterization of the Renaissance may appear flat, but his methodology nonetheless indicates how we might begin to restitute some of the modes of poetic language that are particular to the Renaissance, without framing the period according to the protocols of instrumental reason. For it was precisely the naturalized relation of the modern subject to history that Foucault was writing against. As he describes it, we encounter at the beginning of the nineteenth century the "threshold" of a modernity "that we have not yet left behind": an era in which history is what defines the subject in his relation to everything that is.[28] In contradistinction, Foucault wants to arrest the "impression . . . of an almost uninterrupted development of the European *ratio* from the Renaissance to our own day" and to provide instead a "historical analysis of scientific discourse" that is geared "not to a theory of the knowing subject, but rather to a theory of discursive practice."[29] His method

in *The Order of Things* is to work backward through an archeology of knowledge rather than forward in anticipation of modernity. And in this way he works against the teleology whose force he also acknowledges. Foucault estranges his method from the imperatives of modern history by adapting it to an earlier episteme of the Classical period: he describes knowledge as a "discursive practice" rather than as a philosophical abstraction attributed to conscious reason. I have endeavored to adapt my own method to the turns and tropes of Renaissance poetry in order to describe the temporal process of poesy, rather than its hypostatization as an aesthetic or epistemological object. My aim in following Foucault is to propose a materialist history of the work of the poetic imagination by means of a methodology appropriate to the sixteenth century.

Foucault's resistance to the teleological imperative of the modern subject—the imperative that history reveal itself, in the guise of a picture, as the continuous development of modern consciousness—accounts for his decision, in *The Order of Things*, to describe epistemological fields rather than to theorize epistemological change. And he distances his method from modern historiography by assuming the guise of an earlier period. Foucault's description of the Classical era contains numerous examples of the frame as a figural device that illustrates the Classical episteme: from the *tabula* of the relationship between things, to the table or "quadrilateral of language," to the details of the discussion of *Las Meninas*, to his claim that modern thought has detached itself from "the squares it inhabited before." Foucault's episteme are all framed, but he pointedly resists explanations of the breaches that frame them, leaving lacunae in the places where idealism had allowed ideas to engender ideas. Foucault first balks at explaining historical transitions in his introduction to the Classical era, self-consciously questioning the legitimacy of framing periods but then demurring from any answer; and he does it again at the beginning of Part II—a rhetorical partition that coincides with the rupture between the Classical and the modern eras—in a section titled "The Age of History." In the second instance, Foucault grants that epistemic ruptures must be analyzed, but denies outright they can be explained.

> For an archaeology of knowledge, this profound breach in the expanse of continuities, though it must be analysed, and minutely so, cannot be "explained" or even summed up in a single word. It is a radical event that is distributed across the entire visible surface of knowledge, and whose signs, shocks, and effects it is impossible to follow step by step. Only thought reapprehending itself at the root of its own history could provide a foundation, entirely free of doubt, for what the solitary truth of this event was in itself.[30]

The closer Foucault's study comes to the nineteenth century, to the inaugural moment of a modernity that Foucault admits he has "not left behind," the more emphatically it refuses causal explanation.

Summarizing how the archaeology of knowledge resists the progress of reason within traditional history, Foucault writes in the Preface to *The Order of Things*,

> *Perhaps knowledge succeeds in engendering knowledge*, ideas in transforming themselves and actively modifying one another (*but how?*—historians have not yet enlightened us on this point); one thing, in any case, is certain: *archaeology, addressing itself to the general space of knowledge*, to its configurations, and to the mode of being of the things that appear in it, *defines systems of simultaneity*, as well as the series of muta-tions necessary and sufficient to circumscribe the threshold of a new positivity.[31]

This archaeological method prioritizes space over time, displacing continuous history with "systems of simultaneity." In this respect Foucault's approach bears a resemblance to Ferdinand de Saussure's claim that language, though di-achronic by nature, could only be thoroughly analyzed as a synchronic system. Foucault, however, insisted that he was not a structuralist, and his distinction is not to be dismissed: he claims to describe not closed systems but, rather, mu-tually informing epistemological and discursive fields. Even so, the structuralist and the Foucauldian approach alike depend on a certain framing of the episte-mological field: any project that renders discrete "systems of simultaneity" or emphasizes the "space of knowledge" over against diachronic history inher-ently implies a philosophical act of framing.[32] Foucault would later respond to precisely this charge when he acknowledged that an archaeology of knowledge "seems to treat history only to freeze it."[33]

To frame a period marks off the space of epistemological change, but it effectively bypasses the complex question of change itself. Framing harbors ideas, concepts, and events from the historical current of an imagined global teleology. By framing discursive fields, Foucault was resisting, at least in part, the legacy of Hegel's *The Philosophy of History*. Although many scholars have found unpalatable the idea of a universal spirit working itself out in history toward absolute freedom of consciousness (not to mention the triumph of the German state), Hegel's works have nonetheless offered a persuasive model for explaining the resemblances that can be observed among disparate forms in a given culture as well as the changes in modes of social and cultural expression, from artistic styles to political and intellectual thought.[34] The struggle to re-place the "expressive causality" of Hegelian idealism has been a vexed one.[35] Marx's inversion of Hegelian philosophy, while dispensing with the mystified spirit, had a teleological emphasis of its own that later Marxist scholars have of-ten found hard to shake. In *The Archaeology of Knowledge*, Foucault explains that

archaeology does have a description of change, one that observes the sequence and succession of discourse rather than thought: "Paradoxical as it may be, discursive formations do not have the same model of historicity as the flow of consciousness or the linearity of language" (169). But in *The Order of Things*, Foucault simply refrains from any attempt to explain historical change, preferring instead to look at "systems of simultaneity." These frames seem to offer an alternative by dispensing with teleology, but framing alone does not undermine teleology. As Frederic Jameson has pointed out, synchronic modes of analysis imply a diachronic sequence that gives those framed moments meaning and order.[36] Hegel's own history unveils itself as a succession of four framed periods: Oriental, Greek, Roman, and Germanic. Framing is easily assimilated within the very notion of a totalizing progressive history that it appears to oppose. Foucault's framing of history treats discourse as an object (rather than a trace of thought), whereas the picturing of history takes the subject as its point of departure. And yet the importance of framing in the early iterations of the archaeology of knowledge reveals the extent to which that project was still governed by a subject-object *relation* that codifies time as either progressive change or its suspension.

Theodor Adorno's critique of Hegel suggests that an answer to progressive consciousness must work through a dialectic that is geared both to the nonidentical and to the temporal or contingent. According to Adorno, Hegel cedes history and time itself to logic, just as philosophy has always ceded the temporal to the conceptual.[37] "The concept's immanent claim," Adorno writes, "is its order-creating invariance as against the change in what it also covers." All thought that gives primacy to identity over nonidentity observes the archaic logic of the concept: "The concept hypostatizes its own form against the content. With that, it is already hypostatizing the identity principle."[38] Adorno acknowledges that in *The Philosophy of History* Hegel was "set upon a transition of logic to time." Because Hegel's idealist dialectic "conforms to the primacy of the universal," however, it is "resigned to timeless logic."[39] For Adorno, this "primacy of the universal" extends from the philosophy of history in Hegel's work to Hegel's articulation of the dialectical progression of time, even to his descriptions of historical eras. Criticism, Adorno grants, cannot do without concepts, but it must disavow its faith in the absolute identity of concept, reorienting the concept toward nonidentity. "Necessity compels philosophy to operate with concepts, but this necessity must not be turned into the virtue of their priority—no more than, conversely, criticism of that virtue can be turned into a summary verdict against philosophy."[40] Over and against the framing of concepts, Adorno proposes a "negative dialectics" that is negative only insofar as it is a dialectics no longer "glued to identity."[41]

Foucault's archaeology participates in a similar critique of identitarian logic. "Continuous history," he explains, "is the indispensable correlative to the founding function of the subject."[42] Even *The Order of Things* has the effect of reorienting the concept (of "man," at the very least) in the direction of non-identity: it is a work, as I have said, oriented toward "discursive practice" rather than the "knowing subject," to tables of knowledge, rather than pictures of consciousness. Notwithstanding the reliance on framed periods in this earlier work, Foucault explicitly claims in his later work that historical periods are not the object of archaeological description. Nor does a discourse about discourses seek a "hidden law" or a "concealed origin" imagined to be the mindset or world picture of an age. Its task is rather to "make differences: to constitute [things said] as objects, to analyse them, and to define their concept."[43] Its task, that is, it to take a "thing said" and constitute what once appeared to be a form of thought as an object, defining the concept by means of the object, rather than by means of a concealed principle seen in the object. In this respect, Foucault expresses in *The Archaeology of Knowledge* as subtle and qualified a discourse on objects and concepts as one finds in Adorno's work.[44] Yet it is also a discourse of objects and concepts that recognizes, perforce, its own contingency: that recognizes its own time-bound place as a thing said, and a thing said in response to a philosophy of history in which the concept was invariant and identitarian.

Foucault writes in "The Discourse on Language" that discourse permits the introduction of chance, discontinuity, and materiality "into the very roots of thought."[45] And Foucault's archaeological method of working backwards also bears a resemblance to Althusser's insistence, in his articulation of "a materialism of the encounter," that materialism work backward from the result to its elements rather than forward from a precedent structure to its outcomes. *The Order of Things* does not endeavor to return the concept of history to time in the negative dialectical way that Adorno suggests. Nor does it return history to the kind of chance materialism that Althusser describes as "the materialism, not of a subject (be it God or the proletariat), but of process, a process that has no subject, yet imposes on the subjects (individuals or others) which it dominates the order of its development, with no assignable end."[46] And yet *The Order of Things* is not inimical to either project. It may even indicate, because its method depends upon the Classical *episteme*, a practical reliance on contingency that belies a philosophy of contingency in Althusser. Althusser at times appears to return the invariant concept of history to an invariant *concept* of process.

In *The Order of Things*, Foucault acknowledges historical periods as frames: as apparatuses within which discourses appear, disappear, and intersect and as names that are given to clusters of discourse. Yet he never makes fully intelligible the procedure of framing that informs his own methodology. His project is

to demystify the world picture and to lay bare the relationship between history and the visual sovereignty of the modern individual. A similar demystification of the modern concept of the frame would have to lay bare the entire subject-object relation that is implicated in constituting discourse, or the thing said, as an object or concept. Just as Foucault looked to the Classical era to expose the relationship of the subject to representation, and to avoid crafting a world picture of his own, I look to the Renaissance to expose the epistemology of subject and object in the framing of discursive concepts, and to avoid framing the Renaissance. Whereas Foucault finds a *tabula* in the place of the aesthetics of the picture, I propose a technology of framing in the place of the epistemology of framing. We should not expect *The Order of Things* to do for the Renaissance what it did for the Classical age. But we can and should, I think, return to that earlier work from the methodology laid out in *The Archaeology of Knowledge* because it gives us a model practice for returning the invariant concept of history to the particulars of temporal change.

By looking back to the Renaissance in order to focus on the technology of framing, my aim is to convey the place of temporality, contingency, and historical process in poetic language. Foucault offers a model for thinking backwards through history and for working against the notion that "knowledge succeeds in engendering knowledge." His study is conditioned by its description of the Classical age, and by its resistance to the imperatives of modern history. It is in this accession to historical contingency, and not to the period as a concept that something can be learned about temporal change. As Althusser states, writing about the aleatory materialism of chance encounter in the tradition of Lucretius, Democritus, and Epicurus, "although there is no Meaning to history (an End which transcends it, from its origins to its term) there can be meaning *in* history, since this meaning emerges from an encounter that was real, and really felicitous—or catastrophic, which is also a meaning."[47] My aim is to recognize poetic language in time so as to renew the question of historical change, not in the idealist tradition, nor in the materialist tradition of a critic like Jameson, but in the tradition of archaeology.[48] This is not simply to reproduce Foucault's method, but rather to work backwards to a historically anterior apprehension of temporality and historical process that would, for its part, cancel out the spatial frames of Foucault's archaeological method, much in the way Foucault works back through the world picture to the frame. By stripping away the mystification of progressive diachronic time, and the framed periods that are its counterpoint, my aim is to reconstitute the tangible, material, and temporal underpinnings of transparency in language and representation and to explore the material craft of figurative language—the "how" of its revealing—as both *techne* and *poiesis*.

The Frame before the Work of Art

An anonymous early fourteenth-century Venetian nativity housed in the Philadelphia Museum of Art has the curious feature of bones in its frame (see fig. 2).[1] The panel has an engaged frame. Its border is not alienable from the image but structurally continuous with it: in this case, a molding of gesso and applied gilt mounted directly on the panel. The raised edge of the border extends around the perimeter of the rectangular panel and forms spandrels in each of the upper two corners, between the curved edge of the figurative image and the extreme edge of the panel. The spandrels are fitted with glass, and behind the glass are bone fragments, presumably the sacred relics of a martyr.[2] The display of relics behind glass in recesses adjacent to the painted image is consistent with other reliquary frames, such as the two Sienese reliquaries in the Walters Art Museum in Baltimore and one the Museum of Fine Arts in Boston (see figs. 3, 4, and 5). Both of the Baltimore reliquaries evoke the architecture of a church. Though the Philadelphia panel appears to be a comparatively modest image, nail holes in the back of the panel suggest that the nativity scene may have been affixed to other panels as part of a larger altarpiece. The presence of reliquary niches indicates that the Philadelphia panel bears a relationship to cult shrines.[3] Its reliquary niches, however, are fewer and less pronounced than either of the Baltimore pieces, and a larger portion of the Philadelphia panel is covered by its painted image. By virtue of its quadrilateral shape, the Philadelphia panel also bears a resemblance to the framed picture. Hans Belting has suggested that ecclesiastical painting was largely responsible for detaching devotional imagery from the architecture of the church, and Jacob Burckhardt has similarly argued that the altarpiece is a nascent form of the freestanding work of art.[4] The Philadelphia panel suggests such a transition.

Figure 2. Unknown Italian, *The Nativity and Adoration of the Magi*. c. 1340. Philadelphia Museum of Art: The John G. Johnson Collection, 1917.

What is remarkable about this devotional object, and what sets it so clearly apart from the work of art, is that what a modern viewer might identify as its frame—the gilded border with relics set behind glass—is no frame at all but rather the cardinal feature of the whole object. It might be said that the entire image functions to frame the sacred bones of the martyr.[5]

Figure 3. Lippo Vanni, *Reliquary with Madonna and Child with Saints*. c. 1350. The Walters Art Museum, Baltimore.

That the depiction might have functioned as a frame runs counter to modern expectation. But in fact the depiction in its entirety—not only the picture but also the matter composing the picture—offsets the relic. The materials that tend now to be separated off from the image and associated primarily with the modern frame—namely, carved wood, gold, and in some cases glass—would have been integral to the meaning of a fourteenth-century devotional image. Gold is used throughout the Sienese Adoration mentioned above, not only at the edges of the image but also in the crowns of the magi and the halos of the holy figures. More elaborate reliquary frames, like those at the Walters, would

Figure 4. Naddo Cecarelli, *Reliquary Tabernacle with Virgin and Child*. c. 1350. The Walters Art Museum, Baltimore.

Figure 5. Lippo d'Andrea, Reliquary diptych: *Christ on the Cross with Saints Francis and Onofrius; The Virgin and Child with Saint Lawrence.* Museum of Fine Arts, Boston. Gift of Mr. and Mrs. John Templeman Coolidge. Photograph © Museum of Fine Arts, Boston.

have used gold as the ground for the entire image. The taint of its worldly value did not lead to the relegation of gold to the frame until the Renaissance, when the painterly depiction of light in a picture was distinguished from gem and ornament.[6] That gold foil was generally beaten from coinage for the production of medieval icons and images did not prevent this substance from suffusing the image with its other properties, purity and reflectiveness, conveying therein the divine light of God.[7] Similarly, wood, the substance that would later be used only for the canvas stretcher and the ornamental frame, provided the entire support for the image or, as it was then called, the table. Through the material substance of wood, medieval iconography linked the tree of life with the cross on which Christ was crucified.[8] Even if the wood were not visible, the knowledge that the reliquary is fabricated in part from wood is one way that the reliquary frame would have been interpreted as matter and not simply as image. Just as gold suffused the image with divine light, the wood out of which it was built embodied Christ's sacrifice. Rather than being centered on the depiction alone, the ritual significance of such a sacred object would seem to be conveyed through the totality of materials composing the image.

No single part of the table, not even the raised border at the edge, would have been identified in the fourteenth century as a frame: *frame* simply did not have this meaning then. To frame such an image, according to the meanings of the word at the time, would not have meant to enclose it, but to make, sustain, or advance it: the word might have expressed that the image was of gold and pigment framed or that it was a table made to frame devotion. But the word *frame* did not begin to denote the structure encasing a painting until the emergence of the alienable quadrilateral frame in the latter part of the European Renaissance. This was true not only for the wooden frames of painting but also for other visual devices that might now be called frames because they delimit or ornament the image. Neither the decorative border of a fresco, nor the drollery marking off a narrative scene in an illuminated manuscript, nor the cartouche in a map, to name just a few examples, would have been called a frame before the sixteenth century. And yet, at that point, the word *frame* had been in use for centuries. What exactly did the word *frame* mean before it named the apparatus that delimits an image? And what was it about those earlier meanings that suited the word to this new denotation? In what respect did the earliest quadrilateral frames embody older meanings of the word *frame*? Measuring material changes in the framing of paintings alongside the etymological shift in the word *frame* reveals some of the features of this object that acquired the name of *frame*, and differentiates that object from the features that the frame would acquire in the modern era.

The unique character of framing in the Renaissance cannot be explained by the emergence of the alienable quadrilateral and the correlative shift in the word *frame* if it does not factor in the kinds of material arrangements that were expressed by panels, tables, and borders before they were called frames. Renaissance framing was defined in part by the emergence of an alienable quadrilateral that was not yet associated with the aesthetic and conceptual paradigm of the work of art. Yet Renaissance framing was also defined by the lexical and material expression of metaphysical substance in worldly and temporal matter, and by craft practices that had already begun to dissociate the "frame" of a given thing—the thing *in potentia*—from its structured place within vertical hierarchies of medieval resemblance and signification. A look backward to the late Gothic reliquary frame shows the extent to which these changing modes of signification were bound up with the handling and status of matter. These reliquaries suggest that there was a growing emphasis placed on vision as a part of devotional practice. And yet the presence of glass in these reliquary frames reveals that this emphasis on vision was not necessarily pictorial. The increased emphasis on vision seems to have had more to do with the place of evidentiary matter in spiritual, intellectual, and imaginative apprehension.

This emphasis on the visual apprehension of matter complicates the standard history of the picture frame, which charts the transition from the engaged to the alienable frame as a shift from medieval modes of signification that were sacred and iconic to modern ones that are aesthetic and representational. The Renaissance frame does not properly belong to either mode, and neither does it belong exclusively to the treatment of images. For, questions and concerns about the presentation and perception of images and matter were intimately bound up with the status of the word. And it was precisely the practical orchestration of image, word, and matter that seems to have defined the temporal character of Renaissance framing. The textuality of framing was especially pronounced in England. There, an explicit rhetoric of framing—seen in sixteenth-century logics such as Thomas Wilson's *Rule of Reason* (1551) and Ralph Lever's *Arte of Reason, rightly termed Witcraft* (1573) that frequently refer to the framing and knitting of words and sentences—complemented these other changes in the visual presentation of created matter. The English rhetoric of framing betokened the shifting status of the English vernacular and the craft of writing. And although that rhetoric of framing complements changes in the framing of images, these complementary changes do not always neatly align to express a singular conceptual narrative about changing modes of signification. As the word *frame* began to be used to refer to the picture frame, it brought the production of images into contact with the rhetoric of framing as *poiesis*, the making of language and matter. Yet there is also a disparity in, and sometimes an explicit resistance to, the comparability of the discourse of framing to certain forms of visual abstraction and picturing. Perhaps one of the clearest examples of this is in the respectively visual and textual recuperations of classical forms. The Renaissance frame was an invention in the modern technological sense of a novel instrument or method, and it appears so especially with respect to the reinvention of linear perspective. But Renaissance framing was also invention in the classical rhetorical sense of discovering and reanimating a known topic.

In the final section of this chapter, I look at a Renaissance frame that stages material and technical invention as rhetorical *inventio*, rather than visual abstraction. This frame appears as part of an anecdote in John Lyly's second euphuistic work, *Euphues and His England*. Lyly's description of a two-hundred-foot wooden panel, carved and decorated but without an image, presents a specifically English framing of classicism differentiated from Continental visual models of framing and representation that were keyed more to the rediscovery of linear perspective than to the interpretation of classical texts. The recognition of the Renaissance frame as a rhetorical invention as well as a material and technical invention helps to situate the frame in relation to the humanist rediscovery of classical texts, and not only to the rediscovery of classical perspective. And it also suggests the extent to which framing was a site of material

and imaginative craft during the Renaissance, not only as an object but also as a discourse.

The Emergence of the Alienable Quadrilateral Frame

According to the Oxford English Dictionary, the word *frame* did not regularly signify the quadrilateral that surrounds a work of art until the very beginning of the seventeenth century. It is not that frames had once gone by a different name so much as that the frame as we now know it—a quadrilateral ornament alienable from the image contained within it—had only recently emerged as a distinct and independent object. The word preceded the object: before it became associated with pictures, *frame* had prior significations having little to do with images or even with the more general category of vision. Derived from the Old English verb *framian*, which means "to profit, to benefit, to advance or to make," frame was, at least through the sixteenth century, used primarily as a verb to signify an implicitly beneficent activity.[9] When frame was used as a noun, it referred to the internal design rather than the external ornamentation of a thing: the timber frame of a building, for instance, or the frame of the universe. The meanings that predate the seventeenth century tend to evoke skeletal forms of organization, forms that are often now subsumed under the more specific attribution *framework*. The competing, indeed prevailing, contemporary sense of the word *frame* is that which delimits or squares off: the frame of a painting, a frame of reference, the photographic edge and hence the frame of a projected motion picture.[10] The etymological shift in the word *frame* can be described in general terms as the movement from an older set of meanings that emphasized "bodying forth" to a current emphasis on "cordoning off."

Earlier meanings of frame are extant in current use: we still refer to the frame of a barn, to the framing of an argument, and to the human body as a frame. The date 1600 marks neither a clean break from older meanings nor the single originating instance of a new semantic unit, but is simply a late estimate of when frame came to signify the quadrilateral apparatus around a painting. Yet *frame* may also have conveyed some its far-ranging significance to this object. *Frame* was an appropriate term for this wooden apparatus because it was already used in reference to wood joinery; the appearance of a new definition of *frame* at roughly the same time that the alienable frame emerged is at one level a simple instance of naming. But this naming did not only tack a new entry onto the list of things designated by *frame*; the word developed a primary identification with the quadrilateral frame that it still has today. The close conjoining of the lexical *frame* with that quadrilateral object seems over time to have eclipsed older verbal and material forms of framing and to have outshone

the very terms of the convergence. What is striking about this shift is that this plain object—the very frame that was in the process of being differentiated as the dross material foil to a transcendent and inspired art—could exert such influence over a word that already had a semantic register of important conceptual connotations.[11] But here appearances are not so deceiving; the modern quadrilateral is at once mundane and overwrought: of this world and yet gilded to the extreme.[12] That seemingly mundane frame, it turns out, also codifies the complicated set of relations between the contemporary aesthetic and epistemological conditions that are required if a crafted object is to be valued as *art*.

The emergence of the alienable frame—one that is discontinuous with the surface of the representation—was a gradual process. Many of the earliest freestanding panel paintings had continuous molding: a single panel was hollowed out, leaving a raised border around the periphery of the panel. As these panel paintings became larger and more elaborate, beveled edges carved from separate pieces of wood were added for decoration and support. The use of additional molding kept panels from warping and also allowed supports to be constructed out of more than one panel of wood.[13] Whether the molding was continuous or affixed, frame and panel were prepared together prior to the application of paint. The inscription on one fourteenth-century frame reads, "Simone Cini, the Florentine, made the carving; Gabriello Saracini overlaid it with gold; and Spinello di Luca of Arezzo painted in the year 1385."[14] Examples of panels prepared with an affixed beveled border, such as Duccio di Buoninsenga's *Rucellai Madonna*, date back to the second half of the thirteenth century. Once the beveled border was built to include a niche or rebate that could hold the panel in place, the painting of the panel was no longer reliant on the prior carving of the frame. By the middle of the sixteenth century square rebate frames were widely used in the Netherlands.[15] Likewise the movable, decorated square frame called a *cassetta* emerged in Italy during the sixteenth century.[16] By the end of the Renaissance, canvas had replaced wood as the principal painting surface; emerging notions of artistry had begun to distinguish painting over other crafts, including frame making; and the production of freestanding paintings within a market economy was rivaling an older patronage system that had traditionally bound the work produced to its place of production.[17] Among these changes was the development of a frame that was alienable from the image. The craft of framing became supplemental to the new art of painting, and frames themselves became secondary to a new category of object, the *work of art*.[18]

This transition in the framing of painted images presents itself even in England, which was, for its iconoclasm as much as its geographical insularity, at a remove from the major sources of Renaissance painting in sixteenth-century western Europe. English devotional and ecclesiastical images from the period are scant, since most were displaced or destroyed during the Reformation and, later,

the civil war in England. But portrait frames provide a more abundant source of evidence, and on the basis of that evidence, Jacob Simon has asserted that "the story of the picture frame in England begins in the sixteenth century."[19]

Though there is no surviving inventory of paintings in the royal collection from 1550 through the reign of James I, a comparison of the inventories of Henry VIII and Charles I does suggest that the picture frame emerged sui generis in the almost century-long interim between the two inventories.[20] This is not to say that images did not thereto have borders that we would now identify as frames. A painted image might be joined, as explained above, either with continuous molding or with an engaged frame, but neither appears to have then been called a frame. As long as the border of a picture was joined with the wooden ground of the image, it was rarely differentiated and labeled as a frame. In the inventory of Henry VIII, panel paintings are referred to as "tables" or "tablets." Simon notes that "the few references in Henry VIII's inventories to elaborate frames . . . do not allude to picture frames at all but to embossed velvet or sculpted images."[21] The same inventory notes that parchment and painted cloth were framed: "Item foure tables of parchment sett in frames of wodde" and "item a painted clothe with Tryumphe called the hurlinge of the canes sette in a frame of woode wanuttree colloure."[22] Nowhere in the inventories of Henry VIII and Edward VI is it stated that a "frame" accompanies a panel painting; "frame" is used *only* when the object framed was not only divisible from the frame but made of an entirely different material.

From this evidence we could speculate that the word *frame* began to be applied to pictures only when stretched canvas replaced wood panel as the predominant ground for the painted image: when, that is, the substance of the frame was no longer contiguous with the surface of the painting and could be made as an auxiliary border. Whereas the panel with its extended beveled border had provided in a single structure both the containing and the supporting functions associated with framing, canvas divided these functions. A wooden stretcher or frame still supported the image painted on canvas, but the structural and visible functions of the frame were sundered. Painting on canvas thus prompted the production of discrete, quadrilateral frames. As painting moved onto canvas, both kinds of framing—the tectonic form associated with older meanings of *frame* and the quadrilateral form associated with newer meanings of the word—were still materially present in the frame apparatus, but the function of the frame, as well as the nomenclature, increasingly shifted to the visible frame, to the ornamental quadrilateral rather than the structural armature. By the time of Charles I, when Abraham van der Doort was hired to make an inventory of the royal collection, "pictures" and "frames" had acquired the discrete names we now give them and both were described in some detail. An entry from the van der Doort inventory describes first a Titian and Arntine

canvas in a gilded frame and then "a ffatt Vulcan" and a "fatt Venus" on pan-
els in a "black and guilded quarrell manner frame."²³ Once the frame has been
distinguished as a separate object, it is identified as such not only for images
"painted uppon cloth" but also for images "upon boards Painted." The archival
attention to the frame in this inventory coincides with the documentation of a
trade in paintings between the king and the lord of Barksheare. Painting on
canvas and its complementary frame facilitated the exchange of painted im-
ages, as with the paintings "chaunged" above, and the subsequent commercial
trade in painted images.

 If the alienable frame is understood to have emerged exclusively out of the
engaged molding of a private devotional or secular image, then it makes sense
to assume, as Simon does, that frames went from relatively little value at their
inception to considerably greater value and significance. Frames did become
increasingly ornate and they did increase in value over the course of the seven-
teenth and eighteenth centuries. This increased value, however, is attributable
not to the frame in its own right but to its adjacency to painting. For it was at
this time that painting underwent a transformation in status from artisanal craft
to fine art. By the time of Charles I, frames were already elaborately carved,
gilded, and independent of the image, as they had not been for earlier free-
standing images in the royal collection. But frames did not become aestheti-
cally valuable in their own right the way that paintings did. Whereas painting
became rarefied as the work of unique artists, frame making by contrast be-
came an increasingly anonymous craft. This anonymous craft, however, has an
auspicious prehistory. Independent frames—though they would not have been
called frames—were being produced, in the form of the carved wooden altar-
piece, by sculptors long before the emergence of the alienable quadrilateral
frame. In the context of that history, it becomes clear that the crafts associated
with frame making had already been devalued and that, relative to the artistry
of painting, the value of the frame was in fact declining.

 Altarpiece frames wrought separately from the images they displayed predate
the *cassetta* and rebate frames by at least a century. Separable though they were,
altarpiece frames were in many respects distinct from the alienable quadrilateral
frame. Until the eighteenth century, surviving payment records for the pro-
duction of frames are almost exclusively documents pertaining to the pro-
duction of altarpieces and date largely to fifteenth-century Italy.²⁴ These
commissions indicate that altarpiece frames were usually made prior to or in
tandem with, and at a greater cost than, the painted panels they contained. The
fundamental formal difference between the altarpiece frame and the alienable
frame is that the altarpiece frame, both in appearance and in production, was
more properly an architectural structure. The altarpiece was designed to reiterate
the features of its setting, the Gothic cathedral, for example, and was therefore

distinct from the alienable quadrilateral frame of a freestanding painting, which was bound to no particular architectural site. Alienable quadrilateral frames also contain architectonic elements, but to the extent that those elements refer to architectural space, they do so as portals or windows that open onto an external space rather than repeating the overall interior space.

The emergence in the fifteenth century of a square tabernacle frame bounded on the sides by classical columns has been emphasized more for its square shape than for its architectural elements. After a century of increasingly complex winged altarpieces designed to imitate the cross section of the Gothic cathedral, there was a tendency in the second half of the fourteenth century to recentralize the image of the altarpiece into a single pictorial space, though the top of the image was still often structured as a series of arches. Burckhardt writes of these precursors to the square tabernacle: "By now, too, Italy had created the unified altarpiece consisting of a single pictorial field, an innovation that was to be of immense importance for the whole subsequent history of western art."[25] The single pictorial field is an "innovation . . . of immense importance" because it is coordinated with perspectival representation.[26] Since Leon Battista Alberti's 1435 articulation of painting as a window onto the world, a delimiting quadrilateral has been linked with the very notion of a picture: in current Italian *il quadro* designates any painting regardless of shape.[27] That is to say, a delimiting quadrilateral is associated with the very idea of the *work of art*. The single pictorial field was less the natural evolution of a ritually significant altarpiece than it was an innovation imported to altarpiece production from painting practices that had been deeply influenced by mathematics, neoclassicism, and humanism. Like the altarpiece frame before it, the alienable frame is independently wrought. But the altarpiece frame imitates the surrounding architecture in order to integrate the image with its environment, whereas the alienable quadrilateral frame facilitates the arrangement of a pictorial field meant to transport the viewer into an imagined other space.

As the art of painting was elevated over that of carving, the concurrent uniformity in the shape of a *work of art* as a painted rectangular table allowed for frames to be interchangeable.[28] The documentation of frames became relatively scarce, as did original frames themselves, once the painting proper was granted special artistic value and frames were deemed extrinsic to the work. As paintings were increasingly incorporated into domestic and secular settings, it was the frame that was made to bear the marks of historical contingency. The frame was no longer structurally tied to the surrounding architecture but could be changed like upholstery and furniture to keep pace with interior design. The *work of art* itself remained a durable and permanent fixture, while the frame became expendable and, like clothing, subject to fashion.[29] At this point, the production and sale of frames ceased to be as carefully documented. Once

out of style, the frames were not deemed worthy of keeping. The status of the frame and the *work of art* diverged; the frame was no longer commensurate with the image, as it had been in altarpiece commissions, either in the specifications for its production or in its monetary worth. That is not to say that commissions of secular work expressly devalued the frame, but that the commercial trade in works of art overvalued the painting at the expense of the frame. It is as though the frame took upon itself all the worldly or commercial taint involved in the work of art having become a commodity. Commodity value dissolves the identification of an object with its maker. The value of art, by contrast, depends entirely on the object's connection to a single individual talent. Whereas the frame once located the painted image within an ecclesiastical architecture, it came to locate the aesthetic image within the "architecture" of the marketplace. Art became the mystified product of genius, and the frame, it seems, became an object much like any other.

The alienable picture frame is an innovation that straddles two competing valuations of the painted image, one sacred and one secular. The privileging of the *quadro* as the space of representation, which helped to facilitate the perspectival rendering of space, seems to advance a secular view of the image insofar as it signals the presence of human reason and calculation in the production of sacred and secular images alike. And yet, insofar as the quadrilateral frame made possible the later aesthetic valuation of the object, the quadrilateral frame seems to perpetuate a quasi-mystical view of the image. As painting was increasingly recognized as the product of human rather than divine inspiration, it looked increasingly idolatrous. Thus quadrilateral framing may have been both a provocation of and an answer to iconoclasm. Whereas iconoclasm strips the graven image of its pretended divinity, framing remystifies the painting as a work of art, ultimately restituting the lost iconicity of the painting through the aesthetics of the sublime.[30] If our purpose were to chart this transition from the sacred to the aesthetic, the picture frame might easily be associated with a newly secular valuation of art. Separated off from the image, the picture frame helps to install a burgeoning notion of artistry, demarcating and distinguishing the newly privileged space of painterly depiction. Subordinated as pure matter and relegated to craft practice, the frame allows painting to remain mystified, even as the terms of that mystification are translated out of a religious context and into an aesthetic one. One of the effects of charting a transition from the spirit of God to the human spirit in this way is that it permits painting to remain otherworldly. So long as the requisite material transactions of such an ideological transposition are sloughed off onto the frame, the illusion that painterly production is and always was mystified in some way can pass undisturbed. A history of Renaissance framing that explains the emergence of the alienable quadrilateral frame exclusively in terms of

images, and not also in terms of language, presupposes the autonomy of painting and projects an aesthetic understanding of both the painting and the frame onto this moment of the emergence of the alienable quadrilateral.

Such a history ultimately glosses over the particularity of the emergence of the alienable quadrilateral at the intersection of these two systems of valuation. The ease with which the metaphysical potency of images could be converted into an emulation of human artistic ingenuity was, in all likelihood, one of the things that provoked charges of idolatrous thought. Iconoclasm does not evince a culture in which images no longer hold mystical power but a culture in which images are so captivating that the possibility of their unauthorized use—to worship something profane, for instance—warrants their destruction. The dismantling of sacred objects in sixteenth-century England suggests less a desire to dismiss or avoid images per se than an active need to divest crafted images of their iconic status and to present them as material artifice.[31] The concerns about idolatry in sixteenth-century England—and iconoclasm represents one such concern—were not limited to the treatment of images; they were concerns about the status of matter and the proper regard, on the part of the beholder, for matter. How does one understand the divinity inherent in the visible created world without falsely worshiping it? How does one ensure that one's apprehension of spiritual reality is a true apprehension and not the effect of an idolatrous imagination? These concerns were brought to bear on the recognition and interpretation of all signs, whether verbal, visual, or material. Renaissance framing, as both a lexical and material practice, answered these concerns by intimating the proper temperance of spirit and matter in all acts of creation and reception. Insofar as framing participated in translating the sacred image into a secular representation, it did so at a practical rather than conceptual level. At the same time, framing made it possible to recognize rhetorical invention as both a material craft and a creative and intellectual process.

The Reliquary Frame

In the reliquary panels with which I began this chapter, the material composition of the panel is part of its design for worship. The worshiper is not, presumably, meant to apprehend bones, gold, wood, tempera, and glass together as a dead image—the dross but necessary means to an immaterial and purely contemplative end—but as matter suffused with divinity, as matter through which it is possible to recognize the miracle of incarnation, divine intercession, and the promise of redemption. The panel invites a devotional practice that is attentive to the significance of matter itself: it prompts the viewer to look into the materials at hand for their meaning and purpose rather

than looking past them, as one might seek anagogically the transcendental meaning that lies above and beyond the material sign. The priority of the relic sets the terms for this devotional and heuristic practice: acknowledging that the relic is a sacred object depends on the belief that divinity can inhere in even the basest matter, that the dismembered fragment of a corpse may be a sanctified thing, and even that the inanimate object may have efficacy as a divine intercessor.[32] The image and the relic together demonstrate the efficacy of matter to convey divinity and to register the faith of the observer. The frame—or at least the structure that we would now call the frame—establishes the ground, both literally and figuratively, on which the image and the relic are comparable: it places image and relic in physical proximity, ensuring that the bone can be identified as the sacred fragment of a martyr and that the image can be recognized as no mere graven image, but as an image inspired by divine making. The engaged frame does not isolate the unique and precious object so much as it establishes adjacencies between things.

The embedding of relics within ecclesiastical imagery is not new to the fourteenth century.[33] Yet the use of rock crystal and glass in the devotional object as a way of displaying the relic does announce a novelty with respect to the treatment of the relic at this particular moment in pre-Reformation Europe. In the fourteenth century, monstrances (vessels for display of the host) and reliquaries of all kinds began to incorporate first rock crystal and then glass into their design in order to make visible the host or relic.[34] As the image on the cover of this book shows, transparent stones, fashioned as rings and set into a silver hand reliquary, might serve as a window onto the finger bone fragment of a martyr contained within the devotional object. Rock crystal fashioned into a cruciform might contain a fragment of the true cross; cylindrical monstrance vessels of rock crystal rendered the host visible from all sides (see figs. 6 and 7). In his colloquy on pilgrimages—a colloquy that appears to have been based on visits to England in 1512 and 1514—Erasmus describes a display of the Virgin's milk enclosed in crystal high on the altar at Our Lady of Walsingham, or St. Mary's-by-the-sea, as he calls it, making fun of the practice of pilgrimage as sightseeing.[35]

The sudden demand for rock crystal was at least partially responsible for the push to develop perfectly clear glass as a cheaper alternative to rock crystal. It was no longer enough to believe that the relic was there, it needed to be seen: the relic was uncased from caskets and set into elaborate displays, and its visually verifiable material presence played an increased importance in devotional practice.[36] Reliquary paintings are representative of a broader set of devotional objects that were designed to emphasize the visibility of the relic.[37] Though the painted reliquaries place the carefully preserved remnant of a saint in a visibly adjacent relation to other uniquely crafted, if not divinely authored,

Figure 6. Reliquary Cross for a Thorn from the Crown of Thorns. c. 1425. Italian, possibly Sienese. The Walters Art Museum, Baltimore.

Figure 7. Monstrance of Thadea Petrucci. c. 1400.
Sienese. The Walters Art Museum, Baltimore.

Figure 8. Sixteenth-century Spanish reliquary. Victoria and Albert Museum, London. Bequeathed by Dr. W. L. Hildburgh FSA. Courtesy of V & A Images.

materials—pigment ground from precious gems, gold pounded out to the thinness of a hair, bits of inscribed text, glass that has been blown and cut into roundels—the glass, above all other materials, demonstrates most clearly a devotional and heuristic practice in which worldly matter was simultaneously

EMBLEMA XXX.
Candor est lucis æternæ & speculum. Sap. 7.

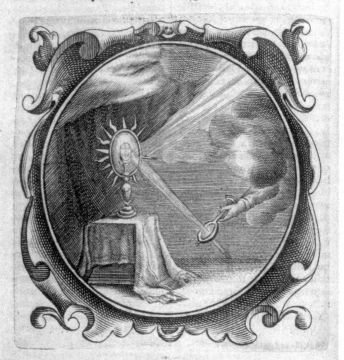

ACCENDIT ET ARDET. ₐ
DOMINICA SECUNDA POST PENTECOSTEN.

§. I. *Hostia Eucharistica, qua mirificè facit ad illuminandos & inflam-*
 mandos animos.speculo caustico comparatur.
§. II. *Accedite ad eum, & illuminamini.* Psal. 33.
§. III. *Quinam ex hoc pane intellectus, sibi radium divinæ sapientiæ*
 mutuarint.
§. IV. *Umbram fugat veritas : noctem lux eliminat.*
§. V. *Speculum Eucharisticum fidelium corda inflammat.*
§. VI. *Dispositiones animi pravæ, ad flammas ex Eucharistico speculo*
 concipiendæ.
§. VII. *Proxima ad divinas flammas concipiendas dispositio, fervens de-*
 siderium.
§. VIII. *Quo amoris incendis, Deipara Christum utero conceperit, & in*
 Eucharistia sumpserit.

ₐ 3. Metamor. DOMI-

Figure 9. Henricus Englegrave, *Lux Evangelica* (Cologne, 1655), vol. 2,
486. Courtesy of the Division of Rare and Manuscripts Collection,
Cornell University Library.

recognized as both a physical reality and a transparent screen through which the suffusion of divinity in matter may be glimpsed. One sixteenth-century Spanish reliquary is composed entirely of glass roundels in a rectangular arrangement, some of the roundels containing relics with identifying text, some containing reverse painted images of saints (see fig. 8). The use of rock crystal and glass in these devotional objects suggests that faithful understanding depends on the visual sense perception of a physically proximate and verifiable object, and the proper interpretation of that matter. The use of glass in this image is not so much a symbol of something—in the way that the depiction of light passing through a glass vessel in a painting of the Annunciation may be said to symbolize the Immaculate Conception—as it is a kind of exemplary instrument for the appropriately spiritual perception of matter. Of course, the use of glass as a symbolic figure for the transparent spirituality of divine matter continues to be used in Counter-Reformation imagery, as the seventeenth-century Catholic emblem book, *Lux Evangelica*, reveals (see fig. 9).

Given the novel use of glass in the reliquary altarpieces, and given the novelty as well of these reliquaries as freestanding devotional objects, it is tempting to see the earlier reliquary objects as breaking with medieval tradition. For that reason, at least one critic has identified such frames as "pre-Renaissance."[38] In other cases, however, these works have been categorized as part of the International Style or International Gothic.[39] The use of glass for didactic religious purposes is certainly one of the defining features of the Gothic period. Eamon Duffy, among others, has pointed out that stained glass windows shifted catechetical teaching from the wall to the window: even a locution such as "I see the light" indicates that the window had become the locus of learning for an illiterate laity.[40] But the use of glass in the reliquary painting does not function like the "anagogic window" as described by Abbot Suger, where an instructional narrative is lit from behind and above, directing the viewer's attention to a truer light.[41] Instead, they direct the viewer to the spirituality inherent in dross matter.

There is further evidence that glass used in this way was an important material ground in objects meant for private contemplation. The Walters Art Gallery in Baltimore houses a small reliquary diptych, of two hinged wood panels containing plaques of *verre églomisé*, or glass that has been backed with gold foil and then incised and painted (see fig. 10). These *verre églomisé* panels often left breaks in the gold-foil backing where minuscule reliquary shards and paper inscriptions could be patched in, so that words and relics appear alongside the incised and painted imagery under the smooth unifying surface of the glass plate.[42] Glass, it seems, was a material support and structuring device for both communal didactic imagery and the hortatory imagery of private devotional contemplation. The painted image with its engaged frame and the *verre*

Figure 10. Reliquary diptych. *Crucifixion and Nativity.* c. 1400. Umbrian. The Walters Art Museum, Baltimore.

églomisé reliquary diptych are, like stained glass windows, heuristic instruments; but unlike the stained glass, these late Gothic innovations are orchestrated around the relic. To put it in crudely schematic terms, they are heuristic instruments for the proper interpretation not of divine light but of matter that appears moribund and fragmented, though it is in truth divine. It would be difficult to categorize these detached devotional objects as either iconic or aesthetic. They orchestrate a relationship between their elements. Wood and glass, image and text, are all part of the apparatus that makes possible the visibility and interpretation of the sacred material fragment. These are objects that draw our attention to the materiality of the sign, or perhaps it is more accurate to say that they are objects that draw our attention to the signification of matter.

In the Naddo Ceccarelli reliquary frame at the Walters, scraps of paper with identifying text are enclosed along with the relic in the recesses that are fronted with glass roundels. The presence of those scraps of text, combined with the diptych structure of some of the painted reliquaries and *verre églomisé* pieces,

are a reminder that these objects belong not only to the history of painting and the visual sign but also to the history of the book and the linguistic sign.[43] In the Ceccarelli reliquary frame, text and image appear to be interchangeable, mutually reinforcing "extraneous signs" in the identification of the sacred relic.[44] Yet the history of ecclesiastical painting suggests that the dynamic between word and image in the determination of spiritual matter was in fact more contestatory. Hans Belting reports that although "in the twelfth and thirteenth centuries there was still violent disagreement over whether there should be images on the altar," a synod at Trier in 1310 demanded that every altar should bear an inscription or an image of the titular saint.[45] There were those who believed that the word alone should have priority and presence at the altar. A response to this position seems encoded in the very structure of the winged or folding altarpiece, which draws on the authority of the word by imitating the apparatus of the book. Reformers, of course, challenged the legitimacy of images within devotional practice, and at the same time were concerned with defining just exactly what happened to the material substance of the host upon the verbal blessing of the priest.[46] And though it would seem that, for Protestants, it was the word alone that had the capacity to confer or elicit the sanctity in matter, the need to exclude images attests to their continued power. The fate of word and image remained deeply intertwined in the struggle over who or what would arbitrate the presence of divinity in material reality, and how. The apparatuses of both language and imagery in this period were equally concerned with and embattled over the status of matter.

Even as proto-Reformation Catholics, such as Erasmus, were mocking the worship of relics, others, such as Sir Thomas More, were defending them in early sixteenth-century England.[47] After the injunction against and removal of images and relics initiated by Thomas Cromwell in the late 1530s, the worship of relics in England would have been largely unsanctioned. Nonetheless, it would not have been an anathema to come across a devotional object with bones in its frame. *The Booke of Christian Praiers*, arguably the most popular printed books of hours in the Elizabethan period, contains text bordered with pictorial exempla on every page (see fig. 11). In the second half of the book, coinciding with the hours of the dead, the borders are composed of allegorical scenes of Death commingled with other block woodcut impressions of either a skeleton or a pile of bones and sometimes both, but at least one of these per page. The first half of the book populates its borders with passages from scripture coupled with illustrations. And though the book of hours is an entirely different kind of devotional object than the reliquary frame, like the reliquary frame *The Booke of Christian Praiers* also inverts our expectations of center and margin. Prayers and devotions occupy the center of the page, but passages from scripture are set into cartouches as part of the ornamental border. The sacred

Praiers. 122

forth. Trulie thou O mercifull Father
hadſt of thine owne goodnes made this
worke of childe bearing eaſe, but our
ſinne hath made it ſorrowfull, and full
of danger.

O moſt gratious workman, let thy
pitifulneſſe amend the thing whiche our
ſinfulneſſe hath marred, and either a-
bate my paine, that I may not haue
need of ſo great ſtrength, tendance, and
cunning: or elſe increaſe my ſtrongthe,
power, and courage, that I may be a-
ble to ouercome all the paine of my tra-
uell, Amen.

A praier to be ſaid of ſuch
as be vnder the croſſe.

HOw long wilte thou forget me O
Lord, for euer? how long wilte thou
hide thy face from me?
Howe long ſhall I ſeeke comfort in

Both ſheepe and ſhepheard all muſt die,
We taught the ſame, the ſame wee trie.

The Doctor.
Doctor diuine a
laſt: thy reading
houre is paſt.

The Preacher.
Preach no more
about: thy glaſſe
is cum out.

KK.ii. my

Figure 11. Richard Day, *Booke of Christian Prayers* (London, 1590), 122 (KK_{ii}r). By permission of the Folger Shakespeare Library.

text is placed in what most modern readers would view as the margins or the frame of the printed page.[48]

The depiction of bones, set into the structural border, serves as a *memento mori*, as matter for contemplation, not as an intercessory object like the relics in the Sienese reliquaries. Even so, the presence of bones in each reveals techniques of arrangement and signification that link these two instruments of worship and contemplation despite the fact that they are otherwise radically separated by doctrine, geography, and chronology. The prayer book leaves allowance for the recognition of the image, the bone, and the textual fragment alike as worldly matter, as *vanitas*. Other prayer books hierarchize the words and images in their decorative borders. In one, the memento mori of a skull is printed in the border at the bottom of each page, flanked by incantatory language and prayer that has been offset in marginal cartouches, the top border depicts the transcendent word of God, and on the side borders are named figures from scripture.[49] If these borders direct the reader to treat the prayers and meditations that make up the central text as matter for transcendent contemplation, they also keep such contemplation grounded. In a reverse painted glass diptych, the relics are arranged with identifying text in the border that surrounds the central image; it is the relic that grants authority to the image. In the printed prayer manuals, the central text may be said to function as transparent material, material to be looked through. Yet the border around it reiterates the ritual "hours" of contemplation and anchors contemplation to its worldly and temporal circumstance. Despite the differences in these artifacts—most notably the difference between actual bones and the representation of them as a symbolic reference to the vanity of worldly things—they share similar techniques of arrangement. Something is conserved in the structure or technology of the artifacts, despite the distinct devotional and interpretive practices that they solicit and codify. I do not propose that a lineage of influence links these objects but rather, that the Renaissance technologies of framing and glassmaking are inclusive of both these early reliquary and textual forms. These technologies provide a different set of reference points through which to view the forms that emerge at the end of the Renaissance, the alienable quadrilateral and the sheet glass window. A look backward to the reliquary frame in addition to forward to the quadrilateral frame reveals how textuality, transparency, and the apprehension of matter defined the technology of the Renaissance frame.

Word, Image, and Frame

I have thus far spoken about a technology of framing that is both textual and visual without making reference to the classical tradition of the sister arts of

poetry and painting that was revived with enthusiasm during the Renaissance. If the emergence of the alienable quadrilateral and the corresponding changes in the word *frame* brought the production of images into contact with a rhetoric of framing, then is not the discourse on the sister arts the proper place for an investigation of the technology of framing? My answer is no, and my reason is that the technology of framing does not belong to the sister arts, which is principally a tradition of picture and idea. If we understand the Renaissance frame exclusively in terms of the emergence of a privileged pictorial space, then it is possible to extrapolate a corresponding narrative or poetic space that observes the dictum, *ut pictura poiesis*. But if we understand the Renaissance frame in terms of its late Gothic or pre-Renaissance forms, then the correspondence seems less clear. What would be the literary counterpart to such a frame? And why is it so much easier to imagine a "speaking picture" than a "speaking table" or "speaking panel"? The answer to the latter question lies, at least in part, in the long tradition that has rendered familiar the idea of a verbal picture. Yet the real difficulty in finding a literary counterpart to the Renaissance frame is not that it demands novelty or ingenuity but that the task is an essentially impossible one. The Renaissance frame belongs neither to poetry nor painting. It might, in fact, be more accurate to say that the Renaissance frame is the material foil to the *paragone* of poetry and painting.

The comparison of poetry with painting goes back at least as far as Horace, who urges that the poet should, like the painter, imitate the natural integrity of things, rather than inventing monstrous forms. Through the Renaissance, the traditions of *ekphrasis*, *ut pictora poiesis*, and *paragone* conveyed a sense of contest between different forms of imitation that were not yet understood as "art" in the modern sense. Although painting would later come to exemplify the aesthetic, in the early Renaissance the artisanal practice of painting in Italy had to legitimate itself—it is worth noting—through comparisons to rhetoric.[50] The modern system of the arts, and the privileging of painting as a work of art, inflected that tradition of comparison between poetry and painting such that the distinctiveness of poetic language came to be defined in largely pictorial and aesthetic terms.[51]

An influential early example is Gotthold Ephrain Lessing's 1766 book *Laocoön*.[52] Lessing differentiated poetry from painting on the grounds that each depends on distinct modes of sensory apprehension, and in this way he emphasized the autonomy of poetry and painting. At the same time, however, *Laocoön* made the comparison of poetry and painting central to the study of poetic language. Lessing's project was not only to differentiate poetry from painting, it was also to differentiate poetry from other forms of language: to find out what made poetry artistic. For Lessing, the artistry of poetic language lay in its capacity for picturing. In effect, Lessing's work defined poetry by its

simultaneous propinquity toward pictures and sensory difference from paint-
ing. The differentiation of modes—poets work with figurative language,
whereas painters work with pigment—is built on an underlying premise that
poet and painter alike produce pictures.

In her 1947 book *Elizabethan and Metaphysical Imagery*, Rosamond Tuve ar-
gued that the emphasis on poetry as the sensuous apprehension of beauty de-
rives from a modern system of the fine arts. Tuve observes that Renaissance
poetry, by contrast, did not separate the logical structure of a poem from its
ornamentation. And she warns against an agonistic reading of the Horatian
formula *ut pictura poesis*, claiming that the Renaissance relationship between
poetry and painting was cooperative rather than competitive. Not only did
poets and painters share a unified "frame of reference," the inherently logical
frame of Renaissance poetry united word and image.[53] Although Tuve's
reading stresses the logical rather than the sensuous aspects of poetic lan-
guage and thus moves away from the aesthetic experience of poetry, an aes-
thetic idea—the logical frame—still defines the special character of poetic
language.

On the one hand, the sister arts are defined by a competition over which
medium has a superior claim to the sensuous apprehension of beauty. On the
other hand, the sister arts are defined by collaboration in an overarching logic
that unites them. Scholarship subsequent to Tuve has sought to unite these two
strains. For Ernest Gilman, the overarching term that links the verbal to the vi-
sual in the seventeenth century is neither a sensuous particularity nor a logical
abstraction, but "wit."[54] Murray Krieger makes the argument that *ekphrasis* ar-
ticulates the independent functions of verbal and visual representation, while
also expressing the desire for a natural sign, or an abstract universal and unify-
ing principle. Whereas Krieger does not collapse verbal and visual media into
a single abstract principle, he does claim that *ekphrasis* is motivated by the semi-
otic desire to represent the unrepresentable: a desire for the (conceptual) abyss
that, as Krieger recognizes, is at odds with empiricism.[55] An aesthetics of the
sublime resonates in this *ekphrastic* desire for the unrepresentable.

The unrepresentable abyss also figures in Jacques Derrida's discussion of
Kant in *The Truth in Painting*. Derrida points out that Kant intended his Third
Critique to bridge the abyss between pure and practical reason and then argues
that Kant ultimately deployed rational principles to explain the very aesthetic
judgment that he at first claimed could not be explained by way of reason. Al-
though Derrida's own text is open to the criticism that it too uses philosophy
to resolve the enigma of aesthetic judgment (turning to Kant, for instance, to
address the relationship between word and image), it does nonetheless aim to
foster a materialist account of the unrepresentable abyss in its exploration of
the frame.[56]

Derrida opens the book with a quotation from Cezanne who writes, in a letter to Emile Bernard, "I owe you the truth in painting and I will tell it to you."[57] Derrida's rhetoric discloses that the frame works to suture boundaries between disciplinary practices and idioms: between poetry and painting, and between aesthetics and reason. For Derrida, what the frame covers over is the abyss between idioms, it covers over the abyss in the guise of philosophy and in the guise of identity. "It never lets itself be simply exposed," for if it did, it would reveal that it belongs to neither of its adjacent idioms, but to both of them.[58] It would reveal its marginality, its nonidentity. For Derrida, the analytic of the beautiful, and indeed the entire Third Critique, functions as a frame or parergon that is neither fully internal nor fully external to philosophy. In the Third Critique, "Kant applies an analytic of logical judgments into an analytic of aesthetic judgments at the very moment that he is insisting on the irreducability of one kind to the other."[59] Kant imagined that aesthetic judgment, though an enigma to both pure and practical reason, could autonomously inhabit the divide that separates these two branches of philosophy; Derrida wants to show that the analytic of the beautiful is far more mediated than Kant suggested.

In a passage meant to demonstrate that a parergon like the frame, despite its seemingly ornamental and auxilliary status, does in fact perform a certain kind of work, Derrida reveals that the frame is at once mundane and transcendent, logical and sublime, philosophical and artistic: "The frame labors indeed. Place of labor, structurally bordered origin of surplus, i. e. overflowed on these two borders [the first two Critiques] by what it overflows, it gives indeed. Like wood. It creaks and cracks, breaks down and dislocates even as it cooperates in the production of the product, overflows and is deduc(t)ed from it. It never lets itself simply be exposed."[60] What Derrida points out, rather poetically, is that the frame, unnoticed, does a good deal of "work" to maintain elevated abstractions.

Did the Renaissance frame perform this kind of "work"? Because frames engaged with the painted panel were replaced during the Renaissance with frames that were alienable from the paintings they enclosed, it would seem that the quadrilateral picture frame is an invention in the modern technological sense and a departure from an older sense of framing as techne. The alienable quadrilateral frame certainly appears to be of a piece with other innovations attributed to the Renaissance that have been equated with subjective mastery, namely the work of art and the reinvention of linear perspective. But to see the Renaissance frame in this light is to define it by its subsequent history: by its place within a modern history of painting that looks back to fifteenth-century Italy as the origins of the work of art. As an adjunct to that history, the salient feature of Renaissance framing is its conceptualization and anticipation of the work of art: its emergence as the idea of an alienable quadrilateral that sets the

parameters of linear perspective. But empirical evidence about frames troubles this chronology. Whereas the evanescence of the work of art is traced to the fifteenth century in Renaissance painting, it is generally agreed that the alienable quadrilateral frame is a later Renaissance innovation. And thus, what constitutes the "Renaissance" frame is by no means clear. What is to be made of the fact that the emergence of the alienable quadrilateral frame is acknowledged to have been a late Renaissance phenomenon? Would this mean that the Renaissance proper is somehow later than we had imagined or would we have to conclude that the paradigmatic "Renaissance" frame is not one that is alienable from its image? And furthermore, what should be made of the fact that many of the innovations in the quadrilateral frame were first initiated in the Netherlands, rather than Italy? The emergence of the alienable frame has been linked to the reinvention of linear perspective and, because perspective involves mathematical and geometrical calculation, to the new science and progressive rationalism. Yet it is well acknowledged that the distinction between artisanal innovation and scientific or technical inventions was less rigidly defined during the Renaissance than it is today.[61] Framing, precisely because it was both a craft and an art, should encourage us to think not merely about the practical and material foundations from which modern concepts emerged, but also about the continuously shifting relations of matter and meaning in history.[62]

Framing has, in fact, been overly inflected by its relation to perspective. In his work on linear perspective as a symbolic form, Erwin Panofsky explains that what distinguishes modern perspective from its classical antecedents is that, beginning in the Renaissance, "aesthetic space" and "theoretical space" appear to be one and the same sensation.[63] Panofsky acknowledged that this perceptual consolidation of visual symbolization and logical form happened, not in a single thunderclap of perspectival innovation but over the course of a long and complex history. Even so, for Panofsky, Renaissance perspective inaugurated a "view of space [that] even with its still-mystical coloring, is the same view that will later be rationalized by Cartesianism and formalized by Kantianism."[64] Svetlana Alpers argues that Panofsky's understanding of perspective as not only a painterly practice of the Italian Renaissance but also a symbolic form, was foundational to the very idea of the work of art as a representation and signifying practice for the entire discipline of art history.[65] Panofsky reminds his readers that, etymologically, perspective means "seeing through." For Alpers, that notion of seeing past the thing to the meaning that lies beyond it underwrites the entire iconographic tradition. Alberti's window suggests a frame that enables this notion of perspective as "seeing through." But the reliquary frame and the printed book of hours give us another version of the Renaissance frame, one that is not meant to be looked through but

looked into. Here, framing is trained on the material features of the object. The frame, as it has been most readily understood, is what demarcates a privileged aesthetic or philosophical domain. But it is also, to borrow a phrase from Glenn Peers, "where the reality of an image is declared."[66] The frame is also the material and temporal foil to the abstractions that it offsets. To overlook this is to see only what the frame means and not how framing actually works.

A Frame without a Face

In a chapter titled "Alberti's Window: The Rhetoric of Perspective," S. K. Heninger writes, "By insisting upon a frame [the frame of the window through which Alberti's painter looks], Alberti devised a new rhetoric for painting."[67] Heninger links this rhetoric of painting to a series of framing devices—the title page, the dedicatory epistle, marginal annotation, narrative voice, the creation of fictive space or *historia* in narrative—that he deems novelties in Renaissance writing. The example of framing is part of Heninger's larger argument that the Renaissance is the meeting point of two competing aesthetic ideologies, a logocentric aesthetic of the past and a materialist and empiricist aesthetic of the future that Heninger terms "hylocentric." In the transition between these two aesthetics, Heninger argues, the mathematical mysteries of poetic meter and divine proportion give way to the sense-based properties of verbal imagery. The fictive spaces created by textual framing devices are the literary correlative of the new Renaissance frame and the aesthetic that it represents. To illustrate his claims, Heninger turns to the first of John Lyly's euphuistic prose works, *Euphues: An Anatomy of Wyt*.

There are good reasons to consider Lyly's prose in light of painting. Euphues, though a character of Greek origins, travels to Italy and absorbs (perhaps too much) the culture of his friend Philautus. Both of Lyly's euphuistic narratives are replete not only with direct references to classical painters and their painting practices but also with innuendos about the painterly colors of rhetoric. And Heninger's claim that Lyly's text expresses a new kind of framing is not inconsistent with earlier scholarship on this work. John Dover Wilson, attempting to grant Lyly's prose works an importance beyond their usefulness as rhetorical exercises, argued that Lyly's fiction was a pivotal marker between medieval and modern sensibilities: "the style of Lyly is transitional in structure as well as in ornament." Specifically, Wilson claims that, geared as it was toward aristocratic privilege, "euphuism anticipated the literature of the *ancien regime*": "Subsequent writers had much to learn from a book in which the principle of design is for the first time visible."[68] For Wilson, Lyly is

important not for producing an efflorescence of painted rhetorical figures but for the "design" and structure he brought to entire works. More recent scholarship, while less inclined to style Lyly as a proto-Rococo prodigy, has also seen the euphuistic fictions as forward looking, tracing the origins of the novel, as Wilson did, to Elizabethan prose writings such as Lyly's. Robert Weimann speculates that early modern prose works like Lyly's can be viewed as the "self-sustained images and imaginings of a *subjectum* in a new mode of representation."[69] For Heninger, *Euphues: The Anatomy of Wyt* bears out the framing features of Alberti's new rhetoric of painting: "Few works of sixteenth-century fiction are more assiduously framed than Lyly's *Euphues: The anatomy of wyt* (1578)."[70]

One thing that troubles this account is that the sequel, *Euphues and His England*, presents the reader with an actual frame—a frame explicitly announced as a figure for the narrator's prose representation of England—that is nothing at all like a window to be looked through. On his return to Greece from England, Euphues sets forth a description of England: though he dares not depict the sovereign, he offers a figure of England in the form of a gigantic prepared panel. But before I turn to the description of frame itself, a further bit of introduction may be helpful. The final section of *Euphues and His England* is a description of England addressed to the ladies of Italy, subtitled *Euphues' Glass for Europe*. In the prefatory letter of the *Glass*, addressed to the ladies of Italy, Euphues announces that his glass is nothing like the newfangled glasses of Italy, nothing like pocket mirrors that ladies carry in their fans, or the ornate goblets that they sip wine from, or even the chains of glass beads that they wear around their necks. To look upon his glass, which is as bright as the beam of the sun in contrast to those garish glasses, he recommends spectacles of judgment and belief. The *Glass* proceeds by way of "dazzling" descriptions of the sceptered isle, finally arriving at its blazing center: "Oh ladies, I know not when to begin nor where to end. For the more I go about to express the brightness, the more I find mine eyes bleared." It is the picture of the sovereign that stops Euphues in his tracks: "Another sight there is in my glass, which maketh me sigh for grief I cannot show it; and yet had I rather offend in derogating from my glass than my good will." Blinded by greatness, Euphues offers a frame in place of a portrait of Elizabeth:

> I hope that though it be not requisite that any should paint their Prince in England that cannot sufficiently perfect her, yet it shall not be thought rashness or rudeness for Euphues to frame a table for Elizabeth, though he presume not to paint her. Let Apelles show his fine art, Euphues will manifest his faithful heart; the one can but prove his conceit to blaze his cunning, the other his good will to grind his colours.[71]

Enlarging his praise of Elizabeth as Prince, the section ends with the speaker making recourse to prayer above praise, and offering, in turn, a Latin verse, "Jovis Elizabeth," which effectively says that Elizabeth is so good a sovereign as to be a god, and so good a woman as to be a man. The *Glass for Europe* is a mirror in which Euphues "frame[s] a table" of Elizabeth and then offers, instead of a painting, a bit of verse. The mirror, the frame, and the verses are figures for the description of England. And these figures are all defined by what they are not: they are not to be compared with new-fangled glasses, they do not trade in cunning, they are not painted like the ladies of Italy, but framed like the English sovereign.

The *Glass* claims that there is a classical precedent for framing a ruler. The putative source for Lyly's anecdote is Pliny, who notes in a passing reference Alexander's public edict proscribing all depictions of him except those made by specific named artists.[72] But Lyly embellishes the anecdote with a fictive account of Parrhasius, and his frame:

> When Alexander had commanded that none should paint him but Apelles, none should carve him but Lysippus, none engrave him but Pyrgoteles, Parrhasius framed a table squared every way two hundred foot, which in the borders he trimmed with fresh colours and limmed with fine gold, leaving all the other room without knot or line. Which table he presented to Alexander, who, no less marvelling at the bigness than at the bareness, demanded to what end he gave him a frame without a face, being so naked, and without fashion being so great. Parrhasius answered him, "Let it be lawful for Parrhasius, O Alexander, to show a table wherein he would paint Alexander if it were not unlawful, and for others to square timber though Lysippus carve it, and for all to cast brass though Pyrgoteles engrave it." Alexander, perceiving the good mind of Parrhasius, pardoned his boldness and preferred his art. Yet enquiring why he framed the table so big, he answered that he thought that frame to be but little enough for his picture, when the whole world was too little for his person; saying that Alexander must as well be praised as painted, and that all his victories and virtues were not for to be drawn in the compasse of a signet but in a field. This answer Alexander both liked and rewarded, insomuch that it was lawful ever after for Parrhasius both to praise that noble king and to paint him.[73]

What Parrhasius presents to Alexander is not the ornamental quadrilateral of a modern frame but a prepared wooden panel: he "framed a table" of immense proportions "without knot or line" decorated only at the borders and otherwise left blank. He does not presume to paint the table, only to craft it. Following a brief exchange, Alexander, "perceiving the good mind of Parrhasius, pardoned his boldness and preferred his art." Rewarding the painter as much

for his craftiness as for his craft, Alexander grants him dispensation both to praise and to paint.

If Parrhasius gains through his cunning the right to practice the "art" of praise, his frame is also a reminder that praise is an *arte* or *misterie*, which, like any other, involves the manipulation of matter. The crafting of this gigantic frame is more like squaring timber than carving it, more like casting brass than engraving it. Drawing the anecdote to a close, Euphues applies the example of Parrhasius and his frame to yet another list of artisans whose work is "but begun for others to end," and includes among them Euphues himself. Implicitly acknowledging the hierarchy of trades that privileges intellectual over manual arts, Euphues nonetheless defends the comparison between the framing of praise and artisanal labor: "He that whetteth the tools is not to be misliked though he cannot carve the image."[74] In Lyly's anecdote, Parrhasius simultaneously presents Alexander with a crafted object and an occasion for "enquiring." Insofar as Alexander questions Parrhasius about his curious object, the crafted frame provokes a dialogue; the frame and the dialogue together constitute proof of Parrhasius's ability to praise. Parrhasius crafts an object that seems entirely artificial since it is all apparatus and no *mimesis*—"a frame without a face"—yet holds the promise of being most like the nature of things: in this frame, Alexander's "victories and virtues" can be drawn not "in the compass of a signet, but in a field," a frame big enough to hold Alexander's person and physically representative of his conquests. Lyly's frame, and framing in general, reveals that the particular materiality of language in the late sixteenth century was a hybrid of, on the one hand, natural and mechanical orders, and, on the other, wit.

Whereas the text of *Euphues and His England* is addressed to the ladies of England, *Euphues' Glass for Europe*, though a description of Elizabeth's England, is addressed to the ladies of Italy. This "English Glasse," he writes, "shoulde be a myrour to you, to Europe, to the whole worlde," simultaneously offering a reflection of England to the outside world and urging the world to justify itself to the image. Lyly's *Anatomy of Wyt* had imported the precepts of classical learning to England by imitating Italian courtly wits. By contrast, *Euphues and His England* exports the crafted prose of England to the world that lies beyond its borders. Just as Italian visual artists use tools of English ingenuity, namely the rhetoric and logic that had been the strength of the English university, to advance their own representations, so Lyly uses a tool of Italian invention, the glass mirror, to project his crafted image of England.[75]

CHAPTER TWO

The Craft of Poesy and the Framing of Verse

Framing once defined any act of bringing matter into presence in conformity with a design or pattern: the divine creation of matter, the crafting of an object in accordance with the collective "misteries" of an artisanal guild, even the habituation of one's "feeding" to "bitter sauces," as Shakespeare writes in Sonnet 118.[1] This patterning did not, as I have argued, imply the imposition of instrumental reason onto objective matter; rather, it demonstrated an accession to materiality. To frame is to acclimatize reason, action, or behavior to the matter at hand. Framing frequently indicated the conjoining or the conversion of one medium, or one means, to another—collective knowledge to manual skill, painting to poetry, the imaginary to the sensible—and in every case, it demonstrated the indivisibility of meaning and matter.

As human devising, framing approximates divine making when it works through matter. And *frame* usually has a negative connotation when it is used to denote devices that are wrought strictly in the mind. God frames the world by his word, and framing shows up as a key term in the poetic manuals of the late sixteenth century. That the word *frame* should appear so frequently in the poetic and rhetorical manuals indicates the degree to which language itself was recognized as worldly matter. There are echoes, in these uses of *frame*, of the medieval notion of the poet as maker, but the specificity of framing in these tracts also distinguishes this sixteenth-century notion of making from earlier connotations. Renaissance examples of *frame* evoke notions of temporal and material process: framing foregrounds the shaping and fashioning of language and matter over its divine inspiration. The framing of language emphasized poetic invention as techne, a conjoining of artful manipulation and imaginative invention. And while the imagination of the poet played a rôle in that

54

framing of language, the imagination itself was understood as a worldly instrument. *Frame* captures the sense that the word is a material creation and that material creation is a text. It indicates that poetic making was a material and technical process of joining or admixing the already extant matter of words and of tempering song with image.

The poetic tracts of the late sixteenth century consistently used the word *frame* to describe the organization of language rather than images. These tracts were also concerned to define poesy in relation to other trades. Not only were these treatises defenses of poetry but many of them functioned as craft manuals as well. The recurrence of the word *frame* in these texts evinces their efforts to orchestrate a relation between divine systemic order and the application of trade or craft knowledge. To recall Thomas Wilson's phrase from the *Arte of Rhetorique*, "Every one accordyng to his callyng frameth thynges thereafter."[2]

Mary Thomas Crane has also noticed the preponderance of the word *frame* in the logical and rhetorical manuals of the sixteenth century.[3] Crane sees framing as an important concept for the formation of the bourgeois humanist subject, not so much because it implies making or laboring according to one's vocation, but because it plays a role in humanist educational practice. With the commonplace book as her model, Crane argues:

> During this period, the twin discursive practices of "gathering" these textual fragments [from the vast space of Greek and Latin literature] and "framing" or forming, arranging, and assimilating them created for English humanists a central mode of transaction with classical antiquity and provided an influential model for authorial practice and for authoritative self-fashioning.[4]

Crane cautions that this humanist subject is bourgeois but not necessarily individualistic. The educational "notebook method," she argues, used aphoristic and sententious textual fragments that "were already 'framed' by their participation (as commonplaces) in the dominant cultural code."[5] And she points out that this notebook method indicated that the frame of discourse is first and foremost located outside of the mind of the student.[6]

Yet humanist framing, for Crane, is primarily about "closure," "control," and "limitation."[7] To frame is to "repackage," to "contain," and to "discipline."[8] Texts are seen as "fields or containers," and the relation between text and matter is metaphorical.[9] Where logic and rhetoric manuals describe the craft of language as a framing of matter, Crane understands that to be the framing of *subject* matter. For Crane's humanist educators and logicians, an act of framing implies "stability and solidity" and masks an interest in social mobility.[10] This overarching emphasis on framing as a strategy of containment and control, even if it is applicable to humanist educational discipline, leads her to

posit a "more general desire to realize a stable and authoritative language."[11] Yet many of the elements that Crane identifies in discourse as running counter to framing—for instance, fluidity, process, utterance, the notion of "leading" or inclining toward something—only seem so when *frame* is defined as a strenuous impulse toward containment. Considered within the broader network of meanings associated with the word *frame*, those very elements show themselves to be expressions of sixteenth-century framing.

Crane's discussion centers on authoritative self-fashioning and commonplace humanist educational disciplines, a form of framing that is quite distinct from the poetic framing of verse and imaginative prose in the vernacular. In her understanding of framing as a kind of cordoning off, Crane seems to have identified the germinal stage of a kind of thinking that Adorno identifies as the commonplace habits of thought that are perpetuated through disciplinary and traditional frames of reference. Yet Humanists also urged that education include the recognition and apprehension of poetic language. And the poetic theorists of the late sixteenth century suggest that, in poetic language, it is possible to measure the cadences, customs, and patterns that govern both the nature of a given language and its place and movement in time. This poetic framing of language does not necessarily enable or advantage the autonomy, self-sufficiency or authority of the subject, but instead connects subjects to objects, and brings the subject into the stream of language.

The Frame of Verse

Though the poetic manuals acknowledge that language can be assembled according to the dictates of instrumental or masterful mortal cognition, the framing of language specifically indicates the capacity of language to inform and shape the utterances of a person's speech or language in consonance with an essential structure. It is this capacity in language to *frame*—to inform, to shape, or to incline the speaker to the effect of material utterance—that bespeaks the material causality of figurative language in the sixteenth century. In his conduct book, *The Scholemaster*, Roger Ascham admits of a kind of framing that inheres in discourse itself. In the section on imitation in the second part of his text, "The Ready Way to the Latin Tongue," Ascham says that the differences between authors are best gauged not by dividing the kinds of discourse into low, medium, and high style but first and foremost through differences in discourse, "as the matter of every author requireth." Regarding the different discourses of poet, historian, philosopher, and orator: "These differ one from another in choice of words, in framing of sentences, in handling of argumentes, and use of right form, figure, and number, proper and fit for every matter."[12]

Generic distinctions reveal themselves at the interface between rhetoric and subject matter. One of those interfaces is the "framing" of sentences: it lies somewhere between diction and argument as one aspect of a process in which there is a "proper" implementation "fit for every matter." Ascham's division of discourse into genres does not rely exclusively on a division of subject matter but attends also to the texture of each generic discourse. Ascham describes decorum as a set of affinities rather than precepts, and genre as a thing to be engendered rather than a prescribed set of rules.

In his *A Defence of Poetry*, Philip Sidney uses *frame* specifically in the context of versification. He says that ancient verse is more rigorously metrical than modern verse because, in addition to marking the number of syllables and where the stresses fall, ancient verse also marks the length of syllables: "The ancient marked the quantity of each syllable, and according to that framed his verse; the modern, observing only number (with some regard of the accent), the chief life of it standeth in that like sounding of the words, which we call rhyme."[13] The arrangement of clauses in this passage is suggestive. For it indicates that framing is the process of bringing language into verse in accordance with metrical patterns that have been already "marked" or "observ[ed]." English can only approximate in rhyme what the ancients achieved with classical versification. One frames verse in accordance with the natural rhythms of a given language, rather than imposing meter onto an arrangement of words. Verse should not only obey but also embody the metrical structure of a given language. Framing describes the process of conforming language to certain regulated patterns; but it also connotes the eloquence inherent in the cadences of spoken language.

William Webbe makes reference to both versification and decorum in his explanation of English poetry:

> English Poetry therefore, beeing considered according to common custome and auncient vse, is where any worke is learnedly compiled in measurable speeche, and framed in wordes contayning number or proportion of iust syllables, delighting the readers or hearers as well by the apt and decent framing of wordes in equall resemblance of quantity, commonly called verse, as by the skyllfull handling of the matter whereof it is intreated.[14]

Poetry is not only a work "framed *in* wordes" that have the proper number of syllables; it is an apt "framing *of* wordes" to both metrical quantities of "equall resemblance" and subject matter. It is not enough to explain poetry as the expression of an abstract and inherent order to language: a "proportion of just syllables." Webbe elaborates on his initial formulation that poetry "is where any worke is compiled in measurable speech, and framed in wordes," simultaneously

repeating and "intreating" it. Poetry is thus further qualified as an "*apt* and decent framing of wordes" "*delighting* the readers or hearers" (emphasis added). For Webbe, *frame* is an appropriate word to describe not only metrical rigor but also verbal grace. Poetry is a treatment of matter, "where any worke is learnedly compiled in measurable speeche." But so too must the matter be "intreated" by its verse: there must be versification in the very "handling" of the matter. English poetry is to be considered according to both "auncient use" and "common custome." The "matter . . . intreated" in verse, as Webbe puts it, or what Ascham calls "Argumentes," are in both cases "handled." The "framing of wordes in equall resemblance of quantity," which for Webbe defines what is "commonly called verse," shows an aptness to the patterns of language.

The characterizations "aptness" and "resemblance" suggest that something is framed when it is consonant with a systemic order. In the sixteenth century, the noun *frame* frequently referred to the structure of the universe in its entirety: the manifold spheres, their harmonic motions, the intricate assembly of all things created. As Henry Peacham writes in *The Compleat Gentleman*:

> If we consider arightly the frame of the whole universe and method of the all-excellent wisdom in her work as creating the forms of things infinitely divers, so according to dignity of essence and virtue in effect, we must acknowledge the same to hold a sovereignty and transcendent predominance as well of rule as place each over either.[15]

Here the word *frame* epitomizes a cosmological order, the kind of order considered characteristic of the sixteenth century by E. M. W. Tillyard, with all of his emphasis on the chain of being and, albeit in a very different vein, by Foucault, who defines the sixteenth century as one organized according to resemblance and similitude.[16]

Thomas Wyatt sets out to describe this universe in a poem from *Tottel's Miscellany* titled "The song of Iopas vnfinished," though, as the title reveals, this is a universe still in the making. Wyatt writes, "That same (quod he [Iopas]) that we the world do call and name: / Of heauen and earth with all contents, it is the very frame."[17] What these lines say in their elaborate syntax is "the very frame of heauen and earth and everything in it is the same that we do call and name the world." But by construing these lines such that "name" brings forth a rhyme with "frame," Wyatt emphasizes that it is even in the naming of the world that the frame of the universe is brought into presence in all of its fullness. Webbe wrote that readers are delighted by the "apt and decent framing of wordes." It is worth noting, though, that to "consider arightly the frame" of the universe is to recognize both "dignity of

essence and virtue in effect," both the forms of things and their infinite diversity. With both "dignity of essence and virtue in effect," the craft of framing verse echoes not only the structure but the "method" of material creation: all that is made and named, in "essence" and "effect," is orchestrated within the frame of the universe.

In his *Defence of Ryme*, Samuel Daniel aligns poetry with nature and custom in reaction to Thomas Campion's claims that English poetry should emulate classical quantitative verse:

> The approbation of many ages . . . must giue them [forms of versification based on classical models] their strength for any operation, as before the world will feele where the pulse, life and energie lies; which now we are sure to haue in our Rymes, whose knowne frame hath those due staies for the minde, those incounters of touch, as makes the motion certaine, though the varietie be infinite.[18]

Daniel suggests that "the pulse, life and energie" of the world can be felt in the "knowne frame" of indigenous English "Rymes." The frame of poetry must have both "due staies for the minde" and "incounters of touch" to be both perpetual and infinite in its variety. The sensory experience of material reality, as in poetic rhyme, obeys a "knowne frame" that brings the "minde" into accordance with the world and ensures that its "motion" is "certaine."

The emphasis, in all of these examples, is not on an individual's ability or willingness to emulate or represent transcendent structures. The poet does not simply duplicate certain metaphysical patterns; rather, poetic language is informed by those patterns. In Sidney's account, the poet's framing of verse is secondary to the "marking" and "observation" of the cadences of language. Webbe, in the passage cited earlier, does not even mention the poet, but provides a definition of English poetry in the passive voice. Poetic eloquence is not solely generated by the agency of the poet. The musical and lexical harmony of the world's frame manifests itself in verse. For a writer such as Daniel, this shows itself in the valuation of nature over artifice:

> Custome that is before all Law, Nature that is aboue all Arte. Euery language hath her proper number or measure fitted to vse and delight, which Custome, intertaininge by the allowance of the Eare, doth indenize and make naturall. All verse is but a frame of wordes confined within certaine measure, differing from the ordinarie speach, and introduced, the better to expresse mens conceipts, both for delight and memorie. Which frame of words consisting of *Rithmus* or *Metrum*, Number or measure, are disposed into divers fashions, according to the humour of the Composer and the set of the time.[19]

The expression of "mens conceipts" and "the humour of the Composer" are practically incidentals, "divers fashions" of a "frame of wordes." The fundamental rhythms of a language are habituated and even domesticated or "indenize[d]" to the ear by custom. Language, it seems, inhabits its speakers.

This is not to say that the contrivance of the poet does not factor in to the account but rather that the harmony between the frame of the universe and the frame of verse must show a resemblance. Daniel claims that he might have admired Campion's work "had our Adversary taught us by his owne proceedings this way of perfection, and therein fram'd us a Poeme of that excellencie as should have put downe all." Daniel's complaint is that Campion's poesy does not *evince* his claim that classical versification is the way to perfection. Indeed, had Campion "fram'd us a Poeme" that could show through its own "proceedings" or craft that the vaunted "excellencie" of classical versification constitutes a "way of perfection," then Campion would have "put downe" the whole debate over classical versification. Instead, Daniel maintains, the poem Campion includes to illustrate his position disrupts what it should rightly uphold. To exemplify his own point, Daniel singles out four words whose natural stresses are violated by Campion's meter: Elizabeth, funerall, spirituall, and prodigall. Daniel stops short of drawing conclusions about the particularity of these four rhythmically distorted words. But the very fact that these four words are singled out and arranged together is likely to have had an added bite, given that Daniel's text was published in the year following Elizabeth's death. Campion's forced meter violates the natural cadences of the English language. But what is worse is that the violations imply a willful disregard for English honor and custom. For Daniel, decorum is a metrical as well as generic matter. Daniel cautions against excessive poetic and rhetorical contrivance when he comments that Rome was able to prevail only by virtue of having been well-framed, by virtue, that is, of having ultimately honored custom over artifice and commonwealth over oratory: "Had not unlearned *Rome* laide the better foundation, and built the stronger frame of an admirable state, eloquent *Rome* had confounded it utterly."[20] Daniel continues to use *frame* to describe the parity between the cadences of language and a larger superstructural frame, even though the superstructure is the frame of state rather than the frame of the universe.

In *Pierce's Supererogation* (1593), Gabriel Harvey distinguishes poetic language that engenders the universal frame of nature from the kind of poetic framing enacted by someone like Thomas Nashe. Harvey, mocking the voice of someone who has come to Nashe's defense, recounts the fellow's argument:

> You that purpose with great summes of studdy & candles to purchase the worshipfull names of Dunses & Dodipoles may closely sitt or sokingly ly at your

bookes; but you that intende to be fine companionable gentlemen, smirking wittes and whipsters in the world, betake yee timely to the liuely practis of the minion profession, and enure your Mercuriall fingers to *frame* semblable workes of Supererogation. Certes, other rules are fopperies; and they that will seeke out the Archmistery of the busiest Modernistes shall find it nether more nor lesse then a certayne pragmaticall secret, called Villany, the verie science of sciences, and the Familiar Spirit of Pierces Supererogation.[21]

The "lively practice of the minion profession," presumably those who among others things write and publish for a living, is characterized as a "pragmaticall . . . Villany." And the "Archmistery of the busiest Modernistes" is easily imitated by any "Mercuriall fingers" willing to "enure" themselves "to frame semblable workes."

Against this "smirking" opportunistic framing, Harvey has positioned the kind of language that shows itself to be aligned with a natural frame of order. Harvey's invective begins with a warning to the reader not about the kind of writer Nashe is but about the kind of writer he is not:

Euen when he stryueth for life to shewe himselfe brauest in the flaunt-aflaunt of his courage, and when a man would verily beleeue he should nowe behold the stately personage of heroicall Eloquence face to face, or see such an vnseene Frame of the miracles of Arte as might amaze the heauenly eye of Astronomy: holla sir, the sweete Spheres are not too prodigall of their soueraine influences.[22]

Harvey's exaggerated and artificial prose is meant as a satire of Nashe. Nashe's readers, Harvey inveighs, get the "flaunt-aflaunt" of Nashe's swaggering false bravado rather than a glimpse of the "sovereign influence": they get an artificial order of resemblances rather than a natural one. Instead of observing divine ideality reflected in matter, Nashe's readers will be misled into thinking they "behold the stately personage of heroicall Eloquence face to face." Nashe's verse is not consonant with the frame of the universe but instead falsely leads "a man . . . verily [to] beleeue" that he could "see such an unseene Frame of the miracles of Arte." Nashe would seek to "amaze" the heavens rather than being amazed by them. But, Harvey assures with a bit of sarcastic understatement, "the sweete Spheres are not too prodigall of their soueraigne influences." The "sweete spheres" do not simply fall into alignment with the rhetorical devisings of "smirking wits." The natural order of resemblances, as this passage from Harvey seeks to remind its reader, is hierarchical; the heavens are reflected in matter, but not the reverse. The heavens do not mirror prodigal behavior. What qualifies for Harvey as poetic achievement is verse that

reflects transcendent structures; poetry should invoke a frame that joins earthly vision with a more esteemed heavenly vision.

For this satire of Nashe, Harvey may have had in mind Nashe's preface to Sidney's *Astrophil and Stella*. In that preface (1591), Nashe writes, "Here you shal find a paper stage streud with pearle, an artificial heau'n to ouershadow the faire frame, & christal wals to encounter your curious eyes, whiles the tragicommody of loue is performed by starlight."[23] Unlike those writers who seek to harmonize verse with the frame of the universe, Nashe, like Sidney, consciously courts artifice, though he insists more emphatically than Sidney that his artifice is not immaterial. Whereas those who would emphasize "transcendent predominance" in all things, including language, might accuse Nashe of indulging his own vain and fanciful imaginings, Nashe responds that it is they who are self-aggrandizing. They do not care as much as they say for craft or "the perfection of arts," but rather, Nashe impugns in his 1589 preface to Robert Greene's *Menaphon*, they "embowell the cloudes in a speech of comparison." Nashe remarks that the "high witte indeauours" of "*Stanihursts . . .* strange language of the firmament" depart from "common phrase" of those, like himself, who "are not vsed to terminate heauens mouing in the accents of any voice."[24] From Nashe's perspective, he has not debased divine harmony or made the pretense of aspiring to divinity through his own artifice. On the contrary, to call attention to the artifice of verse is a statement of humility in the face of divine language rather than a pretense of voicing heavenly glory.

Elsewhere, Nashe disparages both those who, though completely ignorant, take advantage of the press to publish their follies and those who, "more exquisitly furnished with learning shroude themselues in obscuritie." Nashe stands accused, he reports, of artificiality and insubstantial eloquence by both kinds of writers. Nashe refutes the charge, but not by defending fanciful imagination. On the contrary, Nashe argues that because he, as a professional writer, actively practices his craft, his work is far more material than these other vague invocations of natural order, for they "sette before vs nought but a confused masse of wordes without matter, a Chaos of sentences without any profitable sense, resembling drummes, which beeing emptie within, sound big without."[25] Though Nashe looks down on mechanical artificers who debase the art of poesy by publishing vulgar verse, so too does he dismiss the university as the "Nurse of follie," which traps poetry in the pampered realm of the liberal arts.[26] "Wherefore seeing Poetry is the very same with Philosophy, the fables of Poets must of necessitie be frought with wisdome & knowledge, as framed of those men which have spent all their time and studies in the one and in the other."[27] For Nashe, poetry is a "diuine kind of Philosophy" and should be "framed" by those who spend their lives in its study and practice, by those tradesman who are skilled in its art. In defending his trade, Nashe contends

that the arguments about natural versus artificial poesy are, to some degree, false ones. The real issues, it seems, are how the art of poesy will be constituted as a craft or trade and in what respect it can thus be said to frame matter.

A New Stamp on Judgment, Thomas Nashe's *Have with you to Saffron Walden*

A little more than halfway through the dedicatory epistle of Thomas Nashe's *Have with you to Saffron Walden or Gabriel Harvey's Hunt is up* there is an empty frame of fleurons, a rectangular printed border left blank "purposely," as Nashe indicates in the sentence that follows (see fig. 12). The printed border affords room for inscription, inviting the handwritten addition of an authorizing signature, a verification, a doodle, a sketch, a notation—indeed, these are all possible points of entry for the audience to have a hand in the text. Unlike the empty remaindered space of a margin, or the fraction of a page left empty at the end of a chapter, this patch of open page, centered within the text, is conspicuously demarcated by an ornamental border. The fleurons—printed though not by lettertype—draw equal attention to the surface of the page and to the technologies of inscription. This is not a text that privileges its content as an imaginative *locus* that is entirely indifferent to the contingencies of its production. But nor is there much emphasis here on the materiality of the signifier per se. It is not the matter of the word that is important here; the device of the printed border belabors instead both the page and the means of its inscription. The ornamental border marks a division between printed text and manuscript hand, but it also announces their adjacency as practices of inscription.

When Nashe addresses the possible manuscript additions to that blank space, he speaks not of the instrumental counterpart to moveable type—that is to say, the pen—but of the hand. "Purposely that space I left that as many as I shall perswade . . . may set their hands to their definitive sentence and with the clerke cry *Amen* to their eternal unhandsoming." The printed border calls attention to the technologies of writing and Nashe intimates that "the hand" is one of those technologies. The word "hand" has the resonance of handwriting, as having a hand in something, and of manual labor. The polysemy of the word *hand*, but also the physical hand, the hand that writes, are both part of the techne of language. With the device of the printed border, Nashe reveals that the technologies of language are not simply of an instrumental or machine character but also of a social character, like the techniques of a given craft or trade.[28] This is not only to say that "the medium is the message"—that language is inseparable from its mode of transmission—but also that its mode,

Figure 12. Thomas Nashe, *Have with you to Saffron Walden*. (London, 1596), B₃v–B₄r.
By permission of the Folger Shakespeare Library.

whether print, script, or even a solitary utterance, always betokens social *praxis*. The shaping of language is techne: it does not simply represent labor and craft, it is in itself a form of work.

In Nashe's writing, even stylistic personality is a technology as such, a technique in the crafting of language comparable to the other material implements that shape and define language. Personality, rather than an expression of inward identity or autonomous authority, is a techne in the crafting of a rhetorical style. To foreground the technologies of language is to demonstrate that the materiality of language is always an index of language as labor, and Nashe conveys the same point through wordplay. The letter to "the dapper Mounsier Pages of the Court" at the beginning of *The Unfortunate Traveller* opens with a quibble on the pages of a book and the pages at court: "a proper fellow page of yours," the narrator writes, "hath bequeathed for wast paper here amongst you certaine pages of his misfortunes."[29] But even here in the pages of *Have with you to Saffron Walden*, there is evidence that the writer who works at language in order to master language and to place it in the service of his own authority fails to see how language in fact works him over.

Nashe's writing is often perceived to be all gimmick but no substance, stylistically arch and even aesthetically engaging, but ultimately *about* nothing. Seen as such, the typographic contrivance of an empty frame would appear to

be the perfect figure for Nashe's work. The empty frame is emblematic of Nashe's writing not because it is without substance but because it exposes the identification of good judgment with social authority and, to use Nashe's words, "puts a new stamp on judgment," which is to say puts judgment to the stamp of the popular press. Nashe does not assert a surpassing judgment, nor does he, as Peter Holbrook has suggested, "construct a unique form of authorial social power."[30] Rather, Nashe's writing undermines the equation of textual and personal authority and celebrates instead, to quote Lorna Hutson, the "dispersal of discursive authority" in favor of a "plasticity of discourse."[31] Jonathan Crewe has understood the priority of rhetoric over identity in Nashe's work as the "alienation of language from its supposedly primordial character as speech."[32] Nashe's rhetoric against identity is not a reaction against an ancient metaphysics of presence, but a resistance to proprietary forms of language that contravene the use of language as something that is commonly held.

For such an irascible, opinionated, and invective writer, there is a surprising amount of critical consensus about Nashe—or at least there is considerable consensus about the indeterminacy of Nashe's writing. Critics have always found it difficult to speak of Nashe's overall project. The work is violent, fragmentary, and topical; it speaks of the accidents of experience rather than the accumulation of wisdom. And yet there is a persistent desire to seek an overall project. Similarly, Nashe's writing is often perceived as pure rhetoric. Yet most critics also acknowledge a nagging sense that there is a very strong presence in this work of the real: of violence, of penury, of professional writing in the late sixteenth century. Nashe's work is clearly satirical, yet most critics are hesitant to call him a satirist. Perhaps the most compelling and widely shared assessment is Lorna Hutson's: the "distinctive aesthetic and polemic coherence of each of Nashe's pamphlets," she writes, "can be best understood by analogy with the carnivalesque pastimes of pre-Reformation society in the model of dialogic, menippean satire."[33] What differentiates Nashe's work is that he tends to incorporate the censorious negations of satire with the generative creativity of figurative experimentation, often in one selfsame device. *Have with you to Saffron Walden* is replete with gestures and devices that operate on two fronts, as taunting criticism on the one hand and as playful possibility on the other. The empty frame is one such device: it mocks the mannered sociability of university humanism even as it figures forth an urban fellowship of print readers.

In *Have with you to Saffron Walden*, Nashe looks backward to pre-Reformation humanism in order to craft a forward-looking vernacular among readers of print culture. The figure of the empty frame demonstrates his resistance to the triumph of another strand of humanism, a strand that was more fully institutionalized among educators; that emphasized reason and proportion as a principle of

intellectual and social self-fashioning; and that has been subsequently identified as the prototype of possessive individualism and sovereign subjective consciousness. Nashe's writing responds to this proprietary view of language, reacting against the instauration of language, spoken and written, as a utility in the creation and maintenance of social identity. Nashe holds instead to another strain of humanism that understands language as divinely given and commonly held, a strain that depends on a particular reading of northern humanists like Erasmus and More. Nashe writes against identity and authority, but not against personality. Indeed, the coherence of Nashe's work may depend on personality above all else. In Nashe's work, language is alienated from identity; but writing is also a distinctly unalienated form of labor. In writing, perhaps more than any other craft, personality is techne. Where language is understood to be temporal matter and writing is understood to be a trade and a craft, personality is no more than an implement, a technique of making, not an authority or an identity.

Subtitling his work *Gabriel Harvey's hunt is up*, Nashe states explicitly that the text belongs to the print debate waged between himself and Gabriel Harvey, a doctor of law and the writer and scholar often remembered for his public correspondence with Spenser. The heat of the exchange between Harvey and Nashe took place in 1592 and 1593. Nashe took a conspicuously long time to compose his final word in the debate. When *Have with you to Saffron Walden* appeared in 1596, it had been three full years since Harvey and Nashe had printed their last round of pamphlets. The lull in publication coincided with Harvey's retirement—after a long, often embattled, academic career—to the town in Essex where he had been born, Saffron Walden (hence Nashe's title). With these explicit references to Harvey in the title, Nashe throws over his penchant for fictive subterfuge: his earlier works had more elaborately encoded titles like *Pierce Penniless his Supplication to the Devill* and *Strange Newes of the intercepting of certain letters*. The mock encomium of *Have with you to Saffron Walden* includes a fictional biography of Harvey, a colloquy on Harvey's writings, and a feigned letter from one of Harvey's tutors. And because the satire is targeted so overtly at Harvey, there is no mistaking what this text is about.

Readers familiar with Nashe, however, are liable to balk at the notion that Nashe would be satisfied with so overt a satire; and as it happens, the subject of Nashe's text is not really Gabriel Harvey per se but the various means, and especially the various *discursive* means, by which Harvey sought to secure his social authority.[34] Nashe refers throughout *Have with you* to a whole host of textual and discursive apparatuses used by humanist educators and self-fashioned gentlemen to bolster their social identity. The dedicatory epistle, the *album amicorum* or friendship album, and the *musarum lachrymae* or lamentations and encomia for the deceased—these are all textual practices, Nashe points

out, whose primary purpose is to maintain and perpetuate the mannered sociability of gentle or learned individuals. The empty frame, as it is included in Nashe's text, serves as a graphic and as a discursive allusion to many of those textual practices. Before demonstrating how the empty frame works as a visual pun, laying bare those discursive apparatuses, it will help first to say how Nashe explains, at a manifest level, the presence of this printed border in his text.

The frame appears in the dedicatory epistle, at the bottom of a page that is set apart from the rest of the epistle by its smaller, italicized type and by a heading that reads: "A Grace put up in behalfe of the Harveys." A "grace put up" at university was a formal appeal to the fellows of a college or another governing body for a degree, promotion, or dispensation from scholarly requirements. Successful degrees and permissions were also called "graces." Though Nashe clearly means to evoke several meanings of the word "grace"—grace of God, grace as the form of address for a person of rank as in "your grace," grace as the defining feature of *sprezzatura*, and the more general sense of grace as favor— here he sets up an appeal to the learned "Reverences" of Cambridge to grant graces to the "reprobate brace of Brothers of the Harveys." Here is Nashe as he "humblie sueth" for graces on behalf of Gabriel and Richard Harvey:

That whereas for anie time this foure and twentie yeare they haue plaied the fantasticall gub-shites and goose-giblets in Print, and kept a hatefull scribling and a pamphleting about earth-quakes, coniunctions, inundations, the fearfull blazing Starre, and the forsworne Flaxe-wife; and tooke upon them to be false Prophets, Weather wizards, Fortune-tellers, Poets, Philosophers, Orators, Historiographers, Mountebankes, Ballet-makers, and left no Arte undefamed with their filthie dull-headed practise: it may please your Worships and Masterships, these infidell premisses considered, & that they haue so fully performed all their acts in absurditie, impudence, & foolerie to grant them their absolute Graces to commence at Dawes crosse, and with your general subscriptions confirm them for the profoundest Arcandums, Arcanians, and Dizards, that haue been discouered since the Deluge: & so let them passe throughout the Queenes Dominions.[35]

Just below the appeal is the decorative bordered square where, presumably, the learned officials might confer their judgments, confirming or denying these "general subscriptions" or "graces" with a signature of "placet" or "non placet."

Nashe's humor is at its most mean-spirited here, for Gabriel Harvey was in fact twice denied the graces of Pembroke Hall, first in the early 1570s when he sought his master's degree and again toward the end of the decade when his fellowship was up for renewal. More than just Schadenfreude, though, this barb fits into a pattern in Nashe's satire of mocking Harvey not for his failure to gain approval but for investing himself so ardently in those structures of

authority. Harvey was incensed that Nashe constantly publicized the fact that Harvey's father was a rope maker: yet in *Have with you* Nashe makes clear that his derision is not directed at the father's profession but at the son's shame. The blank printed frame patently satirizes Harvey's institutional vulnerability, but it also satirizes Harvey's own overly compensatory reverence for textual authority. Harvey's extensive library is notorious for the exhaustive if not obsessive marginalia and annotations that fill its pages. The empty printed border, then, is also an ironized impression of Harvey's textual practice. For, if there was one thing Harvey was unable to abide, it was a bit of blank page.

The empty border that Nashe uses to mock Harvey's marginalia is the self-same device that Nashe uses to figure forth his own textual practice. Nashe made his living as a professional writer in London. The frame furnishes him with an opportunity to invite his readers to insert their own marks right into the center of his text. Rather than providing supplemental commentary as marginalia to the authoritative text, the reader's hand in Nashe's work is constitutive of the text's authority. And Nashe indicates that his own text takes its authority from any fool he can persuade. "Purposely that space I left" Nashe writes, "that as manie as I shall perswade they are Pachecoes, Poldavisses and Dringles, may set their hands to their definitive sentence, and with the Clearke helpe to crye Amen to their eternall unhandsoming."[36] It is not merely Nashe but a rabble of readers who comprise the central authority of this text. In this inverted grace, any idler or fool can have a *hand*, literally and metaphorically, in the unhandsoming of the Harveys, or in the reader's own unhandsoming, since to sign on to what the Harveys profess is to damn oneself, to write the "definitive sentence" of one's own "eternall unhandsoming." Nor does Nashe leave the Harveys themselves out of this company, for the inverted grace is alternately a place where the Harveys may authorize themselves, as they are wont to do. "Thou art in in a place," Nashe says below, "where though maist promote thy selfe." To turn the satire back on the satirist, as Nashe does when he admits that his readers are a bunch of fools and vagabonds, is by no means atypical of satire. But the empty frame is also a positive figure for the fact that this text is created for and by what Nashe elsewhere calls a "usuall market" of fellowship.

Nashe is not, in the end, interested in pitting his own judgment against Harvey's, but in opening up Harvey's judgment to this "usuall market" of readers and writers. In response to the claim that Harvey's "stile" is "commended by divers (of good judgment) for the best that ere they read," Nashe says that with the printing of *Have with you to Saffron Walden*, he "wil set a new stampe on their judgments." Nashe means by this "new stampe" not the superimposition of his own judgment but something afforded by the mechanics of the printing press. Having taken Harvey's own work, with its "senseles sentences, finicall

flaunting phrases, and termagent inkhorne termes," and having "fram'd it in [Harvey's] own praise and apologie," Nashe "puts a new stamp" on the "unflattered picture of Pedantisme" by laying it out for public critique. At one level, *Have with you to Saffron Walden* pitches itself with gleeful scurrility against its antagonist Harvey. At another, however, it makes an effort to transform this battle of personal one-upmanship between Nashe and Harvey into a contest about whether English vernacular writing will answer to a lineage of learned authority or to a "usuall market of fellowship." For Harvey, publication affords the opportunity to make public his own judgments; for Nashe, print culture puts judgment itself to the press.[37]

Neither Harvey nor Nashe can be said to have instigated the battle in which they became primary combatants. Rather, they entered a fray that had been gathering steam since the 1580s between scholarly humanists and reformers, on the one hand, and professional London writers, on the other. The contention between Harvey and Nashe, though certainly personal, was perhaps as much about the medium as it was about the message. At its foundations, at least, the argument had little to do with personal animosity between the two men. Rather, the tension was one between two literary and intellectual circles. Its enmity was exacerbated by charges and countercharges that both circles were involved in another infamous exchange of pamphlets, the Martin Marprelate pamphlets. The debate that took shape between Harvey and Nashe, though clearly inflected by these religious and personal allegiances, has an additional component: whether private consciousness and individuated social identity—which is to say, authority itself—ought to be the foundation of public print culture. What hangs in the balance, at least for Nashe, is whether language will serve as a social instrument or whether it will instead be understood as a property of instrumental reason.

In his fictionalized account of Harvey's life, Nashe pokes fun at the way Harvey elides language with personal intention and identity by replacing the particulars of Harvey's biography with playful inventiveness. Nashe's life reports that Harvey's mother had several dreams when she was pregnant with Gabriel, the last of which is as follows:

Shee thought that, in stead of a boye (which she desired), she was deliuerd and brought to bed of one of these kistrell birds, called a wind-fucker. Whether it be verifiable, or onely probably surmised, I am vncertaine, but constantly vp and downe it is bruted, how he pist incke as soone as euer hee was borne, and that the first cloute he fowld was a sheete of paper; whence some mad wits giu'n to descant, euen as *Herodotus* held that the *Aethiopians* seed of generation was as blacke as inke, so haply they vnhappely wold conclude, an *Incubus*, in the likeness of an inke-bottle, had carnall copulation with his mother when hee was begotten.[38]

Nashe's physical description of Harvey drives home that Harvey has left no distinction whatsoever between his life and his learning. Nashe describes "his skin riddled and crumpled like a piece of burnt parchment; & more . . . wrinkles and frets of old age than characters on Christs Sepulcher . . . look on his head, and you shall finde a grey haire for euerie line I haue writ against him."[39] Having forged his identity through books as a compensation for bloodlines, and having so wedded his learning to his person, it only follows, Nashe wickedly implies, that the output of Harvey's mind is no different from the output of his body and that his prodigious inking of papers is tantamount to a bunch of "fowld" clouts.

The intimate association of identity and text in Harvey's corpus, as it were, makes it all too easy for Nashe to satirize Harvey's work as just so much superfluous excrement. Throughout *Have with you*, Nashe makes a mockery of the compiling, epistling, and marginalia that he associates with Harvey's discursive practice. He teases Harvey for his crabbed commentaries, for his self-indulgent letterbooks, and for the collection of arcane sententiae in tablebooks. Nashe refers to books of "COMMON place," that march back and forth over the same terrain, to a "packet of epistling" as big as a pack of woolen cloth and a "vast gorbellied volume" of commentary for which "scarce a whole elephants hyde and a half would serve for a cover." Nashe's character Piers Respondent bristles at having his "margent bescratcht (like a merchants booke) with these roguish Arsemetrique gibbets or flesh-hookes, and ciphers and round oos like pismeres egges."[40] It is one thing that these might be Harvey's private discursive practices, but quite another when the popular press disseminates them through publication. And indeed large volumes of commonplace books or *pandectae locorum* were being preprinted, among them one complied by John Foxe. Nashe even accuses Harvey of having been the compositor of a bunch of a preprinted almanacs tablebooks, supposedly authored by one Gabriel Frend (see fig. 13). Faced with the technological novelty of the printing press, Harvey and friends perpetuate magical superstition, rote compendious accretion, and the preservation of outmoded social bonds, fetishizing along the way the manuscript hand that consolidates the bond of textual practice to private property and identity.

Nashe's demarcation, then, of a printed bordered space to be filled with script gestures beyond the official imprimatur of university graces. With its implied juxtaposition of print and script, the empty frame serves as a graphic allusion to other printed books that were meant to be inscribed with a manuscript hand. And Nashe may also be referring here to the printed album amicorum that was fashionable among students and travelers in the sixteenth century. These books may have been composed entirely of blank bordered pages to be filled in by persons of note, superiors, or friends as a kind of

Figure 13. Gabriell Frend. *A breife and playne Prognostication* (London, 1598), title page and recto page. This item is reproduced by permission of The Huntington Library, San Marino, California (call number RB 30068).

catalog of shoulders rubbed. Alternately, they may have been printed emblem books (devices from Ovid seem to have been a favorite), the versos left entirely blank or bordered with fleurons for inscription (see figs. 14 and 15). Typically the album amicorum would contain some combination of portraits, commonplaces, and escutcheons or other heraldic devices. The word *graces* links the protocols of the university with those of the album amicorum, since "graces" could refer to any beneficence shown by a social superior, as Nashe himself later says "some better frends than [Harvey] was worthy of . . . afterwards found him unvorthy of the graces they had bestowed vpon him."[41] And Nashe's reference to "graces to commence at Dawes Cross," the proverbial meeting place of fools, that will allow passage "through the queenes dominion" would seem to echo this reference to a travelogue album amicorum, though Nashe is certainly also making reference, as a foil to the album amicorum, to the use of domestic passports to codify and regulate identity in an effort to control the movements of vagabonds and thieves.

Ex humili confcendit in altum.
Ad Joh. Joachimum Nüzelium Norib.

Præruptum ex humili confcendit origine montem,
 Impulfuq̃ levis profilit unda rota.
Si quibus ingenium natura, & ftirpis honorem:
 Et fortuna nimis parca negavit opes,
Sperate, & certo vires, animumq̃ labori:
 Veftraq̃ cælefti credite vota DEO.
Magnas fæpe frequens induftria perficit artes:
 Cum vis fecuros ingeniofa facit.

D 4 *Quando*

Figure 14. Nicolaus Tauellas, *Emblemata physico-ethica* (Nuremberg, 1595), D₃v–D₄r.
By permission of the Folger Shakespeare Library.

What rankled Nashe is that the Harveys disguised as genuine fellowship the upward social movement they garnered for themselves through the institution of the university, even as they propounded theories of social leveling through humanist learning and Puritan doctrine. Nashe's biographical account of Harvey borrows several stock elegiac phrases from the musarum lachrymae (tears of the muses) that were commonplace commemorative publications in the sixteenth century. Harvey had produced and published such a text for one of his early patrons, Thomas Smith, though Nashe's character Piers Penniless Respondent can barely be bothered to describe it. When he reaches that point in his oration of the life where he takes account of Harvey's works, he classifies, along with "innumerable other of his rabble routs: and scoffing his *Musarum Lachrymae* . . . which to give it his due, was a more collachrymate wretched treatise, than my *Piers Penniless*, being the pittifullest pangs that euer a mans Muse breathd foorth."[42] In Harvey's formulaic encomia to such figures as Smith and Sidney, poetic language—and wretched poetic language at that—is

put to the service of personal identity. Nashe claims the inverse for his own text: poetic language that is all the more superior for its assumption of a personal stance of wretchedness or "pittifullness" and all the more poetic for the pace and energy of its prose.

For Nashe, this is a contest over both poetic language and Christian principle, a contest between the institutionalized graces of degree (that is, university degrees and social degree) and a religious grace that inheres in folly and humor. And it is a contest between Harvey's discursive practices—he who "exercised to write certain graces in ryme doggerel"—and the poetical graces that Nashe prefers, graces that show a facility for cadence, alliteration, and invention.

This contest is staged in dedicatory epistle, yet another instrument, as Nashe points out, of the consolidation of textual and social authority through guises of sociability among men of distinction. *Have with you to Saffron Walden* contains Nashe's longest and most farcical dedicatory epistle. Nashe addresses the text to the barber of Trinity College, Richard Lichfield, "The most Orthodoxall and reuerent Corrector of staring haires . . . , speciall superuisor of all

Figure 15. Johann Ulrich Höcklin, *Album Amicorum* (1564–74) of Johan Posthium, Germersheim Tetrasticha in Ovidii Metamorphosii (Tubingen, 1563), 127ᵛ–128ʳ. By permission of the Folger Shakespeare Library.

excrementall superfluities for Trinitie Colledge in Cambridge, and (to conclude) a not able and singular benefactor to all beards in generall."[43] Though directly addressed to Lichfield, both Richard and Gabriel Harvey are implied, Richard for having authored the *Book of Beards* and Gabriel, himself, for having asked Spenser in a letter he later published, to send clippings from his ample mustachios. Nashe then transforms these overly mannered conventions of friendship and patronage into an epistle that is really dedicated to every Tom, Dick, and Harry, or at least anyone who might happen to share the nickname of its dedicatee, that gallant patron Richard Litchfield. Here is the opening address:

> Acute & amiable Dick, not *Dic mihi, Musa, virum*, Musing Dick, that studied a whole yeare to know which was the male and female of red herrings: nor *Dic obsecro*, Dick of all Dickes, that, in a Church where the Organs were defac'd came and offred himselfe with his pipe and taber . . . nor Dick Swash or Desperate Dick .. nor *Dick of the Cow* . . . but paraphrasticall gallant Patron Dick as good a fellow as euer was Heigh, fill the pot hostesse: courteous Dicke, comicall Dicke, liuely Dicke, louely Dicke, learned Dicke, olde *Dicke of Lichfield* I am sure thou wondrest not a little what I meane, to come uppon thee so straungelye with such a huge dicker of Dickes in a heape altogether: but that's but to shew the redundance of thy honorable Familie, and how affluent and copious thy name is in all places, though *Erasmus* in his *Copia verborum* neuer mentions it.[44]

Now "Dick" may not have exactly the same resonance that it does today, but nicknames were commonly used to imply baseness, bawdiness, and licentiousness. Granting that his own noble patron might just as easily be any commoner who goes by the nickname Dick, Nashe replaces the nominal relations of distinctive family names with the linguistic playfulness of punning on first names alone.

By transforming his "gallant Patron Dick" into a generic Dick, Nashe points up the fact that both the system of literary patronage and the humanist tradition of authorizing discourse through literary allusion operate according to the same logic as the ancestral authority of birthright. In his litany of fellows named "Dick," Nashe includes a quibble on the Latin verb *dic*. His "acute and amiable Dick" is not a learned or studious Dick, "not *Dic mihi, Musa, virum*," he says, citing Horace, who was in turn citing Homer. Of course, in the process of poking fun at these lineages of literary allusion, Nashe's own allusion is as clever and layered as they come. Yet because the text plays as much on the commonplace name as on the literary allusion, it is as funny for a reader who knows only that it is Latin as it is for someone who can recognize the allusion.

Nashe had made a move in an earlier work, as Lorna Hutson points out in her discussion of *Pierce Penniless*, to distance the pamphlet exchange from the conventions of patronage and to cast it as a debate in which the audience's authority to judge would derive from the sophisticated reading practices of print consumers rather than their acquiescence to social authority. Nashe had contracted to print *Pierce Penniless* entirely free and clear of any prefatory matter, with only the introduction of a title page. But the text was pirated by another printer, who published it with a prefatory letter of his own and a moralizing title page. That Nashe, in the second edition, had to include a prefatory letter explaining that he had originally intended to present readers with an unmediated discourse demonstrates the acute irony of the failed first edition. Nashe had wanted the reader to judge the text independent of any nominal or factional endorsement. He had wanted the text to have allusive associations with other vernacular texts, rather than associations with powerful patrons who effectively functioned as stock moral arbiters. Nashe did not dismiss humanist textual practice out of hand, but what he emulated was the playful combination of social irreverence and religious reverence in pre-Reformation writers, and what he derided was the pious didacticism and mannered civility of the more institutionalized forms of humanism.

In *Have with you*, Nashe reconstitutes the persona Piers Penniless in the slightly altered form Piers Penniless Respondent, as if to remind Harvey that there is a discursive authority in penury. Though adversaries may "bandie factions," "Harvey and I," Nashe writes, are "(a couple of beggars)." And Nashe's trump card in *Have with you to Saffron Walden* is that he transfers the rhetoric of invective and abuse between himself and Harvey into a dialogue among friends, all of whom, though none of them singularly, represent Nashe and Harvey themselves. For Nashe, the sociability of language, at its best and its worst, depends on the plasticity of identity. Nashe openly courts penury and abjection through the expenditure or wasting of language; he recognizes language as a machinery of recombinant parts that precedes and outlasts any given book or speaker; and he sees the potential for printed language to create collectivities of persons unknown to one another. True authority for Nashe is not a social position but the reanimation of collective forms achieved by dissolving identitarian authority into the sociability of verbal play.

The blank frame is a visual pun in which Nashe abjures the authority of the personal signature in favor of mechanically wrought common space. In the marketplace of print, social identity need not be a person's "definitive sentence"; a kind of mechanical anonymity can replace supplications to a gracious patron. And *Have with you* replaces the imprimatur of the proprietary authorial self with a technology of representation—an empty frame that, with its own mingling of gracious poesy and "definitive sentence," draws attention to

the material apparatus of representation, in this case the printed page. Rather than linking identity to writing, the empty frame links figurative inventions to the technical invention of the printing press, suspending, if only for a moment, the notion that texts are the exclusive offspring of one person's ideas.[45] Through this conscious play on the structure of the epistle dedicatory whose appeal to the singular patron is perfectly at odds with the principle of reaching a wide audience through printing, Nashe embeds a frame within a frame within a frame. And while it virtually implodes the dedicatory letter, so too does it open up the space of the printed page.

Framing to Advantage

Derived from the Old English *framian*, which means "to advance, benefit, or make prosper," the word *frame* in the sixteenth century customarily carried the connotation of positive virtue.[46] But it was also at this time that *frame* began to acquire a denotation that informs the contemporary expression "frame up."[47] Even though the dominant sense of *frame* still echoes its Old English origins as an act characterized by a beneficent or profitable harmony of activity and purpose, the use of *frame* to denote a self-interested scheme, though it traces back at least to the fourteenth century, does become more prevalent in the sixteenth century.[48] The first example cited by the *OED* of framing falsehoods dates to 1514: "Than frame they fraudes men slylie to begyle." An example from 1608 describes a personification of slothfulness as "wittie in nothing but framing excuses to sit still." What is perhaps most interesting about these examples is that when *frame* does denote autonomous intention, it does not signal advancement, benefit, or prosperity but is always negatively inflected. The word *frame* marks the seemingly real effects of intentional agency—the beguiling of others through fraud, the opportunity to laze around after making excuses—as untruths, as mere assertions that are unconnected to truth because they are not framed in accordance with "good purpose." In these examples, where *frame* refers to an autonomous intellectual design, the word still carries that inflection of a universal design, a truer reality within which the illusion of autonomous ideality will always be coded as false.

Framing also appears in sixteenth-century discourses of policy and politeness, where the sense of framing as an inclination toward or conformity to something takes on a far more worldly cast. In *The Taming of the Shrew*, Biondello is told to "frame [his] manners to the time."[49] *Frame* still means "to conform," but not necessarily to divine purpose. It implies tactical rather than metaphysical profit or advancement. Yet here, and even in the examples of framing falsehoods and excuses, the activity is still joined to its object and not

divided from it. In each of these instances, *frame* is used as a verb; in every case the object of the action is some facet of human behavior ("fraudes," "manners," and "excuses"); and in two cases the object of the verb becomes the subject of another action ("to begyle," "to sit still"). Framing often takes both an object and a direct object, as "manners to the time." The activity of framing is not one that maintains, either syntactically or semantically, a sharp distinction between subject and object. Framing describes activities, including thoughts, in which agency is coextensive with environs and effects. *Frame* denotes actions that are not confined to the subject or agent but pass over onto the object or, even more frequently, take their cue from the object. Even as *frame* begins to connote strategic advancement, rather than collective or spiritual profit, it still describes an action in which one thing is brought into conformity with another.

In the sixteenth century, framing did not connote conscious mastery but, rather, technologies of human making. There is a sharp contrast between this older sense of framing and its current one in the phrase *frame of reference*, which has come to be used as a commonplace expression for denoting a set of known facts or principles that guide the understanding. According to the *OED*, the expression "frame of reference" was first used at the end of the nineteenth century in mathematical and scientific contexts to name a "system of coordinate axes in relation to which position may be defined and motion conceived of as taking place." In the twentieth century, *frame of reference* began to be used figuratively to evoke "a set of standards, beliefs, or assumptions governing perceptual or logical evaluation or social behaviour." These recent uses of *frame* also speak of an order by which things and actions can be measured or codified, but with human reason as the arbiter of that order. A *frame of reference* is a logical principle or knowledge base that enables thought, judgment, or evaluation. The word *frame* is now used to denote instrumental reason. Whereas *frame* was used in the sixteenth century to refer to human devising, it never indicated the capacities of human thought without also intimating the limits of human reason. Indeed, the use of the word *frame* was usually a reminder that pure ideation is proper only to God—for example: "Through faith we understand that the worlds were framed by the word of God, so that things which are seen were not made of things which appear" (Hebrews 11:3). The divine framing of the world through the word both enables human understanding and reveals its limits; the framing of the world grants all things that are seen, as well as the awareness that things seen are fashioned out of things that do not appear.

This is not to say that one could not speak, in the sixteenth century, of a *frame of mind* to designate inward forms of human thought and emotion. But these references to the frame of the heart, the soul, or the mind intimated not

the autonomy but the disposition of the faculty named: its bent, its sway, or its habituation. Though *frame* was also used to denote a negative disposition or intention to do evil, it did not necessarily mean autonomous action, since the human susceptibility or habituation to evil is still framed by God's design for humankind. It was a common fallacy for the sinner to *think* that his or her actions were governed by independent will and agency. But whenever the word *frame* was used to this effect, it also implicitly pointed up the fallacy of human belief in the pure autonomy of thought and action. When Thomas Wilson glosses "[frame of the heart]" in his 1616 *A Christian Dictionary* as "the inward secret thoughts, inclinations and purposes of the soule," he conditions this explanation with a biblical citation, "as it is expounded by *Moses* himselfe Gen 6.5. *The whole frame*; that is, y thoughts of mans heart are euill continually, according to the translation of *Tremelius* it shoulde thus be read."[50] The biblical citation referred to in this definition reads: "And God saw that the wickedness of man was great in the earth and that every imagination of the thoughts of his heart was only evil continually." Wilson's gloss indicates that the "frame of the heart" speaks to the inward state of the soul, to its "thoughts, inclinations and purposes," but specifically with respect to "the whole frame" of wickedness, the wickedness that is a collective and continuous mortal condition. The "frame of the heart" is not simply one man's private conscience but "every imagination of the thoughts" in the "heart" of all of mankind. To put it another way, the "frame" of the heart is the inward and secret truth of the human heart as it is made and seen by God; it is both singular and universal, both secretly known and unknowable. This "frame" is not a self-governed context but an inclination to do good or evil.

Since Burckhardt's *The Civilization of the Renaissance in Italy*, individuated calculation, reflection, and ingenuity have been seen as a hallmark of the Renaissance and the modern individual. We must be careful, however, not to assume that individuated thinking is the same thing as modern subjectivity, or that cunning calculations are prototypical of a modern subjective consciousness that instrumentalizes its object as that which stands before the subject to be known. To be witty or cunning meant that one had a facility for quick joinings and connections, an ability to match one thing with another, and a talent for crafting resemblances. And the terms "machination" and "craftiness" indicate a kind of devising that would have been recognized not as an ordering thought or principle but as the manipulation, sometimes without scruple, of what simply lies at hand: a way of tailoring the most adventitious outcome out of a limited set of parameters. Purely autonomous ideation belongs only to God; the human mind, though endowed with the capacity to apprehend metaphysical ideation, especially as expressed in the divine order of worldly matter, is in itself a time-bound instrument. Even when *frame* was used to

denote contrivance or devising, it did not yet indicate the sovereign consciousness of the modern subject.

To follow Heidegger on this point, the modern age may have "introduced subjectivism and individualism," but "the essential foundation of the modern age" is a metaphysical distinction between subject and object. It is not that "man," as Heidegger puts it, "frees himself from previous obligations, but that the very essence of man itself changes, in that man becomes subject." The subject is that which "gathers everything onto itself. This metaphysical meaning of the concept of subject has first of all no special relationship to man and none at all to the I." What makes this subject modern is not that "the position of man in the midst of what is" differs from that of the medieval period, it is rather that "man himself expressly takes up this position as one constituted by himself " and even defines that position as new. "What it is to be is for the first time defined as the objectiveness of representing, and the truth is first defined as the certainty of representing."[51] Heidegger makes an important distinction between the person who thinks and the subject as a concept that structures the way a person thinks; it is not that each period has its own metaphysics of the subject but that the metaphysics of the subject is the condition of the modern age. And framing is not yet modern, so long as it is a way of making or fashioning—even of making thoughts or behaviors—rather than a way of representing or an epistemology.

The Framing of Concepts

There are important reasons for grounding historical inquiry in the study of words. Words can be a way of understanding human thinking and abstraction as social history. For Reinhart Koselleck, whose *Archiv für Begriffsgeschichte* was a collection of "concept histories" based on specific words that Koselleck had identified "as indicators of social structures or situations of political conflict," concept histories provide knowledge about society that cannot be gleaned purely from empirical data.[52] For Koselleck, there are certain historical realities and experiences that can be understood only as concepts. And yet concepts exist only in and through language: only as they are manifest in words. Concepts have a kind of "carrying capacity": though every concept is the "concentrate of several substantial meanings," it is identified with a single word. Every concept is identified with a word, but not every word is a concept, and Koselleck explains the distinction in this way:

> The signification of a word can be thought separately from that which is signified. Signifier and signified coincide in the concept insofar as the diversity of

historical reality and historical experience enter a word such that they can only receive their meaning in this one word, or can only be grasped by this word. A word presents potentialities for meaning; a concept unites within itself a plenitude of meaning. Hence a concept can possess clarity but must be ambiguous.[53]

Both concepts and objects (material or immaterial) are named by words: but the concept, unlike the object, cannot be thought of separately from the word. Koselleck's distinction seems to break down around the uses of *frame* in the sixteenth century: *frame* does name objects that can be "thought separately," and it "presents potentialities for meaning," but it also "unites within a plenitude of meaning." *Frame* seems to muddle the distinction that Koselleck draws between concepts and words.

A similar distinction underpins Raymond Williams's *Keywords*. And where *frame* fails as a keyword, it reveals a certain limitation in the keywords project as well. *Frame* does not intuitively suggest itself as a keyword because it seems to lack the historic proportions of the sociopolitical and cultural concepts such as "aesthetic," "capitalism," "dialectic," "industry," "romantic," and "work" that make up Williams's keywords. Williams explains in his introduction that keywords, unlike "*barber* or *barley* or *barn*," are "words of a different kind." Williams's keywords "involve ideas and values" and are not easily defined by a single dictionary definition, though he is also careful to state that his project of "historical semantics" has a materialist methodology that is "deliberately social and historical."[54] *Frame* seems to qualify as such a keyword, if we consider its uses outside of aesthetics and philosophy: its use, for instance, in memorializing the specific set of sociopolitical and historical circumstances that conditioned the composition of the U.S. Constitution by its "framers." But since the same word signifies the structural quadrilateral that contains a painting, *frame* can also be as unambiguous as "*barber* or *barley* or *barn*" in its reference to a material object. Connoting both a conceptual process and a tangible object, *frame* seems at once too intellectual and too material to bear out the social and cultural relevance that characterizes Williams's keywords.

The occlusion of words that are identified with things or objects (over and against concepts, ideas, or values) in both projects suggests that perhaps what is needed is a keyword history of the word *concept*. For, despite his materialist intentions, Williams seems also to be framing concepts.[55] And I use "framing" intentionally here, since the modern notion of a concept appears to be that it is something intellectually framed. As the sociologist Erving Goffman argued in his 1974 book *Frame Analysis*, there is evidence to suggest that we bracket off information to customize and understand it.[56] I do not wish to pursue a full keyword study of *concept* here, but I do want to indicate that dismissing the historically semantic significance of words that signify things as well as objects

overlooks the possibility that the relation between words and things might itself be social and historical. In fact, the historical relationship between words and things would seem to be one of singular importance for any project that inquires into the relation between signification and empirical study. The focus on concepts orients language toward subjective consciousness. And it is precisely because we frame concepts as we do objects and works of art that a word like *frame* might be a worthwhile keyword.

The limitations of a keyword or concept-history project cannot simply be answered by including a word such as *frame* in the analysis. By leaving out such words that express both mundane matter and "ideas and values," indeed by leaving out the conditions by which words can function in paradoxically material and immaterial modes simultaneously, these projects effectively mark off a limit that excludes figurative language. And thus the implication is that figurative language would not factor into a "social and historical" account of historical semantics. It is abundantly clear from his work that Raymond Williams did not neglect the role of social history in the interpretation and analysis of literary and figurative language. The question that stands open is, for me, whether materialist critics have fully considered the role of figurative language in social history. And what I am suggesting is that the temporality of language in the sixteenth century, which can be observed in past uses of *frame*, presents a materialist poetics that might serve as both a historical and a philosophical alternative to the modern framing of language as either figure or concept, but never matter and meaning conjoined in time.

The Tempered Frame

The sixteenth century did not have a concept, such as it is in modern philosophy, of the frame as an alienable quadrilateral. The word *frame* did nonetheless have conceptual connotations. It is more difficult to identify historical difference in the early modern uses of *frame* when the word appears as an abstraction rather than as a substantive. For instance, the modern notion that one frames an argument by consciously construing its parameters, though it appears to be applicable, does not entirely capture the implication of the Duke's locution, in the final act of *Measure for Measure*, that Isabella's accusation of Angelo hath "the oddest frame of sense." When Isabella openly accuses Angelo of perfidious dealings, directly contradicting his reputation for unassailable rectitude, the Duke rejoins, "If she be mad, as I believe no other, / Her madness hath the oddest frame of sense, / Such a dependancy of thing on thing / As e'er I heard in madness" (5.1.60–63).[1] The Duke, who has not disclosed that he knows the truth of Isabella's claim, acknowledges that the content of her accusation appears to be madness, but says that he will entertain the charge because her rhetoric is eloquent and logical and has the structure and order of reason. For rhetoric to show "such a dependancy of thing on thing" implies that it bears a relation to the truth. Just and true reason, as this play seems to remind its audience, comes not from the laws of men but from a higher moral law. That Isabella's claim has a "frame of sense" suggests that her rhetoric conforms to the frame of divine reason that reveals itself as a "dependancy of thing on thing" in the natural order of creation. The implication is that the truth has its own "frame of sense" that surmounts all contrivance or devising.[2] Similarly, when Guildenstern importunes Hamlet—to "put your discourse into some frame and start not so wildly from my affair" (3.2.308–9)—his

complaint is that Hamlet's discourse is too much a thing of his own devising. Guildenstern is not asking Hamlet to "frame his argument" in the modern sense; rather, he is asking Hamlet to stop responding with quiddities and to align his discourse sensibly with the conversation at hand. What these examples reveal is that proper discourse is not so much framed by the speaker as it is framed to its object.

Thomas Lodge's 1579 *Defence of Poetry* contains a passage that at once illustrates an outmoded sense of the word *frame* and its outmoded conceptual orientation as an activity that orchestrates something toward its end or purpose. Acknowledging that classical poetry is trained toward the experience of pleasure rather than Christian moral truth, Lodge nonetheless wants to esteem all poetry as a noble pursuit. In the interest of vindicating classical poets, Lodge writes:

> What so they wrot, it was to this purpose, in the way of pleasure to draw men to wisedome: for, seing the world in those daies was vnperfect, yt was necessary that they like good Phisitions should so *frame* their potions that they might be appliable to the quesie stomaks of their werish patients.[3]

On the grounds that like substances must be used to cure ills, a physician must produce noxious medicines to heal a nauseated patient; likewise, classical poets, to appeal to their imperfect, non-Christian readers, had to produce verses that aim to please. Insofar as the word *frame* describes the contrivance or devising of a concoction by the physician, modern definitions suffice to make this passage intelligible. But the passage also describes this devising in terms that are specific to the sixteenth century. Lodge, who was himself a physician, is drawing on a Paracelsist notion of physic that like cures like, over against the more traditional Galenist belief that one should meddle with the humors in order to keep them in balance.[4] *Frame* is especially apt in this context because it describes a form of making that conforms itself to its object.

The modern notion of framing is so overwhelmingly associated with the rigid joints of picture frames in particular, but also with built structures in general, that it is jarring to a contemporary reader even to imagine the framing a fluid. But in the sixteenth century framing referred to mixing as well as joining. Fluids and even vapors could be framed. In Book I of *The Faerie Queene*, Edmund Spenser describes Archimago's illusory conjuration of Una as "fram'd of liquid ayre" (1.1.47).[5] That the framing of a potion serves an explanatory function in Lodge's metaphor suggests that it would not have been jarring to a sixteenth-century reader. Nor would the comparison of a poem to a medicine have been an unusual one. Though Lodge, as a physician, may have had a particular stake in this comparison, the metaphor of the poem as a philter is

a classical one and is used repeatedly in the poetic tracts of the late sixteenth century.[6]

Any attempt to discern what exactly *frame* meant conceptually will run into one of the central paradoxes of the substantive uses of the word in the sixteenth century: that is, that it refers both to skeletal structures—the human skeleton, the timber frame of a building—and to the concoction of fluids—from humors to potions. What seems to a contemporary ear to be a paradoxical connection between joining and inmixing might not have been so in the language of the sixteenth century. *Frame* designated both fluids and solids because the word was used to describe the engendering of any kind of matter. In the sixteenth century, framing does not describe the idea behind the material but the idea made material. *Frame* also signifies the integration of skeletal and fluid structures, and of spirit and matter in the human body itself. The word indexes the notion that the body is a microcosm of the universe, for, used as a noun, *frame* could designate both the body and the universe, whose harmonious motions and crystalline structure also evince a simultaneity of fixity and flux. As a verb *frame* could mean simply "to make," but it could also mean "to incline towards" or "to advance or avail," implying process, benefit, and even the end or telos of a thing that comes into presence as matter. When *frame* is used in the context of language, it conveys that sense of naturally ordered correspondences and the attendant properties of fixity and flux. It is not only that in the sixteenth century *frame* meant different things but that *frame* suggests how differently things meant. Language did not express meaning according to a binary logic of the sign, which imagines the word to be a picture of the thing it signifies; rather, it articulated an ordered network of matter.

According to Christian theological tradition, the signs of divine ideality were present in the order of nature as well as in scripture. Christian hermeneutics had always held that the iconic unity of the sign could be read both vertically, activated by the topoi designated in the arts of memory, and through the historical unfolding of the word.[7] But in the sixteenth century there was an increasing awareness, due in part to the rise of both vernacular writing and print culture, that in addition to the fact that human history unfolds according to scripture, the languages in which that history unfolds reveal temporal variation. The characterization of language itself as both fixed and fluid carries over into the efforts made by sixteenth-century writers, in treatises on vernacular poetry, to define the crafting of language. It was precisely because *frame* echoed God's material creation that this word, when used to describe poesy as a craft or trade, could convey that language was material and that the framing of language was a manipulation of matter, rather than a craft of memory or contemplation.[8] To say that a system of natural resemblances resonates in sixteenth-century uses of *frame* is not, therefore, to reinscribe linguistic usage within a

medieval epistemology. On the contrary, this flexibility in the application of the word suggests that mechanistic as well as iconic resemblances began to be ascribed to the divinely crafted matter of language and that sixteenth-century figurative language was invested with a particular material causality. The uses of the word *frame* in relation to language suggest that there is a instrumental causality in language that is distinct from anything we might identify as instrumental reason, for though that causality is manifest only in the materiality of written and spoken language, it is never entirely proper to the conscious reason of any single speaker or writer.[9] A single material utterance of the word *frame*, though it may suggest a specific use in its context, was not imagined to be cordoned off as an independent unit, a word attached to a little idea. Rather, utterances are shaped as part of the crafting of a fluid medium. Just as the fashioning of every individual cabinet or horseshoe is both a manifestation of the "arte" or "misterie" of carpentry or forging and also a contribution to that "arte," a craft is not so much an abstracted set of skills as it is the sum of the collective labors of a group of artisans over the course of time. To apprehend the use of a single sixteenth-century utterance or inscription of *frame* is to imagine it within a mobile crafted network of material language. Comparing *frame* with associated words like *mold, fashion,* and *temper* reveals that, in its various uses, *frame* signaled the joining of divine and mobile harmonies with the temporal unfolding of artisanal craft, a joining that was most readily and acutely expressed in figurative language.

"Moulde" and Frame

Many sixteenth-century writers were wary of artifice as an audacious exercise of reason unhinged from God's voluntary materialism. The dedicatory poem initialed "TN" in Antony Munday's 1579 *The Mirrour of Mutabilitie* answers precisely this concern:

> The Carver often cuts from hard and craggie stone
> Some rare device or curious woork in hope to please ech one
> And some that look theron oft times at random talke
> When they themselves can hardly frame the like of reder chalk.[10]

The implication of this passage is that it is misguided to derogate a "rare device or curious work" as artifice when it should simply be a given that human labor is artificial and can never attain to such divine spiritual framing as the creation of Adam out of "reder chalk." In this passage, the framing of sculpture must be distinguished from God's framing of man precisely because the resemblance is

so striking. Though *frame* means "to make," when used as a noun it denotes the human body, and thus the word recalls God's framing of mortal flesh even when *frame* is used in reference to human artifice or making. By referencing, without presuming to duplicate, the framing of man, this poem forestalls the charge that its own creation begets a vainglorious and idolatrous materialism. Other writers seeking to defend artifice refer to God's framing as the original act of artifice. Richard Haydocke, in his 1598 translation of Giovanni Paolo Lomazzo's 1584 treatise on painting, writes:

> For who knoweth not, that at the beginning of the world before man was cre-ated, God himselfe was the first Plasticke-worker? who taking some of that vir-gine elementary earth, which himselfe had first created, with his owne hande hee framed the moulde of the first man, and afterwardes most miraculously inspired it with a living soule.[11]

When the word *frame* is used in proximity to the word *moulde*, it tends to re-fer specifically to God's framing of Adam out of dirt. Timothy Bright's 1586 *A Treatise of Melancholy* is exemplary in this respect, though he claims man was made of no ordinary dirt, like the animals, but "that likely it is, mans body was made of purer mould as a most precious tabernacle and temple, wherein the image of god should afterward be inshrined." Bright explains:

> This tabernacle thus wrought, as the grosse part yeelded a masse for the propor-tion to be framed of: so had it by the blessing of God, before inspired, a spirituall thing of greater excellencie, then the redde earth, which offered it self to the eye only.

Though endowed with this "spirituall . . . excellencie," mortals must take care not to attempt to wrest reason from its bodily site. For reason, Bright goes on to say, "rising from the bodie . . . becommeth . . . an instrument unhandsome for performance." It should instead respect the "corporall inclination of the spirit," where body and spirit are both "corporeall and earthly: the one, in sub-stance, and the other in respect of that mixture, wherewith the Lorde tem-pered the whole masse in the beginning."[12] Indeed, whereas *frame* implies the spiritual inspiration of the body, mold implies its correlative material limitation.

It is just such a false division of mind and body that seems to account for the speaker's melancholy in George Gascoigne's poem "Woodmanship." Gas-coigne uses the word "mold" in his poem to mean simply the earth: "My mind is rapt in contemplation, / Wherein my dazzled eyes only behold/ The

black hour of my constellation, / Which framëd me so luckless on the mold."[13] But in the context of this contrast between the speaker's "dazzled eyes" and his "luckless" fortune, "mold" exaggerates the speaker's abjection by marking the distance between his circumstances and his "contemplation." What leaves the speaker wandering in the wilderness, what makes him "wood" or mad, is that his mind is divorced from his bodily activity, or rather that his trade is melancholy itself, for he practices the craft of "woodmanship," a craft in which the mind is removed from its right reason by being divided against the body.

Frame refers, in this period, not so much to the physical body, or that "grosse part," but to the tempering of that "masse" into "a spirituall thing." As *frame* refers to the tempering of spirit and flesh, to be "unframed" or "out of frame" describes the division of the body from the soul at death. Munday's "Complaint of Nabuchodonozor" contains the lines, "His Angell did preserve them in the flame, / So that they did no harme at all sustayne: / No, not one hear did perish out of frame."[14] And the anonymous poem titled "The testament of the hawthorne" in *Tottel's Miscellany* describes a similar parting of the spirit from the body at the end of life. Bemoaning an unrequited love, the speaker in this poem laments,

> And if you want of ringing bels,
> When that my corps goth into graue:
> Repete her name and nothing els,
> To whom that I was bonden slaue.
> When that my life it shall vnframe,
> My sprite shall ioy to heare her name.[15]

Life is "vnframed" when the abiding spirit departs from the "corps."

The "moulde" of the body is contingent, temporal matter. But because God has framed the seemingly anarchic multiplicity of human beings, there is a link between that radical diversity and the universality of divinity. As Queen Elizabeth muses in a letter:

> When I a gathering make of common pathes and trades, and think upon the sundrie sortes of travailars in them, I fynde a muse; no greater when multitudes be gathered, and faces many a one, amongst the whyche, not two of all be fownd alyke. Then wonder breedes in me how all this wordlye masse so longe is made to holde, where never a moulde is framed alyke, no never a mynde agrees wyth any other. And were it not that heavenlye dower overcometh philosophie, it could not content me well to remember that an evel is betterd, the less it be endured.[16]

Faced with the multiplicity and diversity of the "worldlye masse" and the dis-
agreements that emerge "where never a moulde is framed alyke," one almost
forgets that there is "heavenly dower" that "overcometh philosophy." And yet
without the belief that the heavens govern this diverse framing, there would be
no provocation to correct evil. Though the plurality of matter, the "moulde,"
seems utterly without unity, the belief that it is "framed" is what grants a
"heavenlye dower" to this "worldlye masse."

 That the body is dross matter or "moulde" reveals that its frame is fickle,
changeable, and mortal. "Moulde" makes its way into the title of this text in
the *ars morendi* tradition: *The Mirror of Mans Lyfe Plainley describing, what weake
moulde we are made of: what miseries we are subject unto: how vncertaine this life is and
what shal be our ende.* The closing poem by Stephen Gosson, "Speculum Hu-
manum," admonishes the reader to "keepe in mynde thy mould and fickle
frame."[17] Remember, that is, that the salvation of the soul, though it is implied
in the benefice of the frame, is never ensured. Because the frame is material, it
is subject to change, degeneration, and sin.

 It is no surprise, then, that *frame*, used in a derogatory sense, is the word that
gets used to describe accusations of supernatural meddling. Reginald Scot,
who criticizes witch-hunters for creating the alarmist fiction that evil spirits
can take on "earthlie forms and shapes of men," titles chapter 1 of book 4 of
his *The Discoverie of Witchcraft* "Of witchmongers opinions concerning euill
spirits, how they frame themselves in more excellent sort than God made vs."
To believe that evil spirits can frame themselves, says Scot, is to imagine that
these spirits can assume better mortal forms than "the bodies of them that God
made in paradise, and so the divels workmanship should exceed the handie
worke of God the father and creator of all things."[18] Here, *frame* pinpoints the
crafting of the things made, whether the craftsmanship of the "handie worke
of God" in creating the world or, alternately, the imagined craftsmanship of
the "divels workshop." But it is precisely because the word *frame* implies that
human acts of making are disposed toward studied obedience to God, that this
same word, used to connote willful disobedience, has such a strong rhetorical
effect of dissonance.

 Samuel Harsnett, in *A Declaration of Egregious Popish Impostures,* uses *frame* in
just this way, ironically inverting the belief that there is a kind of commutative
benevolence in any act of framing. He accuses Catholic priests of staging pos-
sessions and ("to rivet the frame more sure") of "instructing theyr schollers" to
not only enact but also "frame themselues" to the performance of exorcism:

> Loe here the Captaine of this holy schoole of legedermaine tells you, what was
> the highest point to be learned in this schoole, and what was the perfection of a

scholler, of the highest forme: to wit, to *frame* themselues iumpe and fit vnto the
Priests humors, to mop, mow, iest, raile, raue, roare, commend, & discommend. . . .
As euery scholler in this schoole had the wit, and good grace to *frame himselfe* be-
times, to the bent of his holy Maister. . . . For if he could once read his lesson in his
Maisters eyes and face, what needed any other hard horne-booke to beate about his
head: but if he were dull, and slow, vnto this *framing himselfe*, and must heere his les-
son many times said ouer by hart by the Priest and yet could not learne his cue . . .
then hee must tast of the discipline of the schoole . . . & that was the discipline of
the *holy chaire*.[19]

Frame works so well in the context of Harsnett's sarcasm, precisely because
these instances of framing are the contrivances of priests, whose own rhetoric,
as we know from the testimonies annexed to Harsnett's text, used *frame* in
earnest in the belief that they were banishing the devil from his habitation
within the *frame* of those who were possessed. In cases of conjuring or perfor-
mance, where the body is believed to violate its God-given function, framing
does not fit the mold.

But if it is the case that *moulde* inflects the meanings of *frame*, the reverse is
true as well. Like *frame*, *moulde* can refer either to matter that is shaped or to the
pattern or template that shapes the matter. A poem titled "The Oration of Syl-
vanus" written in praise of Queen Elizabeth by the Earl of Hertford as part of
the entertainment for the Queen's progress at Elventham in Hampshire reads:

> Faire Cinthia, whom no sooner Nature fram'd,
> And deckt with Fortunes, and with Vertues dower,
> But straight admiring what her skill had wrought,
> She broake the moulde; that never sunne might see
> The like to Albions Queene for excellence.[20]

In association with frame, *moulde* refers more frequently to flesh than to plain
dirt or earth and to the matrix in which flesh is shaped, the womb, more
than any other kind of pattern or template. Observing wife, mother, and
son, Coriolanus's phrasing dismally combines respect with harsh banality
when he refers to his mother, Volumnia, as "the honor'd mould / Wherein
this trunk was fram'd" (5.3.22–23). The commonplace juxtaposition of fe-
male matter and male form suggests that, in the context of the sexual gener-
ation of the body, framing is insemination whereas the womb is the mold. In
The Winter's Tale, Paulina brings the baby Perdita before her father, admon-
ishing Leontes for his suspicion that Hermione has been unfaithful and that
the child is not his:

> Behold, my lords,
> Although the print be little, the whole matter
> And copy of the father- eye, nose, lip,
> The trick of 's frown, his forehead, nay the valley,
> The pretty dimples of his chin and cheek, his smiles,
> The very mould and frame of hand, nail, finger.
> And thou, good goddess Nature, which hast made it
> So like to him that got it, if thou hast
> The ordering of the mind too, 'mongst all colors
> No yellow in't, lest she suspect, as he does,
> Her children not her husband's!
>
> (2.3.98–108)

Perdita is, flesh and bone, the child of her father. "Mould and frame" indicate that Perdita is both flesh and form, "matter and copy," matter shaped in the pattern of Leontes. In using "mould" as well as "frame," Paulina seems to assure Leontes that Hermione's womb bears only the pattern of Leontes, since Perdita was shaped in Hermione's womb as in Nature, in "mould" as well as "frame." The child is so like her father, the framed pattern has so thoroughly impressed itself upon the moulde of Nature, that Paulina goes so far as to call forth Nature to counteract the father's framing imprint lest the yellow jealously of Leontes's disordered mind show itself to be imprinted in Perdita. *Frame* and *moulde* together may evoke classical notions of the imposition of form on matter, but from a more Pauline perspective, that conjunction also suggests that the divine ideality impressed into all nature is realized only through a voluntary inclination of the will to the conjunction of spirit and matter.

Fashion and Frame

Both *frame* and *fashion* denote making and are at times used interchangeably. But if *moulde* implies limitation in matter, *fashion* implies limitation in time. *Frame* implies infinite making, an action that is ongoing, a tempered deed that corresponds with universals. *Fashion*, on the other hand, denotes strictly temporal making. *Fashion* can also denote divine making, but it is a form of making that has its end point in temporal matter, unlike *frame*, which indicates advancement and implies an end point in the future: in potential time, or, alternately, in eternal time. Spenser, in his first "Hymne in Honour of Love," praises "Great god of might, that reignest in the mynd, / And all the bodie to thy hest doest frame."[21] With the help of the word *frame*, the verse seems to collapse the agency of God and the agency of the body: the body frames itself

to do God's will. But the body frames itself to God's behest only because God reigns in the mind, and thus frames the body to the task. Framing is an eternally active creation into which the body is interpolated. In the next hymn, where Spenser treats of God's creation of the physical and where we might expect to find *frame* again, he uses *fashion* instead:

> Therefore of clay, base, vile, and next to nought,
> Yet form'd by wondrous skill, and by his might:
> According to an heavenly patterne wrought,
> Which he had fashiond in his wise foresight,
> He man did make, and breathd a living spright
> Into his face most beautifull and fayre,
> Endewd with wisdomes riches, heavenly, rare.
>
> Such he him made, that he resemble might
> Himselfe, as mortall thing immortall could;
> Him to be Lord of every living wight,
> He made by love out of his owne like moulde.[22]

The action here, the making of the "moulde" rather than the "mind," is the work of a craftsman, albeit a divine craftsman. It is a deed "wrought" by "wondrous skill." In reference to God's creation of the first man, the poem emphasizes that this is a past action, limited in time: "He man *did* make" by "an heavenly patterne wrought, / Which he *had fashiond* in his wise foresight." Fashioning, identified here with the crafting of "clay, base, vile, and next to nought," denotes a divine action in worldly time, an action that is not ongoing and eternal, but restricted to the past. When Spenser writes in Sonnet 8 of the *Amoretti*, "You frame my thoughts and fashion me within," he seems to be using *frame* and *fashion* to account for different kinds of activity, one of the mind and one of the body.[23] The beloved frames the speaker's thoughts, as the two preceding lines reveal, just as "Angels come to lead fraile mindes to rest / in chaste desires on heavenly beauty bound." And in fashioning him "within," as the succeeding lines reveals, the speaker says, "You stop my toung, and teach my heart to speake / you calme the storme that passion did begin." The "within" that is fashioned is not necessarily the interiority of the speaker, but his body. This activity seems to be more about fashioning limitations on the self—controlling passion, for instance—than what Stephen Greenblatt has called "self-fashioning."[24] Fashioning disciplines the body, where framing inclines thoughts to heaven, but the two acts are correspondent to one another. To "frame" is to draw matter toward its spiritual disposition; to "fashion" is to shape matter according to divine fiat, to copy it out.

There is a similar split between *frame* and, in this next case, "facyon" in an anonymous text from much earlier in the century. The 1537 text is a treatise against idolatry, and its title page reads, in part: *A treatise declaryng and shewing dyvers causes taken out of the holy scripture of the sentences of the holy faders, & of the decrees of devout Emperors, that pyctures & other ymages which were wont to be worshyped ar in no wise to be suffred in the temples or churches of Chrsten men.*[25] It is a poorly written and repetitive text, but I have quoted it at length, in part to show how frequently (seven times) the word "facyon" recurs in these passages. In the two sections of passage below, the first is concerned to show that God's word and the natural world are more active signs of divinity than are images, which are static. And the second is preoccupied with whether an artificial work is a work of God or a work of man:

> Let us not therefore have ymages, not of stone, nat of wood, nat graven, or cast in any molde (al which god hathe ones forever forbyden). . . . But let us rather consyder the verye worde of god. . . . Besides this, let the whole *frame* of this worlde be a monumente and token to put is in remembraunce of god that whatsoever true godlynesse is remaynyng in us: it may nat by the workes of men, but by the workes of god well & after a godly *facyon* considered, enflame and kindle us to the praysyng & lovyng of him. So that if after this maner & *facyon* we wold have lust and pleasre to learne Christe perfytely in all thinges, & his workes with a certayne lyvely felyng & iugement of the mynde, which shuld transforme & change us: without dout the love of god shuld be mervelously augmented & encreased in us, & we shulde alsoe (as it were in a glasse) see, with what comelynes, & after what maner and *facyon* the course of thys lyfe oughte to be passed over and brought to an ende, whiche no ymages canne ever be able to teach us. (emphasis added)

Frame is only used to describe the structure of the universe, and it is the only "monumente" in this passage. It provokes a "remembraunce" of God and ensures that "godlynesse is remaynyng in us." This attention to temporal duration continues. The works of God are known only "after a godly facyon considered"; "after this maner & facyon" of praysyng" the believer will "learne Christe." The "lyvely felyng" of God's works "shuld transform & change us" and reveal "after this maner and facyon the course of thys lyfe oughte to be passed over and brought to an ende." An image cannot teach all of this motion and passage of time. *Fashion* is identified with duration in the first part of the passage, where it is coupled with "maner." In this next part of the passage, *fashion* is identified with matter and coupled with "shape."

> Let them say (I besech you) howe or after what maner god is knowen by images, whether it is by the mater & stuffe put rounde about them: or els is it by the shape

and *facyon* brought i to the stuffe. If it be the stuffe of the images what he is knowen, then what nedeth any shape or *facyon* to be brought in by the workeman: & why is nat god shewed and knowen as well by al maner of stuffe before ye any images be made, syth all thinges do witnes & declare his glori. But if the shape & *facyon* broughte in to the stuffe be the cause of the knowlege of god: what nedeth than any payntynge or any other stuffe at all: and why is natte god knowen rather by the very lyvely creatures whose shapes or ymags be so perfectly knowen. . . . Fr trees or stones so more surely and lyvely putte us in remembraunce of god, whan they are consydered of us, havyng their owne naturall shape & *facyon* so as they were fyrst created of god: than whan by the worke and craft of men beynge deryved of theire owne naturall shape, they doo expresse & resemble unto us the image and lykenesse of man, or of any other thynge. The soner shall the remembraunce come to thy mynde of the karver or Payner, whose workmanship thou dost merveyle at, than the remembrance of god, the creator and maker of althings. (emphasis added)

Fashioning refers to the particular expression of tempered matter, whether it is imagined to be made by God or by persons.

Sylvester's translation of Du Bartas's *Divine Weeks and Works* also couples *frame* and *fashion* in its differentiation of an order temporal from an order eternal. Asking "Thou scoffing Atheist that enquirest, what / Th'Almightie did before he framed that [the world]?"[26] Sylvester anticipates the argument that God could not have existed before the Creation and counters that craftsmen do not cease to be when they are not practicing their trades. Before the Creation, God "meditated the worlds idea." God's idea exists above and beyond worldly time; framing, it seems, is the link between God's eternal and temporal making.

> So God, before this frame he fashioned,
> I wote not what great *Word* he uttered
> From's sacred mouth; which summon'd in a Masse
> Whatsoever now the Heav'ns wide armes embrace.
> But where the Shipwright, for his gainfull trade,
> Findes a all his stuffe to's hand alreadie made,
> Th'Almighty makes his all and every part
> Without the helpe of others wit or Arte.[27]

In between meditating the world idea and fashioning its frame, God uttered the "great Word." And, to return to the question posed to the "scoffing Atheist"—what did the almighty do "before he framed" the world?—framing designates the link between eternal meditation and temporal fashioning. Utterance summons the "Masse" and fashioning crafts the world. God can, of course, create matter out of nothing and without the help of any other "wit or

Arte." The craftsman, on the other hand, labors "for his gainfull trade": he has the help of the other laborers in his trade as well as the help of God's "wit" and "Arte." The matter that God has fashioned directs the craftsman's trade, for he "Findes as his stuffe to's hand alreadie made." When God creates the earthly matter, his labor is described as a temporal labor, as fashioning.

Roger Ascham's *The Schoolmaster* distinguishes speech that is framed toward God and reason from "oaths" of "the newest fashion." Ascham expresses his horror at a child who can "roundly rap out so many ugly oaths" but who "could in no wise frame his tongue to say a little short grace":

> This last summer I was in a gentleman's house where a young child, somewhat past four year old, could in no wise frame his tongue to say a little short grace, and yet he could roundly rap out so many ugly oaths, and those of the newest fashion, as some good man of fourscore year old hath never heard named before; and that which was most detestable of all, his father and mother would laugh at it. I much doubt what comfort another day this child shall bring unto them. This child, using much the company of servingmen and giving good ear to their talk, did easily learn which he shall hardly forget all days of his life hereafter.[28]

This child, according to Ascham, has not been brought into bad frame, but into no frame at all. To "frame" the tongue to give grace to God, the child's speech must first be framed to reason. "I wish to have them speak so as it may well appear that the brain doth govern the tongue and that reason leadeth forth the talk." But when, as happens even in the best schools in England, propriety in speech is neglected "so in young wits as afterward they be not only marred for speaking but also corrupted in judgment, as with much ado, or never at all, they be brought to right frame again."[29] In Ascham's text *frame* necessarily means "right frame" because of the connotations of benefit and profit associated with the word. The opposite of a child rightly framed is a child "marred for speaking but also corrupted in judgment." The "company of servingmen" have fashioned the child's speech, rather than framing it to reason and thus to God.

The resonance of godly speech in the word *frame* seems to account for the introduction of this word into the 1611 King James Bible in the shibboleth episode from Judges 12. The 1611 edition emends the Bishop's Bible and the Geneva Bible, both of which use the phrasing "And he sayde Sibboleth: for he coulde not so pronounce," and the Coverdale Bible, which reads "he sayde: Siboleth, [fo]r he coulde not speake it righte." The full passage from the 1611 edition reads:

> 5 And the Gileadites tooke the passages of Iordan before the Ephraimites: and it was so that when those Ephraimites which were escaped saide, Let me go ouer; that the men of Gilead said vnto him, Art thou an Ephraimite? If he said, Nay:

6 Then they said vnto him, Say now Shibboleth: and he said Sibboleth: for hee could not frame to pronounce it right. Then they tooke him, and slewe him at the passages of Iordan: and there fell at that time of the Ephraimites, fortie and two thousand.

The 1611 version seems intent on rendering the passage with precision. One can understand why translators would want to "frame to pronounce" this particular passage "right." This version takes words from both of the earlier texts: though these translators prefer "pronounce" from the Geneva and Bishop's Bibles instead of the Coverdale phrasing "speake," they also retain the word "right" from the Coverdale version, emphasizing that the shibboleth test hinges not on the Ephraimite failure to speak but to "pronounce . . . right." What matters in the shibboleth test is not that shibboleth means an ear of corn or, alternately, a stream, but that in its material utterance it is either rightly framed to God or not at all.[30] The divine word cannot be borrowed, it must be embodied.[31] If the speaker has not been framed to God, then he cannot pronounce the divinity of the word. The Ephraimite tries to "frame" or contrive a right pronunciation that only the properly "framed" tongue can speak.[32]

Spenser's Frame of Temperance

The mortal body is framed of both "moulde" and water, and this mixture bespeaks the mingling of flesh with spirit. Du Bartas's *Divine Weeks and Works* puts it this way:

> Almightie Father, as of waterie matter
> It pleas'd thee make the people of the Water:
> So, of an earthly substance mad'st thou all
> The slimie Burgers of this Earthly Ball . . .
> Thearfore, to forme thine Earthly Emperour
> Thou tookest Earth, and by thy sacred power
> So tempred'st it, that of the verie same
> Dead shape-les lumpe, did'st *Adams* bodie frame.
> Yet, not his face downe to the Earthward bending
> (Like Beasts that but regard their bellie, ending
> For ever all) but toward th'azure Skies
> Bright golden Lampes lifting his lovely Eyes;
> That through their nerves, his better part might looke
> Still to that Place from whence her birth she tooke.[33]

God's tempering of substance frames the body to join intellectual and sense perception. As George Chapman writes in *Ovids Banquet of Sence*, "Gentle and noble are theyr tempers framde, / That can be quickned with perfumes and sounds" whereas "they are cripple minded . . . That lye like fire-fit blocks, dead without wounds, / stird up with nought, but hell-descending gaine."[34] The sense perception of watery and melodic substances, "perfumes and sounds," is, for Chapman, consonant with divine reflection. To explore how this tempering of the body intersects with the question of artifice, both visual and poetic, I turn now to book 2 of Spenser's *Faerie Queene*, the book of temperance, where, in the context of a fictive epic narrative, Spenser must adjudicate the tempered mingling of spirit and body with the temporal fashioning of both verbal and visual artifice.

Canto 11 of book 2 of Spenser's *Faerie Queene* leaves off with Arthur laid up in bed in Alma's castle recovering from the wounds he received in defeating her enemies. The next and final canto of book 2 takes up again with Guyon, whose journey is already under way to the Bowre of blisse. The twelfth canto begins:

> Now gins this goodly frame of Temperance
> Fairely to rise, and her adorned hed
> To pricke of highest praise forth to aduance,
> Formerly grounded, and fast setteled
> On firme foundation of true bountihed.
>
> (2.12.1)

Who or what is meant by "this goodly frame of Temperance"? Is it Alma? The phrase "*her* adorned hed" specifies a female figure, and Alma is the most proximate female personification of temperance. But, assuming that this canto picks up where the last left off, the action expressed in these lines befits Arthur more aptly than Alma, since Arthur was last seen consigned to bed and attended by Alma who stays at his bedside to dress his wounds. Might not the "goodly frame" be the body of Arthur healed enough that he "Now gins . . . fairely to rise"? The opening lines of canto 12 solicit, only to confound, connections to the preceding narrative as if to announce that the beginning of this canto is not just a scene change but a conspicuous break from what has preceded it. Does "this goodly frame," then, refer to Guyon himself, whose legend is that of temperance? Perhaps, but then we are still left with the problem of the feminine possessive pronoun of the second line. This transition does not simply redirect the focus of the narrative to Guyon or, for that matter, to any one point of identification or any single allegorical figure.

The description of "this goodly frame" cannot exclusively refer to any one of the characters in book 2, unless we can find a hermaphrodite among them. For though "this goodly frame" has the feminine indication of "her adorned hed," so too does it have the masculine indication of a knight who, if not pricking on the plain, rises "To pricke of highest praise forth to aduance." There is a precedent for such a mingling of the masculine and the feminine and it is Alma's castle, the figure of the temperate body. The castle is first described in canto 9:

> The frame thereof seemd partly circulare,
> And part triangulare ô work diuine;
> Those two the first and last proportions are,
> The one imperfect, mortall, fæaminine;
> Th'other immortall, perfect, masculine,
> And twixt them both a quadrate was the base,
> Proportioned equally by seuen and nine;
> Nine was the circle set in heauens place,
> All which compacted made a goodly *Diyapase*.
> (2.9.22)

This complex passage has occasioned extensive commentary, beginning as early as Sir Kenelm Digby's 1643 exegesis.[35] Digby explains that the circle is the mind, the triangle the body, and the quadrate the four humors. But he also states that the "frame" is the "bodie of a man inform'd with a rationall soul": together "they make one perfect compound," a compound Spenser has only divided into its "severall parts" for ease of explanation. The immortal rational soul, deemed male, and the flesh, deemed female, are "joyned together to frame a compleat Man."[36] Since physical bodies tend to be gendered either male or female, the description of a "goodly frame" in both masculine and feminine terms is a reminder that temperance is not limited to the care of the body. More than a means of fending off death, which in canto 11 is handily personified as Maleger, temperance involves the recognition of the human mixture of the mortal and the immortal. So then is "this goodly frame of Temperance" Alma's castle, an allegory of the framed body?

It is; but whereas the castle was the allegorical figure used to describe the body, here the metaphor is returned to its source, the body, for in this passage the castle is set in motion. The "goodly frame" of this passage is both structural and mobile. The "goodly frame" *was* an architectural structure, "*Formerly* grounded, and fast setteled / On firme foundation of true bountihed" (emphasis added). Like the description of the "goodly frame" that is both a body that can "fairely . . . rise" and an "adorned hed," Alma's castle, or the House of

Temperance, is coupled with another frame. Alma's castle is the frame of the body complete unto itself, and yet it has an "other wondrous frame," the "Turret" of the brain.

> . . . that great Ladie thence away them sought
> To vew her castles other wondrous frame.
> Vp to a stately Turret she them brought,
> Ascending by ten steps of Alabaster wrought.
>
> That Turrets frame most admirable was,
> Like highest heauen compassed around,
> And lifted high aboue this earthly masse,
> Which it suruew'd, as hils doen lower ground
> But not on ground mote like to this be found,
> Not that, which antique *Cadmus* whylome built
> In *Thebes*, which *Alexander* did confound;
> Nor that proud towre of *Troy*, though richly guilt,
> From which young *Hectors* bloud by cruell *Greekes* was spilt.
>
> The roofe hereof was arched ouer head,
> And deckt with flowers and herbars daintily;
> Two goodly Beacons, set in watches stead,
> Therein gaue light, and flam'd continually:
> For they of liuing fire most subtilly
> Were made, and set in siluer sockets bright,
> Couer'd with lids deuiz'd of substance sly,
> That readily they shut and open might.
> O who can tell the prayses of that makers might!
>
> Ne can I tell, ne can I stay to tell
> This parts great workmanship, & wondrous powre,
> That all this other worlds worke doth excell,
> And likest is vnto that heauenly towre,
> That God hath built for his own blessed bowre.
>
> (2.9.44–47)

This "other wondrous frame" of the intellect that is "lifted high aboue this earthly masse" is still a "Turrets frame": it may be lofty enough to offer a "suruew" over the turrets of pagan history, but it is not limitless in its sights. This "turrets frame" remains "arched ouer head." It is artfully crafted, not through any devising of its own, but through its "makers might." The brain, "deckt with flowers and herbars daintily," might seem a "blessed bowre," but in fact it

only "likest is" to God's bower. This world is merely an other world seen from the "suruew" of God's "blessed bowre." The passage is a reminder that Christian thought can only rise above the "proud towre[s]" of classicism in its recognition that the brain is God's creation. The "goodly frame" of Alma's castle has an "other wondrous frame," an "adorned hed" that is both of the body and other from it.

It is only in traversing the "Diyapase" frame of the castle into that "other wondrous frame"—only after Arthur and Guyon are brought up to the turret—that the chronicle of Briton kings can be put forward. Even then, the poet pauses to worry, "Who now shall giue vnto me words and sound / Equall vnto this haughtie enterprise?" The enterprise is, in part, the telling of "the famous auncestries / Of my most dreaded Sovereign" (2.10.1), Elizabeth. But it is also the daunting prospect of attempting to tell God's story, a story "that to her [Elizabeth's] linage may compaire," but that is already told perfectly and completely in all the things of creation. "How shall fraile pen, with feare disparaged, / Conceiue such soueraigne glory, and great bountihed?" (2.10.2). In the remainder of the canto, the poet does manage to "conceiue," "fraile pen" notwithstanding, both the chronicle of Briton kings and its mythical dynastic link to Faerie land. Before the poet puts forward the particular conceptions of his own imagination, the historical myth of Fairie land, he moves first through the body to the brain, and through the brain to human history, reminding the reader at each stage that the poem remains within the world of God's creation. Only at that point—and then again only with some trepidation at the "haughtie enterprise"—does the poet move from human history to the imagination.

What the turret of the brain is to book 2, Contemplation's hill is to book 1. In book 1, Redcrosse Knight goes to stay in the House of Holinesse, where "His mortall life he learned had to frame / In holy righteousnesse" (1.10.45). He is then led up a hill to Contemplation, who reveals to him his place in Elfin history. In Elfin history, where Redcrosse Knight and Saint George are read as one, "name and nation [are] red aright" (1.10.67). If the function of Elfin history in book 1 is to read the signs of Christian salvation together with English history, the function of Elfin history in book 2 is to read the divine scale of nature together with English history. In book 1, allegory becomes history: the iconic sign of the Redcrosse is identified as Saint George; in book 2, history becomes allegory: the chronicle of Briton kings is written into the poetic allegory, invented here as an Elfin ancestry that stretches from Prometheus to Gloriana. Inasmuch as book 1 is about the reading of allegory, book 2 is about the writing of it: both are Christian, but the former concerns the creation of allegory with respect to scripture and the iconic sign, and the latter concerns the creation of allegory with respect to divine creation and the natural sign.

If book 2 concerns the writing of allegory, that is not to say that it is about the creation of a work of art.[37] On the contrary, Spenser addresses the crafting of poetry within the context of the legend of temperance precisely because tempering echoes the shaping of basest matter, since God is said to have tempered Adam out of red clay. It is true that inserting the writing of allegory into the legend of temperance likens poetic craft to divine creation, but Spenser makes a very careful hierarchical distinction between these two acts of creation. Insofar as Spenser acknowledges that poesy involves ideation, he is equally careful to circumscribe human ideation within the structure of God's material universe. Spenser takes such care in identifying poesy as a form of tempering in order to distinguish his poesy from precisely the kind of artifice that fancies itself a world of its own invention, such as the artifice, in the Bower, of *Genius*. Other poets articulated poesy's relation to the real far more in terms of what we might now call realism. In Sonnet 28 of *Astrophil and Stella*, Sidney claims that his poem does not reach beyond its expression as allegories are wont to do; his own poetry *is* love. With his references to "nation," "changelings" (as Spenser calls Saint George at 1.10.65), and "allegorie's curious frame," one would think that Sidney was targeting Spenser directly.

> You that with allegorie's curious frame
> Of other's children changelings use to make,
> With me those paines for God's sake do not take;
> I list not dig so deep for brasen fame.
> When I say *Stella*, I do meane the same
> Princesse of *Beautie*, for whose only sake
> The raines of *Love* I love, though never slake,
> And joy therein, though Nations count it shame.
> I beg no subject to use eloquence,
> Nor in hid wayes to guide Philosophie:
> Looke at my hands for no such quintessence;
> But know that I in pure simplicitie,
> Breathe out the flames which burne within my heart,
> *Love* onely reading unto me this art.[38]

Sidney contends that his poem is neither an expression of the idea of love nor the single-minded pursuit of sensual pleasure, but the actual breath of his burning heart. For Sidney, "allegorie's curious frame" pretends to "brasen fame," "eloquence," and "Philosophie," and, though it feigns an attention to craft by looking at its "hands," allegory looks to matter only to find therein "such quintessence."

For Spenser, on the other hand, the "frame" of allegory is what ensures that even the most fanciful aspects of the poem bear a relation to the real. He anticipates, in the proem to book 2,

> That all this famous antique history,
> Of some th'aboundance of an idle braine
> Will iudged be, and painted forgery,
> Rather then matter of iust memory.
>
> (2.proem.1)

Spenser alleges that Faerie land is real, as real, he says later in the proem, as the Americas were before they were known to Europeans. And given that the Americas were so frequently imagined as a new Eden, the reference confirms Spenser's contention that what history unfolds to the imagination is as material as the tempering of clay. The "antique history" of Faerie land is "matter of just memory": it has always been there, but its reality is not yet universally justified with memory. If the "antique history" of Faerie land is "matter of iust memory," the poem as an imaginative work is matter of just frame. This poem imagines Faerie land as part of the created world, and it does so by passing through one frame and into another that is both within and beyond the first.

Likewise, it is in the connection between frames that are both the same and other that the "goodly frame" that is Alma's castle, the human body and the House of Temperance, rises "To pricke of highest praise forth to aduance," rises, that is, to poetry or the language of praise. For, in this passage alone, the same word, *frame*, denotes the body (a frame with a head), an architectural structure (a frame that has a foundation), and poetry (a frame of praise). Language issuing from such base matter as the human body can praise the heavens—the "fraile pen" can "conceiue such soveraine glory"—because the signs of God's universal understanding are already present, in language as in the body, in the created world. Poetry can, therefore, praise the heavens, but only in its recognition of the word made flesh: the poem expresses itself as a body integrated in its mortal feminine and its immortal masculine elements and shows that Christianity makes it possible to recognize the divinity embodied in the matter of words. The "goodly frame" that rises with "her adorned hed / To pricke of highest praise" is the operation of allegory itself, the work of the poem or at least this legend of temperance. The frame of allegory, "Formerly grounded, and fast setteled / On firme foundation of true bountihed," is indivisible from the natural provisions of the divine ideal or the "bountihed" of God's material creation. The crowning motions of poetic allegory are not the triumph of the human idea but part of God's design in history.

Finally, then, in answer to the question about what is meant by the "goodly frame of Temperance," the "frame" refers to all of its poetic articulations of temperance—from personification to the letter. The "frame" is allegory itself. "This goodly frame" speaks the very poiesis of allegory itself, a poiesis of polysemy that, as Maureen Quilligan has pointed out, does not divide language into levels of meaning but rather enacts the integration of the literal and the metaphorical.[39] Quilligan, who defines the formal qualities of allegory as a genre, is also careful to explain historical changes in the allegory. And while *The Faerie Queene* can be located within the history of allegory, the history of allegory is also presented within book 2 of *The Faerie Queene*. Harry Berger Jr. has shown that the integration of classical and Christian temperance in book 2 addresses the relation of history to myth; so too does the legend of temperance in book 2 comment on the history of allegory.[40] Because the allegory of temperance contains the forms of allegory that precede this poem in its history, temperance can, at different moments in book 2, picture itself as Alma or as Arthur or as Alma's castle. But ultimately "this goodly frame" of temperance does not mean any one of them singularly because picturing is not ultimately how this allegory conveys meaning. "This goodly frame" manifests the allegory of temperance, not as the idea or image of an abstract structure, but as a mobile network of verbal matter.[41] Mixing levels of meaning just as the body mixes spirit with flesh, this frame compounds the poem with the body and with the word. The "goodly frame" is allegory made material in that it unfolds the history the word made flesh.

A compounding of the ideal and the material, the legend of temperance is also a compounding of time: *temperance* has its root in the Latin *temporare*, meaning to mix, but that root is also related to the Latin word for time, *tempus*. It is not that the poet makes a "goodly frame" of allegory to approximate the divine idea of the word made flesh but that the divine idea reveals itself in the movement of "goodly frame" of allegory, as in all temporal matter. As Berger has shown Spenser's poetry presents its readers with a "dynamic," rather than a picture; and that dynamic is a "temporal concept" instead of a "static and spatial one."[42]

Verbal allegory, the poem itself at its particular stage in Christian history, is the surest way to evoke the vertical symbols of truth—the world as a mirror of the divine ideal—while also revealing that the worldly manifestations of divine ideality—words, things, bodies—are always unfixed and moving in time. If one attempts to picture the "goodly frame of Temperance," one realizes before the sentence is up that "she" has changed utterly. It is not that this poem does not make pictures but that the operation of allegory, expressed as a "goodly frame of Temperance," cannot itself be pictured. In the here and now of this utterance of *frame*—that is, "*Now* gins *this* goodly frame"—the language of the

poem shows itself to be a body in motion, the divine significance of matter as it exists in time. The "goodly frame" is neither the body nor the rational soul, neither material creation nor the divine idea: "This goodly frame" names the engine that joins the terms in these pairs and the pairs to each other in time. The "frame" is the temporal and mobile engine of the word made flesh; the "frame" is the body and the poem, material signification in motion.

Berger has argued that the modern tendency to divide the intellectual from the poetic and to see verbal cues as visual symbols has polarized interpretations of book 2 into those based on aesthetic and moral premises and those based on theological premises; he maintains instead that the work of book 2 is precisely that of bringing classical temperance into alignment with Christian temperance. Berger makes clear that the mingling of abstract and material registers in Spenser's poetry of temperance is distinct from the allegorical theories, both classical and medieval, that preceded it and the interpretive strategies that have succeeded it.[43] Spenser takes classical moral philosophy and joins it with medieval theology to yield a poetics of temperance that is both practical and didactic. Berger explains the particularity of Spenser's poetics of temperance first by showing that allegorical personification in the poem does not divide the intellectual from the poetic and then by locating Spenser's poetic vision within the language of allegory. I would elaborate this last point to say that this poetics of temperance also steers away from both the visual ideality of classical philosophy and the visual emblematics of medieval exempla to ground temperance in figurative language.[44]

Though Berger's claims here are focused on the allegory of book 2, they tell us something about the way modern thought contorts the language of *The Faerie Queene*. The modern tendency to divide the intellectual or conceptual from the literal or poetic has confused our ability to see how the Renaissance struggled to coordinate both classical and Christian understandings of the relationship between the metaphysical and the material, specifically the relation of matter to both ideal forms and Christian divinity. Renaissance texts, and especially English poetic texts, show an increasing interest in explaining the correspondence of the material world to an ideality that was very differently defined in patristic theology than it was in the classical philosophies revived by humanists in reaction to medieval scholasticism. In patristic philosophy, the theological mystery of the joining of matter and spirit had been a subject for contemplation. In the face of an influential Italian humanist Neoplatonism that privileged a philosophy of vision and mind, it may have been increasingly important to *explain* the correspondence between the ideal and the material, to ground it in language. Neoplatonism, which was so useful in explaining how the mind perceived abstractions, also threatened to explain ideality as imagination rather than as divinity.[45] Spenser acknowledges that his "famous antique

history," because it is not immediately recognizable as an allegory in the tradition of the medieval arts of memory, risks being deemed "th'aboundance of an idle braine." But those with "better sence" will know that just because it is new does not mean that it is artificial. New discoveries can easily be natural, given "That of the world least part to vs is red." Spenser maintains that his Faerie land is no "painted forgery" but a real place to be found "By certaine signs here set in sundry places" (2.proem.2–4): reality that is yet to be read.

That Spenser chose to write an allegory at all suggests an adherence to the iconicity of words and things and the belief that the world was a language of divine creation. The language of the poem does not operate according to the binary logic of the sign that predominates in modern conceptions of language. For this same reason, Spenser's allegory cannot be adequately explained by approaching the poem as a formal contrivance. *The Faerie Queene* works the way it does not simply because allegory works that way but also because, to some extent, sixteenth-century language worked that way.[46] But, as Berger has pointed out, it is equally inadequate to explain *The Faerie Queene*, ignoring the fact that it is a poem, as the expression of a "habit of mind," be it that of humanist allegory in which "anagoge and letter are reduced to idea and image" or that of theological allegory, which mystifies the joining of the facticity to the spirituality of things.[47] Both of these allegorizing gestures, the Neoplatonic ideal and theological anagoge, produce an impression of timelessness in seeking to approximate the ineffability of universal truth or divine eternity. Spenser's allegory, however, acknowledges that the worldly manifestation of divine ideality cannot be removed from historical process, and language is no exception: the world may be the language of all things, but the unity of words and things "to vs is red" at different times in different places. Spenser may want to hold on to certain archaic resemblances, but so too does he insist that allegory articulates the reality of language in time. Spenser's conspicuous archaisms draw attention to the fact that language undergoes historical change. And his language contains innovative coinages as well as archaisms.[48]

Even (and perhaps especially)[49] in the case of Spenser, late sixteenth-century figurative language functions neither as a system of resemblances and similitudes nor as a binary logic of signification. To insist on the iconicity of language or, alternately, to reify language as a semiotic system is to overlook the way sixteenth-century writers were in the process of articulating figurative language as a special category of idealized matter involving a special category of craft. It was axiomatic for many sixteenth-century writers that purposeful divine ideality inheres in matter as in language. But whether poesy belongs to the artisanal manipulation of matter or to a divine unfolding of the word was another question. On the one hand, the telos of a thing or an action—indeed anything that could be defined as beneficent and purposive ideation, including

human thinking—is attributable to the presence of an eternal divine ideality. But writers such as Spenser were articulating imagination as a temporal form of ideation that has an instrumental place in history and poesy as an artisanal craft shaped not only by divine purpose but also by human invention. As language was increasingly subject to the inventions of human history, and as the matter of language increasingly shaped that history, that mysterious joining of spirit and matter in the iconic sign became unhinged. Yet language was still recognized as matter. Indeed, at this moment, when language obeyed neither a system of iconic signs nor a logic of binary relation, words expressed a particularly clear relation to matter. Once the Renaissance insistence that language is crafted matter is taken at its word, it becomes valid to explore changes in signification as a series of material transactions rather than as a purely idealist transition. *Frame* happens to be a particularly good place to begin because it is a word that describes both an idea made manifest and the manipulation of matter according to human design.

Poetic Offices and the Conceit of the Mirror

In the sixteenth century, framing did not indicate the finalization of an aesthetic object, but rather an active process of making. In framing something, an artisan made the materials at hand conform to the principles of a given "arte or misterie," though it was understood that those principles were in large measure already determined by the properties of the materials used in a given trade. Though framing could describe craft practices of every kind, framing was conspicuously identified with the crafting of poetic language. Framing was once understood as a process of tempering, a process, that is, of mixing solids and fluids, spirit and substance, thought and matter.

The tempered substance of glass and the craft of glassmaking are instrumental to understanding the craft of poetry in the late sixteenth century. Poetry and imagination have long been linked to a glass or mirror: the metaphor is so pervasive that it seems universal. Scholarly accounts in the second half of the twentieth century have challenged that seeming universality by showing how the metaphor changed from one historical period to the next, but they have not, in general, attended to either the material properties of glass or the practice of glassmaking.[1] For Renaissance writers, the material composition of the mirror, be it steel or glass, was a matter of significance to the mirror metaphor. The attention in Renaissance texts to the material specificity of the metaphor is a response to innovations in glassmaking, specifically the innovation of the crystal glass mirror. Yet these texts do more than document the innovation of a new object; the composition of the mirror seems to affect the very substance of the metaphor. Precisely because of the long-standing metaphor that links the mirror to the text, the introduction of the crystal glass mirror raised the possibility that discourse itself might be subject to technical innovation. Imagined as

an object like a steel mirror, discourse could be said to function as invention in the traditional sense, a medium held up to reflect the correspondences among things as they exist naturally. But if discourse were glass, it could function as an instrument in shaping reality, as more of an invention in the modern sense of the word. Innovations in glassmaking seem to have revealed, or in some cases threatened to reveal, a synthesis of technical and poetic invention across a wide range of discourses. In what follows, I show not only that poesy was likened to glass materials but that poesy and glassmaking, though each was something of an anomaly within the organization of trades, were identified as similar craft practices. This awareness of how the "offices" of poetry were linked with other social estates permanently altered the metaphor that linked the book to the mirror.

Mirrors of Steel and Glass

In 1576, just a few years after the newly invented crystal glass pocket mirror was first available as a novelty import in England, George Gascoigne published a verse satire conspicuously titled *The Steele Glas*. The poem is an estates satire for the sixteenth century and, as such, levels its invective on all of society. Yet as its title indicates, the poem orchestrates its censure around a single paradigmatic object, the crystal glass mirror. In everything from its manufacture to its exchange to its use, the crystal glass mirror signals social and material changes that contravene the modes of production and signification that Gascoigne identifies with the traditional steel glass.

The crystal glass mirrors that Gascoigne bemoans were not the first mirrors made from glass, but they were the first that rivaled steel "glasses" made entirely of alloyed metal. Convex glass mirrors had been produced in Germany and Holland and exported to England as early as the fourteenth century. These convex or pennyware mirrors were made from forest glass—a thick and slightly greenish-tinted glass—that was blown into globes and lined with lead. Pennyware mirrors needed no maintenance, whereas steel mirrors, because they oxidize with exposure to air, required regular polishing.[2] But the convex surface of the mirror did considerably distort the proportions of its reflection. Although convex mirrors were relatively inexpensive, most mirrors imported and sold in England, well into the sixteenth century, were steel and silver mirrors. Before the introduction of the crystal glass mirror, high-quality steel glasses seem to have been preferred over convex glass mirrors.[3]

The crystal glass mirror was the product of two distinct innovations: a perfectly clear glass and a light metal tain. In 1500, Flemish mirror makers developed a new process for silvering the glass of convex mirrors, using an alloy of

quicksilver and tin rather than lead. The new tain of quicksilver and tin made for a lighter mirror, both in its weight and in the brightness of its reflection. The practice was picked up by Venetian glassmakers who used the process to silver pieces of *cristallo*. Cristallo glass, an absolutely colorless transparent glass, was itself a recent innovation: fifteenth-century Venetian glassmakers discovered that the addition of *barilla* soda yielded a molten glass batch that could be blown very thin.[4] Cristallo was used primarily for the production of delicate and ornate tableware, but it also proved an ideal recipe for sheet glass.[5] When blown into a cylinder that was then cut open and laid flat to harden, cristallo offered a thin, clear, and flat surface for silvering.[6] This silvered crystal glass, thin and light enough to be fashioned into portable mirrors, reflected a clear, undistorted image and never needed polishing. By 1570, crystal mirrors were being produced in Venice, Antwerp, and Rouen and imported by goldsmiths into England.[7]

The new crystal mirrors were both wildly popular and widely sanctioned. Crystal pocket mirrors were comparatively expensive items and were frequently worn tied to the waist like jewels.[8] A late sixteenth-century Italian emblem book shows the crystal glass being used as a personal impresa (see fig. 16). The French moralist Jean des Caurres, railing against the practice of wearing mirrors at the girdle, seems most offended by the fact that they are even worn in church:

> O Dieu! helas, en quel malheureux regne sommes nous tombez? de voir une telle deprauité sur la terre que nous voyons, iusques à porter en l'Eglise les mirouers de macule pendans sur le ventre. Qu'on lise toutes les histoires diuines, humaines, & profanes, il ne se trouvera point, que les impudiques &meretrices les ayant iamais portez en public, iusques à ceiourd'huy, que le diable est dechainé par la France: ce qui est encoreplus detestable deuant Dieu & deuant les hommes, que toutes les autres abominations. Et combien qu'il n'y ait que les Courtisans, & Demoiselles masquees, qui en vsent, si est ce qu'auec le temps n'y aura bourgoise ny chambriere (commes elles sont, dés à present) qui par accoustumance n'en vueille porter.
>
> [Oh Lord! Alas, under what evil influence have we fallen? to see such depravity on earth as we see, to the point of bringing to church these mirrors of corruption hanging from the belly. Were one to read all the histories—divine, human, and profane—it would never be found that impudent and meretricious women had worn mirrors in public until this day, when the devil is set loose in France: which is more detestable before God and before men than all other abominations. And though none but courtesans and masqued damsels use them, if these times are any indication, every last bourgeois woman and chambermaid (as there are, even at present), by force of habit, will want to wear one.][9]

The crystal glass mirror was neither a distorted reflection nor did it require polishing, and thus in no way did it serve as a reminder that God alone sees and

DI ANTONIOMARIA

 O Specchio di Criftallo è Imprefa d'Antoniomaria Maruffo piacentino e fu ri-
trouamento à Imitatione della hiftoria,o della fauola la qual vuole che la pru-
dentia fi dipinga con lo fpecchio in mano, guardando fe ftelfa, impercioche,
niuno puo effere prudente fe non conofce fe medefimo,e chi piu perfettamente
conofce fe fteffo, piu perfettamente viue e diligentemente a fini ottimi condu-
ce le fue operationi . come però il Criftallo,o il vetro faccino tale effetto in rap-
prefentar le proprie effigie delle cofe, è volgarmente a ciafcuno manifefta noti-
tia,con cio fia che come nell'acque le quali non ondeggiano fi feruono le effigie di tutte le cofe vifi
bili per refleffione, cofi dal criftallo medefimamente col mezo dell'artifitio,reflettono fimilitudini
di tutte le cofe vifibili. Quefta voce, c R I S T A L L o è greca compofta di due parole dinotando gie-
lo contratto,effendo la verità,fecondo Plinio,che quanto il freddo è maggiore tanto piu perfetto il
criftallo fi genera . l'intentione del fudetto Maruffo academico è rapprefentata dalla natura dello
fteffo fpecchio,volendo dinotare tutti i fuoi difegni non douerfi condurre al fin loro,fe prima non
fi vedeffero, e confideraffero riufcibili, per la conferenza c'hauer dee il difegnatore col difegno,
perche come a vn Pefcatore non riufcirebbe il difegno di guidare vno Effercito,cofi à vn zappato
re non riufcirebbe d'amminiftrare la Giuftitia, nella quale il zappatore fpecchiandofi non vedreb
be nello fpecchio la fua propria fimilitudine, fpecchiandofi adunq; quefto academico nello fpec-
chio della fua profeffione effendo dottor di legge,rimane accorto di quáto deue e può fare nel fuo
effercitio, percio vedendo fe fteffo vfa il Motto c v N c T I S A E Q V E F I D V M cioè come fedele
a fe fteffo,tale farà a ciafcuno il medefimo,congiongefi poi diligentemente al Motto il nome acade
mico cioè I L G I V D I C E, con cio fia ch'Egli in quel tempo che fu nella Academia degli A ffidati
riceuto,adminiftraffe in Pauia la publica giuftitia, eletto Giudice fotto la Podeftaria del Signor
Gianpaulo Chiefa allhora fenatore di Milano, laquale Imprefa è piaciuta à molti,& in verità con-
tiene la vera proprietà di fimigliante fpettacolo . Antoniomaria è nato della famiglia Maruffa,già
più

Figure 16. Luca Contile, *Ragionamento Luca Contile sopra la propieta delle imprese* (Pauia,
1574) Gg₁v. By permission of the Folger Shakespeare Library.

judges each person as he or she truly is. Indeed, the clarity of the reflection seems to have been perceived by some as a usurpation of divine vision. Wearing a mirror to church flaunts this usurpation in the very place where one should be most conscious of being seen by God. The mirror had for so many centuries served as a figure of God's divine creation that it was an affront, or so it seemed, that any bourgeois citizen could produce in an instant, and without any effort or travail, a counterfeit image of crystal clarity.

To a moralist such as des Caurres, the crystal mirror signaled a disregard for both the hierarchy of social estates and the estate of man before God. Even to less strident critics, crystal mirrors were identified with vanity, flattery, social climbing, and moral lassitude. In Ben Jonson's *Cynthia's Revels*, Amorphus, after referring to the face as an index of the mind, says, "Where is your page? Call for your casting-bottle, and place your mirror in your hat, as I told you: so. Come, look not pale, observe me, set your face and enter."[10] And Charles Fitzgeffery's 1617 *Notes from Black Fryers* describes a "spruse coxcombe" who "Never walkes without his looking-glasse / In a tobacco-box or diall set / That he may privately conferre with it."[11]

The material history of the mirror seems to offer empirical confirmation of the Renaissance as an age of secularization, humanism, individualism, and emergent subjectivity. In Benjamin Goldberg's history of the mirror, the Renaissance was the point at which the Pauline doctrine that human knowledge of God is seen "as through a glass, darkly" came into conflict with the "clear mirror" of "humanistic philosophy." Sabine Melchior-Bonnet, who is sensitive to the technical innovations in mirror making and the modern "banalisation de l'objet," also identifies the Renaissance as the period when the mirror ceased to be invested with magical properties and instead became emblematic of the modern subject. In his compendious study, *The Mutable Glass: Mirror-Imagery in Titles and Texts of the Middle Ages and the English Renaissance*, Herbert Grabes claims that between the thirteenth and seventeenth centuries—a period he is tempted to call the "Age of the Mirror"—the mirror metaphor shifted. Once a figure of divine ideality, the mirror became a metaphor for human consciousness and originality.[12]

Debora Shuger, however, resists the tacit link between the invention of the glass mirror and the emergence of modern subjectivity. Admitting that she set out to establish that very connection, Shuger concludes instead that the presumption is false, at least with respect to the Renaissance mirror. She quite rightly observes that the Renaissance mirror was more transitive than reflexive: the mirror was meant to direct the viewer's gaze toward a moral or spiritual lesson rather than back upon the viewer's self. The mirror may ultimately coincide with modern subjectivity, but it is not the invention of the glass mirror per se that brings about this effect. In fact, Shuger's conclusion that the

Renaissance mirror "functions according to an ontology of similitude" effectively recasts the mirror as the image of a medieval mind-set.[13]

The conclusion that the Renaissance mirror—be it steel, convex, or crystal—"functions according to an ontology of similitude" avoids making the Renaissance mirror modern before its time. But it also entirely dismisses the question of technical innovation. That the glass mirror did not directly inaugurate modern subjectivity does not of course mean that its material innovations were insignificant. Registering the impact of those innovations, though, requires a shift in focus away from the subject-object relation and toward the relation of matter to meaning. Grabes's important scholarship on the preponderance of mirror titles suggests that the key question in understanding the Renaissance mirror is not how the mirror as an object led to the formation of the subject, but rather how the mirror as an object informs the mirror as a metaphor.

Gascoigne's *Steele Glas* directly addresses the impact of technical and material innovation on the conventional metaphor of the book as a mirror. Although the poem may seem, by its title, to be a nostalgic, if not reactionary, throwback, it fully apprehends the particular phenomenon of the mirror in the sixteenth century. With its assertions that the crystal glass mirror is emblematic of, if not instrumental in, broad-ranging social and poetic changes, the *Steele Glas* chronicles the dynamic relationship of matter to meaning in the mirror metaphor. And in so doing, the poem demonstrates the role of materials and technology in a metaphor that for centuries had served not only as a figure of divine ideation but as a practical instrument for human contemplation of the divine Logos.

The Mirror as Text

Specifying that his text is a *steel* glass, Gascoigne aligns his poem with a tradition of scriptural exegesis that would, over and against the worldly vanity of a novelty item like the crystal glass, reveal its shadowy truths according to the Pauline example, "as through a glass, darkly." The mirror title is a convention that presents the text as a didactic exemplum, leading its reader through the process of contemplation to a moral or spiritual truth. The initial appearance of mirror titles dates to the *speculum* titles of the thirteenth and fourteenth centuries—*Speculum mundi, Speculum ecclesiae, Speculum iudiciale*—and may have coincided with the invention of convex mirrors.[14] The metaphor of the book as a mirror linked figurative language to material invention long before the innovation of the crystal glass. As late as the sixteenth century, actual mirrors had elaborate frames that incorporated allegorical animal figures and even carved letters (see fig. 17).

Figure 17. Mirror Frame, Ferrara, 1502–1519. Victoria and Albert Museum, London. Soulage Collection. Courtesy of V & A Images.

Patristic and scholastic commentators had described scripture as a mirror, though other "texts" were believed to mirror the divine as well: in some cases all of created nature was a text, in others it was the human mind or the life of Christ that presented a textual mirror of divinity.[15] A person looking in an actual mirror might have seen in his or her image not an independent subject but rather a miraculous divine scheme of creation elaborated in the person's every feature—eyes, nose, lips, skin—and in the substance of the mirror itself. Sixteenth-century writers maintained that knowledge of the divine was accessible to human reason through nature. A more immediate perception of the divine was possible through revelation, and the mirror stood for revelation as well: at least in the cabalistic and hermetic traditions in the sixteenth century, mirrors and crystal balls were believed to have magical properties of vision and

prognostication.[16] From scripture to nature, from the human mind to the crystal ball, what all of these permutations of divine text share—what makes them all mirrors—is that they reflect both sensible reality and eternal truth. These mirrors, like scripture, reflected divine ineffability in the shapes of worldly things that were accessible to the temporal and sensory limitations of human understanding.[17] The mirror title was an important device not because it likened the book to a mirror per se, but because mirror, text, and nature were interchangeable and indeed inextricable expressions of the divine Logos.

A text was deemed creditable if it could be said to mirror the divine idea and, in turn, mirrors were creditable if they enabled viewers to "read" their own images correctly. This was true of actual mirrors, and not only mirrors as metaphors. Heinrich Schwartz has observed that, at a time when large numbers of pilgrims were journeying to Aachen for the display of its four most sacred relics, Landgraf Ludwig Hessen returned from his pilgrimage to Aachen of 1431 with "mirrors and signs," the latter being small metal emblems, as mementos of his journey. He also notes that Gutenberg was involved in a mirror-making venture at roughly the same time that he was involved in a printing enterprise. Schwartz believes that Gutenberg and his associates were making convex mirrors to sell to these pilgrims, who bought mirrors and held them up in order to capture the fleeting glance of the sacred relics as they were displayed. The display of relics, it appears, was not only something to see but something to be seen by: the mirror betokened that moment when the pilgrim had a vision of *and* was visible before the sacred relic. Every subsequent glance at this mirror memento might serve to remind the believer of that glimpse of sacred divinity.[18] The mirror captured a reflection of the divine that could be discerned not through any immediate image in the glass, but only by seeing past the transitory reflection of the body to contemplate or "read" the divine image of the self that is held by God.

The appearance of a mirror or a glass in a book title signaled that the text was both a reflection of divine ideation and a practical instrument through which that ideal might be emulated. This kind of contemplation was considered to be an active craft. In medieval discourses on devotion, the mirror is evoked as a figure for pious contemplation and private study. In her discussion of the art of memory, Mary Carruthers cites Gregory the Great, as he paraphrased Augustine: "Holy scripture presents a kind of mirror to the eyes of the mind, that our inner face may be seen in it." Carruthers argues that, in late medieval writings, memory is an active process and ideas pass through the body to be quite literally digested: "The full process of meditative study is completed" when "what we read is transformed into our very selves, a mirror of our own beauty or ugliness, for we have, like Ezekiel, eaten the book."[19]

By referring to his own text as a glass, Gascoigne seeks to invoke the tradition of discerning shadowy spiritual truths through the active craft of contemplation. But the mirror metaphor in and of itself no longer conveys that "full process of meditative study." To recapture that sense of the labor of contemplation and reflection, Gascoigne must specify that his is a steel glass, a glass that requires the effort of polishing—some labor on the part of its user—before it can be expected to render a proper image.

Crystal Conceits

This attention to the divine authority that inheres in things—texts, mirrors, nature—deemphasizes poetic authority, for it means that the poet is also a reader of divine text. Gascoigne presents the didactic exemplum of the steel glass as much for his own benefit as for that of his readers. Having earned a reputation for concupiscence on the page and off in his "reckles youth," Gascoigne heralded his reformation with the publication of *The Steele Glas.*[20] He declares in the dedicatory epistle his newfound intent to match the "magnanimitie of a noble minde" with "industrious diligence."[21] Whereas his earlier work had dallied in sexual and poetic license, *The Steele Glas* occupies itself with properly productive labors.[22] This is not Gascoigne the translator and purveyor of Italian rhetoric, but Gascoigne the devoted countryman, using the late medieval convention of estates satire to reflect on the state of domestic industry in England. Disdainful of poetic conceits that have entered English verse just as any fancy new import—like the crystal glass mirror—might enter the English marketplace, Gascoigne touts instead an invention, "from auncient clyffes conueyed" (53), that is both inherited and wrought. *The Steele Glas*, Gascoigne writes, presents "words of worth . . . With this poore glasse, which is of trustie Steele,/ And came to me, by wil and testament / Of one that was, a Glassmaker in deede." The glassmaker "in deede" is the classical satirist Lucilius, who bequeathed the steel glass to those who would see themselves as they are "Bycause it shewes, all things in their degree" and the glass mirror to those who "love to seme but not to be" (55).

Gascoigne's steel glass links the poem with its past, consolidating its relation not only to the tradition of scriptural exegesis but to the recovery of classical texts as well. Gascoigne laments that in these "our curious yeares," everyone has a glass, but very few actually see themselves:

> That age is deade, and vanisht long ago,
> Which thought that steele, both trusty was and true,
> And needed not, a foyle of contraries,

But shewde al things, euen as they were in deede.
In steade whereof, our curious yeares can finde
The cristal glas, which glimseth braue and bright,
And shewes the thing, much better than it is,
Beguylde with foyles, of sundry subtil sights,
So that they seeme and couet not to be (54).

Appearances in a glass mirror beguile and delude the viewer. The glass mirror is detached from "true" and "trusty" matter, showing things as they seem to be but are not. Gascoigne does refer to the materiality of the glass mirror: a "foil" was the tin and mercury alloy that was used as the backing of a glass mirror and "site" denoted the curved plate of glass before it was silvered. But his material references are also puns and thus his solid references melt into conceits: the metal foil is a "foyle of contraries," and glass sites "Beguylde with foyles" become "subtil sights" or views. Gascoigne's punning language demonstrates how, in the all too perfect reflections of a glass mirror, the material composition of the instrument drops away, leaving the viewer with a mere impression of the image in the glass.

This propensity toward facile reflection is evidence, for Gascoigne, that "peuishe pryde, doth al the world possesse." And peevish pride is itself to blame for the fact that "every wight, will haue a looking glasse." Thus Gascoigne also expresses the concern that a "glasse of common glasse" can only turn back on itself, begetting pride with pride, and circumventing worldly dependencies in human thought and behavior with its hasty and immaterial reflections. "This is the cause," the verse continues, "that Realmes do rewe, from high prosperity / That kings decline . . . that plowmen begge . . . That Souldiours sterue," and so on for eighteen more lines whereupon he concludes, "This is the cause (or else my Muze mistakes) / That things are thought which neuer yet were wrought, / And castels buylt, aboue in lofty skies" (55).

Gascoigne's muse of trusty steel can reveal that the glass mirror is a mark of "curious yeares" that are characterized by "peuishe pryde" and "weening ouer well" (54). The glass mirror cannot reveal pride, but can only, like a conceit, recirculate pride in a new disguise. Gascoigne is careful to establish that the glass mirror works its effects only in the realm of human fantasy. The glass mirror can aggrandize the pride that makes "the world goeth stil awry," but it has no bearing on the realm of temporal cause and effect. Gascoigne wants to point out that the glass mirror is not causal, but only conceited. In the lines immediately preceding the passage cited above where the glass mirror is first mentioned, Gascoigne seeks to explain the state of "this weak and wretched world":

And as I stretch my weary wittes to weighe
The cause thereof, and whence it should proceede,

My battred braynes, (which now be shrewdly brusde,
With cannon shot, of much misgouernment)
Can spye no cause, but onley one conceite,
Which makes me thinke, the world goeth stil awry.
(54, emphasis added)[23]

The glass mirror provides no purposiveness, no telos for how things "should proceede" in the world itself or in the mind of the speaker, whose "weary wittes" and "battered braynes" reflect the "weak and wretched world." Looking for the cause of the world's decline, Gascoigne finds instead only a conceit, an immediate or incontinent cause rather than a temporal one. Looking for solid evidence, something his wits can "weighe," Gascoigne finds only a figure, a trifling thought, a bit of fancy.

The glass mirror has no proper place in the temporal order of matter: it is either a castle in the air or a crass material luxury. The glass mirror is thus quite literally a conceit, since *conceit* denoted not only an inventive rhetorical trope but also a fancy article or trifle. Thomas Starkey, for instance, writes of "marchantys wych cary out thyngys necessary and bryng in agayn vayn tryfullys and conceytes."[24] Gascoigne himself remarks that "daintie fare" has quickly led to "excesse on Princes bordes, / [Where] euery dish, was chargde with new conceits, / To please the taste, of vncontented mindes" (59); and later he applauds the emperor who cared not "For Baudkin, broydrie, cutworks, nor conceits" but only "such like wares, as serued common vse" (71). *Conceit,* from the Italian *concetto,* a word that has been so central in describing the fanciful inventions that are distinctive to the sonnet tradition, simultaneously refers to precious and persuasive trifles, objects that have too much significance attached to them.[25] In *A Midsummer Night's Dream,* Egeus accuses Lysander of having "stol'n the impression of [Hermias's] fantasy / With bracelets of thy hair, rings, gawds, conceits, / Knacks, trifles, nosegays, sweetmeats—messengers / Of strong prevailment in unhardened youth."[26]

The glass mirror is an object associated not with "cause" but with "conceit": it produces "fantasy," "prevailment," or, as Gascoigne puts it, a "foyle of contraries." Unlike the steel glass, which offers a decorously imperfect reflection of divine intent in the causation of the material world, the glassy mirror proves to be not only a false reflection of reality but also a false instrument within it. The glass mirror, instead of manifesting divine ideality and its social embodiment, provokes self-generated ideas in the minds of mortals. As a steel glass, poetic invention gathers and reflects the wisdom of its predecessors and polishes anew the spiritual and ethical reflections that may illuminate the conditions of the present. A poesy that would liken itself to the innovation of the crystal glass mirror obscures these intersections of past and present, reading and

writing, of creation and consumption, and offers only topical conceits that are tied to neither a fixed place nor a temporal value. Rather than an object wrought by a known craftsman situated by his trade within a stable social network of material production, the crystal glass is a rarified conceit: an object that accrues meaning incontinently as it is exchanged.

Glozing Glass

Gascoigne fashions *The Steele Glas* as the didactic exemplum of a commonwealth of estates: a social order that linked a person's status on earth with his or her standing before God, and a person's land or station with his or her labor or vocation. Gascoigne's poem favors principles of social organization that are, quite literally, continent, grounded, stationary. Fashioning his poem as a steel glass, Gascoigne chooses a mirror whose particular substance calls to mind England's natural resources and mining industries of tin, copper, and lead. He chooses a mirror whose particular substance must be polished with each use before it will yield an honest and true, if not perfectly glistening or sharp, working reflection. And he chooses a mirror whose particular substance will link the poetic mirror with the patriotic sword, and thus his career as a poet with his career as a soldier. The steel glass reveals even the poet's own labors of scouring the work of his predecessors. With this material specification, Gascoigne effectively foregrounds the active labor that comprises social tropes of birth, property, and use or consumption.

Above all, the particularity of Gascoigne's steel glass specifies what it is not: a newfangled import, the crystal glass mirror. Whereas the steel glass is identified with the estates of the realm, with land and domestic resources, with social custom and degree, the crystal glass is identified with mercantile trade, with fluid and artificial value, with sudden social mobility. For Gascoigne, the crystal glass is commodious and useful only in the most fleeting and provisional of senses: in its exchange and consumption, it shows neither a coherence with the past nor a continuity with temporal causation. It is, rather, a conceit in both sixteenth-century senses of the word: a luxury item and a fanciful idea. The particular substance of the crystal mirror is the guarantor, for Gascoigne, that the reflections of the glass mirror are not grounded or continent like the steel glass, but utterly incontinent, in the multiple senses of that word. That is to say, the crystal glass mirror is fluid, effeminate, unrestrained, unmoored from terra firma, and—a meaning of incontinent that is now obsolete—immediate, sudden, without temporal interval.[27]

The crystal glass mirror would have seemed incontinent in both its consumption and its production. Crystal glass mirrors were not produced in England until

1624. At the time Gascoigne was writing, crystal glass mirrors were imported primarily from Venice, though also occasionally from Antwerp.[28] The manufacture of glass mirrors could not be tied to any English sense of place. These new glass mirrors, unbound to any continent land in England, were imported from overseas and valued, as products of mercantile exchange, according to the liquid media of money. The manufacture of these foreign imports was especially mysterious since they were the result of recent technological innovations and since the Venetian Council of Ten was especially strict in guarding the trade secrets of the glass industry in Murano, the primary site of glass production in Venice.[29] Glassmaking also tended to be a family trade, so that the secrets of the craft were handed down from one generation to the next, rather than shared among members of a guild.[30]

What *was* known about the origins of these objects made them smack all the more of incontinence. One might trace the glass mirror to its place of production, but that place proved to be no more continent a terrain than Venice. Nor could glass production in Venice be explained by the presence of any earthbound material. The raw materials used in the Venetian glass industry were all shipped in from elsewhere: quartz-rich stones from the Ticino River, soda ash from the Near East.[31] Indeed, what appears to have made the glass industry succeed in Venice has nothing whatsoever to do with land resources and everything to do with the supremacy of Venetian maritime trade.[32]

Finally, glassmakers do not appear to have labored according to degree in any traditional sense at all. Because of the hard physical labor involved, it would seem that glassmakers would be classed as mechanical or artisanal laborers. In fact, most glassmakers had an unusually elevated status as compared with other artisans.[33] Until the seventeenth century in most parts of Europe, England notwithstanding, glassmakers owned the glasshouses where they practiced their craft. Glassmakers in Normandy and Lorraine solicited, and were granted, noble rights and privileges on the basis of their craft. It even seems that these glassmakers were resented for their upward class mobility, for Godfrey reports that other members of the lesser nobility refused to integrate them into the feudal establishment through allegiances of intermarriage.[34] In Venice, the daughters of glassmakers were permitted to marry Venetian nobles and the average wages of master glassblowers exceeded by threefold the average wages of other skilled artisans.[35]

Glassmaking was anomalous among artisanal trades because glassmakers were bound neither to manorial estates nor to the corporate guild structures in towns. The tricks of the trade may have been as closely guarded as the secret arts or "misteries" of any guild, but most glassmakers practiced their trade independent of guild regulation. When governed at all, glassmaking was regulated by contract law and legislative governance. This is evident from legal

documents in the case involving Gutenberg's mirror-making partnership: the documents reveal that the partners were seeking to protect the technical secrets of their craft after the death of one of the members.[36]

Medieval glassmaking had not fallen under guild regulation because it was primarily an itinerant trade. Furnaces for the production of the crown glass used in stained glass windows were set up near cathedrals during construction. The need for a steady supply of wood as fuel was another reason for the transience of glassmakers. In England, glassmakers continued to move about well into the sixteenth century, often making special arrangements with aristocratic landowners for rights to build temporary glasshouses and to burn wood on the property.[37]

That glassmakers continued to move about even when they had been granted noble rights and privileges indicates that the social and economic capital of glassmakers did not inhere so much in their property as in the more portable asset of trade secrets. The trade secrets of glassmaking were often, like property, passed down through bloodlines, but unlike real property they were mobile assets. The first patent for the production of cristallo vessel glass in England was issued in 1567 to Jean Carré, who had previously emigrated from France to the Netherlands before finally settling his practice in London. Furthermore, during the sixteenth century, cristallo production had inflated the social status of the glassmaker by identifying the work as a creative, imaginative, and noble craft. Hugh Tait reports that when Archduke Ferdinand of Tyrol, son of Emperor Ferdinand I, set up his own personal glasshouse at Innsbruck in 1563, he requested that the Venetian Council of Ten select for his workforce "whichever of the glassblowers of Murano had the most 'fantasy in him.' "[38] Glassmakers relied on autonomous rather than corporate trade secrets and gained credibility through personal rather than collective ingenuity.

The rapid innovations in glassmaking during this period, combined with the secrecy and relative autonomy of individual glassmakers, meant that glassmaking privileged imaginative technical inventions—inventions, not in the classical sense of refashioning or finding anew, but in the more modern sense of unique and novel ingenuity. The craft practice that produced crystal mirrors was not circumscribed by the traditional order of social estates. The conveyance of and demand for the crystal glass connoted fluidity and lack of restraint. But what made the crystal glass especially suspect to someone like Gascoigne was that it was incontinent in both its production and its consumption. The crystal glass could produce an immediate reflection without effort and without any temporal interval elapsing.

The material specificity of Gascoigne's metaphor is indicative of his general lament in *The Steele Glas*: that a commonwealth of local production is being supplanted by a newer model of specialized manufacture and overseas trade.

But it also indicates Gascoigne's awareness that this new form of economic production and exchange simultaneously alters the way that a society perceives and represents itself. Whereas the steel glass, the object and the poem, are products of a domestic industry based on traditional estates and vocations—in which both the production and the use of the object can be situated in time and space—the crystal glass mirror belongs to an economic model that not only dissociates the object from the labor involved in its production but also from the labor involved in its consumption. In this poem, material production and economic exchange are indivisible from the production and exchange of ideas. Instead of an object that truly reflects social reality in a collaboratively wrought image, the crystal glass, from Gascoigne's perspective, reflects the fanciful conceits of the private consumer.

George Gascoigne's Satire of Steel

Acknowledging that his classical bequest must be "scowrde" for its present satirical purpose, Gascoigne writes, "I see you *Peerce*, my glasse was lately scowrde" (78). The poem polishes up an ancient legacy to reflect the estates satire of *Piers Plowman*, which in turn reflects Gascoigne's England as a system of social estates so overtaxed and disarrayed that petty vanities and corruption threaten to render the whole system obsolete. Gascoigne's solution is neither to embrace the new economic system of trade privileges nor to hold fast to an outmoded feudal order, but to preserve the principle of a commonwealth of estates through honest labor and duty, in accordance with degree. It is the job of the poet to link how things could be with how things are, to link thought and imagination with matter. And it is for this reason that Gascoigne insists on the mediated materiality of verse that is a steel glass.

The poem imagines the possibility of an ideal commonwealth, but only by way of negative example, as the inverse of actual labor and vocation in England. Through an exhaustive catalogue of occupations, the speaker imagines a time "when brewers put, no bagage in their beere, . . . When printers passe, none errours in their bookes, . . . When goldsmithes get, no gains by sodred crownes" (79–80), all the while enumerating the vices of tradesmen and professionals and inveighing against the deleterious effects of pride at every level of human society, from priests and kings to peasants and soldiers. The poem can indeed imagine things better than they are "in deede," but unlike the false perfect glimmering of the crystal glass, Gascoigne's poem, as a steel glass, reflects that imagined ideal only through the tarnished surface of present vices.

Gascoigne is equally careful not to overemulate the past. Gascoigne's glass is "scowrde" by its study of *Piers Plowman*: looking back to the past polishes the

glass that reveals present vices. But the poem also invokes the history of satire as a tarnished genre, in order to turn the corrosive wit of his predecessor onto his own nostalgia. For Gascoigne derides poetry that would "bite mens faults, with *Satyres* corosiues, / Yet pamper vp hir owne with pultesses" (77). By the poem's own admission, the social estates it would conserve are already outnumbered and obsolete. The last hundred lines of the poem contain a litany of the very merchants and tradesmen who had always troubled—and did so increasingly at the time that Gascoigne was writing—the division of the population into the three pat categories of peasant, knight, and priest. And the poem lists four instead of the customary three estates. Gascoigne's retrogressive posture, rather than nostalgia pure and simple, should perhaps be read in terms of the resurgent interest in *Piers Plowman* among sixteenth-century radical reformers who urged economic reforms to remedy the burdens that the decrepit feudal system placed on the commonwealth. As Lorna Hutson has pointed out, however, those same reforms very quickly enabled new forms of economic and social privilege.[39] Gascoigne laments that aspect of feudal society that, in principle, had guaranteed all persons a sense of place in society and before God: the notion of goodly labor according to degree. Yet in virtually the same breath, his satire acknowledges that the monopolies and trade privileges that make him wistful for the past are nothing more than feudal inequities in a new guise.

The poem invokes the system of three estates—lords spiritual, lords temporal, and commoners—normally identified with feudal social organization, but in a strangely altered form: "I see, within my glasse of Steele / But foure estates . . . The King, the Knight, the Pesant, and the Priest" (57). Instead of the traditional three estates, Gascoigne lists four. He has added the king as an estate, separate from the lords temporal. In addition, Gascoigne notes that the priests are "the last that shewed themselues" in his glass (74). Though the enumeration of four such estates is an oddity, there is a precedent in John Hooker's 1572 *Order and Usage of the keeping of a parlement in England*, which lists four estates: king, nobles, commons, and clergy. Hooker consolidates the three classical estates of mixed government—monarchy, aristocracy, and democracy—with the three medieval estates of peasant, knight, and priest.[40] And Gascoigne follows suit, positing a social organization that amalgamates classical legacy and medieval custom. Consistent with the mirror that reflects it, this image of society is both an alloy and an old substance polished up for new purposes.

Gascoigne's ordering of the estates is not so much a critique of the church as a commentary on its loss of estate. Recognizing that the Crown's seizure of church lands diminished the priestly estate in England, Gascoigne nonetheless holds the *office* of the priest in high estimation. And on this point, Gascoigne is

careful to distinguish offices as godly deeds rather than entitlements: "Although they were the last that shewed themselues, / I saide at first, their office was to pray" (74). Lamentable though it may be that the church is no longer the landed estate it once was, it is the godly duty of the clergy to maintain an estate through the office or practice of prayer.

Office is a double-edged word for Gascoigne. Well aware that the proliferation of secular offices and entitlements is nothing more than feudal privilege in a new form, Gascoigne inveighs against offices that delude men—men who are in truth no more than peasants—into believing that they have elevated themselves above their mean estate. Even so Gascoigne advocates the performance of one's offices or deeds, insofar as offices denote the labor of one's estate. Priests are listed last, but the most tenuous estate in Gascoigne's text is the peasantry. Nowhere is the decline of feudal society more pronounced than among peasants, and no longer is the plowman the representative peasant. Rather than dispensing with this estate altogether, Gascoigne enlarges the category of peasant to accommodate merchants, artisans, and tradesmen. The marginal caption "Strange Peasants" sums up the passage on peasants, opening with, "All officiers, all aduocates at lawe, / Al men of arte, which get goodes greedily, / Must be content, to take a Peasants rome" (68). The poem closes with an appeal to priests to pray for the tradesmen who abuse their offices with such occupational misdeeds as shoddy craftsmanship and pilfering. But these abuses pale in comparison to Gascoigne's disdain for those strange peasants whose offices are newly created and seem to have no relation to the provision of necessities.

Gascoigne describes the estate of peasants as "strange" because their work no longer ties them primarily to the land, but identifies them with a dizzying array of "offices." Some of these "strange" peasants would have been strangers indeed, given the number of foreign artisans working in England, for the new mercantile economy prompted the overseas exchange of both goods and workers.[41] And Gascoigne also counts English merchants among his list of peasants. In fact, Gascoigne devotes as many lines to merchants as he does to all other peasant officers and advocates combined. It is no surprise that Gascoigne's satire is at its most biting when he addresses merchants, that class of peasants that, at least to his mind, is least bound to the land, and least beholden to the system of estates. What is somewhat surprising, however, is that Gascoigne presents the merchant as an inverted priest. After reproving the merchant suppliers, their luxurious trifles, and the vain desires of their consumers, Gascoigne says that in truth he cannot even see these mercantile tricks or chimeras in his steel glass:

> These knackes (my lord) I cannot cal to minde,
> Bycause they shewe not in my glasse of steele.

> But holla: here, I see a wondrous sight,
> I see a swarme, of Saints within my glasse:
> Beholde, behold, I see a swarme in deede
> Of holy Saints, which walke in comely wise
> Not deckt in robes, nor garnished with gold,
> But some vnshod, yea some ful thinly clothde,
> And yet they seme, so heauenly for to see,
> As if their eyes, were al of Diamonds,
> Their face of Rubies, Saphires, and Iacincts,
> Their comly beards, and heare, of siluer wiers. (72)

Here, Gascoigne truly shows his meaning "as through a glass, darkly." For where Gascoigne's steel glass clouds over in mists, his poetic mirroring is in its fullest effect. A swarm of saints takes the place of the indiscernible merchant. Heavenly profit proves the mirror opposite, down to the last figurative gem, of the merchant's lucrative gain, for the saints are "Not deckt in robes, nor garnished with gold." But in the steel glass of the poem, their "thinly clothde" humility is comparable to the most priceless gems.

The merchant, like every member of Gascoigne's society, faces the choice of performing his offices in his own self-interest or in the interest of society. But the vices of other tradesmen—the vintner who mixes water with wine, or the pewterer who infects tin with lead—amount to little more than a predictable nuisance: "(Tush these are toys, but yet my glas sheweth al)" (80). But the merchant, as the converse of the priest, has the power to affect negatively every estate in the realm. Merchants, by the misuse of their offices, threaten to dissolve the system of estates, whereas priests, by their offices of prayer, promise the maintenance of men's estates.

The merchant is also the converse of the poet. The offices of the merchant can disrupt the very fabric of society, and can even cloud the perception of vice that is so crucial to proper moral action. What the merchant obscures with "knackes," the poet must reveal in figures of truth. If it is the office of the priest to pray for the preservation of man's estate before God, it is the office of the poet to make visible the decadence of man's estate on earth. In the final lines of the poem, Gascoigne elides the offices of poet and priest with the plea "I pray you pray for me" so that together they may "shew, all colours in their kinde":

> And yet therin, I pray you (my good priests)
> Pray stil for me, and for my Glasse of steele
> That it (nor I) do any minde offend,
> Bycause we shew, all colours in their kinde.

> And pray for me, that (since my hap is such
> To see men so) I may perceiue myselfe.
> O worthy words, to ende my worthlesse verse,
> Pray for me Priests, I pray you pray for me. (81)

The poetics of the steel glass, rather than proliferating conceits as so many crystal glass repetitions of pride, ends with the repetitive verbal incantations of prayer. In the simple repetition of the word *pray*, the poem consolidates the voice of the poet with that of the priest and suggests, perhaps, that in the steel glass of satire, invective is a tarnished form of prayer.

The Temporal Temper

The Steele Glas ends with the conspicuous repetition of a single word: it ends, that is, by calling attention to its own medium of language. The steel glass, a duller and less precise instrument of reflection than the crystal glass mirror, always reveals that its reflection is conditioned by its medium. Like the steel glass that oxidizes with exposure to air and must be polished for use, a poem requires labor: it must be read and digested before the fullness of its depiction emerges. The steel glass, as both object and poem, links production and consumption with reading and writing. A glass mirror indicates the extravagant immediacy of both poetic and commercial conceits, whereas the poetics of a steel glass, in its very substance, bespeaks a model of making and consumption, as Gascoigne puts it, "in deede."

At a manifest level, Gascoigne's poem reveals the reorganization of social estates and the simultaneous emergence of mercantile economies that were taking place as he wrote. But Gascoigne's poem also seeks to explicate the dynamic relationship between those socioeconomic formations and specific discursive inventions. The steel glass is identified with a stable system of professional trades, the crystal class with merchants and social mobility; the steel glass with land and national strength, the crystal glass with fluidity and global commerce; the steel glass with divine authority and worldly temporality, the crystal glass with human agency and fleeting vanity; the steel glass with labor and causation, the crystal glass with conceit and incontinence. For Gascoigne, imaginative inventions are perforce material and causal: language and human imagination are part of the divinely fashioned temporal register. Like the metaphor of the mirror that is calibrated to material changes in the physical object, Gascoigne's poetics express the material facticity of historical change, rather than the progress of human thought.

Gascoigne was not alone in registering the impact of the crystal glass mirror on the mirror metaphor. Stephen Batman, for one, embraces the new invention, titling his 1569 book of moral emblems *A Cristall Glasse of Christian Reformation.* He explains in the epistle to the reader that he means the book to be

> This cristall glasse wherein we may learne godly reformation, whose brightness shineth not to the beholders therof in this world a light to every christian man, but in the world to come a most precious and everlasting brightnes in endles felicitie. As I sayd, a manifest shew of all coloured abuses that raigne in every state, and set in the frame of most plentiful & Christian examples. The substaunce wherof is the perfect glasse of godly reformation, beautifed with the cristall light of all celestiall vertues, right fruitful for every man to cary, and most nedeful for this our present tyme.[42]

For Batman, the crystal glass perfectly figures for the reader an ideal reformation: its reflection shows the abuses of the world while its substance makes the reader mindful of the crystalline spheres of heaven.

For the Puritan Thomas Salter, writing in 1579 his *Mirrhor of Modestie*, the glass mirror is so negatively identified with worldly pride that it can in no wise evoke the celestial spheres, least of all in its glassy surface. Salter explains that the *Mirrhor* is a manual for matrons on proper religious training for young women:

> In my judgemente, there is nothyng more meete, especially for young maidens, then a *Mirrhor*, there in to see and beholde how to order their dooyng: I meane not a christall *Mirrhor*, made by handie arte, by whiche maidens now adaies dooe onely take delight daily to tricke and trim their tresses, standyng tootyng twoo howers by the clocke, lookyng now on this side, now on that, least any thyng should bee lackyng needefull to further pride, not suffering so muche as a hare to hang out of order: no, I meane no such *Mirrhor*, but the *Mirrhor*, I meane is made of an other matter, and is of muche more worthe than any chrystall *Mirrhor*, for as the one teacheth how to attire the outwarde bodie, so the other guideth to garnishe the inwarde mynde, and maketh it meete for vertue, and therefore is intituled a *Mirrhor* meete for Matrones and Maidens, for matrones to knowe how to traine up such young maidens as are committed to their charge and tuition, and for maidens how to behave them selves to attaine to the feate of good fame.[43]

Like Gascoigne, Salter avers that his text is decidedly not a glass mirror. But unlike Gascoigne, who disdains the crystal glass in favor of a steel glass, Salter favors an entirely abstracted mirror metaphor, one that "guideth to garnishe

the inwarde mynde." Salter strips his metaphor of physical attributes until it is only as material as the language that conveys it: the word *mirrhor* itself, for instance, or the book that goes by that name. Salter compares spiritual contemplation not to any actual mirror, but to an idea evoked by the word *mirrhor*.

With the invention of the crystal glass mirror, the time-honored metaphor of the book as mirror seems to have become too material, too attached to worldly thought and reflection. Acknowledging the incursion, both Batman and Salter qualify their use of the mirror metaphor, distinguishing the worldly crystal glass from a more spiritual heavenly reflection in order to exhort their readers toward spiritual contemplation. But there are notable differences in the means by which each author qualifies the mirror metaphor to satisfy the ends of spiritual contemplation. In Batman's 1569 text, the mirror metaphor functions allegorically, referencing two hierarchically ordered levels of meaning: the reflection of worldly vices on the one hand and the contemplation of celestial matters on the other. These levels of reference resemble one another not through any moral, ethical, or ideal similitude, but rather through the crystalline substance of the metaphor that links them, a substantive resemblance that ultimately points up their true differences. Salter's mirror metaphor, by contrast, divorces itself from any material resemblance, from any actual experience of doing up one's hair in a given mirror, for instance, to establish a correspondence between spiritual contemplation and the book that directs that purpose. For Salter, the metaphor of the mirror is itself closer to spiritual contemplation precisely because it is absent of any material signs or shows. Salter establishes a conceptual parity or resemblance between language and contemplation by excising the metaphor of any material references. Salter's metaphor is thus semiological rather than allegorical in its functioning.

Gascoigne's *Steele Glas*, on the other hand, reflects an image of Renaissance poetics that is neither allegorical nor semiological, but mediated or tempered. For Gascoigne, the crystal glass mirror holds forth the false promise of ideation divorced from material and temporal causation. What distinguishes the steel glass is its capacity to reflect temporality, to reflect, that is, the passage of time as a particular property of the divinely created universe of physical matter. Using a metaphor of tempered steel to reflect temporal matter, Gascoigne describes in his own words the meanings already inherent in matter. For Gascoigne, only the conspicuously material metaphor of the steel glass, which is both reversionary and prospecting, both imaginative and mundane, can define the present in its relation to both the past and the future as a moment of historical change.

The "Offices" of Poetic Craft

Shakespeare's Sonnet 77, which looks at the outset to be about memory and contemplation, ends with a focus on the "offices" and joint labors of reader and writer. Whereas Gascoigne's poetic "offices" are incantatory, echoing the prayers of a priest or officiant, these poetic offices promise to "profit" and "enrich" poetic language. They do so, in part, by showing that the seemingly instantaneous and visual effects of the poetic conceit are in fact the result of poetic labors: the labors of reading and writing on the part of both the poet and the beloved. Instead of a kind of contemplation that withdraws from worldly things, the conceits of this poem suggest a more promiscuous performance of "offices." The sonnet begins with the presentation of a mirror as a memento mori, a mirror that bespeaks a specific kind of contemplation and emblematic book learning, and transforms that relation into one in which the book, conditioned by economic metaphors of labor and profit, is the result of a material collaboration of reading and writing, making and looking.[44] The first quatrain rehearses the familiar image of the mirror as an exemplum of the contemplation of mortality:

> This glass will show thee how thy beauties wear,
> Thy dial how thy precious minutes waste;
> The vacant leaves thy mind's imprint will bear,
> And of this book this learning mayst thou taste.

The glass and the dial are a reminder of mortality. Through contemplation and study, and by leaving the "mind's imprint" on "vacant leaves," this learning is internalized. The lines express the contemplation of death in the tradition of the medieval art of memory; "this learning," like the meditation Mary Carruthers compares to Ezekiel's eating of the book, "mayst thou taste."[45] The glass, the dial, and the book all function emblematically, enjoining the young man to remember his mortality through the contemplation of these tangible signs.

Katherine Duncan-Jones, also commenting on the regressive mood of these lines, has pointed out that this first quatrain makes use of a standard rhetorical device as well. The head note to sonnet 77 in her edition reads:

As if to reinforce his self-description as a monotonous and old-fashioned poet in the previous sonnet, the speaker deploys the hackneyed figure of *correlatio,* much used by Sidney, and popular in the sonnets of the 1590's. . . . Though it has often been suggested that the poem is designed to accompany three gifts, or a gadget incorporating all three, there is no clear indication of this, and the echo of *thy*

glass in 3.1 counts against this notion. Metaphorically, all three [the mirror, dial, and book] may be found in *Son* [Sonnets] itself, which offers an admonitory image of the youth, a chronicle of his subjection to time, and pages which await his annotation.[46]

Although Duncan-Jones does not think the speculation that this sonnet accompanied the gift of a blank commonplace book or table-book can be verified,[47] she acknowledges (in a later note) that the "vacant leaves" of "this book" may refer either to a notebook or to the blank marginal space of the Sonnets. For Duncan-Jones, the three objects are rhetorical rather than referential. The "hackneyed figure of *correlatio*" links the table book to the text of these poems, just as the glass corresponds to the image of the young man and the dial to his subjection to time. The rhetorical device of *correlatio* seems to work as emblematically as any memento mori. The objects enumerated—the glass, the dial, and the book—all point to the larger themes of the sonnet sequence. But their formulation here suggests that this rhetorical device is also underwritten by a kind of polysemy. For the correlation of the three objects is routed through an unspoken pun on the word *son*: the son whose image mirrors the father's, the sun that is charted by a dial, and the word *son* that with a bit of annotation easily becomes *sonnets*, thus betokening the heir whose absence has occasioned so much of the writing in the sequence. As emblems, the material objects of the poem are hierarchically linked to "higher" meanings that create an allegory of worldly impermanence. But they also work their way down, literally, through the body that digests them. And as conceits, they circle back on themselves through a contemplation of the material letter: the homonymic pun of son and sun, and the graphic pun that reveals son (as in son and heir) to be a truncated form of sonnet. If the rhetorical trope of *correlatio* seems "hackneyed" in this first quatrain, it is in part because it and the medieval memento mori tradition overlay the same four lines of verse, repeating an old tradition as if by rote. The sonnet even seems to imply that contemplation is no longer a craft, as it had been in the monastic tradition, but has instead become, on the one hand, the hollow echo of Christian allegory and, on the other, the precious devices of witty rhetoric.[48] Yet there is another trace to the *correlatio*, a subtext rather than a supertext, in the graphic and aural pun on the word *son*: the paradoxical materiality of a word not even spoken.

The next quatrain returns to the image of the glass and seems to restate the initial lesson—your reflection will remind you of your mortality—but in an altered form: "The wrinkles which thy glass will truly show, / Of mouthed graves will give thee memory." In the next two quatrains, the poem reiterates the glass, the dial, and the book and with their repetition meaning begins to inhere in the material description itself rather than in an idea that lies above

and beyond the material object. At the second mention of a mirror, and with the added promise of a glass that "will truly show," it is said that the "wrinkles" seen in the glass will give memory of "mouthed graves." At first glance, the sonnet seems simply to repeat in this line its opening admonishment: wrinkles should be a sign of mortality, of the gaping jaws of death or "mouthed graves" in which corpses are buried. But the wrinkles do not only signify or point to "mouthed graves," they *are* "mouthed graves" if one imagines wrinkles as engravings etched on the face around the mouth. At the same time that the phrase "mouthed graves" simply refers back, in a new phrase, to what has already been named "wrinkles," the phrase also opens up myriad other references. The "wrinkles" visible in the mirror around the mouth of the beloved, wrinkles that betoken the grave, are also instantaneously made to betoken, in the punning phrase "mouthed graves," the voice that has been engraved or written, as the utterances of poetic language. Here, instead of functioning as the clue to a rhetorical riddle or as the memento mori that prompts the contemplation of mortality, the glass in the second quatrain leads to an opposite effect: in circling back on itself, the image in this glass produces a proliferation of meanings through even a single phrase like "mouthed graves."

In response to the rhetorical puzzle whose solution is not put into words and to the emblem whose significance lies in an abstraction for which the figure is only a sign, the sonnet introduces empirical observation of the object and the letter. This time, the glass is not something to be looked past to get at the idea of the grave or of youth, but to be looked into: by way of the specific observation of wrinkles in the glass, the word "graves" stands as a material as well as a semiotic reference. Graves are made material, very simply, because the word "graves" is written down in this line, whereas in the first glass mortality is loosely invoked. But the "mouthed graves" are also material in that they refer to things already on the page: the lines of verse themselves, but also the wrinkles on the face mentioned earlier in those lines of verse. Instead of enumerating images—the glass, the dial, the book—that all point toward a single admonitory moral or the answer to a riddle, the second two quatrains of the poem describe the same "gadgets" in ambiguous phrasing that fans out into an array of possible meanings. Far from closing down on meaning, the materiality of this phrase opens up the possibility of meaning. To whom do the mouthed graves refer? Do they belong to death personified? Are mouthed graves wrinkles? Are they lines of verse? If wrinkles, are they those of the young man who sees them in his glass? Or is the young man who sees his own wrinkles in the glass reminded of the even more advanced wrinkles of his aging lover? If lines of verse, are they those of the poet? Or is this a strict reiteration of the first quatrain, reminding the young man to mark the pages of the book he has been given?

The fact that one cannot exactly determine the referent of "mouthed graves" is, I want to suggest, part of the meaning of this poem. Even the poem's most straightforward descriptions of the activities it prescribes for the young man, because those activities amount to the young man creating a written record of this memory in a tablebook, seem to beg the question of whether it is the young man's activity or the poet's that is accounted for here. It is, after all, usually the poet who does the looking and the writing that the young man is instructed by this poem to do. The ambiguity about who is looking and writing that began with "mouthed graves" returns in the third quatrain where the figure of the tablebook reemerges:

> Look what thy memory cannot contain,
> Commit to these waste blanks, and thou shalt find
> Those children nursed, delivered from thy brain,
> To take a new acquaintance of thy mind.

The poet's message to the young man seems simple enough: write down those thoughts that you are liable to forget and they will prove to be, like your heirs, a record of your memory. But the logic of these lines is slightly unsettling. One cannot look to one's own current memory to discern what it will not contain in the future. Perhaps the suggestion here is also that the young man should look not only to his memory but to the memory *of* him set down by the poet—"thy memory" could be construed both ways—to determine what the poet's verses may have left out. Though the young man seems to be directed again to the blank pages referred to in line 3 as "the vacant leaves," its seems significant that they are now "*these* waste blanks." The use of the demonstrative pronoun seems even more pronounced if one considers that Booth has modernized the quarto's phrase "waste blacks" to "waste blanks" on the grounds that "blacks" is likely to have been the compositor's error in overlooking a nunnation mark. But "waste blacks" makes sense in the poem if we consider that the phrase is a self-abnegating reference to the inky lines of the poet's own book of verses and not just the blank pages of the young man's tablebook.[49] Indeed, these "waste blacks," the poet's inky lines, are also "vacant" or "blank" because they are transparent; through them, the young man has access to his own lost memory, reflected back to him by the poet.

The uncertainty about whose labors are named in this poem is exaggerated even further in the next few lines. The poet invites the beloved to "commit to these waste blanks [blacks]," reproducing his memory as if by biological reproduction, a form of reproduction that is necessarily collaborative. The word "delivered" calls to mind the labor of childbirth, and thus that another person's labor is required to produce this "new acquaintance of thy mind." This line

does not only evoke the labor of the mother in childbirth. The description that the young man will find his writings returning to him like "children nursed" evokes an entirely different class of labor, since the children of a gentleman—such as the young man, who is identified as "Mr" on the title page and whose "gentle" status is confirmed throughout the poems—were generally turned over to wet nurses who held a lower social rank than the babies they nursed.[50]

The presence of these other forms of labor suggests that this sonnet, which is seemingly about the writerly activities of the young man, may also be about the collaborative production of these verses. The final couplet involves a conspicuous introduction of economic metaphors, metaphors of labor and profit that might easily have been seen as an affront if applied to a gentleman's private commonplace book.[51] The final lines read: "These offices, so oft as thou wilt look / Shall profit thee and much enrich thy book." It is possible that the poem is intentionally equivocal about whether the phrase "thy book" of the final line refers to the young man's tablebook or the poet's book about the young man. This kind of doublespeak allows the poem to compare and even equate the young man's higher "offices" with those of the poet, while it can still demur that the taint of profiteering falls on the poet. The shared practice of writing in this sonnet is always put to the service of praising the young man, but it also makes visible the poet's craft. Look to your own book, the poet might be saying, to memorialize yourself for posterity, but also so that I might allude to it and enrich my book of you.[52]

The very next sonnet in the sequence begins, "So oft have I invoked thee for my muse, / And found such fair assistance in my verse." In fact, the sonnets on either side of Sonnet 77 query the role of the young man in the poet's craft. In Sonnet 76, as Duncan-Jones points out, the poet assumes a "monotonous and old-fashioned" voice: "Why with the time do I not glance aside / To new found methods and to compounds strange?" The poet bemoans that, although he praises his "sweet love," he ends up "Spending again what is already spent." The poet gets nowhere but rather "keep[s] invention in a noted weed / That every word doth almost tell my name, / Showing their birth, and where they did proceed." In Sonnet 76, the poet's craft does not, of its own accord, gain him anything like what we would now call cultural capital. The traditional form of poetic invention that, as Sonnet 76 recalls, finds out an "argument" and proceeds by "dressing old words new" leads neither to the "profit" of Sonnet 77 nor to the "grace" and "fair assistance" that the poet gains from the influence of the young man in Sonnet 78. And it is important to note that the poet does not advance through what a modern aesthetic sensibility would define as artistry. If the poet manages a novel form of poetic invention in Sonnet 78, it is not expressed as a new "method," a pure expression of wit, or the

"mind's imprint" that he attributes to the young man. Rather, it is an invention that pronounces hierarchical divisions at the same time that it locks them together, as it does by joining the poet's scribal craft with the young man's station.[53] Though the poet claims, in Sonnet 78, to be only a compiler of the young man's "majesty," he also imagines his craft as the young man's progeny: "Yet be most proud of that which I compile, / Whose influence is thine, and born of thee." And, remembering that "art" readily referred to the "misteries" of artisanal trade in the sixteenth century, the poet concludes in a couplet that intertwines what "thou art" with his own poetic artifice, "But thou art all my art, and dost advance / As high as learning my rude ignorance."[54]

Sonnet 77 turns from the late medieval memento mori tradition of contemplating one's own mortality to a model of regenerative productivity through the collaboration or shared duties of the poet's more commercial "offices" and the "mind's imprint" of the young man. Sonnet 77 starts with an old-fashioned comparison of verbal and visual contemplation that also has a figure of time, the dial, inserted into the center of this comparison. By the end of the sonnet, reading seems inextricable from writing, and contemplation inseparable from the offices of looking. The sonnet integrates thought with matter and vision with language in such things as wrinkles that are also "mouthed graves" while it also integrates the young man's memory with the poet's craft through the shared labor of writing. And the figure of the dial indicates that there is a timeliness in the way that this sonnet crafts this material conjunction of the visual and the verbal in verse. In this sonnet, the passage of time is not recorded in terms of a medieval model that, with its focus on the hour of one's death, establishes a hierarchy dividing the mundane emblem from the spiritual moral. But nor does this sonnet escape from time through the atemporality of a rhetorical trope that turns sun into son through a witty device that divides use from signification. This sonnet marks the progress of time through its own poetic craft, a craft that eternalizes the memory of the young man through the shared offices of looking whereby the poet and the beloved steal glances at each others' books.[55]

This sonnet dispenses with received, emblematic methods of knowledge and memory in favor of a posterity that is effected by empirical observation, by forms of observation and recording that are achieved not through imitation alone but also through laborious craft. In this sonnet, lines of verse are transparent not in spite of but because of their materiality. The "waste blanks" and "mouthed graves" of this poem register what memory cannot contain; they reproduce the functioning of the mind in time. And as such they reveal the functioning of the mind not as a container, but as an active instrument of making that is comparable to the lines of verse themselves, the mind as a transparent instrument in its own right.

Poesy, Progress, and the Perspective Glass

In George Herbert's collection of poems, *The Temple*, the opening stanza of "The Windows" reads:

> Lord, how can man preach thy eternal word?
> He is a brittle crazy glass:
> Yet in thy temple thou dost him afford
> This glorious and transcendent place,
> To be a window, through thy grace.[1]

Referring to "man" as a "brittle crazy glass," Herbert's phrasing recalls the notion that mortals, though made in the image of their creator, reflect divinity only in the weak substance of flesh, which is fragile and easily broken. "Crazy" means here not "insane" but cracked as a glass, though the derivation indicates that our own word for an unsound mind still bears a trace of that older notion of the mind as a mirror. The "brittle crazy glass" recalls a similar passage from Shakespeare's *Measure for Measure*, in which Isabella muses that "proud man dressd in a little brief authority, most ignorant of what he's most assured—his glassy essence—like an angry ape plays such fantastic tricks before high heavens as makes the angels weep" (II.ii.118–22). The window in the poem seems to offer an answer to this fragility of mortal flesh. In "the temple"—which is to say, in the church, in the temple of the body, and in this collection of poems—the "glassy essence" of the body can be illuminated with the transcendent light of grace, and thus transformed from a crazy glass to a window.

Jean Hagstrum, writing about this poem alongside Herbert's "The Church-floor," says,

The "Church-floor" is really not about the floor of the church at all but about the human heart that it exemplifies. And the "Windows" is concerned less with the object than with its metaphorical meaning. Like all iconic poetry it contemplates the material, but not to suggest how skillfully it has been used or how miraculously it represents reality. What matters is that the glass, although fragile, has a lofty and important place in the church, that upon it has been pictured the life of Christ, and that through it shines the light of the day. These facts symbolize the frailty of the priest as a man but his dignity as an imitator of Christ's life and as a transmitter of divine grace.[2]

For Hagstrum the poem is iconic because it symbolizes the dilemma of the priestly intercessor, and the human condition in general, as an image in a stained glass window: an image, presumably, that depicts the story of Christ illuminated by a divine light that "anneals" it. In this reading, the poem describes a pattern of symbolic imitation in which the priest looks to Christ as a model and then inspires the laity to do the same.

The example, however, is not the picture but the illumination of "light and glory" that transforms the "brittle crazy glass" of mortal flesh into a "holy Preacher." It is an example of annealing rather than *mimesis*.

> But when thou dost anneal in glass thy story,
> Making thy life to shine within
> The holy Preacher's; then the light and glory
> More rev'rend grows, and more doth win:
> Which else shows wat'rish, bleak, and thin.

It is significant that the poem does not prompt its reader to look at an image of Christ pictured in the window. The poem shows instead how divine light "anneals" its stories within the "wat'rish, bleak, and thin" substance of mortal flesh. The poem is not iconic in a traditional sense: it does not present poetic images as transparent means to a spiritual idea, transporting the reader to a signified meaning that lies above the material word that produces them. The window is not something to be studied and copied; it is something to be. And the point of Herbert's poem, as I see it, is not to "symbolize." Its poetic images disclose meaning in a different light; they reveal, in their attention to the materiality of glass, the possibility and also the fragility of flesh as an instrument of grace.

The final stanza applies this annealing to the mingling of "Doctrine and life" in the preacher's speech.

> Doctrine and life, colours and light, in one
> When they combine and mingle, bring

> A strong regard and awe: but speech alone
> Doth vanish like a flaring thing,
> And in the ear, not conscience ring.

Life and light combine to make the preacher's speech, like the image, "holy." But "speech alone"—that is, speech without light and life—is a "flaring thing": a passing illumination, a dazzling but ephemeral display that rings only in the "ear" and not in the "conscience." Although the poem seems to draw an analogy between speech and images, and to suggest even that speech should emulate the image, its emphasis is on the annealing of divine illumination with mortal life. The negative example of "speech alone" at the end of the poem has the principal effect of rendering speech and image alike as weak comparisons to the annealing of light in the living body, and a secondary effect of suggesting that the written poem, unlike spoken rhyme, may be one "thing" that can in "conscience ring." This negative example at the end implies that the lively word cannot be represented in any form, even by the poem. And yet with that phrase "speech alone" (which might lead the reader to expect that the poem will reveal something that is unique to speech), these final verses intimate that the poem, read in silence, may perhaps ring true.

Herbert's poem seems to wrest language from iconicity and return it to matter, to the physical character of annealing in glass, and to the living body. In its compounding of language and life, "The Windows" presents an annealed subject, rather than a subject defined in its relation to objects. This poem, which was published in 1633 and therefore comes later than most of the materials in the ensuing chapter, may seem out of place. I have included it to show that whereas seemingly iconic images in poems are not always patently so, the most progressive empiricist discourses, like Francis Bacon's, sometimes appear to be. This overlapping suggests something particular about Renaissance language and signification, which sets it apart from the iconic sign of divine similitude and the modern logic of the representational sign. Herbert's poem suggests a certain indistinctness among subject and objects (both physical and metaphysical). It renders material the belief that persons are made in the image of God and takes quite literally the idea of "man's glassy essence." And it does not treat language as a system of objective signs that are transparent, to the point of being immaterial, in relation to their targeted meanings. As with other Renaissance metaphors of glass, "The Windows" demonstrates the transparency of language *as temporal matter*. There appears to have been no better conceit than the perspective glass to demonstrate how language could be simultaneously transparent and material.

As Foucault has pointed out, the articulation of the linguistic sign as a map or picture of the thing it represents dates to the seventeenth-century *Logique de*

Port-Royal, by Antoine Arnauld and Pierre Nicole.[3] The modern presumption that language is so transparent as to be immaterial—that what matters is the signified concept and that words are merely pointers—has a corollary in Alberti's perspectival dictum that the painting should be like a window onto the world. Like the signifier, the painting should not call attention to its surface; rather, it should produce the illusion of a space that lies beyond the surface of the image. But in the sixteenth century, "perspective" referred both to a set of geometrical techniques for rendering three-dimensional space onto a two-dimensional surface, and to optical instruments such as lenses, mirrors, and panes of glass. Insofar as Renaissance poets are perspectival poets, they are so primarily in this latter sense. For optical instruments showed transparency as a material attribute. In this chapter, I look at glass instruments and "perspective glasses" in both poetic and scientific discourse, showing that these instruments demonstrated the material transparency of figurative language and its observations, but also the material transparency of the mind and its observations. Optics played a central role in perspective before perspective was exclusively identified with abstract rationality.

Multiformitie Uniforme

In a passage from *The Arte of English Poesie* that is meant to redress the charge that poets are "light headed" and "phantasticall," George Puttenham compares the imagination to a perspective glass or mirror. That the mind is like a glass is a familiar enough metaphor, but Puttenham's handling of the metaphor grants it a particular materiality, a materiality aimed precisely at the charge that the poetic imagination is pure fancy. The poetic imagination, Puttenham concedes, can be the seat of frivolity and distortion, but it is just as often a medium of truth and virtuosity: "Phantasie," he writes, "may be resembled to a glasse . . . whereof there be many tempers and manner of makinges, as the *perspectiues* doe acknowledge." Puttenham's defense of poets hinges on an observation about the matter of the imagination: the imagination is as material and as uniquely tempered as any mirror or perspective glass. And it is precisely because phantastical thinking is both universal and temporal that "the inventive part" of the mind "is to the sound and true judgment of man most needful." So long as it is "well-affected," phantasy is "not onely nothing disorderly or confused," it is also "very formall, and in his much multiformitie *uniforme*."[4]

Puttenham's metaphor for the imagination has a carefully qualified material composition. What seems at first to be the universal feature of the imagination—that it is reflective like a glass or mirror—proves also to be one of its accidents. The selfsame metaphor that shows the imagination to be "uniforme" accounts

as well for its "multiformitie": like a glass in its "many tempers and manner of makings," the imagination is unique and particular in its every instance. With the phrase "multiformitie *uniforme*," Puttenham indicates that the "very formall" bearing of poetic phantasy—literally, its "*form*"—inheres in the plasticity of verbal expression. Rather than demonstrating a separation of universal forms from their material effects, the inventions of poetic phantasy show that metaphysical truth is inextricable from temporal mutability. Here, Puttenham measures the integrity and authority of English poesy not by its adherence to classical philosophy or its continuity with poetic antecedents, but by way of a contemporary technology, the perspective glass. In fact, Puttenham's mirror metaphor is a digression from his mustering of historical evidence to show that poets have in the past been treated with reverence rather than derision. Puttenham's concerns in this chapter are finally presentist and material—he ends the chapter by admonishing poets to disregard the stigma of print and publish their works—and his metaphor for the imagination works to that effect. As an abstract metaphor, the glass may reveal something axiomatic about the imagination, but what the "perspectiues doe acknowledge" is the situation of poesy within created matter at specific moments in the unfolding of worldly time: its temporality, in the full sense of the word. The perspectives—and by "perspectiues," Puttenham means perspective glasses rather than geometrical or mathematical perspectives—index the particular integration of the formal and the finite that defines, for Puttenham, the character of figurative language in the late sixteenth century.

With the figure of the perspective glass, Puttenham is able to offer a tangible example of how the poetic image or phantasy—which is otherwise so easily dismissed as a lightheaded delusion or an ephemeral thought—could appear to be an airy figure of nothing, a mere transparency, and at the same time prove to be a technical instrument in the practice of a substantive craft. An instrument of the eye rather than the hand, the perspective glass is paradoxically concrete and invisible. Though a solid object by any common sense measure, the perspective glass is useful only insofar as one looks right through it. On both philosophical and practical grounds—from the time-honored metaphor of knowledge as insight and reflection to the use of perspective glasses in observing the heavens—the perspective glass was an instrument that seemed to balance on the threshold between physical realities and metaphysical truths.[5] This figure of the perspective glass is exemplary for a writer like Puttenham who maintains that poesy is neither exclusively ideal nor exclusively material, neither a clairvoyant revelation nor a vulgar imitation, but a palpably transparent instrument, an amalgam of imaginative and technical devices. Puttenham reiterates this quality of palpable transparency in the penultimate chapter of the book, where he compares poesy to a pair of spectacles, offering another example of poesy as a phantastic amalgamation of nature and artifice.

Comparing poesy to a mirror and spectacle, Puttenham offers a conspicu-
ously visual, though not pictorial, rendering of the poetic image.[6] Here, the fig-
ural aspect of language is linked to the material temper of the imagination, to
the instrumentality of the perspective glass or lens, and to the substance of glass
itself. Accordingly, the poetic image is neither iconic nor perspectival (in a
modern sense), neither symbolic nor enframing, for it is not so much a visual
picture as a material imagining. It is significant that in this particular effort to
demonstrate the materiality of poesy, Puttenham does not make the immediate
or obvious choice of accentuating the materiality of the spoken or written
word; for what is at issue in this instance is the capacity of poetry to conjure im-
ages in the mind. To contend that there is a particular materiality to poetic
phantasy distinguishes it from purely speculative contrivings of thought on the
one hand and from the visual spectacle of performance or graven imagery on
the other. Poesy is characterized therefore not as a spectacular display but as an
actual spectacle, an eyeglass that artificially reproduces in an altered medium the
natural activity of sense perception. The poet's work may prove, at times, to be
mimetic—imitating a complete emplotted action or representing physical ob-
jects as they appear to the eye—but what distinguishes the poetic image is that
its primary medium is the material imagination. According to Puttenham's per-
spectives, the poetic imagination is a process rather than an aesthetic or pictorial
domain; and that process is simultaneously as natural as the sense perception of
sight and as artificial as the instrumental technology of a perspective glass. Put-
tenham's metaphor of "the perspectives" demonstrates that in poesy, as in sense
perception, the imagination is enjoined to temporal reality.

Puttenham's Lens of Poesy

The penultimate chapter of Puttenham's *Arte of English Poesie*, to judge by
its heading, concerns the relation of artifice to nature in poetic dissembling:
the chapter title reads *That the good Poet or maker ought to dissemble his arte, and
in what cases the artificiall is more commended then the naturall, and contrariwise*. The
aim, here again, is to redeem poetic dissembling from the charge of artificial-
ity and disingenuousness. Puttenham invokes the familiar division of nature
from artifice only to collapse it, arguing that it is the nature of poetic artifice
to dissemble. To say, as Puttenham does, that it is natural for the poet to dis-
semble is to unsettle that familiar division of nature and artifice, but it is also
to redress the ambiguous position of poetry in the social hierarchy of trades
and professions.

As Puttenham's chapter bears out, suspicions about the artifice of poetry go
hand in hand with suspicions about the courtier as one who dissembles his

social rank or estate.[7] Although poetry is essentially a craft, now that this "vulgar arte" has been dressed in the "gorgeous habilliments" of "poeticall ornament" and brought from "the carte to the schoole, and from thence to the court," poets enjoy a loftier status than the average craftsman. Puttenham notes this discrepancy not to shoulder poets out of their elevated position at court, but to encourage poets actively and "cunningly" to maintain that status. Thus Puttenham offers what

> may serve as a principall good lesson for al good makers to beare continually in mind, in the vsage of this science: which is, that being now lately become a Courtier he shew not himself a craftsman, and merit to be disgraded, and with scorne sent back againe to the shop, or other place of his first facultie and calling, but that so wisely and discreetly he behaue himselfe as he may worthily retaine the credit of his place, and profession of a very Courtier, which is in plaine termes, cunningly to be able to dissemble.[8]

With this "vulgar arte" having found its way out of the "shop" and into the "profession of a very Courtier," the "good maker" who follows Puttenham's advice will "dissemble" accordingly.[9] Puttenham encourages the poet to leave behind his status as craftsman and to behave wisely and discreetly at court. True enough, Puttenham admits, the profession of a courtier is "in plaine termes" a form of dissembling. But when the poet behaves as a courtier, it is an honest dissembling. For, even as he masks his actual status as a craftsman by dissembling, the poet is also practicing his craft. Recalling "the Courtly figure *Allegoria*, which is when we speake one thing and thinke another,"[10] Puttenham says that false semblance is a central feature of the art of poesy. "Th'art of Poesie be but a skill appertaining to vtterance"[11] and "in the usage of this science" the poet dissembles the "profession of a very Courtier." To deride poets as fraudulent is to be ignorant of the nature of their craft.

Puttenham urges the courtier poet who has been elevated above his original estate, "the place of his first facultie and calling," to behave according to his current status: to "retaine the credit of his place" by "shew[ing] himself not a craftsman." Puttenham urges the poet to "shew" or dissemble his profession, to practice the craft of not being a craftsman. Yet the better part of the chapter is spent comparing poesy with other trades. After encouraging the courtier to "shew himself not a craftsman," Puttenham catalogs the various ways that the poet is like a craftsman. Indeed, Puttenham goes to some length to articulate the ambivalent status of the poet as both "craftsman" and "professional," explaining that "it is not altogether with him [the poet] as with the crafts man, nor altogether otherwise then with the crafts man."[12] Puttenham proceeds by way of equivocal comparisons: the poet may take pride in his work as any cobbler

might, though the poet is no cobbler; the poet imitates the material world much as a painter or a carver does, but does not always "worke in a forraine subject viz. a lively portraiture in a table of wood"; the poet may be a "coad-jutor . . . alterer . . . and in some sort a surmounter" of nature, manipulating nature like a gardener, joining natural matter like a carpenter, but he is "most admired when he is most naturall and least artificiall."[13] Eager as Puttenham is to justify the poet's status as a "professional" courtier rather than an artisan, he does not entirely abstract the practice of poesy from artisanal craft or from the natural and material world.[14]

On the surface, Puttenham's attention to craft and nature finds a comple-ment in Sidney's A Defence of Poetry, which, although published in 1595, was thought to have circulated in manuscript for several years before its publica-tion. Both arguments answer the charge that poems are merely the conceited musings of courtly wits. Sidney's text responds to the four "most important imputations laid to the poor poets": that reading poems is a profligate activity, that poets are liars, that poems are wanton fantasies, and that Plato banished poets.[15] Puttenham observes that, despite an esteemed tradition, those who are now ignorant of the art of poesy "doe deride and scorne it in all others as su-perfluous knowledges and vayne sciences."[16] Other "knowledges" and "sci-ences" may be rightfully elevated, given the hierarchy that holds the intellect superior to the body, above the work of the common artisan.[17] Poesy, however, is singled out "in all others" as "superfluous" and "vayne" because it is identi-fied with the imagination. Thus Puttenham and Sidney both want to ground poetic imagination in productive labor. It is the imagination that identifies the poet as a maker, as Puttenham puts it, "such as (by way of resemblance and reuerently) we may say of God: who without any trauell to his divine imagi-nation, made all the world of nought."[18] But to ensure that the identification of the poet as a maker is indeed reverent rather than aggrandizing, both Sidney and Puttenham emphasize the "travell" of the poet as that which distinguishes poetic from divine creation. So Sidney explains that the delivering forth of the poet's "idea" or "fore-conceit" "is not wholly imaginative, as we are wont to say by them that build castles in the air; but . . . substantially it worketh."[19]

Both authors argue that poetic imagination is substantial, but for Puttenham that substance is entirely of this world.[20] For Sidney, poetic imitation is ulti-mately a departure from the natural world. The poet works out his idea in a substance that surpasses nature, crafting a "golden world" over and against na-ture's "brazen" one.[21] And when Sidney says of the poetic "fore-conceit" that "substantially it worketh," the substance he refers to is proper to poetry and not to material nature: "The poet only bringeth his own stuff, and doth not learn a conceit out of matter, but maketh matter for a conceit."[22] For Putten-ham, on the other hand, poetic invention and imagination work "even as

nature herself working by her own peculiar vertue and proper instinct and not by example or meditation or exercise as all other artificers do."[23] Poesy may involve some degree of fancy or artificial devising, but for Puttenham poetic imagination does not involve the kind of a priori abstraction suggested by Sidney's *idea* or fore-conceit.[24] Puttenham emphasizes instead the materiality of mental processes. By expressly denying that poesy is "meditation" and by arguing instead that it works like nature itself, Puttenham does not dismiss the fantastical human imagination, but rather suggests that human fantasy is natural and material. Nowhere is this clearer than in Puttenham's chapter "Of Stile," where he refers to "qualities of stile" as "humours" and "complexions." Style is none other than the "tempered and qualified" properties of a person's mind and "his inward conceits be the mettall of his minde."[25] Style is what one is by nature: it is as much the result of temperament as contrivance. Whereas Sidney maintains a division of artifice from nature, suggesting that the poet's ideas bear fruit in an alternative and artificial "golden world," from Puttenham's perspective artifice and nature are blended.

Puttenham differentiates poesy from other trades by arguing that the craft of poesy is artifice that works like nature itself. There are some actions, says Puttenham, "as be so naturall and proper to man as he may become excellent therein without any arte or imitation at all (custome and excercise excepted, which are requisite to every action not numbered among the vitall or animal)."[26] To construe those "naturall and proper" actions as more artificial than natural would be as ridiculous as using spectacles or an ear trumpet when one has perfect vision and hearing, or using a fancy pair of bejeweled or "ennealed glooves" to feel.[27] For Puttenham, poesy qualifies as one of those natural actions. Indeed poesy is virtually identical to another set of actions "naturall and proper to man," that is, sensual perception:

> But what else is language and vtterance, and discourse and persuasion, and argument in man, then the vertues of a well constitute body and minde, little lesse naturall then his very sensuale actions, sauing that the one is perfited by nature at once, the other not without exercise and iteration.[28]

The only difference between seeing, hearing, and feeling, on the one hand, and language, utterance, and discourse, on the other, is that the latter are a "little lesse naturall" and "perfited" by "exercise and iteration." Though the artifice of poesy should not be overemphasized, it must be acknowledged that poesy does involve some artifice, some "exercise and iteration." To deny the artifice of poesy would be as inane as exaggerating it; after all, Puttenham says, repeating his reference to spectacles, it is "better to see with spectacles than not to see at all." Here, Puttenham singles out the spectacles from both the ear

trumpet and the "ennealed" gloves as his preferred metaphor for expressing the balance of nature and artifice in poesy.

Puttenham repeats the metaphor of the "spectacle" once more as he specifies the nature of poetic artifice. Unlike arts such as painting or carving that produce "bare imitations," grammar, logic, and rhetoric enact "by long and studious obseruation rather a repetition or reminiscens naturall, reduced into perfection, and made prompt by vse and exercise." To illustrate the contrast between the mimetic "bare imitations" and the "reminiscens" of nature, Puttenham distinguishes the arts of language, especially speech, persuasion, and disputation, as those "by which the naturall is in some sorte relieued, as th'eye by his spectacle." Imitation, the primary mode used by painters and sculptors, reproduces its object in a "foreign subject," in wood and pigment for instance, materials that differ from those of the object. Poets do this too, Puttenham points out, when they speak of "another mans tale or doings." But although poesy is likened to a litany of craft practices, it also involves utterance and thus its primary feature is that it extends nature into artifice. Utterance repeats "by observation naturally" what is suggested by nature itself and repeats even the nature and function of the body and mind, like the eye that is "relieued . . . by his spectacle."[29] What the mind takes in through sensual perception, poesy puts out through utterance—and what the mind has taken in remains essentially unchanged in this conversion, save that it is "reduced unto perfection" by that bit of poesy that is artifice. As a figure of poesy, the spectacle has something of the quality of a mirror in that it duplicates or repeats sensual perception.

The metaphor that poetic language is to the natural sign as the spectacle is to the eye is crucial to Puttenham's differentiation of the language arts from other crafts. Spectacles enhance the view of nature, just as poesy graces the "common course of ordinary language."[30] The "naturall is . . . relieued" by the spectacle because it draws natural objects into sharper, clearer focus through careful observation; poesy does the same to everyday speech. The spectacle is transparent; it does not transform the substance of its object, as a painting transforms a real apple into an apple made of paint, nor does poesy coin words and language in an alternate medium. Poesy, like a spectacle, brings ordinary language into special focus.

In addition to bringing something into focus, however, the lens of the spectacle also acuminates the eye's own sense experience. While bringing into focus objects perceived by the eye, spectacles also mediate the beams projected from the eye. Spectacles "relieue" strain on the eyes: since the eye is itself a lens, the glass spectacle repeats both the substance and the function of the eye. Thus the spectacle relieves not only "the naturall" world but the natural eye: not only the things observed but the organ of observation. Puttenham's remark that the "naturall . . . is relieued" intimates that the natural world,

brought into focus by the spectacle, becomes textured, as in a sculptural relief. But the full phrase, "the naturall is . . . relieued, as th'eye by his spectacle," equates the eye with nature. The eye does not only perceive the natural world, it is itself natural. Poesy, according to this metaphor, emphasizes the continuity of the perceiving eye with the natural world, rather than demarcating, as in the picture model of perception, the speculations of the conscious subject over and against the material object. The passive construction of Puttenham's metaphor confirms that poesy does not divide subjective agency from objective reality, but coordinates them, aligning physical perception with material nature. The spectacle draws nature into relief, but it also functions like the eye itself, it re-lives the eye. The spectacle represents a kind of synthesis between objective reality and subjective sense experience: it is not proper to either one, but nor is its transparent substance a "foreign subject" to either the "naturall" or the eye. Like the spectacle, poesy synthesizes "long and studious observations" with speech. Poesy repeats sense perception, but in reverse. Poesy is never merely a fanciful projection, for the workings of the mind are inextricably bound to its natural sense perceptions.

For Puttenham, reminiscence is not divided from natural memory; rather, the lens of poetry is a "reminiscens naturall." Francis Yates has claimed that the reassessment, by Albertus Magnus and Thomas Aquinas, of artificial memory, or that function of memory that is triggered by external sense perceptions, made possible the inclusion of artificial rhetoric as a part of prudence. In the Aristotelian tradition, moral judgments or prudence belonged strictly to memory that inheres in the mind, memory that is—and the terms get somewhat complicated here—natural. Aristotle divides the arts of memory into, on the one hand, reminiscence or artificial memory, which is provoked by the sense perception of matter, and, on the other, natural memory. Later writers sought to join artificial and natural memory, and thus to make rhetoric not only virtuous but worthy enough to be engaged with dialectical thought.[31]

Puttenham describes the work of the mind as a joining of nature and artifice rather than a strictly mimetic representation. Poesy is like a lens because it reduces nature "unto perfection." But the lens also reduces and distills the "long and studious observation" of poetic imagination itself. As George Chapman wrote in his 1598 continuation of Christopher Marlowe's *Hero and Leander*, "For as a glass is an inanimate eye, / And outward forms embraceth inwardly: / So is the eye an animate glass that shows / In-forms without us."[32] The figure of the lens indicates that poesy distills not only nature but its own craft. A poem distills nature—the natural material world as well as ordinary language—and at the same time distills the nature of thinking. Breaking down the division of nature from artifice, Puttenham reinvents poesy as a craft of dissembling that,

by its nature, imitates the sensual perception of the external world and fashions, in turn, poetic projections of the material imagination that are no more or less than sense perceptions in reverse.

Natural History and History Mechanical in Bacon's Writing

Despite his hesitations about eloquence and ornament in speech, Francis Bacon's work shares with Puttenham's the dual concerns of challenging the division of nature and artifice and exploring the comparison of trades.[33] Because he is concerned to ground science and the intellect in observations of the material world, Bacon reacts against a strict division of mind from matter much in the way that Puttenham reacts against the separation of nature from artifice. In order to restore "the commerce between the mind of man and the nature of things," as he writes in the proem to *The Great Instauration*, Bacon advocates that natural history be turned on its head.[34]

Bacon lays out, in the second book of the *Novum Organon*, twenty-seven "Prerogative Instances" for a new interpretation of nature, the sixth being "*Instances Conformable* or *of Analogy*; which I also call *Parallels* or *Physical Resemblances*."[35] In that section, Bacon explains that, instead of exercising "overcurious diligence in observing the variety of things, and explaining the exact specific differences of animals, herbs, and fossils," people should focus their efforts on "the investigation and observation of the resemblances and analogies of things, as well in wholes as in parts." Bacon's "instances conformable"—which range from the syllogism in logic to the analogy between the roots and the branches of trees—are all examples that at first glance seem counterintuitive: Bacon wants to reveal not only the empirical resemblances that lead to new axioms in scientific knowledge but also the presumption of difference that hitherto obscured those resemblances. His first example is the observable conformity of "a looking glass and the eye," a conformity that exposes natural history for its habit of separating the animate from the inanimate:

> From which conformity, to say nothing of the mere observation of the resemblance which is in many respects useful, it is easy to gather and form this axiom— that the organs of the senses, and bodies which produce reflexions to the senses, are of a like nature. Again, upon this hint of understanding easily rises to a higher and nobler axiom which is this: that there is no difference between the consents and sympathies of bodies endowed with sensation and those without sensation, except that in the former an animal spirit is added to the body so disposed but is wanting in the latter.

Bacon radicalizes Aristotelian materialism, in this instance by breaking down the foundational distinction of Aristotle's *De Anima* and by grouping animate and inanimate objects together according to their empirical resemblances. The "instances conformable" that form new axioms in Bacon's science call to mind the "reminiscence naturall" that is for Puttenham the basis of the arts of language. Though Bacon focuses on the relation of sense experience to reason— the "hint of understanding" that "rises to a higher and noble axiom"—whereas Puttenham focuses on the relation of sense experience to imagination, each author upsets a received binary in his effort to substantiate the working of the human mind. Bacon calls into question the absolute division of animate and inanimate substance and Puttenham challenges the mutual exclusiveness of nature and artifice. Both illustrate the conformity or resemblance of mind and matter by likening the eye to a glass.

Arguing that the arts of language produce a "reminiscens naturall, reduced unto perfection, and made prompt by use and exercise," Puttenham uses the glass lens of a spectacle to exemplify both the substance and the function of poesy. Bacon too is interested in observing not only resemblances in physical matter but also in the correspondence between sensory understanding and "the bodies which produce reflexions to the senses." Like Puttenham, who uses the physical correspondence of the eye to the spectacle to illustrate his understanding that poesy repeats the nature of the mind, Bacon observes the correspondence between the eye and the looking glass to exemplify the way empirical science derives its axioms from material nature. Puttenham does not claim a substantive difference between sensory and intellectual observation, whereas Bacon keeps separate the "hint of understanding" in sense perception from reason. Nonetheless, Bacon's "prerogative instances" are part of what he calls the "art of interpreting nature."[36] And he includes in that art the comparison of trades.[37] But does it make sense to draw out the similarities in two such different discourses? Bacon is interested in science; Puttenham in poesy. Bacon is the proverbial father of modernity; Puttenham has been dismissed as a derivative thinker.[38] Still, in a case like this one, where glass features centrally in descriptions of the mind, the crossover in the work of Bacon and Puttenham mitigates the extremity of these distinctions. For Bacon's science is also rhetorical, and innovation and tradition often go hand in hand in the work of both Bacon and Puttenham. These specific tropes of glass reveal that if intellectual activity was being newly defined in terms of method, so too was it defined, across discursive boundaries, in similarly material, technical, and social terms. In some respects, these definitions of intellectual activity rely on traditional understandings of the mind: both Bacon and Puttenham, for instance, understand the mind to be natural, drawing on the Christian belief that the mind evinces the divine presence in man while it is also part of God's material

creation; both also identify thinking as a craft, which, as Mary Carruthers has shown, was also true for the scholastics.[39] But both Puttenham and Bacon situate intellectual activity within human history through the novel understanding of the intellect as a trade.

If Bacon repeatedly puts his materialism to the service of what appears to be a timeless and immaterial realm of "higher and nobler axiom[s]," he is nonetheless more concerned to situate his "art of interpretation" within a progressive history of the mechanical arts than he is to maintain it within the theoretical scientific tradition that dates back to classical sources. Or, to put it more succinctly, Bacon rejects the notion of a golden age of natural philosophy and seeks to integrate scientific theory with practical innovation. "I regard that the mind, not only in its own faculties, but in its connection with things, must needs hold that the art of discovery may advance as discoveries advance."[40] Among the various kinds of history, Bacon writes,

> the use of History Mechanical is of all others the most radical and fundamental towards natural philosophy; such natural philosophy as shall not vanish in the fume of subtile, sublime, or delectable speculation, but such as shall be operative to the endowment and benefit of man's life: for it will not only minister and suggest for the present many ingenious practices in all trades, by a connexion and transferring of the observations of one art to the use of another, when the experience of several mysteries shall fall under the consideration of one man's mind; but further it will give a more true and real illumination concerning causes and axioms than is hitherto attained.[41]

A natural philosophy steeped in the history of mechanical arts avoids "subtile, sublime, or delectable speculation." It is not that this philosophy is without its own brand of ideality, since it does yield "a more true and real illumination concerning causes and axioms." But it is specifically a progressive ideality because, rather than deriving from a classical science, this natural philosophy links itself to practical innovations that advance "by a connexion and transferring" of "observation and experience" from one art or mysterie to another. Instead of a natural philosophy that could "vanish in the fume of speculation," Bacon advocates a form of "History Mechnicall" that will not only "minister" to the "present" but "shall be operative to the endowment and benefit of man's life." Bacon recognizes that the adherence to and emulation of the natural philosophy of classical science goes hand in hand with the notion of history as mutability. In the place of this notion of history, one that imagines the degeneration of scientific thought from its purer origin, Bacon wants to equate science with a notion of historical time that is based on mechanical progress and advancement,

a notion of time that is focused on the present and that imagines the present as the "endowment" of future benefits.

In his "Preparative Toward Natural and Experimental History," Bacon even seems to argue that science, namely his own art of discovery and interpretation, gains the most by its inquiry into those arts that transform nature:

> Again, among the particular arts those are to be preferred which exhibit, alter, and prepare natural bodies and materials of things, such as agriculture, cookery, chemistry, dyeing, the manufacture of glass, enamel, sugar, gunpowder, artificial fires, paper and the like. Those which consist principally in the subtle motion of the hands or instruments are of less use, such as weaving, carpentry, architecture, manufacture of mills, clocks, and the like.[42]

Puttenham privileges the art of poesy as one that mingles nature with artifice, and one that ultimately unsettles the assumption of a natural hierarchy that equates social identity with a specific vocation. Bacon does something similar for those arts, including glass manufacture, that are not strictly manual, but "exhibit, alter, and prepare natural bodies and materials of things." The arts that are altering and preparative, rather than strictly manual, ultimately unsettle the hierarchy that separates the mechanical from the liberal or intellectual arts. The description of glassmaking as an unusual and transformative art is echoed elsewhere. Antonio Neri's 1612 L'Arte Vetraria, translated into English by Christopher Merret in 1662, says that glass is "one of the true fruits of the Art of fire. . . . It hath fusion in the fire." Glass is unlike other metals in that fire separates and congregates like elements in metal "but in Glass 'tis far otherwise, for that is made by uniting and mixing different parts of salt and sand."[43] Neri goes so far as to say that glass, though it can be made to look like rock crystal, is "a thing wholly of art and not of nature," because the sand and ash that glass is made of are so utterly transformed in its making.

Puttenham suggests that poesy distills observation, that poetic language preserves the process of its making by converting sensual perception into the natural artifice of thought. It might also be said that glass products similarly preserve a record of their making. In glass production, a mixture of sand and ash is heated until the batch is fluid, at which point molten glass is blown, molded, and allowed to harden, the end result being a solid that has the appearance of a liquid. Glass is a chemical anomaly: Bacon and Merret both refer to glass as a "concrete juice."[44] When molten glass cools, it does not crystallize as other metals do when they cool: that is, its atoms do not rearrange themselves into the regularly patterned molecular structure of a solid; they simply stop dead in their tracks, retaining the random molecular structure of a liquid, though the substance is rigid.[45]

Glassmaking is one of the "particular arts" that will best contribute to the "Mechanicall History" that Bacon claims will "give a more true and real illumination concerning causes and axioms." And glass objects were ubiquitous as instruments in the empirical investigations from which Bacon derived the axioms of his new natural science. In fact, Bacon describes both the "higher and noble axioms" that he has derived from his investigations and also the procedures for his observations and experiments. Bacon's science is, in that respect, a record of its own making. Given that so many of Bacon's experiments and observations depend on glass equipment of one kind or another, from burning glasses, to graduated glasses, to calendar glasses, to lenses, it seems that the mind's connection to glass is an exemplary one for Bacon's program whereby "the art of discovery may advance as discoveries advance."[46] Though glassmaking is only one of several arts that alter nature, considering the centrality of glass objects to Bacon's experiments, glass and glassmaking seem to play a particular role in "the advancement of learning." Glass is a model substance for the progressive "art of discovery," which advances as innovations in glassmaking advance, just as sight is supplemented, Bacon notes, by telescopes and microscopes, "those recently invented glasses which disclose the latent and invisible minutiae of bodies and their hidden configurations and motions."[47]

Although glass objects may be paradigmatic tools for an art of discovery, Bacon is cautious about using glass and glass objects metaphorically. That is not to say that Bacon shies away from the use of the mirror metaphor to describe the mind's function as a medium for divine ideas. For instance, in another comparison of the eye to a glass, Bacon likens the eye not only to the looking glass plain and simple but to the "mind of man as a mirror": "God hath framed the mind of man as a mirror or glass capable of the image of the universal world, and joyful to receive the impression thereof, as the eye joyeth to receive light."[48] Insofar as the mind is a thing made by God, divinely "framed . . . as a mirror or glass," it is by its very nature made "to receive the impression" of the "image of the universal world." The mind, in its apperception of divine reality, functions just "as the eye joyeth to receive light." Because the intellect achieves knowledge through sense perception, human reason apprehends the "ideas of the divine" as they are reflected in material reality. Reason perceives "the true signatures and marks set upon the works of creation as they are found in nature." Ideas and abstractions in the mind derive from the worldly refraction of divine understanding "wherein as the divine glass is the word of God, so the politic glass is the state of the world or times wherein we live; in the which we are to behold ourselves."[49]

The metaphor that likens the mind to a mirror becomes more complicated, however, when Bacon considers the mind not only as a medium through which "the image of the universal world" is received but also as an instrument

in that understanding. As an instrument of knowledge, the mind is capable of the worst distortions, for Bacon also complained of the "empty dogmas" produced by the "Idols of the human mind."[50] The "Idols of the Tribe," says Bacon, are the result of human nature, specifically the faulty perception of things "according to the measure of the individual and not according to the measure of the universe." On the one hand, the mind is like a perfect mirror capable of receiving universal impressions; on the other, "the human understanding is like a false mirror, which, receiving rays irregularly, distorts and discolors the nature of things by mingling its own nature with it."[51] The mind has a "pernicious and inveterate habit of dwelling on abstractions."[52] Science must endeavor therefore to seek out the "true signatures and marks" that are "found in nature"; only through practice can the mind recognize God-given nature. As an instrumental mirror whose noblest function is the interpretation of nature, the mind must therefore be properly exercised through empirical inquiry, lest it mingle its own imperfect nature with the "ideas of the divine." "The mind of man is far from the nature of a clear and equal glass, wherein the beams of things should reflect according to their true incidence; nay, it is rather like an enchanted glass, full of superstition and imposture, if it be not delivered and reduced."[53] When reason exerts itself "according to the measure of the individual," the imperfect mind "distorts and discolors the nature of things"; its potential to reflect things "according to their true incidence" depends on the practical arts through which the mind can be "delivered and reduced" of its "impostures." In its ideal form, the mind of man, as it is created by God, is like a glass mirror: it can and should reflect things "according to their true incidence." But the mind is also capable of distorting reality, "mingling its own nature" with the things that stand before it: "the Idols of the Tribe" can transform a "clear and equal glass" into an "enchanted glass, full of superstition and imposture, if it be not delivered and reduced." Puttenham is also aware that the mind is capable of distortion, but that acknowledgment does not affect his basic theory of the imagination: he uses the same glass lens to express both sensual perception and imaginative utterance. For Bacon, if the mind is a "clear and equal glass"—and Bacon does admit this as a possibility—it is so only in its receptive function, only in that its divinely created essence can register the "true signatures and marks" of God's design. As an instrument of human reason and imagination, Bacon is only willing to admit that the mind is an imperfect glass.

In his use of the metaphor of the mind as a glass, Bacon reveals that metaphor itself must function like empirical science, advancing only as practical discoveries advance. As the medium of divine ideas, the mind is like a glass mirror, but as an instrument—the very instrument that can deliver the mind from its imperfections—Bacon seems to prefer the metaphor of a steel mirror.

Although it is clear that, for Bacon, formulating axioms should involve the integration of both method and practice, he acknowledges that every form of knowledge must originate with a set of rules that establish the boundaries of that field of knowledge and that name the degree to which a given inquiry can particularize or generalize. Rules that are too abstract are inapplicable in practice; they should instead provide a method that can be refined through practice. Bacon explains:

> The better sort of rules have been not unfitly compared to glasses of steel unpolished, where you may see the images of things, but first they must be filed: so the rules will help, if they be laboured and polished by practice. But how chrystalline they may be made at the first, and how far forth they may be polished aforehand, is the question; the inquiry whereof seemeth to me deficient.[54]

The use of the steel glass as a metaphor here is informative because it likens the ideal set of rules to a reflection that is "polished by practice." A glass that is polished too "far forth . . . aforehand" might produce an overly abstracted and ideal methodology before its practice has been naturally established. Absolute truths, the "ideas of the divine," are as pristine as a glass mirror, as quintessential as the crystalline humor, and as limpid and polished as the eye or mind of man as wrought by God. But science must advance through practice, producing rules that are polished only as "far forth" as inquiry has made sufficient. To pursue knowledge as through the false-perfect image in a crystal glass wrought by human hands may constitute a supererogation, for it would mean believing oneself capable of perceiving perfectly and instantaneously divine truths that can only be known to the human mind through "polishing" or inquiry. Over time, rules and ideas may become increasingly polished "aforehand," before, that is, the labor and practice of new inquiries, but only insofar as the current inquiry has been made sufficient for the advancement of learning.

The rules for future inquiry may prove from the outset to be crystal, rather than polished steel, but science is not there yet: as for how crystalline the rules "may be made at the first," says Bacon, "the inquiry whereof seemeth to me deficient." Crystalline glass is too recent a technical innovation to serve as the model of science. Axioms must not be immediately likened through the use of convenient metaphors to technical innovations; rather, they must follow from them through a process of empirical proof. Metaphors may reflect the advancement of discoveries, but they must not be relied on in themselves to advance those discoveries. Given that this entire passage rests on a metaphor that likens scientific method to a mirror, what this passage further reveals is that metaphor, as much as empirical science, must be worked at and polished,

showing "images of things" only as far forth as they may be "filed" by labor and practice. For Puttenham observation and utterance are essentially inverse procedures, but for Bacon sense perception and reasoning are qualitatively different and cannot be inverted or exchanged. In Bacon's science, there is a difference between what we can perceive and what we can state as truth. Before we can put into play an axiom or metaphor that relies on a newly invented substance, it must be tried and true; metaphor itself must be subject to the practice of empirical inquiry.

Bacon is particular about, but not entirely dismissive of, the use of metaphor: metaphor does not generate, but rather follows from material circumstances just as words derive from things and axioms derive from matter. Metaphor is acceptable as long as it abides by or duplicates the bond between words and things. Where language does not codify the correspondences between word and thing within a system of signification, but functions instead as a social and discursive practice, it is not to be trusted; for the "Idols of the Market Place" are "formed by the intercourse and association of men with each other."[55] Science can situate itself in relation to a mechanical history because it is tied to nature; and because of this same relation, science can generate new rules of inquiry just as technical innovations advance among the mechanical trades. Poesy and discourse do not participate in a progressive history of invention because they are not mechanical trades, because imagination is not, according to Bacon, tied to the laws of matter.[56] For Puttenham, the art of poesy is progressive precisely because it is a social trade: it is not only that poets occupy a hybrid social status at court but also that "custom," "use," and "iteration" are integral to the very definition of poesy as natural artifice. For Bacon, on the other hand, social realities are not material realities: he seeks to reduce language to its logical relation to matter. Bacon's science cannot admit the progressive potential of poesy precisely because it seeks to deliver language from its place in social discourse. In both cases, an understanding of poetic discourse in history depends on the articulation of trade practices and mechanical invention.

Perspectives of Frames and Glass

Puttenham's use, in his *Arte of English Poesy*, of the term "perspectives" to refer to lenses and other optical devices—objects that emphasize the material and plural aspects of the phantastic imagination—draws a sharp contrast to the characterization of perspective in Erwin Panofsky's now-canonical study *Perspective as Symbolic Form*. As Panofsky has explained it, modern perspective is a

"symbolic form" that makes the perception of "aesthetic space" and "theoretical space" appear to be one and the same sensation:

> We shall speak of a fully "perspectival" view of space not when mere isolated objects, such as houses or furniture, are represented in "foreshortening," but rather only when the entire picture has been transformed—to cite another Renaissance theoretician—into a "window," and when we are meant to believe we are looking though this window into a space. The material surface upon which the individual figures or objects are drawn or painted or carved is thus negated, and instead reinterpreted as a mere "picture plane."[57]

Panofsky, entirely aware that perspective could be said to encompass all representations that practice foreshortening, identifies as "fully 'perspectival' space" the organization of an entire picture from a single view and the negation of the "material surface" in favor of the illusion of looking through a window. Panofsky describes this perspective not as a lens but as a window, or, to be more precise, a window frame. The Renaissance theoretician from whom Panofsky draws the image is Alberti, who writes, "First of all about where I draw. I inscribe a quadrangle of right angles, as large as I wish, which is considered to be an open window through which I see what I want to paint."[58] There is no indication that this window is glazed—most would not have been at the time Alberti was writing—and, in any event, the window is open. The window metaphor serves Alberti's purpose not because a window is a glass to be seen through, but because it is a frame through which to behold a scene. Following from Alberti's figure of the window frame, Panofsky emphasizes that perspective rationalizes space. The "fully 'perspectival' view is achieved in the triumph of conceptual depth over material surface or, as Panofsky puts it, when the "entire picture" transforms the "mere" surface into "what we are meant to believe." Panofsky's work reveals that the device of framing and picturing a scene as in a window has a legacy in strictly abstract conceptualizations of both space and representation: Renaissance perspective establishes a view of space that "even with its still-mystical coloring, is the same view that will later be rationalized by Cartesianism and formalized by Kantianism."[59]

Paul Oskar Kristeller was among the first to point out that the most widely received interpretations of the Italian Renaissance were heavily inflected by a modern system of the fine arts that is in fact proper to the eighteenth century. And Svetlana Alpers's work has apprehended the geographical as well as the temporal coordinates of this predisposition toward Italian Renaissance art. Arguing that Panofsky's pictorial theory of perspective has overwhelmingly influenced both Renaissance art history and the methodology of the discipline as a whole, Alpers strips away assumptions that are first gleaned from a single region and then

inflected by retrospective commentary to expose the very different conditions and assumptions under which Renaissance artists in northern Europe worked.[60] For Alpers, the emphasis on perspective as "symbolic form" has inflected basic presumptions about the character of representation. Celeste Brusati extends this discussion to show that the notion of perspective derived principally from Italian sources has obscured the full character not only of the northern European Renaissance but of perspective itself. Brusati contrasts the Italian humanist emphasis on *istoria* with the emphasis on the pictorial and visual experience of the eye in the perspective boxes of the seventeenth-century Dutch artist Samuel van Hoogstraten. In the perspective box, the painted interior of the cabinet, viewed through an aperture, "fills the spectator's entire field of vision with a continuous and unframed view . . . [that] cannot be duplicated in planar easel paintings."[61] Of these perspective boxes, which "conterfeit . . . the picture-making activity of the eye," Brusati writes: "Significantly, it is not the human measure and proportionality of Renaissance perspective but rather the enlarging and diminishing properties of lenses and optical devices that van Hoogstraten associates with perspective."[62] Given that windows and mirrors are regularly depicted in the boxes, and mirrors sometimes used in their construction, it is not only that these perspectives were imitating the natural function of the eye but that they were participating in a technology of vision made available by instruments of glass.

The perspectives described by Brusati are not those that, to put it crudely, have historically won out: the experience of framing and picturing, far more than the experience of the physical mechanics of the eye, fashions modern subjective perspectivism. Panofsky was not oblivious that he was tracing a set of pictorial practices that succeeded as a dominant "symbolic form": their persistence as a symbolic form is one motivation for the story he tells of perspective. But as a result, Renaissance perspective has become a largely evanescent category, its features delineated by the modern concepts they can be said to anticipate. Precisely because the picture model or framing concept of perspective has succeeded as such a prominent metaphor, it has become difficult to restitute the kinds of perspective that were proper to the Renaissance. As James Elkins explains in *The Poetics of Perspective*, Renaissance perspective practice has been extrapolated into so abstract and monolithic a metaphor that it obscures its own origins. Most contemporary scholarship, he argues, imposes a "conceptual unity" on the plural and diversified practices of Renaissance perspective: "Perspective was once a collection of methods, largely unenriched by critical discourse. For us, perspective is an elaborate concept, a metaphor as much as a method, and it is supported by an extensive critical dialogue as well as by a sometimes arcane mathematics."[63] Elkins's approach is to lay bare the actual practices of Renaissance artists, which were "largely unenriched by critical discourse." Elkins hopes to disclose that a "deeply connected tradition"

underwrites the "unstudied variations of Renaissance perspective" without ascribing to that tradition "the compulsive unity of modern perspective."[64]

Since Elkins's project is to provide a clear explication of painterly method as a pluralistic set of perspectival practices, and to free up those practices from the modern metaphor that has elided them, he focuses on perspective as a "construction proper to an artist." Elkins also in turn divides perspective as an artistic conception from perspectival instruments, as is the case in his handling of the window figure in Renaissance perspective. For Elkins, the window figure is one of the fictions of unity attributed to perspective in the Renaissance, when perspective was in fact diversified practice and not the singular unified concept that it has become in modern criticism. Arguing that the window figure in Renaissance texts only retrospectively becomes emblematic of the entire picturing function of the modern perspectival metaphor, Elkins claims that during the Renaissance "perspective windows" were not indicative of any such conceptual unity of space, but were instead devices, such as the grids or "perspective frames" or "machines," that "helped produce perspective views without knowledge of the rules":

Alberti may have borrowed the image of a window from his own *velo*, a device he used to exhibit perspective effects to his friends. In Vasari's words, Alberti used his invention to make "natural perspectives," and the term "natural" suggests Vasari associated Alberti's invention with similar devices employed by scholars of the medieval Latin tradition of the *perspectiva naturalis*, such as burning glasses and curved mirrors. Like those devices, Alberti's instrument required no training in geometry and was therefore an optical instrument rather than a construction proper to an artist.[65]

Elkins's observation that Alberti's window was considered by a later writer to have been an instrument of "natural perspectives" is indeed provocative, for the window is now overwhelmingly associated with the linear geometry of "artificial perspective," whereas *perspectiva naturalis* customarily refers to late medieval optical theory, which, as Elkins points out, was largely reasoned through the study of light refracted by glass instruments. Restricting true Renaissance perspective to *perspectiva artificialis*, or the "construction proper to an artist," Elkins groups together all instruments and devices, window frame and glass alike, as the tools of an outmoded natural perspective not directly linked to geometrical calculation and depiction.

Elkins clears away not only modern concepts and consciousness but also Renaissance instruments and devices from Renaissance artistic practice. The effect is an understanding of Renaissance perspective that remains fundamentally defined by a modern subject-object relation. Seeking to critique and correct the exaggerated significance accorded the modern conscious subject in the deter-

mination of Renaissance perspective, Elkins replaces modern consciousness with early modern method, emphasizing artistic craft over genius. Placing the past in relation to the present as object to subject, Elkins presents true Renaissance perspective as a material base of practical origins against a superstructure of modern abstractions, and even seems in that formulation to valorize objects over subjects. But Elkins does not correct the exaggerated banality accorded the object in the modern determination of Renaissance perspective; for him, the instruments and devices of Renaissance perspective have no part in the "construction proper to an artist." Renaissance perspective, in this view, remains an objective given through which it becomes possible to redefine a novel subject position, replacing the modern conscious subject with the "deeply connected tradition" of the Renaissance artist. Perspective then ultimately preserves an identitarian principle, in contrast, say, to the notion of natural perspective as a sensory or mechanical rather than intellectual function. When "perspective" is narrowly defined as a painterly practice, it leaves out the very mechanical and sensory instruments that reveal the poetics of perspective to have been, at that time, a material mode of perception and figuration, and not an idealized or abstracted metaphor for thinking that mystifies the very practices it names.

Elkins privileges the painter's rational construction over perspective as a mechanics of perception and honors the distinction between artificial and natural perspective over the fact that *perspective* named both modes, before optics and perspective were increasingly specialized as science and art, respectively. In an essay that traces the history of perspective as a metaphor, Claudio Guillén notes the discrepancy between the perspective of framing and the kind of optical perspective, or *perspectiva naturalis*, that in his view comes earlier: "Metaphors based on perspective in painting—*perspectiva artificialis*—do not take hold, outside of Italy, until the early seventeenth century."[66] A few pages later, though, he explains that it is not always easy to differentiate between an optical metaphor of perspective and a framing one:

> The notion of distance, or of a distant view brought closer to the beholder, was a common denominator of the image seen through the perspective glass and the illusion of the *perspectiva artificialis* in painting, so that it is difficult to tell . . . whether one kind of image or the other is being indicated. Toward the end of the sixteenth century and the beginning of the seventeenth, outside of Italy, we encounter an important turning point in the history of our metaphor. The original meanings of the word, referring to optical effects, appear to have been grafted onto the newer frame of reference with which it was becoming associated. A certain significance or metaphorical purpose could be carried over from word to word even though the thing designated might have been different: to put it in other terms, connotation persisted even though denotation changed.[67]

For Guillén, the fundamental principles of perspective obtain—connotations persist—even as its instruments, and therefore its denotations, change. Whereas Guillén looks at perspective as an idea in language, and Elkins at perspective as a set of methods in painting, both deploy a fundamentally modern and subjective definition of perspective: as a concept or as intellectual agency, perspective is in both cases a category of abstract human thought. Yet Renaissance perspective is also composed of those early modern instruments of perception, like the window, that make it difficult to draw a sharp distinction between the metaphor and the practice of perspective in the Renaissance. To apprehend an early modern poetics of perspective in a way that does not simply trace the history of an idea or a concept pictured by a subject requires an attention to the relationship between the instruments and the metaphors of Renaissance perspective. An early modern poetics of perspective must recognize the material distinction between a framed perspective and a perspective glass, even as it acknowledges that these instruments, and the artificial and natural perspectives with which they were respectively identified, were all denoted by the word *perspective*.

Panofsky opens his book by citing Dürer's observation that the etymology of perspective is "to see though" and thus attributes to perspective an enduring principle not unlike Guillén's. Both the frame and the perspective glass are objects to be looked through, but what it means to look through each, the frame and the glass, accounts for two distinct modes of perspective. As a frame, perspective privileges the conceptualization of depth and space: the beholder is prompted to look beyond, or overlook, both the material surface and the experience of sight as bi-ocular and curvilinear, accepting as natural a monocular and geometrical calculation of the appearance of objects in space. Perspectives of glass, on the other hand, proliferate and mutate the field of vision, revealing the dependence of conscious perception on sensory matter: Bushy tells the queen in *Richard II* that sorrow's eye, when filled with tears, "divides one thing entire to many objects, / Like perspectives," a trope that is repeated when Richard shatters a mirror as a final recognition that the ideal image of kingship is no more than its fragile and worldly incarnations.[68] Renaissance perspective—and by that I mean the various designations of the word *perspective* and its cognates—includes both of these rather different modes and practices of visual perception.

That linear perspective ultimately succeeded as a modern framing concept does not mean that as a Renaissance construct it was separate and distinct from the instrumental metaphors of perspective as a glass. In Renaissance uses of the word *perspective* there is a trace of both the modern concept of framing and the figure of the glass as an instrument or device. So, the division of these two different kinds of perspective, while by no means entirely fabricated, is not as

absolute as it has been made to seem by those who have marked that distinction as the difference between medieval and modern, or between natural and artificial perspective. I would venture that peculiar combinations of nature and artifice are precisely what define Renaissance perspective. The example of glass instruments shows that, even if it is possible to trace a broad transition from natural to rational perspective, Renaissance perspective does not narrate this transition, but offers discrete formulations of its own, chief among them a striking integration of material and figurative invention and of nature and artifice.

Natural and Artificial Perspective

There is ample justification for dividing the *contruzione leggitima* of artificial perspective from the optics of curved surfaces or natural perspective, and yet cross-fertilization between these two discourses was not infrequent during the Renaissance. Italian Renaissance treatises on perspective tend to be practical geometrical manuals for painters, rather than discussions about the refraction of light in concave and convex surfaces and the operation of the eye. The latter, classified as treatises of optics, are drawn from a tradition traced to the Islamic philosopher Alhazen through the thirteenth-century writings of Roger Bacon and John Peckham in Britain and of Vitelo in Poland.[69] Alberti observed the distinction in his *On Painting*, perhaps the most widely read of the Italian perspective treatises, though it is worth noting that, by declining to engage in speculations about optical theory, Alberti's text reveals itself to be as much a rhetoric of perspective as a technical manual for artists.[70] John White has pointed out that Lorenzo Ghiberti's *Third Commentary*, by contrast, consolidates theories of optical or natural perspective with those that concern artificial perspective.[71] Leonardo da Vinci's manuscripts regularly integrate information about the function of the eye with methods for the construction of geometrical orthogonals. In a treatise titled "On the Eye," Leonardo brings optical information to bear on Alberti's emphasis on the visual pyramid whose convergence point is the eye: "It is true that every part of the pupil possesses the visual power, and that this power is not reduced to a point as the perspectivists wish."[72] Manuals of perspective across the Continent mingle geometrical method with optical observation and experimentation. Egnatio Danti's *La Prospettiva di Euclide* explains the shift from its first section on radial geometry to its second section on refraction in concave instruments by stating that "la prospettiva precede al trattato degli specchi come il genere alle specie," an example that seems to treat *perspectiva naturalis* as the more technical outgrowth of *perspectiva artificialis*.[73]

Albrecht Dürer's engraving *St. Jerome in His Study* (see fig. 18) offers a lucid example of how optical and linear perspective could mutually inform a single image. Martin Kemp's careful analysis of the engraving reveals that, although it shows a rigorous attention to perspectival geometry, the space is not depicted according to a singular totalizing design.[74] Kemp also notes that the "descriptive, particularizing quality" of the directional light from the windows in this engraving distinguishes it from contemporaneous Italian art.[75] But the windows in Dürer's engraving are also a stunning consolidation of the perspective of framing and the perspective of glass, for though they shed clearly linear radial light into the interior space, that light is also contorted by the roundels of crown glass that glaze the window so that it casts irregular and seemingly liquefied circular shadows on the wall of the window bay. The perspectives of this engraving are both linear and glassy. Glass instruments and perspectives were fully integrated among the diversified theories of perspective, even if glass did ultimately disappear from the idea and the practice of perspective. Whereas the geometrical and linear principles of painterly pictorial practice are expressed through perspectives of framing, the sensory particularities of ocular perception seem to have been expressed as perspectives of glass.

An English example of this conjunction of geometrical and glassy perspectives can be found in John Bate's *Mysteryes of Nature and Art*, an odd compilation of manuals for the augmentation and imitation of nature in everything from the construction of fireworks and waterworks to a treatise on "Drawing, Colouring, Painting and Engraving." The last of these treatises supplies the reader with a "verie easie waie to describe a Towne or a Castle: being within the sight thereof." To "describe" or draw the scene, the reader is instructed first to fashion an apparatus for viewing:

> For in the effecting of this, you must have a frame made and crossed into equall squares with Lute strings, and figured at the end of each string: this frame must have a foot, wherein it must be made to be lifted higher or lower as occasion serveth . . . before this frame must be placed a style or bodkin having a little glasse on the top of it for to direct the sight.[76]

Bate's apparatus for the rendering of a view consists of two parts: a wood-framed wire grid and a glass sight that positions the eye (see fig. 19). Though many manuals depict and describe apparatuses for positioning the eye at a single viewpoint, they do not all place a lens at the punctum (see fig. 20). The use of the lens represents both artificial and natural perspective: artificial because it is part of a constructed viewing apparatus, natural because it stands in for the eye "to direct the sight." The lens artificially augments the eye for the purpose of perspectival construction on a flat grid or plane. But in doing so it grants

Figure 18. Albrecht Dürer, *St. Jerome in His Study*, 1514. Bequest of William P. Chapman, class of 1895. Courtesy of the Herbert F. Johnson Museum of Art, Cornell University.

that there is a natural component to the two-dimensional, artificial grid con-
structed for viewing; a lens "to direct the sight" preserves the notion that eye
beams come forward from the eye in the form of sight. The materiality of that
point in one-point perspective was a matter of considerable attention in Re-
naissance perspective manuals. In addition to Leonardo's comment in "On the
Eye," Salomon de Caus wrote:

> Le poinct duquel nous voyons n'est pas en la superficie de l'oeil mais est dedans
> iceluy & la chose visible se vient representer en la superficie de l'oeil qui est
> comme vn verre & estant la le poinct de veue (qui est vne goute d'eau autrement
> appellées nerf optique) reguarde la chose veüe en la superficie de l'oeil.
>
> [The point from which we see is not on the surface of the eye but is inside of
> it & the visible thing represents itself on the surface of the eye which is like a glass
> & because of that the point of view (which is like a drop of water otherwise called
> the optical nerve) looks at the thing viewed on the surface of the eye].[77]

In between the object or the representation observed and the point of view of
the observer is a material, glassy membrane through which and only through
which the imagination has a visual exchange with the external world. Whereas
the picture model negates the surface of representation as if it were absolutely
transparent, whenever Renaissance manuals discuss the glassy perspectives of
substances that truly are transparent or diaphanous, like a pane of glass or a lens
or the eye itself, they do so with a heightened awareness of the surfaces on
which images are registered.

Glass instruments enabled the understanding of the mechanics of vision.
Medieval optical theorists relied on concave mirrors for experiments into the
refraction of light. And spectacles had been produced for at least a century
before Franciscus Maurolycus first compared the glass lens to the crystalline
humor of the eye in his 1521 treatise, *Photismi*:

> Et quoniam vt iam ratiocinando conclusimus, radiorum visualium per pupillas
> transmissio non aliter fit, quam per conuex vtrimque conspicilia, haud immerito
> licebit nobis pupillas desiniendo, conspicilia naturae & è contrario vitrea ipsa con-
> spicilia, pupillas artis, commutatis verbis appeleare.
>
> [And now since we have concluded, from theory, that the transmission of visi-
> ble rays through the pupil takes place in the same way as through a double-convex
> lens, we may be permitted also to swap words and to define the *pupil* as the *lens of
> nature* and conversely the *glass lens* as the *pupil of art*.][78]

Giovanni Battista della Porta would later compare the workings of the eye
to a camera obscura, as did Girolamo Cardano and Daniele Barbaro, who

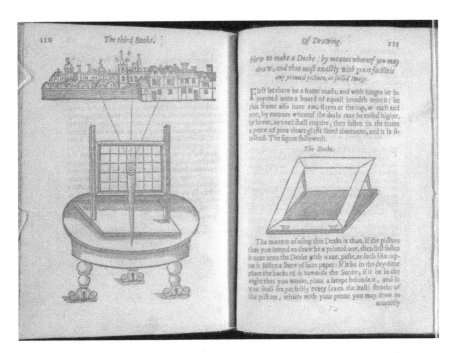

Figure 19. John Bate, *Mysteryes of Nature and Art* (London, 1634), 110–11 (P_3v–P_4r). Courtesy of the Division of Rare and Manuscripts Collection, Cornell University Library.

recommended placing a glass lens at the punctum in the window where light enters in order to demonstrate the function of the crystalline humor of the eye in admitting images to the darkened room of the imagination.[79] A glass lens enables the adaptation of sight to external representations—a scene viewed through a grid or a two-dimensional representation—and at the same time demonstrates how external images are represented on the crystalline humor of the eye and transmitted through the optic nerve to the sense.

In addition to glass sights, other manuals suggest the use of a clear pane of glass on which the object in view can be directly painted. In these instances, the style or bodkin without a lens positions the eye before a pane of glass (see fig. 21). Here the framed glass takes the place of the grid in providing an apparatus that facilitates the rendering of a three-dimensional view onto a two-dimensional surface. In Leonardo's manuscript entry "Of the plane of glass," the glass plane is the very thing that demonstrates seeing objects in linear perspective:

Perspective is nothing else than seeing a place [or objects] behind a plane of glass, quite transparent, on the surface of which the objects behind that glass are to be

Notandum·

Quòd si mons fuerit ita præruptus, vt id quod nunc diximus obser- uare non permittat: is metiendus erit instar turris, alteriúsve rei super terrestri plano sursum eleuatæ. Quemadmodum capite septimo, vel suc- cedentibus octauo, nono, atque decimo capitibus huiusce libri primi monstrauimus.

Figure 20. Oronce Fine, *De Re & Praxi Geometrica* (Paris, 1586), 38 (E$_{iii}$v). Courtesy of the Division of Rare and Manuscripts Collection, Cornell University Library.

drawn. These can be traced in pyramids to the point in the eye, and these pyramids are intersected on the glass plane.[80]

Later manuals rely simply on the idea of a glass pane to illustrate how one might imagine objects at a distance flattened out on a single plane. Joseph Moxon explains in his *Practical Perspective* that writers and painters variously refer to that plane as a section or a glass. Though he concedes that "section" is really the more accurate and appropriate terminology, he himself often uses the term "glass," arguing that those who use the term have reason to do so "because we know as yet no other matter so apt to demonstrate the changing of an Orthographick Figure into a Scenographick [an overview to a cross section] as Glass."[81] The glass plane was also an especially efficacious figure for conjuring the picture plane as the site at which the bases of the two radial pyramids—one converging in the beholder's eye, one converging at the vanishing point—were imagined to meet. The material referentiality of "glass," over against a term like "section," could palpably demonstrate both the anchoring and the division of those two imagined radial pyramids. But the transparency of the glass illustrated that the barrier between these two radial pyramids was an invisible one, something to be looked through. The glass plane was an instrument that made it possible to apprehend the method of linear perspective. Whether as the viewpoint lens or the transparent plane, glass instruments very easily modeled the appearance, though not the geometrical method, of linear depiction. Alberti would have the window thrown open, but for many writers it was not the frame but a glass object of some kind that best demonstrated how depth of field might be registered on a flat surface through the use of a monocular viewpoint. Indeed, for Alberti, who really does inaugurate a picture model of framing, glass in all its materiality would have interfered with his interest in deemphasizing the surface of the image in favor of the pictorial reality it can create, a conjured or thought reality whose transmission from one subject to another is best imagined as one that passes through air.

Perspectives of glass were thus by no means antithetical to pictorial perspective, but they expose the artificiality of rendering objects according to monocular, linear perspective and thus are not serviceable to the more highly abstracted modern concept of perspective as framing. When practitioners can dispense with perspectival apparatuses and still achieve a "fully 'perspectival' view of space," that does not necessarily mean that perspective as a "symbolic form" has emerged from its diversified material practices. The pictorial and rational perspective of visual framing that succeeded into modernity did so over and against another kind of perspective that was sensible, optical, and particularizing, if not to say phantastical and poetic: a perspective of glass. An act of framing may have been the crucial step in applying the principles of planar

Figure 21. Albrecht Dürer, *Institutionem Geometricarum* (Arnheim, 1605), 183 (Q$_{ii}$r). Courtesy of the Division of Rare and Manuscripts Collection, Cornell University Library.

geometry to painting, but a glassy perspective made it possible to perceive how objects might look in planar relation to one another. Glass objects were instruments of suggestion rather than calculation. They were not separate and distinct from the geometrical picture model of perspective, but enabling of it, though what they enable is the cooperation of one mode of vision (that of the eyes) with another (that of the geometrical calculation of lineal rays).

Renaissance perspectives were not only artists' methods, they were also instruments of sensory perception that brought the mind into accordance with material nature. In Hegel's view, sensory perception facilitates the disposition of matter with respect to identity. Perspectives of glass reveal sensory perception to be that which facilitates the disposition of the temporal imagination with respect to matter. Glass perspectives, as metaphor and technology, reveal a

mode of imaginative perception that was trained to temporal matter rather than to the conceptualizations of the conscious subject. It is not quite accurate, then, to say that Renaissance perspective was not yet a concept as it is in its modern metaphorical incarnation: it may not have been a concept, but it was conceptual. Restituting glass perspectives alongside perspectives of framing reveals that Renaissance perspective was differently metaphorical before the picture model aligned with the framing function of the concept and consigned perspectives of glass to the history of optics. Perspective was differently metaphorical because metaphor itself was not yet conceived according to the logic of the conscious subject, but was instead the device or technology in language that discloses the reason extant in the natural order of the temporal world, rather than the musings of the conscious subject. Once metaphor is recognized to have been more closely allied with instrumentation and technology than with concepts of consciousness, it becomes possible to understand these perspectival changes in perception as materially based in the substance of glass rather than ideally based in the progress of consciousness. Before perspective was absorbed into the modern concept of framing, it manifested a nonpictorial mode of both sense and metaphor.

"Shakes-speare's Sonnets" and the Properties of Glass

The first textual example of *frame* as "that in which something, especially a picture, pane of glass, etc. is set or let in, as in a border or case" listed in the *Oxford English Dictionary* is a line from Shakespeare's Sonnets, dated circa 1600. The date is a roughly accurate, if conservative, estimate of when this definition of *frame* would have come into common parlance. Still, the fact the *OED* uses Shakespeare's Sonnets as its earliest example of this definition deserves notice, especially since the example of *frame* taken from the Sonnets does not refer exclusively to an alienable quadrilateral. The line cited, "My body is the frame wherein 'tis held," is the third line of Shakespeare's Sonnet 24, which begins,

> Mine eye hath played the painter and hath stelled
> Thy beauty's form in table of my heart.
> My body is the frame wherein 'tis held,
> And pérspective it is best painter's art.[1]

This "frame" has several meanings: the frame of a painting, the frame of the human body, and the frame as the material realization of a thing *in potentia*, the last of these being a sense of *frame* that is now obsolete. But dictionaries are not designed to describe the use of a word to mean several things at once, as is so often the case in figurative language. They are designed to understand words as signs, a fundamentally visual model of language that imagines the word as the picture of an idea, or perhaps the picture of many ideas, but with each idea individually framed (in the modern sense) as a separate definition. The *OED* uses this example to picture the definition of *frame* as a visual apparatus, but,

ironically, the example tells us that words do not necessarily function according to the visual logic of the sign.

This *OED* citation bespeaks, in miniature, a broader tendency to see Shakespeare's Sonnets pivoting on the threshold of modernity, as if the novelty of expression in these poems could be classed as the first sign of the creative aesthetic production that becomes full-blown in modernity.[2] The signal example is Joel Fineman's *Shakespeare's Perjured Eye*, which claims that Shakespeare rewrites the epideictic tradition in the Sonnets, thereby inventing modern poetic subjectivity.[3] Stephen Booth's edition of the Sonnets, though it seeks to revive a reader's sense of the poems at the time of their initial publication, also retains important traces of his earlier *Essay on the Sonnets* in which he describes reading the Sonnets as an essentially aesthetic experience, an experience that prompts the reader to apply ever-changing "frames of reference" to fluid and mobile forms of verse.[4] And as early as 1964, Murray Krieger's *A Window to Criticism* argued that Shakespeare's Sonnets are the typological *figura* of modern poetics because they integrate the formal and historical features of poetic representation by conjoining the figures of the mirror and the window.[5] Each of these interpretations sought to address the experience of reading the Sonnets in all of their uniqueness and at the same time to respect the contingencies of their early modern production. In doing so, they have followed the prompt of the poems themselves: the Sonnets present themselves in relation to the past and to posterity by continuously elaborating the passage of time—clock time, epochal time, recursive time, and so on.[6] Interposing worldly temporality with poetic tradition, the Sonnets repeatedly demonstrate their own novelty, though not according to the aesthetic categories that define creative production in the modern era. Looking at how these poems register technical and material innovations in glass, my aim is to explore those innovations without binding them to aesthetic and philosophical criteria that are proper to subsequent phases of history. At the level of the conceit, the Sonnets establish a relationship between technical and figurative invention that integrates, in turn, the articulation of thought with matter and social rank with craft production.

Modern readings of the Sonnets emphasize the distinction of subject from object and of the verbal from the visual to an extent that obscures the prevalence of craft, commerce, and property in these poems. The result is that poesy is seen to reflect abstract aesthetic concerns and criteria rather than revealing the systems of social rank and trade practice within which poesy as a craft was once embedded. To illustrate my argument that the poesy of the Sonnets expresses an active engagement of technical with figurative innovation and of artisanal craft with noble rank, I focus on the way these poems factor glass and glass objects into the articulation of their own framing or making. Glassmaking—in terms of both its status as a trade and its newly invented

objects—was a critical reference point for both scientific and poetic discourse in the late sixteenth and early seventeenth centuries. The connection between poesy and glassmaking, as I have shown in the example of Gascoigne's *Steele Glas*, was perceived by some as a threat to poetic tradition. Gascoigne uses the figure of a "steele glas" to hold on to the authority of an emblematic poetic tradition in the face of Italianate incursions associated with the Neoplatonic *impresa*, such as the crystal glass mirror and the poetic conceit.[7] The Sonnets also resist the priority of imaginative ideality, but they do so by embracing the connection between the poetic conceit and the substance of glass. The Sonnets use windows, mirrors, and other glass objects to illustrate that links between the verbal and the visual in poesy can be articulated as technical invention and craft practice, and not only through the recourse to either the symbolic emblem and the Neoplatonic device, on the one hand, or the work of art, on the other.[8]

It has been customary, in both classical and modern contexts, for the metaphor of a window or a mirror to serve as the vehicle for an interpretation that locates meaning beyond or before the text.[9] But these metaphors were altered in the sixteenth century by innovations in glassmaking. The Sonnets suggest that those technical innovations in glass describe innovations of figurative language as well. Mirrors and windows are significant in the Sonnets because their glassy substance exemplifies the way matter and meaning are joined in the late sixteenth-century framing of language. This framing is articulated as the novelty of a distillation in glass as much as it is reminiscent of the harmonic motion of crystalline spheres in the frame of the universe. The framed matter of language is both mobile and static, a kind of "liquid pris'ner pent in walls of glass" (5).

The Mirror of Modernity

In *Shakespeare's Perjured Eye*, Joel Fineman argues that Shakespeare invents modern poetic subjectivity in the Sonnets by leaving behind the visual ideality of the epideictic tradition and substituting in its place "a poetics of a double tongue." The Sonnets rewrite the visual poetics of the poetry of praise: the "ideal complementarity" or "true vision" that Fineman identifies with the young man sonnets gives way to the "suspicious word" of the "duplicitously verbal" dark lady sonnets. In the exchange, Shakespeare rewrites the very idea of the "visionary subject." On the one hand, this is an argument about the poetic tradition: Fineman identifies as "praise paradox" a novel verbal and literary quality in epideictic poetry that departs from the traditional visionary unity of the poetry of praise. On the other hand, this is an argument about the concept of subjectivity itself.[10]

Fineman cites Michael Drayton's sonnet sequence *Ideas Mirrour* as a work that typifies the visionary unity of the poetry of praise. The figure of the mirror in Shakespeare's Sonnets draws on that visionary unity and continues to elucidate poetry as the reflection or imitation of ideas. But in Shakespeare's Sonnets, the figure of the mirror is also newly subject to phenomenological description (perhaps for the first time in epideictic poetry) and that phenomenological description reveals a shift in poetic discourse away from a visual and semantic ideality and toward verbal duplication and literary opacity. It is not only that the Sonnets contain these two versions of visual and literary mirroring, the Sonnets are themselves, in Fineman's rendering, the mirror stage of the modern concept of subjectivity. The Sonnets hold evidence of both an entirely new discursive subjectivity and the visual presymbolic of the modern theory of the subject. Fully aware that his account of the concept of subjectivity in history, as it is tied to the Sonnets, resonates with Jacques Lacan's account of the subject's passage from the Imaginary into the Symbolic order in the mirror stage, Fineman explains: "It seems at least possible that contemporary speculation about subjectivity repeats in a theoretical mode (and the visual etymologies that impose themselves here are important, for 'theory' too begins as 'seeing') what literature accomplishes toward the end of the Renaissance."[11] What Fineman seems to be suggesting here, albeit tentatively, is that what the Renaissance poet or seer presents in a prophetic, even imaginary, mode, the modern subject later theorizes at the level of the symbolic.

Fineman's speculations here are revealing, for what allows him to link Shakespeare's Sonnets with modern subjectivity is a very broadly conceived visual mode that, at times, is detailed with painstaking specificity and at other times is stretched to contain any and every form of ideality. This critique applies not only to Fineman's broadest speculations but also to his most basic and fundamental claims. Indeed, the larger argument is underwritten by one such basic claim: that poetic ideality—whether we mean by that simply an idea or the ideal object of poetic discourse—is fundamentally and primarily visual. At times that visuality may take the form of an ideal complementarity and at times the form of verbal duplicity, nonetheless "it is from this visual idea of the ideal that a specifically visionary poetics acquires or derives its particular coherence."

Fineman is not unaware that "the visual idea of the ideal" is an almost unspeakably broad category. He notes that the metaphors linking sight to thought and ideality are so familiar that they are often, ironically, invisible:

We are dealing here, clearly enough, with a motif or a metaphoreme so central to Western thought, not only to its literary thought, that it is difficult, probably impossible, to separate what is the history of ideas from the concrete idea of "Idea" itself. So massive, so pervasive, so influential is the visibility of this Idea, that the

figurality of the motif is often overlooked, either because it is taken for granted or because it is treated as a dead metaphor whose resonance requires neither explication nor commentary. And yet, in ways which are not at all obvious, it is from this visual idea of the ideal that a specifically visionary poetics acquires or derives it particular coherence. Before it means anything else, "idea," *idein*, means "to see," and this originary visual image colors in specific ways both the physics and the metaphysics of a poetics that thinks itself toward an ideal, whether we think of the *eidola* or *simulacra*, the likenesses, of Stoic optics, the *eidei* or essences of Plato's Forms or Ideas, or the "species," realist or nominalist, of medieval scholasticism (from *specere*, to "look at"). Such "ideas" are, so to speak, materialized in the poetry of praise.[12]

Fineman's project is presumably to focus on the particular "figurality" of that broad motif in the poetry of praise at this given moment in time. He has, however, been fairly criticized for not looking closely enough at the particular figurality of the visual idea in the Sonnets, and for focusing instead on the relation of the eye to the tongue at the expense of the eye's relation to both mind and heart.[13] Though Fineman seems careful here to distinguish among various forms of ideality, the forms of ideality he finds in the Sonnets, and indeed the forms of materiality he finds, are those that square most easily with modern subjective consciousness. What Fineman would refer to as "figurality" should and can be grounded in material and social practice, in part to counteract the teleological imperatives that get placed on those metaphors by modern subjective consciousness and identitarian thought.

Fineman's book does attribute a "specific *materiality*" not only to the dark lady sonnets but to "the way the young man sonnets break the poetics of ideal complementarity." For Fineman, the young man sonnets occasionally break with their own ideal poetic mode to foreshadow the poetic duplicity that comes with the dark lady sonnets. Fineman ultimately associates this "specific *materiality*" with the theme of procreation in the Sonnets, though he also notes a "specific *materiality*" that applies not only to the engendering of flesh but to the way the Sonnets convert visual ideality, through what Fineman calls (quoting Puttenham) chiasmatic "cross-coupling," into the spatial, temporal, and sexual coordinates of the poet's experience. "What the poet now sees when he looks into 'Ideas Mirrour' " (when he breaks, that is, with the "poetics of ideal complementarity") is "a dissolved liquidity within a brittle hardness, this hourglass being, again, the very image of the passing of an ideal time." As Fineman states in a footnote that uncannily anticipates my own argument, that dissolved liquidity within a brittle hardness "is, in effect, the phenomenological description of a mirror."[14]

Fineman's remarkable acuity in describing the "specific *materiality*" in the Sonnets is always, finally, a means for exploring the matter of the body with respect to subjectivity. For Fineman understanding the endlessly mirroring form of the

Sonnets cannot speak to the *"stuff"* of these poems; cannot speak, that is, to the "phenomenal experience" that is "the poet's subjective predicament." "It is by cross-coupling this traditional epideictic phenomenality *in himself* that the poet psychologically *materializes* the self that speaks the paradox of praise."[15] Fineman's account of the experience of poetic figuration, though, places the "stuff" of the Sonnets entirely within the context of an emergent modern subjectivity. In effect, he prioritizes the relation of the mind to the body over and above any other material relation or set of relations. The poetic invention with which Shakespeare inaugurates modern poetic subjectivity is a cross-coupling that articulates "how it *feels* to be the subject of chiasmus, to be subjected *to* chiasmus," that chiasmus being the "unified double" of the ideal and the phenomenal that is also the "rhetorical mirroring of the traditional visual imagery of unity." One might say that Fineman's emphasis on "how it *feels* to be the subject of [the] chiasmus" of the ideal and the phenomenal slots Shakespeare's poetics somewhere in between Christ's passion and Hegel's phenomenology of the spirit.

The problem with Fineman's reading is not that it suggests that the Sonnets are about the idea and the flesh. On the contrary, Fineman explains with tremendous subtlety how the Sonnets integrate the ideal and the material in the body. But Fineman's argument, despite its focus on materiality, is ultimately in the service of an ideality that is interested in materiality only insofar as it registers in the experience of a modern subjective consciousness. The complementarity he associates with the visual ideality of the young man sonnets denies the difference that is repeatedly announced between the poet and young man, the difference of their social stations. There is no a priori ideal complementarity in the young man sonnets because that relation is from the start inflected with differences in social rank. The complementarity that exists between the poet and the beloved in the young man sonnets, I would argue, is a contrived poetic joining of craft and station. And by equating materiality with the literary invention of the modern subject, Fineman is forced to gloss over the materiality of language as a technical invention in these poems. Because, for Fineman, the materiality of the Sonnets bespeaks the invention of a duplicitous literary subject, the materiality of language is inflected with a nostalgia for "the passing of an ideal time," and never inflected with the technical potential of figurative invention.

Walls of Glass and Gentle Work

Fineman's book shows tremendous erudition about both the modern psychoanalytic subject and about forms of visual ideality in the poetic tradition. I wish, however, to bracket these questions of subjectivity and visual ideality to

focus instead on the specific engagement of the material with the figurative within the Sonnets as a way of making sense of Fineman's observation that there is a particular materiality to the literariness of the Sonnets, equated not with "Ideas Mirrour" but with the phenomenological description of a mirror, "a dissolved liquidity within a brittle hardness." In fact, by looking at Sonnet 5, we can see that "dissolved liquidity within a brittle hardness" is not only identified with the "hourglass being" that Fineman associates with "the very image of the passing of an ideal time" but with the poet's craft, which preserves youth and beauty through "hours that with gentle work did frame / The lovely gaze where every eye doth dwell." The passage of time lamented in this sonnet is also positively inflected as the craft of poetic innovation.

Sonnet 5 suggests that those hours will "play the tyrants" and "unfair" the very beauty that nature "did frame" in the young man through "hours" of "gentle work." The fair gentility of the young man would be lost forever "were not summer's distillation left / A liquid pris'ner pent in walls of glass." Here is the "specific *materiality*" that Fineman associates, not with the ideal visual complementarity of mirroring, but with "a dissolved liquidity within a brittle hardness" and with procreation. Drawing on a metaphor that likens the womb to a glass vessel, the young man is reminded that he must leave his "distillation" in "walls of glass."[16] As Sonnet 6 reiterates, the young man must "Make sweet some vial"—a thought that may also be vile insofar as it means that the poet must urge the young man to marry and form a sexual bond with another—if he is to preserve his youth and beauty in an heir.

It is a mistake, I think, to assume that "A liquid pris'ner pent in walls of glass" refers exclusively to heterosexual procreation and not to a sexual exchange between the poet and the beloved. The full text of the sonnet reads:

> Those hours that with gentle work did frame
> The lovely gaze where every eye doth dwell
> Will play the tyrants to the very same
> And that unfair which fairly doth excel:
> For never-resting time leads summer on
> To hideous winter and confounds him there,
> Sap checked with frost and lusty leaves quite gone,
> Beauty o'ersnowed and bareness everywhere.
> Then were not summer's distillation left
> A liquid pris'ner pent in walls of glass,
> Beauty's effect with beauty were bereft,
> Not it nor no remembrance what it was.
>> But flow'rs distilled, though they with winter meet,
>> Leese but their show, their substance still lives sweet.

"Winter" may represent the poet who, in his more advanced age, "leads summer on" to a point of "bareness everywhere," especially if we consider that the couplet does not suggest that the young man's summer has *become* winter, only that the young man has met with winter. His "flow'rs" may have been "distilled" but "their substance still lives sweet" even "though they with winter meet."

Whether or not this sonnet describes the poet's deflowering of the young man, at the very least it can be said that the collaboration of the poet and the young man that produces these poems is its own form of reproduction. For the "liquid pris'ner" of "summer's distillation" is not only "pent" or trapped in "walls of glass" but also penned or written.[17] Indeed, I wish to suggest that the poet's craft is present not only in this pun but in the entirety of the sonnet. "Those hours that with gentle work did frame / The lovely gaze where every eye doth dwell" refer to the hours it took for nature to shape the young man's beauty. But so too do they refer to the hours of poetic composition that "frame" the "gaze" of every reader whose "eye doth dwell" on the poem, so that those eyes are ultimately trained on the young man. For this line draws on the sense of *frame* to express an inclination or direction toward something, such as Shakespeare uses in the prologue of *Pericles*, where Gower says of Antiochus's daughter, "The beauty of this sinful dame / Made many princes thither frame."[18]

"Those hours," with their possible pun on "ours," are the time that "leads summer on" to winter and "confounds him there," where the passage of time can be "Sap checked with frost" and where the craft of the poet can freeze the young man's beauty by recording it in verse. In confounding (which etymologically means pouring together) summer and winter, the poesy of this sonnet confounds the time of nature with the time of craft, the wasting of beauty with the creation of it. And the poem also confounds or commingles the young man's station—expressed in the word "gentle" at line 1 and in phrasing that says at line 4 that he "fairly doth excel"—with the poet's trade that will "frame / The lovely gaze where every eye doth dwell." The result is a poesy that describes itself as a preservative, if not productive, kind of hybrid craft, a kind of "gentle work." And it is through this "gentle work" of poesy that the young man's natural nobility, which "fairly doth excel," and the poet's "pent" or penned craft can be construed as "A liquid pris'ner pent in walls of glass": that is, as different phases of the same substance or as an object in which there is a substantive resemblance between the container and the contained, such as water trapped in ice, sand flowing through an hourglass, or the distillate that is held in a vial. This "gentle work" is a kind of productive labor that works like nature in order to work against her, a union that produces poems but not children. The "gentle work" of this poesy turns "hours" into "ours." The "hours"

that make up that "gentle work" frame a gaze that is always self-referential and still progressive. For the poem is a "gaze where every eye doth dwell," and the eye—itself an organ that contains liquid humors "pent in walls of glass"—that is also an "I" dwells in the material substance of the verses rather than beyond them. This is a poesy that glazes the gaze.

There is further evidence to corroborate my reading that this sonnet frames its poesy as distillation in a glass. Given the older meanings of the word *frame*, which connote fluidity, curative tempering, and molding, glass is a quintessentially framed substance. In glass production, a mixture of sand and ash is heated until the batch is fluid; and the character of this state molten is retained even after the glass is blown or molded and allowed to harden. The result is that in its final brittle state glass retains the liquid qualities of its fashioning. It is a preeminently "tempered" substance: a substance that integrates both liquid and solid properties. The Sonnets are like glass not only because of their metaphorical capacity to mirror but because they are perceived to have a material similarity to glass in being both liquid and brittle. Stephen Booth, as I mentioned above, reads the Sonnets through "frames of reference," but accedes that they are marked by "fluidity" and "constant motion." And the fact that glass seems mobile as well as static means that poesy can explain its own capacity to represent time and motion by comparing itself to glass. "If it be true that the principal part of beauty is in decent motion," Francis Bacon writes in his essay "Of Beauty," then beauty must be expressed by "felicity" and not by "rule."[19] This recalls Bacon's insistence, in the *Noveum Organon*, that objects should be classed together as "instances conformable" through empirical resemblance, rather than received knowledge. As Bacon writes in "Of Praise," a subject pertinent to sonnets (as Fineman's book reminds us), "praise is the reflection of virtue; but it is glass, or body, which giveth the reflection." The properties of the instrument of reflection are as constitutive of the image it produces as the properties of the thing reflected.

Bacon's empiricism applied to such topics as "beauty" and "praise" is expressed also as the distillation of essences. Elsewhere in "Of Praise," Bacon attributes to the highest of virtues a sense-based perception, an attribution that goes hand in hand with the derogation of the representational thinking of "the common people" for whom "shows and *appearances resembling virtues* serve best" (emphasis added). He claims, quoting Ecclesiastes, that for those capable of recognizing it "*a good name is like sweet-smelling ointment*, it filleth all round about, and will not easily away; for the odors of ointments are more durable than those of flowers."[20] Sonnet 5 expresses the same sentiment in its couplet: "But flow'rs distilled, though they with winter meet, / Leese but their show, their substance still lives sweet." This distillation does not describe the extraction of an abstract essence, but the transferal of substance from one thing to

another, from flower to ointment. Distillation, as the "liquid pris'ner pent in walls of glass," describes the poesy of this sonnet, which, even when it seems most transparent, when it has "walls of glass," does not escape from matter, but holds the ink penned on the page like a "liquid pris'ner."[21] This poesy does not eschew matter for meaning, but produces new material out of the old just as a distillate, which, even at its most airy and vaporous, does not escape from matter but remains within a closed system and changes as it moves through different phases of the same substance. This poesy makes sense out of the movement from one phase of matter to another: water to ice, when one imagines the image of the "liquid pris'ner" to be an icicle, sand to glass when one imagines it to be sand running through an hourglass.[22] If poetry is a glassy distillation, "A liquid pris'ner pent in walls of glass," then it expresses an older form of material framing, a framing that is more akin to tempering than to squaring.[23]

Beginning with the lines "Those hours that with gentle work did frame / The lovely gaze where every eye doth dwell," this sonnet exemplifies how remote the collaborative matter and the collaborative labor of its "gentle work" is from the romantic ethos of a poetics of transcendence.[24] Neither the sublimity of the subject praised nor the projection of the self onto the world, the poesy of this sonnet bears all of the potentiality and all of the temperings freighted in the older meanings of the word *frame*. This is not a poetry of signification, but of fixation: "summer's distillation" is the transposition of matter into matter, of flowers to their essence. Time, youth, and poetry are not linked as concepts, but only insofar as each is framed as a glassy substance. This poetic transformation depends on the fact that, phenomenologically, glass is a solid product that contains in its liquid properties the trace of its previous state and the conditions of its making. Although Fineman says that the literariness and materiality of this "hourglass being" are the expression of a poetic subject who laments the passing of an ideal visuality, it also stands to reason that this "hourglass being" is the poetic offspring of breeding and craft. For this poesy of "gentle work" marks the hours of its framing like sand running through an hourglass, an object that holds within it the ingredients of its making and has only to be turned over to make new time when time is running out. This is a poetics of glassy distillation, a "lovely gaze" or an eye whose spherical shape is in itself a miniature natural universe, not because the eye and the spheres mirror each other, but because they share a glassy substance.

Frames, Windows, Perspectives

The attention to glass, and to phase and substance, in Sonnet 5 seems to give weight and measure to the kinds of crystalline conceits that George Gascoigne

dismissed in *The Steele Glas.* Yet the association of glass and sublimation with light-headedness, vanity, and detachment from reality persists. The fanciful imaginings of glass-headed doctors and their dreamed up experiments are humorously depicted in a seventeenth-century emblem book published by Theodor de Bry (see fig. 22). Ben Jonson equates elegy and lyrical love poetry to "glass blown up and fashioned by desire" and suggests, in a miscellaneous poem titled "Proludium," that "lighter numbers" be left to "light brains."

> An elegy? No muse; it asks a strain
> Too loose and capering for thy stricter vein.
> Thy thoughts did never melt in amorous fire,
> Like glass blown up and fashioned by desire.
> The skilful mischief of a roving eye
> Could ne'er make proze of thy white chastity.
> Then leave these lighter numbers to light brains
> In whom the flame of every beauty reigns
> Such as in lust's wild forest love to range
> As one pursuing constancy in change;
> Let these in wanton feet dance out their souls
> A farther fury my raised spirit controls
> Which raps me up to the true heaven of love
> And conjures all my faculties to approve
> The glories of it. Now our muse takes wing,
> And now an epode to deep ears we sing.[25]

Jonson forgoes the "wanton feet" of elegy for the poetic *furor* that a "raised spirit controls." In Jonson's arch characterization, poetic *furor* is a rapturous flight to heavenly glory, whereas elegiac lyric ranges "in lust's wild forest." Elegy does not take to wing but is rather full of hot air, "like glass blown up." Composing an elegy is like glassmaking because in those "lighter numbers" thoughts "melt in amorous fire" whose "flame" is like "One pursuing constancy in change" over against the "true heaven of love." Indeed, even in the Sonnets, conceits of glass can ensnare the view, glazing over the gaze with too much visual mirroring, too much indulgence in fancy.

Sonnet 24 begins with the description of the poet as a painter who has depicted his lover's image in the table of his heart:

> Mine eye hath played the painter and hath stelled
> Thy beauty's form in table of my heart.
> My body is the frame wherein 'tis held,
> And pérspective it is best painter's art.

Figure 22. Theodor de Bry, *Proscemium vitae humanae sive Emblematum* (Franckfurt, 1627), 73. By permission of the Folger Shakespeare Library.

In his edition of the Sonnets, Stephen Booth emends "steeld" to "stelled" for the modernized text of the poem, on the grounds that "stelled," which offers a clearer rhyme with "held," also more precisely evokes the image of a stylus or painter's instrument. Here is supposedly the first notable incidence of the meaning of the word *frame* that will become the predominant definition of the word in the modern era: the frame as an alienable quadrilateral around the work of art. This use of *frame* appears, however, in a poem that also expresses suspicion about "eyes" that are "cunning"; the poem's couplet reads, "Yet eyes this cunning want to grace their art; / They draw but what they see, know not the heart." *Frame* refers not only to the border of a painting but to the body: indeed, to the body as a "table" where "beauty's form" is beheld by the heart rather than by "cunning" eyes. Neither denotation of *frame* alone—*frame* as body or *frame* as border—captures the sense of the poem. Indeed, the body as a *frame* offers only a more archaic, and still visual, ideality in response to the "cunning" eyes that are associated with perspectival vision. It is the way the poem orchestrates a relationship between the past and future that gives it its proper *frame*: the sense of a potentiality that is made real through poetic expression.

Frame is suggestive of a promise that is always present in language, but made manifest in the novelty of poetic composition. *Frame*, as it is used in Sonnet 24, echoes the "hours that with gentle work did frame" the gaze in Sonnet 5 and that will be echoed again in Sonnet 59, which refers to the beloved as a "frame," a "composed wonder" of poetic making and of the natural course of things:

> O that récord could with a backward look,
> Ev'n of five hundred courses of the sun,
> Show me your image in some ántique book,
> Since mind at first in character was done,
> That I might see what the old world could say
> To this composèd wonder of your frame;
> Whether we are mended, or better they,
> Or whether revolution be the same.

It is not unwarranted that the OED might look to the Sonnets for a citation that ushers in a new meaning of *frame*, for these poems are quite conscious of poetic novelty. But as Sonnet 59 indicates, the poems also raise the possibility of a world in decline, whose novelties are nothing other than "revolution" of the "same."

Though Sonnet 24 begins with the frame of the body as a "table of my heart," the mention of "perspective" that "is best painter's art" in the fourth line does seem to convert that bodily frame to a quadrilateral frame and to intimate that the poet is making an effort to keep pace with the "best" or latest techniques of the painter. A shift here from the frame of the body to the

perspectival frame is further suggested by the presence of windows in later stanzas of the poem. The mention of windows so fast on the heels of perspective calls to mind Alberti's injunction that painting should obey the laws of perspective, appearing as a window onto the world.[26] And the attention to glass in the image of the window draws out that "perspective" refers not only to the revival of classical one-point perspective but also to the new glass lenses and mirrors, themselves called perspectives, that were used by artists. The poem begins with the lover holding in the frame of his body the beautiful form of the beloved on the table of his heart. By the end of the first stanza, the emphasis has shifted from the form of beauty to the "painter's art."

The next stanza uses the figure of the window to advance an outright advertisement for this perspective art. The "windows glazed" of line 8 make reference to the increased production and affordability of glass windows in the sixteenth century, reinforcing the image of "my bosom's shop" of line 7 as a commercial storefront. The poem seems to move forward with a kind of mechanical precision, directing its addressee with an imperative "must" at line 5 to search out that image instilled in the poet's heart. The next quatrain reads:

> For through the painter must you see his skill
> To find where your true image pictured lies,
> Which in my bosom's shop is hanging still,
> That hath his windows glazèd with thine eyes.

This forward movement "to find" the picture as the painter has made it very quickly reverts to a backward movement: to a "true image" that has been already "pictured." This imitation of the painter's skill has acquired a kind of urgency and insistence that the beloved, too, should see things from the perspective of the painting: should recognize the skill and look back upon the lover to return the gaze.

The poem presses on with an announced "Now," and a continued forward movement. Though at the *volta*, or turn, of the poem, that forward movement also quickly becomes a rather dizzying, if also glittering, series of new glances or "turns":

> Now see what good turns eyes for eyes have done.
> Mine eyes have drawn thy shape, and thine for me
> Are windows to my breast, wherethrough the sun
> Delights to peep, to gaze therein on thee.

Whereas perspective drives the reader's gaze in the first half of the poem and trains that gaze to look through the window to where the "true image pictured

lies" in the "bosom's shop" of the poet, this prospecting vision is also an image that, once it is "pictured," "lies." Perspectival painting and the "frame" that holds "Thy beauty's form" do not necessarily make this poem new. If anything, it is the glazing of eyes and windows—and the dizzying effect of rapid movement between them, denying the reader the reassuring position of one-point perspective—that constitutes the new, or at least the "Now," of this poem.

Linear perspective and the quadrilateral frame that anchors perspectival representation, though they have become so important to modern ways of seeing, are not features of progress in this sonnet. The sonnet, in fact, seems to resist the constraint and inflexibility of the innovation of one-point perspective, suggesting that perspective is ultimately a threat to poetry. Perspective not only removes its objects into the distance; because it cannot depict objects in motion, it also forces them into a static past. Though infrequently used elsewhere in the Sonnets, the past perfect tense is used twice in the first line—"mine eye *hath played* the painter and *hath stelled*"—and repeated in lines 9 and 10: "eyes for eyes *have done*" and "*have drawn*." The distanced image is "held" in its frame and at line 7 "is hanging still," demanding, or rather begging, to be seen. The imperative to find out where, as line 6 reads, "your true image pictured lies," distinguishes the "true image" from its having been "pictured" and suggests that the framing of perspectival rendering, here expressed through the past participle "pictured," is responsible for this division. That the image is deemed "true" calls forth the pun on "lies" that ends line 6: the "true image," once "pictured," lies still and tells a lie. Indeed, the "true image" of the beloved, although now impressed upon the poet's heart, is also disembodied, abstracted from the life of its source. As the ideal form of that life, this image is not active but "pictured": in "hanging still," it "lies" motionless and tells a lie.

What makes the image false can be found in the command that "through the painter must you see his skill / To find where your true image pictured lies." Perspectival depiction manipulates the surface of the image to give only the illusion of depth and furthermore demands that the viewer look "through the painter," seeing the image from that one point in space where the artist must also have stood in order to make the image. "Perspective" described not only representations that appear geometrically accurate from a single point in front of and at a distance from the canvas but also those anamorphic representations such as the skull in Hans Holbein's *Ambassadors*, or the anamorphic portrait of Edward VI that hangs in the National Portrait Gallery in London. These anamorphic representations, when viewed from the usual position in front of the canvas, look contorted and distended. When viewed from the side, with one eye pressed against the painting, they appear perfectly proportional. Anamorphic representations are an example of a "true image" that "pictured

lies." These paintings were made to exhibit the virtuosity of the painter, hence the line "Perspective it is best painter's art" and the imperative that "through the painter must you see his skill." It may be "best painter's art," but anamorphic perspective makes for a halting line of poetry: "Perspective it is best painter's art" is difficult to scan. Anamorphic perspective allows for two possible subject positions, the one that shows the image in proportion and the one that sees from the front the image skewed, just as this line has two grammatical subjects, "perspective" and "it." But that anamorphic doubled subject, virtuously reproduced in the poem here, does not do much for the metrical patterns of verse.[27]

The "good turns" of the poem come at line 9 when the eyes return gaze for gaze. The phrase "Mine eyes have drawn thy shape" repeats, but with a difference, the formulation of the first two lines of the sonnet, wherein "Mine eye . . . hath stelled / Thy beauty's form." Here it is not the singular eye that might be associated with one-point perspective, but both eyes. And in using "drawn" for "stelled," the trope of sketching is recycled, but in an altered form: whereas sketching is first affiliated with etching, engraving, and instilling, at line 10 it connotes instead the act of bringing out or drawing forth the shape of the beloved. "Now" when the poet's eyes "have drawn" the shape of the beloved, the image is made present and the beloved's eyes "Are windows to my breast." Through windows "glazed" with eyes of the beloved, the speaker can imagine the heavenly gaze of the sun: can imagine that he is the object rather than the subject of the gaze. In this mutual exchange of glances, the false show of depth in perspective is exposed, the distance it creates between the viewer and the viewed is collapsed, and its positioning of all viewers at a single point is undermined. Given the "good turns" that "eyes for eyes" can do in drawing the "shape" of another, the bodily frame seems a potential remedy to the faulty framing of that "best painter's art." Poetry seems here to be the ideal complementarity that responds to a *visual* duplicity, and thus to invert Fineman's claim that this sonnet breaks the ideal complementarity of visual ideality.

The perspectival imperative that has structured so much of modern aesthetic interpretation with its instructions to "look through," as the etymology of *perspective* suggests, the surface to an imagined space beyond it has continued to constrain some of the poetic potential of the first few lines of this sonnet.[28] Commentary on the first lines tends to follow the *OED* in glossing *frame* as the quadrilateral surrounding a painting—the square in which an image is "held." Although acknowledging that the word is also a play on the frame of the body, most editors maintain that the square frame is the primary sense here. It makes sense then to assume that "stelled" refers to the incising of the image with a stylus.[29] One of the techniques painters used for underdrawing their images

before painting was to incise the gesso or chalk surface with a lead-point sty-lus. This technique, in addition to being an effective way to demarcate areas that might be gilded after the image was painted, was particularly useful for rendering the crisp lines and precise curves that were necessary to geometrical and perspectival accuracy in architectural rendering.[30] In other words, the "best painter's art" of perspective, above any other style of painting, would have been the most likely method to employ this type of incised underdraw-ing. What this might mean for the sonnet is something like this: my eye has played the painter and has carved your image right into the table of my heart; my body is the frame wherein this wound must be healed; my eyes are now glazed over with love from staring at you and hoping you'll stare back; your eyes are like windows right to my heart, so if you look at me, it will be like the sun shining to heal my wound. By the end of the poem, the lover has thrown off the perspectival vision that he adopted when he "played the painter" and caused his own initial wound. Eyes are like the windows to the heart, and one look of love is like the sun shining directly into one's breast. A reader who gets the sense that he or she has walked into a sugared-over trap is probably right. For fast on the heels of this account of an eye that corrects the regimentation of perspective with the "good turns" of interpenetrating love, comes a couplet that says, "Yet eyes this cunning want to grace their art; / They draw but what they see, know not the heart." The plural "eyes" together with the demonstra-tive "this" suggest that is it not the initial painter's eye of the poem but the sunny eyes that "delight to peep" that this couplet calls "cunning." Here is an example of the ideal visuality of complementarity and mirroring that Fineman associates with the young man sonnets—only the sonnet seems to be making fun of it.

There are two models of painterly visuality in this sonnet and the poem does not seem to express much longing for either one. The first is the perspec-tival representation that "pictured lies"; and the second, I would venture, with its exaggerated animation of sunlight and its eyes that draw forth shapes (as if by extreme foreshortening), is what we would now identify as mannerism. The sonnet uses temporal indicators to differentiate between the two styles: the geometrically accurate stillness of the image "pictured" is set in the past with such phrases as "hath played" and "hath stelled," while the apparently lively mannerist mode has eyes that "now see." But by saying that the eyes that "Now see" are also still those that "have drawn thy shape," the sonnet suggests that what might seem to be the "good turns" of a new revolution in style, on reflection indicate nothing more than an extreme adherence to the principles that precede them. "Eyes this cunning," which seem to represent "Thy shape" alive and in motion, still demand that "through the painter must you see his skill": they show the "cunning" wit that can represent "thy beauty's form,"

though they "know not the heart." The windows in this poem show some promise of knowing the heart of the matter: insofar as the windows are "glazed with thine eyes," they take on momentarily the glassy properties of a poesy that can glaze its gaze. But these same windows, by "good turns," can spin out of control into a kind of vertiginousness that is ultimately a kind of blinding grandiosity. Eyes that are "cunning," that only "want to grace their art," can end up either staring at the sun or imagining that the sun has nothing better to do than shine into the soul of the poet. They move beyond the poem rather than focusing attention on its surface. A visual mode that privileges its witty devisings above its actual observation of resemblances—such as the resemblance between the gaze of the eye and the glaze of the window—ultimately loses itself in abstraction and falls away from the heart of the poem.

It is not ultimately the actual "heart" that the couplet returns us to, but a metaphorical heart: not the "table of my heart" at the beginning of the poem, but the middle section, the figurative heart, of the poem. Perspective, or "best painter's art," may have wrested "beauty's form" from the frame of the body, violating the "table of my heart" by replacing allegorical embodiment with painterly skill. But in the second quatrain, the "image pictured" is said to be "hanging still" in the "bosoms's shop." In the second quatrain, skill and commerce converge in recognition of material resemblance: of "windows glazed with thine eyes." This material resemblance of glass windows and glassy eyes seems to hold in balance subject and object, poem and painting, lover and beloved, even the allegorical excess of the first quatrain and the conceited excess of the third. The most salient image is that of a window that neither divides subject from object nor offers the subject a prospect on its object, but instead witnesses in its glassy substance the commerce and interaction between subjects and objects. At the heart of the poem is a window that is both reflective and transparent. And thus the heart of the poem is also its attention to surface.

In the 1609 quarto edition, the only authoritative edition we have for the Sonnets, the last word of the first line appears as "steeld."[31] On the grounds that "steeld" does not rhyme with held, editors have sought to resolve the problem by emending the nonrhyming "steeld" to "stelled," and the word "stelled" has been variously glossed as " 'portrayed,' 'carved,' 'styled,' 'mirrored,' 'steeled' (I will here add 'stolen')."[32] But it was possible, according to sixteenth-century patterns of pronunciation, to rhyme "steeld" with "held" if one pronounced both words as one would pronounce "hailed," though the rhyme, because it would have been slightly archaic, may still have seemed a bit forced.[33] Perhaps the imperfect rhyme is no error at all, but part of the sense of this poem. Leaving intact the word "steeld," the reader might be prompted to tweak the pronunciation of "held" in order to rhyme it with "steeld," pressing

"held" into "healed" or, alternately, "haled." These associations are not irrelevant since the poem does imply that the body is the frame that can heal the wound caused by impression of "Thy beauty's form in table of my heart." To pronounce "held" as "healed" or "haled" would make *more* sense of the word *frame*, which in the sixteenth century still bore the trace of its derivation from the Old English *framiam*, which means to strengthen, to advance, to benefit, or to make prosper. Nor would these associations sacrifice the image of the stylus that is foregrounded when "steeld" is emended to "stelled" since "steel" might just as easily refer to a lead stylus as to a steel glass. The point is not to evoke one or another image to the exclusion of the other, but to allow for the coexistence of several images. By emending "steeld" to "stelled," we privilege the rhyming of "held" with "stelled" over "steeld" and thus the image of the poet as the holder of a stylus, whereas the poem makes it possible to imagine the poet as holder of a stylus, instrument of impression, and surface of depiction all at once. In my interpretation of this sonnet, the slanted rhyme of the first and third lines prompts the reader to consider rectifying the rhyme in multiple ways, reading words as superfluities rather than as signs or pointers. The impression that the poem makes on its readers becomes as important as any inscription made by the poet. By deemphasizing the surface of the poem and the impressions that it generates, we limit poetic instrumentality to the kind of instrumentality expressed by the stylus, in which the tool is a mere device governed by instrumental reason.

The surface of the poem is both a window and a mirror. Recalling the true and trusty metal mirror of Gascoigne's *Steele Glas*, "steeld" might also indicate the image of the beloved as captured in a mirror. And the image of a steel mirror makes sense in the context of the succeeding line since, in the 1590s, it is more likely that a steel glass, rather than a table, would have been described as framed. Gascoigne's satire equated the steel glass with the poetic tradition of estates satire and the glass mirror with Italianate conceits. And the evocation of a steel mirror—as well as the pronunciation of "steeld" in a manner that rhymes with "hailed"—would give these first lines of Sonnet 24 an archaic ring. The archaism of a steel glass coincides with the "table of [the] heart," a common emblematic image, but also one reminiscent of the courtly love poetry of the heart that Spenser critiques in the figure of Amoret who carries her heart in a dish while Busirane dips his pen in her blood.[34] The image held in a steel mirror and equated with the body stands in contrast to the mirroring effect produced "Now" in the third quatrain by eyes that are like reflective windows. In this reading of the poem, it is the "steeld" reflection that becomes the image that "pictured lies" in the windows of a commercial shop. The visual ideality of perspectival painting and also of an archaic poetics of courtly love is answered by the kind of commerce equated with windows: the commerce, or

exchange of glances between the poet and the beloved, but also the commerce of goods advertised in a shop window. Unlike the poetic images in Gascoigne's steel glass, the Sonnets do not separate their inventive conceits from commercial exchange: as the poet says in Sonnet 21, "I will not praise that purpose not to sell."

The word "steeld" draws out the connection between the old-fashioned steel glass mirror and "perspective," because, as I mentioned above, "perspective" refers both to representation in recessive space and to glass lenses and mirrors. By overlooking the presence of mirrors and lenses in this sonnet, we lose the sense that this poem consolidates these surfaces of steely resemblance and reflective transparency and challenges its readers to consider the instrumentality of the surface. To imagine the poem as an instrumental surface is to imagine, as Puttenham does, that the poem functions like a pair of spectacles. Poems themselves, and not only the pen or the stylus that writes them, are the instruments of both poet and reader alike. The poem can reflect a two-dimensional image, but so too can it function as an enhancement to sight. In Gascoigne's text the movement from steel to glass represents a shift from heroic and poetic valor to deceptive visuality. In Shakespeare's sonnet, the movement from the image "steeld" to the window glazed enhances the poetic conceit without engendering deceptive or illusory thought.

Poetic Invention and the Inventory of Glass

Shakespeare's Sonnet 3 is one in which the poet hastens the young man to produce an heir. The argument follows a figural shift from the mirror to the window. The sonnet, which opens with the image of a mirror, advises the young man that what he is to his mother—"the lovely April of her prime"—his child might someday be to him. Directing the young man first to see his own face in the mirror, and then to see himself as his "mother's glass," the speaker then tells the young man to imagine being able to look back "through windows of thine age" to see in his child "this thy golden time":

> Look in thy glass and tell the face thou viewest,
> Now is the time that face should form another,
> Whose fresh repair if now thou not renewest,
> Thou dost beguile the world, unbless some mother.
> For where is she so fair whose uneared womb
> Disdains the tillage of thy husbandry?
> Or who is he so fond will be the tomb
> Of his self-love to stop posterity?

> Thou art thy mother's glass, and she in thee
> Calls back the lovely April of her prime;
> So thou through windows of thine age shalt see,
> Despite of wrinkles, this thy golden time.
> > But if thou live rememb'red not to be,
> > Die single and thine image dies with thee.

The sonnet instructs the young man that he must learn to see himself not only as a singular "face" but as an inheritor and progenitor. Unless the young man means to "beguile the world," it is his duty to assume his place in the patrilineal transfer of property and to embody the transfer of property through reproduction. The sonnet compares producing an heir to the "tillage" and "husbandry" of an "uneared" womb: "uneared" in that this womb has not yet brought forth fruit, but perhaps also because "uneared" sounds like "unheired." The sonnet even imagines the young man occupying his body as though it were the manor house itself: instead of viewing his child's face as a mirror of his own youth, the young man is urged that he will one day look back on the reflection of his "golden time" in his child's face through the windows of his eyes. A modern reader assuming the transparency of words and images may be prompted to look through the window and the mirror to the ideas that are signified: the mirror is the "self-love" of line 8 and the windows are not simply eyes but also "posterity." Unlike the "tomb" that "stop[s] posterity," windows offer the prospect of looking back at "this thy golden time" from a point in the future.

For Murray Krieger, in *A Window to Criticism*, this sonnet is emblematic of the overall project of the Sonnets: they conjoin a poetics of the mirror with a poetics of the window. In Krieger's theory, the mirror is not a reflection of nature, but "an enclosed set of endlessly faceted mirrors ever multiplying its maze of reflections but finally shut up within itself."[35] It is to the window that Krieger assigns the mimetic function of language usually attributed in modern criticism to the mirror: it is the window that gives readers a view onto the world. The poetics of the mirror has "no historical dimension."[36] Krieger proposes that the New Criticism has treated the poem as a mirror, as an enclosed aesthetic object whose meanings and reflections are ultimately locked into their own system of referentiality and shut off from the world and from history. The poem as window, in Krieger's formulation, belongs to the old historicism, which sees the poem as window onto the world. Krieger is interested in conjoining these two functions, creating a "new historicism," which he carefully differentiates from the "new historicism" of critics such as Ernst Cassirer, whose idea, incidentally, of "symbolic forms" was so influential to Panofsky's work on perspective. Krieger means to understand the Sonnets within the special discourse of literary language and

creativity while also understanding the place of language within a broader history. Joining those two interpretive strategies, which have based themselves on the mirror and the window respectively, Krieger proposes that the Sonnets, as a window-mirror, are the *figura* of a modern poetics in which the formal and historical significance of the poem are inextricable.

That Krieger was already apologizing in 1964 for recirculating so "tired" a term as "new historicism" shows, to an almost cartoonish extent, that literary criticism has continued to play out the division between formalist and historicist criticism that Krieger codified forty years ago. Krieger wanted to differentiate his method from the "new historicism" of Cassirer by claiming that his own method was phenomenological, and not, as Cassirer's, epistemological. Whereas Cassirer was responsible, in Krieger's view, "for the notion that the mind in its symbolizing powers becomes a constitutive agent, that man constitutes his reality, and a culture its reality, through the symbolic structures that he creates and it creates," Krieger was interested in whether language itself "has any life, any constitutive power."[37] He wanted to understand the poet's activity not as "the imitation of what has already been formulated elsewhere in culture" but as an expression of "truly existential and pre-conceptual forces," something that does not appear to have been "imitated until after the poet has made it perceptible."[38] What is so compelling about Krieger's argument is its genuine effort to answer the neo-Kantian epistemology of the mind as a constitutive agent with a phenomenology of language as a constitutive agent. Where the argument falls short is in its own attachment to a neo-Kantian aestheticization of the "special language of art." For all of Kreiger's efforts to understand poetics as a constitutive agent in history, his isolation of the "special language of art" and his insistence that the phenomenological creativity of poetry is uniquely figural ultimately limits the constitutive agency of figural language to poetic discourse. Despite the efforts of literary criticism, starting in the 1980s, to recirculate yet another "new historicism," the division between formalist and historicist criticism continues to shape the field of Renaissance literary criticism.

Renaissance poetics offers us a model for understanding the constitutive agency of poetic language in history; but it is not possible to apprehend the constitutive agency of poetic language in history unless we first recognize language as temporal matter and not simply as a symbolic system of representation. The mirror, the perspective glass, and the window were comparable to poetic language, not only as metaphors but because language too was phenomenological, in and of this world, a material instrument of observation, perception, and reception, and not only as voice and script but in its impressions on the imagination as the mortal flesh of reason. To the extent that a perspectival view of the world was made or framed during the Renaissance, this was effected through the instrumental innovations, as I showed in the last chapter, of

glass. And to the extent that poetic language framed a novel set of figural prop-
erties in the Renaissance, these cannot be separated from the ways in which
matter generally was recognized as the property of persons. I have just argued,
through a reading of Sonnet 24, that the surface of the poem has the proper-
ties of a glass window. I turn now to a reading of Sonnet 3, beginning with a
reminder that the sonnets repeatedly announce their role in the young man's
posterity, as no less constitutive of his estate than the real property he might
glimpse through his own inherited windows and the real properties of himself
that he might glimpse in a child of his own flesh.

At first reading, Sonnet 3 looks to be a straightforward admonishment to the
young man to take up his place in patrilineal succession. The poem seems to
say: stop looking at yourself narcissistically in the glass and recognize that your
image is also the reflection of an older generation; then you will see that you
too, when old, will treasure seeing your own self reflected, as you were in your
youth, in the face of your child. Keep looking at the mirror and you will see
only a tomb; if you want to continue to see your reflection in all the beauty of
youth as you see it now, you will have to create an heir. And, Krieger might
add, stop looking at yourself as art and see yourself in history. One would be
hard pressed to find a sonnet that makes its point with more forthrightness or
more singleness of purpose. There is no major turn between the octave and
the sestet; there is no movement of thesis, antithesis, and synthesis in the pro-
gression of quatrains. The couplet neither rebuts the preceding lines nor dan-
gles an unsettling caveat. It simply offers a summary recapitulation of the
warning put forward in the poem: "But if thou live rememb'red not to be, / Die
single and thine image dies with thee." With such a direct line of argument, it is
easy enough to make it past the occasional eccentricity thrown up by the poem
without losing sight of its overall message.

But there are eccentricities. If nothing else were to make us balk at this
reading, the phrase "mother's glass" should. Here is a poem that likens the re-
production of the young man's image to "tillage" and "husbandry" of earthy
matter, or that "uneared womb" supplied by a woman summarily referred to as
"some mother" to the young's man's heir. For a poem that encourages the
young man to take up fatherhood and husbandry, it seems odd that the young
man should be called his "mother's glass," rather than his father's. "Father's
glass" would substitute just as easily without violating the rhyme and meter of
the poem. Does this sonnet mean to admit some alternative to its conceit of
patrilineal heredity by introducing this kink of a "mother's glass" into its logic?
And then there is the problem of the window. The sonnet tells the young man
that he should produce an heir so that he too will see his "golden time" re-
flected in the image of his child's face, just as his mother sees "the lovely April
of her prime" in him, her "glass." But the conceit has shifted. The young man

is told that he will see his youth through the "windows" of his age, and not as a reflection in a glass. Is patrimony like a window and matrilineage like a glass? And if so, why is the trajectory from narcissism to patrimony routed through this image of the "mother's glass"?

Margreta de Grazia has argued that identity was once bound up with property in ways that have been obscured by post-Cartesian understandings of subjectivity.[39] And windows were once a prominent site for the display of armorial bearings. Dating at least as far back as the reign of Henry VIII, small roundels painted with heraldic arms were inserted into leaded windows of crown glass, and possibly even into lattice windows.[40] In *Richard II*, Bullingbrook, enumerating to Bushy and Green their crimes, chides that he ate the "bitter bread of banishment,"

> Whilst you have fed upon my signories,
> Dispark'd my parks and fell'd my forest woods,
> From my own windows torn my household coat,
> Ras'd out my imprese, leaving me no sign,
> Save men's opinions and my living blood,
> To show the world I am a gentleman.
>
> (3.1.22–26)

Windows and glass roundels were a way of displaying property and authority, even a kind of divinely sanctioned authority since the display of heraldic arms made from colored glass would have resembled stained glass windows and would even have reiterated the inclusion of arms in church windows as evidence of architectural patronage. In the last quarter of the sixteenth century, lattice, horn, oiled cloth, and leaded windows began to be replaced with plate windows made from single sheets of clear glass.[41] According to Eleanor Godfrey, broad glass production had ceased entirely in England until the method was reintroduced in the last quarter of the sixteenth century by Jean Carré who emigrated to London in 1567 and was granted the first license to build furnaces for the production of cristallo vessel glass and window glass. In the year of his arrival, 214 cases of window glass were imported from the Continent, while in the year 1640 alone there were nine thousand cases of window glass produced in England.[42] The demand for cristallo was sufficiently high to warrant its continued importation even after Carré had begun domestic production. William Harrison writes, for the 1577 edition of his *Description of England*, that it is "a world to see" how "plentiful" glass has become in windows and on tables:

> Our lattices are also grown into less use, because glass is come to be so plentiful, and within a very little so good cheap . . . Now these [older glass windows] are

not in use, so that only the clearest glass is most esteemed: for we have divers sorts, some brought out of Burgundy, some out of Normandy, much out of Flanders, besides that which is made in England, which would be so good as the best if we were diligent and careful to bestow more cost upon it, and yet as it is each one that may will have it for his building.[43]

During this period, persons of moderate means were able to purchase windows and tableware, as well as bottles, urinals, hourglasses, and even pennyware mirrors, though hourglasses and mirrors were almost exclusively imported from the Continent until at least the second decade of the seventeenth century.[44] It would not, I think, be an exaggeration to say that the English household was effectively glazed between 1560 and 1640.

It is easy enough to see why people would have wanted their window casings glazed with clear glass: glass windows afforded both light and protection from the wind. But it is also true that the display of presence and authority would have been made more difficult with the glazing of windows. Lena Cowen Orlin notes that the sixteenth century saw the emergence of "standing palaces" in which the household fittings remained in place even when the palace was unoccupied, whereas household fittings had once traveled with the court in its movements from place to place. "Notoriously, as late as 1567 glass windows were installed whenever the earl of Northumberland visited his castle at Alnwick and, as soon as he departed, were 'taken down and laid up in safety' from damaging winds."[45] Permanently affixing glass windows meant that the display of authority, and indeed the presence of authority, would have been less visible, or, alternately, more transparent and less pictorial, to the outside onlooker.

Godfrey's research shows that glass windows were listed separately in inventories through the end of the sixteenth century, and even notes the curious case in which an alderman bequeathed his house to his wife, but left his windows to his son.[46] The example seems an especially odd one given that women tended to inherit moveables rather than real property in the sixteenth century.[47] But as Orlin explains, windows, wainscoting, locks, oak flooring, and a whole category of objects that she specially classifies as "household fittings" were bequeathed in wills as if they were moveables, not because they were legally considered moveables but because the testators wished to ensure that these fittings and improvements would remain with the household. Despite the fact that household fittings had been deemed part of the real property, and it was therefore unnecessary to itemize them in inventories, the property status of household fittings was regularly challenged by persons who wanted to claim them as moveables:

Anxieties on this subject were most often displayed by male testators, who, consigning their houses to their widows for fixed terms or for life, insisted that

women were to leave important household implements behind for the sons who would eventually inherit. Among the most common language of testamentary documents is the stringent demand that women not "remove" the many items that could fall within the category of fittings.[48]

Household fittings, Orlin shows, were a novel and ambiguous form of property. This variable status meant that they were, for a time, difficult to define and regulate. Clear glass windows, precisely because they were so new to so many households, must have been an especially charged category of household fittings.

Household fittings intensified the value of male property in a way that women seem to have contested: things that might have seemed like moveables, and therefore like women's property, were legally qualified as male property. Orlin quotes Henry Swinburne's 1590 *Brief Treatise of Testaments and Last Wills*: "The glass annexed to the windows of the house, because they are parcel of the house, they shall descend as parcel of the inheritance to the heir." But what Orlin also shows is that Swinburne's very definition of "immoveables" as things belonging not to the person but to the house posed a difficult problem. Fittings "had a liminality he could not completely acknowledge; their dependency was not 'natural' but, literally, constructed."[49] What Orlin's research so convincingly demonstrates is that Swinburne's rhetoric had to define these objects as "immoveable," as actually inalienable to the house. I would suggest that the contested status of household fittings meant that men had a vested interest in understanding the *features* of their property as fundamentally inalienable, had, that is, a vested interest in understanding property as something with inalienable features.

Sonnet 3 encourages the young man to think of his property as inalienable in just this way. It is not simply that the poem tells the young man to shift his gaze from the mirror of self-regard to a historical outlook afforded by the window of his age. The poem encourages the young man to occupy his estate as if its features were as inalienable as the eyes through which he sees. In this way, he will see himself reflected in the face of his child, not as his mother does, in the reflection of a glass that she holds in her hand as a moveable object, but as a full inheritor of his own estate, whose very purview ensures that his property in all its features is as much a dependency on his person as his own physical features, "wrinkles" and all. The equation of windows with the young man's eyes, which is enabled by the material resemblance of their shared glassy substance, links those household fittings to his outlook, and indeed to his very identity. The poem acknowledges that the windows, those household fittings, are comparable to the "mother's glass," comparable to her moveable property, but it naturalizes the property of windows as inalienable. Indeed, the poem seems to

incorporate the logic of moveable property, of objects that capture and transmit personality, into its logic of inalienable male property. The logic of patrimony is not a logic of personal or individuated identity, but a logic of familial identity, of entail. The windows, because they are faceless, unlike the mother's glass, which bears the reflection of her son's face as the image of the "April of her prime," are an appropriate image of property as patrimony. But as household fittings, they borrow the logic of the mother's glass, drawing personal features, to wit the eyes, into the logic of male property. The windows conserve an experience of personhood—the youth who sees his own face in the mirror—ordinarily left to women (and no doubt deemed limited and myopic so long as that identification was intact), but left behind by men whose identity must be constituted by their place within a patrilineage, within, that is, a form of identity that would have been deemed larger, broader, more powerful, and more authoritative.

The windows of this poem show the agglomeration of male property, and the consolidation of properties with property, of personhood with identity. But if the poem demonstrates an attempt to seize the kind of personal authority that would have been equated with women and moveable property, it also demonstrates a debt. The figure of the window may assimilate the logic of women's moveables into a logic of male property, with all of its household fittings, but the "mother's glass" is still named as such in the poem. In a sense, what is being brought into the condition of male property, what is being made inalienable to the awareness of male property and identity, is not only the visage and feature of the "mother's glass" but also the properties and features of poetic language and the poetic conceit. I have already mentioned that the Sonnets repeatedly announce their own role in constituting the posterity of the young man. What I want also to show is how the conceits of Sonnet 3 enable, like the "mother's glass," the consolidation of properties—physical, visible, readable features—with property, authority, and identity. In a sense, they make posterity dependent on the features of poetic innovation. And to understand how this works in the poem, it is necessary to see how the "mother's glass" is linked to a poetic conceit so inalienable to the poem that it is not even named.

According to Stephen Booth's gloss, there is another kind of glass in this poem, an hourglass. Granting that, in the first line, the primary sense of "glass" is "mirror," Booth explains:

> Note, however, that in the proper context [eg. 126.2], *glass* means "hourglass," and that the substantively irrelevant conjunction of *tell* and *time* in this and the following line presents the raw materials for such a context; in quatrain 3 the action of *thy mother's glass* and the *windows* is comparable to reversing the action of an hourglass, making time run backwards.[50]

The first two lines do not directly describe the young man's use of a timepiece to tell the time, nor does the phrase "tell time" appear anywhere in this sonnet. Nonetheless, says Booth, the proximity of "tell" and "time" to "glass" evokes the figure of an hourglass. The words "tell" and "time" also resonate with "face" to evoke a clock, though it is the image of an hourglass that is repeated throughout the sonnet. The mention of time in the second line may retroactively draw out the suggestion that "glass" means both mirror and hourglass. But the words "tell" and "time" are merely the "raw materials" for a context that would enable the reader to understand "glass" as hourglass. That context is borne out, says Booth, in the implication that time runs backward when the parent sees the trace of his or her own youth in the child: the "mother's glass," an image that enables the turning back of time, provides the context within which it is possible to glean that glass might mean both mirror and hourglass. The image of the windows too, because it stages the young man looking back through the "windows" of his age to a "golden time," also contributes to the context within which an hourglass might be a meaningful conceit in this poem.

And indeed the hourglass is a meaningful conceit in the poem, even though it is never directly named or even figured straightforwardly in the poem as an object, but only evoked. Like an hourglass that is pinched at the center, this sonnet has a central crux of two symmetrical questions, the second question the flip side of the first: "For where is she so fair whose uneared womb / Disdains the tillage of thy husbandry? / Or who is he so fond will be the tomb / Of his self-love to stop posterity?" The young man is admonished to keep time moving forward, to "repair" the present by considering the future. Time is coded in this poem as an hourglass that marks the continued passage of time through a series of inversions that register newness only through a recirculation of intractable matter, or sand. The language of the poem prompts the young man to progress by replacing one set of pairs with another: to "repair" the narcissism of his self-reflection in a mirror with the regenerative reflection of one's image in an heir and to "repair" the love he shares with another man that would "stop posterity" by recoupling with a woman whose "uneared womb," once *heired*, will render her "some mother." At the mention of the "mother's glass," the looking glass and the hourglass become inextricable in this poem. Each forward movement is also a reflection: the young man is told that whatever he might wish someday to "renewest" (his youth, for example) must be accomplished through another pairing or "repair." And each reflection indicates a movement forward or backward in time. The young man may project himself into the future by engendering an heir who will reflect his image, but that forward movement will ultimately prove a reflection backwards.

The "mother's glass" provides the context for the hourglass in this poem. And that dual signification of "glass" imagines the idea of the future as the

reproduction of one's youth in the face of the child. The conjunction of the mirror and the hourglass offers a recursive sense of time, reinforced by the seasonal time referenced in the mother looking back to the "April of her prime." It is the window that introduces the idea of epochal time into the poem. Lines 11 and 12 of this sonnet read, "So thou through windows of thine age shalt see, / Despite, of wrinkles, this thy golden time." The phrases "thine age" and "thy golden time" refer to old age and youth respectively. But so too do they evoke "one's present era" and the classical golden age. With the figure of the window, historical time is introduced into the poem. But this does not mean that the poem offers a window onto progressive historical time, as Krieger has suggested. The window does not frame a worldview or a picture onto reality. On the contrary, it too offers a recursive sense of time: the windows suggest the prospect of the future, but it is a future that looks back on "this thy golden time." Time moves forward as mutability, producing "wrinkles," and then progresses backward toward youth and a more "golden time." Time is not figured according to the frame of the window, but according to the glass it contains. The window is a glass like the mother's glass; it reflects time, albeit epochal time rather than seasonal time, like an hourglass, recursively. It is not only, as Booth suggests, that the words "tell" and "time" provide the "raw materials" of that context of recursive time that makes the hourglass in this poem imaginable. It is also the actual "raw material" of glass, and the physical, phenomenological resemblance between the looking glass and the window, that gives the hourglass its presence in the poem. The material substance of glass does not provide a context; it is the actual matter that makes the hourglass an inalienable property of this poem. It helps, of course, that "glass" is a homonym that means both mirror and hourglass while it also refers to the substance that comprises them.[51] But the word *glass* is as material a substance as the stuff that it names.

A poetics of material resemblance, expressed in this sonnet as a series of moveable glass objects, and equated at least momentarily with female inheritance, seems to have for the most part flown below the sight of modern hermeneutic concerns. Actuated by the conventional association of the female with *materia*, the conceit of glass objects in this sonnet, unlike the structure of male estate in the poem, establishes meaning as the grouping of a variable set of objects. This grouping is not unlike a set of moveables that have as the common characteristic among them the woman who owns them. This inversion of property and properties renders identity an effect of the shared properties of objects. The conceit links objects that are not identified in the sonnet only or exclusively as moveables. What really drives the conceit of glass in this sonnet is not so much that these glass objects are property but that they have properties.[52] There is a lesser common denominator than property among these

objects and that is the shared substance of glass. As I pointed out in my earlier discussion of Puttenham and Bacon, the discursive comparison of objects must, if it is to avoid the distorting eccentricities of human thought, be based in the empirical observation of the "natural resemblance" (Puttenham) or "instances conformable" (Bacon) of those objects. The resemblance among the objects in Sonnet 3 is that they are all made of glass. There is a kind of inherited logic represented in the poem that shows images to be correspondent with ideas, and that links the particular to the universal, substance to essence: examples of this are the mirror that signifies self-love and the window that signifies posterity. The logic of the "mother's glass" is, on the other hand, "conceited."[53] It is based not on an idea of transparency in language, but on matter that *is* transparent. It links substance to substance, person to identity, properties to property—creating resemblances that are not founded upon received wisdom or tradition, but on phenomenal observation. This conceited logic does not universalize meaning apart from matter and time. Rather, the conceit works itself out in time and through matter. Sonnet 3 may enjoin the young man to accept a received symbolic and social order, but it also presses meaning out of material resemblance and inverts inherited tradition by means of material observation and its own technical poetic innovations. Taking a page from the glass objects of its conceit, the poem crafts a poetics of substance, though Bacon would deny that figurative language could ever do as much.

Time's Fickle Glass

Prompted by the hourglass of Sonnet 3, which is only implicitly figured in the conjunction of the mirror and the window, I am tempted to say that time itself is "pent in walls of glass in these poems." What would it have meant to add to Kreiger's formalist mirror and historicist window the figure of these poems as an hourglass? The question might seem more substantive if we consider that the hourglass is more explicitly named (and perhaps even typographically figured) in Sonnet 126, the atypical Sonnet that serves as the pivot between the young man and the dark lady sonnets. Sonnet 126 is atypical because the poem—which links together the mispaired couples of the two subsequences—is made up of six couplets, followed by two sets of curved brackets in the place where the closing couplet usually stands: the typographical figure, perhaps, of the hourglass named obliquely in the second line. Lines one and two introduce the image of the "lovely boy"—perhaps the young man, perhaps cupid—holding Time's attribute in his hand, which seems at first to be a mirror and then an hourglass: "O thou my lovely boy who in thy pow'r / Dost hold time's fickle glass, his sickle hour." It is by reading backward from "hour" to "glass"

that the reader can surmise that the mirror or "glass" might be an hourglass: both, after all, are traditional attributes of time. Reading backward and forward from Sonnet 126 into the surrounding Sonnets reveals a notable concentration of temporal markers: "Time" (123.1), "time's love" and "hate" (124.3), "eternity" (125.3) in one direction, "the old age black" (127.1), "harvest" (128.7) and "Past reason" (repeated at the beginning of lines 6 and 7 of Sonnet 129) in the other. An hourglass is an instrument in which time is mirrored: in which a second measure of time exactly reverses the first. But is the hourglass here also a window in Kreiger's sense? Does it speak to the place of these poems in history?

Let us recall that Fineman scripts the two subsequences into a narrative of innovative poetic subjectivity. Fineman acknowledges the interarticulation of the two subsequences, explaining that cross-coupling and chiasmus characterize individual poems and, in the interaction of the two parts, the sequence as a whole. The subtlety of these interarticulations, however, ultimately resolves into a more unequivocal, indeed a more univocal, argument. "The large claim that all of these subordinate claims lead to is that this produces an unusual, but, in the literature successive to Shakespeare's sonnets, a subsequently governing, poetic first person."[54]

For Lisa Freinkel, it is Fineman's reliance on the trope of chiasmus that allows him to "track the play of difference within the sonnets while still maintaining that unifying narrative that quilts together the sequence as a whole." For Freinkel, chiasmus is a trope that construes linear syntax out of recursive movement: "its repetitions enforce rereadings—we double back and thus move forward." But the "universe of Shakespeare's sonnets," Freinkel contends, "is a world *in decline*": "In Shakespeare's post-Reformation world, time's wastes can only recount the continually renewed decline of flesh from spirit." The only consolation for the "continual erosion of time" and the "collapse of narrative fulfillment" is "beauty's in-creasing catachresis": not proper succession, but its polysemous name, "*Will.*" "What is immortal, in the end, is not beauty, nor the figure of beauty, but the abuse of beauty's figure."[55]

Freinkel's account also tells a narrative, albeit a narrative of decline, and that narrative is, in essence, the flip-side of Fineman's. The story of the sonnets, for Fineman, is ultimately the history of the modern poetic subject. Freinkel wants to resist this modernizing and secularizing tendency in sonnet criticism, and so she tells instead of the "decline of flesh from spirit." Freinkel's protagonist is not the modern poetic subject, but the theological author; the problem of authorial intention is not psychosexual, but theological; the speaker's challenge is to represent not homoerotic desire, but the Protestant understanding of the will; the agon opposes not identity and difference, but spirit and flesh; and the platform is not persona, but *figura*. Freinkel tells a story, not of the ascendancy of consciousness, but of the waning of ideality.

For Fineman, the waning of ideality is one part of the narrative of the modern subject. One the one hand, the sonnets evince the progressive teleology of the modern poetic subject; on the other, they demonstrate a falling away from the ideal complementarity of the traditional poetry of praise. These two trajectories, one ascending and one descending, compose the chiastic narrative structure of Fineman's overall vision of the sonnets. Freinkel acknowledges that both of those narratives belong to the discourse of the modern subject, but cautions that the sonnets may not. Freinkel's study draws attention to the implicit historical narratives that underwrite Fineman's argument. Although, in her view, the sonnets imagine a world in decline, Freinkel is wary of hypostatizing the imagined universe of the poems. Historical narratives are imagined by the poems, but Freinkel resists ordering or sequencing the sonnets in any way that would suggest that historical narratives are inherent in the sequence itself. Catachresis is a figure, *the* figure, within the sonnets, but not a figure for the sonnets in history.

Although Fineman claims to have discovered the origins of modern subjectivity in the sonnets, his argument is paradoxically traditional. Fineman has replaced the Enlightenment construct of Shakespeare's interiority with the modern construct of the discursive subject; but in both cases the Sonnets are a narrative that discloses the true identity of the poetic first person.[56] These historical narratives may be external to the Sonnets, yet it is nonetheless important to acknowledge that what occasions their attachment to the Sonnets might well be something integral to the poems: the first person singular pronoun. As Bruce Smith has noted: "By Giorgio Melchiori's calculations, the proportion of pronouns to other words is higher in Shakespeare's sonnets than in the sonnets of Sidney, Daniel, Drayton, and Spenser: 14.7 percent. The most frequent of these pronouns, among the sonnet-writers, is the first person singular. To read Shakespeare's sonnets is, therefore, to acquire a certain identity as 'I.' "[57]

Where Fineman reads "I," Freinkel reads "Will." In her reading, "Will" is a catachresis not only of beauty's proper succession, but also of the poetic first person; a catachres is not only of the subject of praise, but also of the speaking subject. Fineman tells a story of subjectivity; Freinkel tells a story of *figura*. Kreiger tells a story of both: for essentially his story is that the Sonnets are the figure of modern poetics. But what if it is neither the window nor the mirror, but the hourglass that locates the Sonnets in time? What if the question of history here is a little more "pent" up in the language of the Sonnets? What if the point of reference, and pivot point, is nothing other than Sonnet 126? Then perhaps the question that needs to be asked is not one of ideas in history, but a question about the material word itself: What happens in these poems when "I" becomes "Will," when the speaking subject is described in the third

person? The question is not unrelated to the question of what happens when "eye" becomes "will," but it asks that question by making specific reference to the materiality and temporality of the word. It asks: what happens when *the word itself* is no longer seamlessly contiguous with the absolute subject—God, or the mortal whose access to language depends on his or her having been made in the image of God—but not yet sundered from it? What happens when the word has become a thing, but is not yet an object? My sense—as I have tried to show by reading the language of these poems in relation to matter—is that, under these circumstances, the word reveals itself as a technology, looking backward to the past and forward to the future for its coordinates.

Coda: The Material Sign and the Transparency of Language

The inscription of his own name on a glass window is the occasion of John Donne's "A Valediction of my name, in the window." Here is a poem that stages frame and glass together. That the name is engraved on not just any glass but a window calls to mind an empty frame. The casement frames the inscription of Donne's name. Yet the windowpane itself also frames the inscription in its own way. The name is framed *by* the casement, and it is also framed, in the older sense of the word, *of* glass. Written as it is on glass, that bit of script, the word "Donne," is phenomenologically transparent. And yet, in the discourse of the poem, the word is also figuratively transparent: it calls to mind the idea of being finished or "done." Beginning with a description of the name written on the window, the poem proceeds by querying the exact nature of that sign as it is written, as light shines through it, as it is looked at, read, and read into, as it reflects and reveals. The poem is a kind of prismatic study of the name as a material word. Concentrating on the physical property of transparency that is inherent in the name by virtue of its being written on glass, the poem looks backward to the transparent iconic signs of classical and medieval antiquity and forward to the representational signs of modernity. In the first instance, the sign leads to the Platonic idea, the Aristotelian soul, and the divine idea, and in the process mortifies the flesh. In the second instance it reflects the mind of the writer, freeing the fancy, but ultimately stripping the sign of its material efficacy in the world and in history. Without nostalgia for the iconic sign, the poem seems to lament the emergence of a form of modern signification in which the sign is, above all else, tied to the proprietary interests and instrumental reason of the speaker or writer. But, for a passing moment, the poem with its name on the window articulates the possibility of a sign that is

both material and transparent, a sign that holds in balance lover and beloved, writer and reader, subject and object, and finally matter and meaning.

In the opening stanza, the speaker describes the act of inscribing the glass as if it were a "charme" that transmits both the properties of the speaker, constancy or "firmness," and one of the properties of the engraving diamond, hardness, onto the glass:

> My name engraved herein,
> Doth contribute my firmnesse to this glasse,
> Which, ever since that charme hath beene
> As hard, as that which grav'd it was
> Thine eye will give it price enough, to mock
> The diamonds of either rock.[1]

The inscription is left for the beloved in anticipation of the speaker's absence. It is the eye of the beloved that will charm the glass in another way, this time conferring the property value of the diamond, rather than its physical properties—its "price" rather than its hardness—onto the glass. Arthur Marotti has speculated that Donne wrote the poem in 1602, shortly after his clandestine marriage to and then enforced separation from Anne More.[2] Though his name and lineage were ancient enough, Donne had neither estate nor title and was therefore considered an unsuitable match for Anne, daughter of the wealthy and well-connected Sir George More, who had succeeded to the estate of Losely Park in 1600. The poet may have had "firmness," but it was Ann who had price. Giving her eye to the name on the window, it is Ann More who will make "more" of "Donne."

At the time of the marriage, Donne had just finished a term as secretary to Lord Keeper Thomas Egerton, a position that, as R. C. Bald has put it, would have given Donne "every expectation of rising as high in the service of the state as his abilities could take him. . . . the son of a London ironmonger, [Donne] had secured an initial appointment without any advantages of birth, family, influence, or wealth."[3] The disclosure of the marriage provoked the wrath of both Donne's former employer and his new father-in-law. Donne was alienated from Egerton's circle of influence and his father-in-law brought a suit against him in an effort to get the marriage dissolved. At the discovery of the secret marriage, Anne was disinherited. Legend has it, no doubt in response to Donne's eternal punning on his own name, that he wrote a letter to his wife, during the temporary separation that followed their marriage, that he signed "John Donne, Anne Donne, Un-done." Anne's father ultimately dropped the suit against Donne, but never gave Anne any part of her dowry. Donne had inherited little, and his own prospects were considerably curtailed by his having fallen out of favor.

It might be said that when Donne "contributes his firmness to the glass" by engraving his name in the window, he inscribes a word that gathers more authority from its capacity to coin meanings than from its capacity to invoke a singular or exceptional ancestry. Donne's name has no social authority as an iconic mark of heritage, only poetic authority as a multivalent sign. The word does, in a nutshell, what the poet labors to do in his work: with its quibble on "done," the word produces, like the poet himself, a plurality of meanings. So too does the name, written as it is on the window, bespeak the collective and plural enterprise of the love poem. "Donne" is not—until he is "done." The poet may be able to sign the name of Donne, but it is the beloved reader who makes that assignation done or complete. As the speaker says, "You this entireness better may fulfill, / who have the pattern with you still." The name on the window is both written and read; it affords both a view from within and a view from without; it links two persons in a single word. And that name is invested with a set of shared attributes: with the material properties of the word rather than the material effects of patrimony.

I do not mean to suggest that the name on the glass expresses some kind of pure egalitarian union. It is, after all, Donne's name, a name that supersedes, in marriage, the last name of the beloved, and it is a name that superscribes the beloved's act of writing at the end of the poem. Given that the glass vessel was a common uterine metaphor, the inscription of the name on the window has all the hallmarks of the imposition of male form onto female matter. And yet it is precisely this struggle between the word as a sign and the word as matter that gets played out over the course of the poem. There is no doubt that the poem is about Donne's name: the title says as much. But a reader who sees the poem as nothing else but a transparent record of Donne's biography will miss out entirely on what this poem has to say about the contest between words as signs and words as matter.

Attempting to replace the authority of the name with the properties of a transparent sign, and to replace property value with poetic value, the poet is faced with the problem of how to ensure truth and fidelity through a sign. The value of the poem inheres in its transparent "through-shine" quality, its capacity to transmit light and reflect it, to be enlarged by its reader, and seen through other eyes:

> 'Tis much that glasse should be
> As all confessing, and through-shine as I,
> 'Tis more that it shows thee to thee,
> And clear reflects thee to thine eye.
> But all such rules, loves magique can undoe
> Here you see me, and I am you.

It is the capacity of the glass to function as both window and mirror that allows both full disclosure or confession and also clear self-reflection. But it is also the conjunction of the glass and the "charme" of the inscribed name that allows "loves magic" to undo the "rules" of matter, collapsing the distinction between subject and object.

Yet then the poem spins off a set of metaphors, as if striving to gather authority in its proliferation of meanings. The speaker first distinguishes the name from all other marks, as if the transparency of the glass on which it is written were not enough and the name needed to be abstracted utterly from any material signs and to be transparent in principle rather than in matter. The poet makes his inscription in the first stanza as a mark of his constancy, made more constant by the eyes of the beloved. Now the poem suggests that while constancy is an inherent property of the sign, true constancy goes beyond the "point" and "dash" of the material letter, which are only accessories to the true name:

> As no one point, nor dash,
> Which are but accessaries to this name,
> The showers and tempests can outwash
> So shall all times finde mee the same;

The name then becomes a Platonic form or "pattern," an Aristotelian soul, a memento mori. Through the complete transparency or ideality of the sign, the speaker seeks to be the name in essence, unchanging and true, untainted by material temporality. But that essence, it turns out, is not immortal eternity or universal reality. It is instead, simply put, to be finished. To *be* his name is to be done, or rather done in. In all his striving to make the name eternal, essential, and true, he seems only to make it dead. With each successive attempt to find a metaphor of absolute and unchanging truth and steadfastness, the poem keeps returning to the morbid mortal body:

> Or if too harde and deepe
> This learning be, for a scratch'd name to teach,
> It, as a given deaths head keepe
> Lovers mortalitie to preach,
> Or think this ragged bony name to bee
> My ruinous Anatomie.

> Then as all my souls bee
> emparadised in you (in whom alone
> I understand, and grow, and see,)

> The rafters of my body, bone
> Being still with you the, Muscle Sinew and Vein
> Which tile this house will come again.
>
> Till my return, repaire,
> And recompact my scattered body so.
> As all the virtuous powers which are
> Fix'd in the starres, are said to flow,
> Into such characters, as graved bee
> When these stars have supremacie.

Every attempt to look past the material sign to its essential truth, to make it transparent, turns the sign into a "ragged bony name" that reflects the speaker's "ruinous Anatomie." The iconic, emblematic sign fixes "all the virtuous powers" in the "starres," giving them "supremacie" over the "scattered body" and the letter. When the sign is made to be transparent to eternal truths, it cedes all liveliness to the heavens and makes dead images of "such characters, as graved bee," those characters being both persons who are laid in the grave and characters or letters that are engraved.

In the four remaining stanzas of the poem the speaker turns back to the material letter to such an extent that he descends into jealous and proprietary apprehensiveness. Here the speaker attends so strenuously to the materiality of the name, to its fixed place in the glass window, and to its capacity to represent him, that he is again undone, though differently so. Thus the poem seems to correct itself too much in the other direction, becoming appropriative and material to such an extent that it manufactures false abstractions, imaginings, wounded pride, and betrayal. Here the speaker looks past the sign to material reality too stringently and too obsessively:

> When thy inconsiderate hand
> Flings ope this casement, with my trembling name,
> To looke on one, whose wit or land,
> New battry to thy heart may frame,
> Then thinke this name alive, and that thou thus
> In it offendst my Genius
>
> And when thy melted maid
> Corrupted by thy Lover's gold, and page,
> His letter at thy pillow'hath laid
> Disputed it, and tam'd thy rage
> And thou begin'st to thaw towards him, for this,
> May my name step in, and hide his.

> And if this treason goe
> To an overt act, and that thou write again;
> In superscribing, this name flow
> Into thy fancy, from the pane.
> So in forgetting, thou rememberest right,
> And unaware to mee shalt write.

Here the sign is representational: it stands in for the "Genius" behind it. The representational name is "alive," it acts on the speaker's behalf, it "step[s] in" and "hide[s]" all other letters laid at the beloved's pillow, it "superscribes" all acts of treason. It is freed up from the essential truths that kill it, that take away its liveliness as body and matter. And yet it is bound to the vagaries of proprietary thinking, subject to the will and to fancy, limited to the language of property. Whereas the poem suggests earlier that "virtuous powers . . . are said to flow into such characters as graved be," here the motion is reversed and "the name flows into thy fancy from the pane." Mimicking in reverse the transitivity of causes, whereby "virtuous powers" flow into graved characters, or the names that are divinely writ on the things and words of this world, this name in the window imposes the sign onto the fancy and the imagination. This sign too is transparent, a transparent expression of the mind that controls it: it superscribes all other expressions of the letter and makes them "unaware."

In the final stanza of the poem, the speaker disavows the effort to make the sign either constant or permanent:

> But glass, and lines must bee,
> No means our firme substantiall love to keepe;
> Neere death inflects this lethargie
> And this I murmure in my sleep;
> Impute this idle talke to that I goe
> For dying men talke often so.

By sending the reader from the windowpane to the pain of "dying men," and from these poetic lines and figures or "idle talke" back to a "lethargie" in parting that is like death, the poem refuses to value itself for anything more than it is worth, and turns away from thought and letters to the original "firmnesse" that motivates the poet's charmed inscription, that is, to "the firm substantial love" of everyday existence, if not to sex itself. If indeed the ending of the poem returns the reader from the letter to the life, it does so without any redemptive resolution to the problem of property and propriety. The poem strives for, and perhaps glimpses, a kind of collective consolidation of reader and writer, lover and beloved, matter and meaning, but only in the suspended

animation of light passing through the name in the window. The letter is not the life. Nor can it ever fully achieve an eternal or ideal alternative. But if the letter strives not to be "done" but to "go" then it can at least capture language as it happens in time: in this case, the murmurings and "idle talke" of "dying men," the language of temporality and mortality, but also of desire.

In the epistle to his 1601 "Metempsycosis," Donne wrote, "Others at the Porches and entries of their Buildings set their Armes; I, my picture; if any colours can deliver a minde so plaine, and flat, and through-light as mine."[4] Donne goes on to say that, as a new author, he expects that his readers will doubt the authority and worth of his verse, just as he himself does with other new authors. But authority must ultimately be sought in the work and not in the author; and thus readers must judge him by the picture of his mind, rather than the picture of his lineage. A year later, when Donne describes writing his name in the window in "A Valediction," it is as if he were installing the verbal sign of his name where Bolingbroke's coats and impresa had once been blazoned in the window. Here Donne replaces heraldry with a verbal sign, and social ancestry with a transparent or, as he calls it, "through-shine" inscription. Donne suggests that his authority inheres in his authorship, and his admission in the epistle that his "minde" is "so plaine, and flat, and through-light" suggests that the window in "A Valediction" is an image of the mind, and his name in the window is an image of his mind as written in verse. It is almost as if we can begin to see in this formulation a shift from the recognition of the mind as mirror to an epistemology of the instrumental reason as frame, and a shift from iconic resemblance to the representational sign. Indeed, "A Valediction" seems to stage a contest between these two forms of signification, each observing its own visual logic, each with its own sense of transparency. The poem rejects both forms of signification. Yet the vehemence with which the poem rejects the notion that the representational sign is an image of the mind, and the grounds on which that model of signification are rejected, are worth noting. The representational sign frees language from the "virtuous powers" of the heavens, but subjects it to fancy, making it the property of "Genius." The poem seems to have anticipated that while the representational sign frees up the subject as an agent, it strips language of its agency in history as both techne and poiesis.

Notes

Preface

1. Samuel Daniel, *A Panegyrike Congratulatorie Delivered to the King's most Excellent Maiestie at Burleigh Harrington in Rutlandshire. Also certaine epistles, with a Defence of Ryme heretofore written, and now published by the author* (London, 1603), F₂r.

2. "Even what is called *ornamentation (parerga)*, i.e. what is only an adjunct, and not an intrinsic constituent in the complete representation of the object, in augmenting the delight of taste does so only by means of its form. Thus it is with the frames of pictures or the drapery on statues, or the colonnades of palaces. But if the ornamentation does not itself enter into the composition of the beautiful form—if it is introduced like a gold frame merely to win approval for the picture by means of its charm—it is then called *finery* and takes away from the genuine beauty." Immanuel Kant, *The Critique of Judgment*, trans. James Creed Meredith (Oxford: Clarendon Press, 1952), 68.

3. Two important early studies of framing are Werner Ehlich, *Bild und Rahmen im Alterum: Die Geschichte des Bilderrahmens* (Leipzig: E. A. Seemann, 1953) and Guiseppe Morazzoni, *Le Cornici Veneziane* (Milan: L. Alfieri [1951]). The publication date of the Morazzoni's work is unknown, although Nicholas Penny notes that the date of 1951 is listed in several bibliographies; Penny's article, "The Study and Imitation of Old Picture Frames," *Burlington Magazine* 140 (1998): 375–82, provides a useful history of scholarship on frames.

4. Henry Heydenryk, *The Art and History of Frames: An Inquiry into the Enhancement of Paintings* (London: Nicholas Vane, 1963).

5. Meyer Schapiro, "On Some Problems in the Semiotics of Visual Art," *Semiotica* 1 (1969): 223–42.

6. Claus Grimm's survey of European framing, *Alte Bilderrahmen*, was published in 1977 and translated into English in 1981 as *The Book of Picture Frames*, trans. Nancy M. Gordon and Walter L. Strauss (New York: Abaris Books, 1981). See also Friedrich G. Conzen and Gerhard Dietrich, *Bilderrahmen: Stil—Verwendung—Material* (Munich: Keyser, 1983) and Siegfried E. Fuchs, *Der Bilderrahmen* (Recklinghausen: Bongers, 1985). Two important U.S. exhibitions, one in 1986 at the Art Institute of Chicago and one in 1990 at the Metropolitan Museum of Art, produced notable catalogs: Richard R. Brettell and Steven Starling, *The Art of the Edge: European Frames 1300–1900* (Chicago: Art Institute of Chicago, 1986) and Timothy J. Newbery, George Bisacca, and Laurence B. Kanter, *Italian Renaissance Frames* (New York: Metropolitan Museum of Art, 1990); see also the 1976 catalog, Leo Cremer and Peter Eikemeier, *Italienische Bilderrahmen des 14.-18. Jahrhunderts* (Munich: Bayerische Staatsgemäldesammlungen,

1976) and the monumental catalog for the 1984 exhibition, "Prijst de Lijst," translated into English as P. J. J. van Theil and C. J. de Bruyn Kops, *Framing in the Golden Age: Picture and Frame in Seventeenth-Century Holland*, trans. Andrew P. McCormick (Amsterdam: Rijksmuseum, Zwolle, 1995). Other resources for information on European frames are Hélène Verougstraete-Marcq and Roger van Schoute, *Cadres et supportes dans la peinture flammande aux 15e et 16e siècles* (Heure-le Romain, 1989), *La Cornice Italiana: dal Rinascimento al Neoclassico* (Milan: Electa, 1992), *La Cornice Fiorentina e Senese* (Florence: Alinea, 1992), Paul Mitchell and Lynn Roberts, *A History of European Picture Frames* (London: Merrell Holberton, 1997), and Roberto Lodi, *Repertoiro Della Cornice Europa* (Modena: Galeria Roberto Lodi, 2003). For conceptual and historical work on frames and framing, see Jacques Derrida, *The Truth in Painting*, trans. Geoff Bennington and Ian McLeod (Chicago: University of Chicago Press, 1987), Michael Camille, *Image on the Edge: The Margins of Medieval Art* (Cambridge: Harvard University Press, 1992), Louis Marin, *To Destroy Painting*, trans. Mette Hjort (Chicago: University of Chicago Press, 1995), Paul Duro, ed. *The Rhetoric of the Frame: Essays on the Boundaries of the Artwork* (Cambridge: Cambridge University Press, 1996), and Glenn Peers, *Sacred Shock: Framing Visual Experience in Byzantium* (University Park: Pennsylvania State University Press, 2004).

7. It would be difficult and perhaps futile to try to identify a single source for this "framing" trend in book titles. The attention to the frame as rhetorical, philosophical, and artisanal practice in Derrida's *The Truth in Painting* may have been one source. Pierre Bourdieu's *Distinction: A Social Critique of the Judgement of Taste*, trans. Richard Nice (Cambridge: Harvard University Press, 1984), which effectively argues that social and historical context functions as a frame in the social construction of taste, may have been another. Indeed the conversation between scholarly approaches that were considered formalist and scholarly approaches that were oriented to context is likely to have been in itself a source of the scholarly interest in framing. The most immediate and direct influence on those scholarly titles may well have been Jonathan Culler's 1988 *Framing the Sign* (Norman: University of Oklahoma Press, 1988). Culler offers a concise redaction of the rhetoric of framing, at the same time acknowledging that "analysis can seldom live up to the complexities of framing": "The expression *framing the sign* has several advantages over *context*: it reminds us that framing is something we do; it hints of the 'frame-up' ('falsifying evidence beforehand in order to make someone appear guilty'), a major use of context; and it eludes the incipient positivism of 'context' by alluding to the semiotic function of framing in art, where the frame is determining, setting off the object or event as art, and yet the frame may be nothing tangible, pure articulation. Although analysis can seldom live up to the complexities of framing and falls back into a discussion of context, with its heuristically simplifying presumptions, let us at least keep before us the notion of framing—as a frame for these discussions" (xiv).

8. Martin Heidegger, "The Question Concerning Technology," *The Question Concerning Technology and Other Essays*, trans. William Lovitt (New York: Harper and Row, 1977), 34.

9. Although translator William Lovitt takes care to note that *Ge-stell* is meant to evoke a whole family of verbs that have *stellen*—meaning "to place" or "to put"—at their root, some have disputed the translation "enframing," suggesting that "emplacement" is preferable. "Emplacement" might indeed guard against the mistake of identifying "enframing" exclusively with picture framing. But if we recognize the full range of the modern frame's conceptual function, then "enframing" seems quite apt. "Enframing" also captures, perhaps better than "emplacement," the broader range of associated verbs derived from *stellen*—including *vorstellen*, "to represent," and *darstellen*, "to present, to exhibit"—that are meant to resonate in the term *Ge-stell*. And "enframing" sounds "in a lofty sense ambiguous" (33). In its ordinary use, Heidegger notes, *Gestell* means "some kind of apparatus, e.g. a bookrack . . . a skeleton" (20). But Heidegger hyphenates the word to render it active and to give it the "eerie" (20) resonance of its derivation. Samuel Weber notes that Lacoue-Labrathe's translation is "installation," but for his own part suggests "emplacement." Samuel Weber, *Mass Mediauras: Form, Technics, Media* (Stanford: Stanford University Press, 1996), 71. I am grateful to Ben Glaser for bringing Weber's book to my attention.

10. Heidegger, "Science and Reflection," in *The Question Concerning Technology*, 173.

11. Michel Foucault, *The Order of Things* (New York: Vintage Books, 1973).

Introduction: The Renaissance and Its Period Frames

1. Margreta de Grazia, "Words as Things," *Shakespeare Studies* 28 (2000): 231–35. De Grazia writes, "Is a word a thing? . . . If sensible properties constitute thingness, then a word is certainly a thing. It exists either as a sound to be heard or a mark to be seen" (231) and "To answer our opening question: a word is a thing in the sixteenth but a nonthing in the seventeenth century. In the domain of rhetoric, whose purpose was persuasion and not representation, a word was permitted to retain its materiality, for it was the source of this power" (235). See also Juliet Fleming, *Graffiti and the Writing Arts of Early Modern England* (Philadelphia: University of Pennsylvania Press, 2001).

2. Elizabeth Cook, *Seeing through Words* (New Haven: Yale University Press, 1986); this study of the materiality of seventeenth-century poetry has not had the follow-up that it deserves.

3. Jean Hagstrum, in his defining work on the subject, *The Sister Arts: The Tradition of Literary Pictorialism and English Poetry from Dryden to Gray* (Chicago: University of Chicago Press, 1958), acknowledges that pictorialism is but one aspect of poetic imagery.

4. David Summers explains the relationship of the imagination to sense perception and its distinction from the intellect: "The 'senses' with which we shall be concerned are both what were called 'external' and 'internal' senses. The internal senses were all faculties of the soul thought to deal with mental images. Imagination (or fantasy), the power to call up 'before the mind's eye' what was not actually present, was essential to the operations of all these faculties, which were called 'senses' because they dealt with particulars. These particulars were, of course, the 'forms' of particulars at the first level of abstraction from external sense. They were not, however, sufficiently abstracted to be the 'universals' subject to the activities of the intellect. The internal senses performed judgments, which were acts of distinction, comparison, association, and combination. These judgments and operations were literally prerational, although the syllogism, as the paradigmatic operation of reason, and therefore the paradigm of right thinking, seems to have provided the dominant model in attempts to characterize the peculiar structure and cogency of fantasy, memory, recollection, or quick-wittedness. By implication, these operations were deficient kinds of reason. As we shall see, however, by the time of the Renaissance these lower faculties of the soul had come to occupy an unprecedented position of importance, and their relation to reason—even distinctness from it—was very much in question." David Summers, *The Judgment of Sense: Renaissance Naturalism and the Rise of Aesthetics* (Cambridge: Cambridge University Press, 1987), 27.

5. *The Works of John Ruskin*, ed. E. T. Cook and Alexander Wedderburn (London: George Allen, 1906), vol. 22, 337. I am grateful to Jonathan Grossman for bringing this citation to my attention.

6. Paul Oskar Kristeller also acknowledges that the artistic production of the Renaissance was only later codified by a modern system of fine arts that first emerged in the eighteenth century; Kristeller, *Renaissance Thought: The Classic, Scholastic, and Humanist Strains* (New York: Harper Torchbooks, 1961).

7. Timothy J. Newberry, George Bisaca, and Laurence B. Kanter, *Italian Renaissance Frames* (New York: Metropolitan Museum of Art, 1990), 12. The authors note, "A mahlstick could be laid across the outer lip of the panel on which the painter could rest his hand while working without touching the surface of the painting."

8. Thomas Wilson, *The Arte of Rhetorique* (London, 1560).

9. For a discussion of the shaping and ruling of matter, see Patricia Parker's chapter " 'Rude Mechanicals': *Midsummer Night's Dream* and Shakespearean Joinery" in *Shakespeare from the Margins* (Chicago: University of Chicago Press, 1996), 83–115. Crystal Bartolovich discusses the metaphor of "rule" in terms of the newly scientific instruments of surveying in "Boundary Disputes: Surveying, Agrarian Capital, and English Renaissance Texts," PhD diss., Emory University, 1993.

10. A passage from Wilson's earlier *Rule of Reason* makes this point directly: "The substance called materia is ready to be framed of the woorkeman, as hym liketh by the whiche substance, wither thynges naturall or els thynges artificiall are made. As first a man which is a naturall thing is made of body & soule. An image which is an artificiall thyng is made by the handy worke of man & is graven out of stone or molten in golde or in brasse. From this place are made argumentes that both do affirm and also

deny. As thus, if a man have cloth he maie have a garment made if it like hm. But if a manne have no cloathe at al how can be have a goune or a coate." Thomas Wilson, *The Rule of Reason conteinyng the Arte of Logique* (London: Richard Grafton, 1551), 110.

11. The period term "Renaissance" is usually dated to Jules Michelet's 1855 *La Renaissance*, though Johan Huizinga cites an example of the term in Balzac as early as 1829; see Erwin Panofsky, *Renaissance and Renascences in Western Art* (New York: Harper and Row, 1972), 5. Panofsky also points out that Petrarch conceived of his own period as a revival of classicism (10).

12. Jacob Burckhardt, *The Civilization of the Renaissance in Italy*, trans. S. G. C. Middlemore (New York: Penguin Books, 1990), 20.

13. Burckhardt, *Civilization of the Renaissance*, 19.

14. Burckhardt, *Civilization of the Renaissance*, 19.

15. Burckhardt, *Civilization of the Renaissance*, 98.

16. G. W. F. Hegel, *The Philosophy of History*, trans. J Sibree, ed. and intro. C. J. Friedrich (New York: Dover, 1956). For Hegel, art and science put an end to the middle ages. Art especially belongs to the end of the middle ages; it exhibits an "element of truth," but it is "manifested only in a sensuous mode" (408–9). The Church follows art, "but as soon as the free Spirit in which Art originated, advanced to thought and Science, a separation ensued" (409). Together, then, art and science are the "blush of dawn" to a "day of Universality, which breaks upon the world after the long, eventful, and terrible night of the middle ages." That day is "distinguished by science, art, and inventive impulse," but it is "rendered free by Christianity and emancipated through the instrumentality of the Church" (411). Burckhardt's younger colleague, Friedrich Nietzsche, claimed that "the Italian Renaissance contained within it all the positive forces to which we owe modern culture: liberation of thought, disrespect for authorities, victory of education over the arrogance of ancestry, enthusiasm for science and the scientific past of mankind, unfettering of the individual." He sees the German Reformation, by contrast, as "an energetic protest by retarded spirits" still caught in the middle ages who, with "stiff-necked northern forcefulness," threatened forever "the complete growing together of the spirit of antiquity and the modern spirit." *Human, All Too Human*, trans. R. J. Hollingdale, intro. Erich Heller (Cambridge: Cambridge University Press, 1986), 114–15.

17. Wilhelm Dilthey, *Introduction to the Human Sciences*, from *Selected Works*, vol. 1, ed. Rudolph A. Makkreel and Frithjof Rodi (Princeton: Princeton University Press, 1989), 361.

18. E. M. W. Tillyard, *The Elizabethan World Picture* (New York: Random House [1943]), 109 and 3.

19. Hardin Craig's *The Enchanted Glass* (1936) involved a gesture quite similar to Tillyard's. Endeavoring to describe how Elizabethan "man" imagined his relation to the "World Machine," Craig acknowledged that the world may once have been a machine rather than a picture, and yet his attempt to recover an Elizabethan mind-set still conceives of historical difference in terms of a "point of view" too often "disregarded." Hardin Craig, *The Enchanted Glass* (Oxford: Oxford University Press, 1936).

20. Martin Heidegger, "The Age of the World Picture," in *The Question Concerning Technology*, trans. William Lovitt (New York, Harper and Row, 1977), 115–54, at 132. "The Age of the World Picture" was delivered as a lecture in 1938 and first published in 1952. See also Margreta de Grazia, "World Pictures, Modern Periods, and the Early Stage," in *A New History of Early English Drama*, ed. John D. Cox and David Scott Kastan (New York: Columbia University Press, 1997).

21. Heidegger, "Age of the World Picture," 130.

22. Margreta de Grazia, "When Did *Hamlet* Become Modern?" *Textual Practice* 17, no. 3 (2003): 485–503. De Grazia separates the "earlier deictic function" of the word *modern* to refer to "the latest" from its later function, which always insists that what is new is the subject's role within that novelty. It is worth noting here that de Grazia observes that the next horizon of modern readings may be "technological." One of my aims is to suggest "technological" readings that are *not* locked in to a concept of the modern subject that, at least for Heidegger, always defines the position of the individual as "new."

23. See the introduction to Margreta de Grazia, Maureen Quilligan, and Peter Stallybrass, eds., *Subject and Object in Renaissance Culture* (Cambridge: Cambridge University Press, 1995): "In highlighting the subject, Renaissance studies have prodded this history on, for, from its Burckhardtian inception, the

period has been identified as 'the beginning of the modern era'—what we now term the early modern. Once the modern era is seen to start with the emergence of the subject, the course is set for all of its extensions into the future, from Early Modern through Postmodern" (4). For an overview of the subject/object divide from Renaissance neo-Platonism through Kant, see William Kerrigan and Gordon Braden, *The Idea of the Renaissance* (Baltimore: Johns Hopkins University Press, 1989), 76.

24. There have been those who have questioned the validity of the Renaissance as a period, but, as Erwin Panofsky has pointed out, they are rarely art historians. Panofsky writes, in *Renaissance and Renascences*: "It is perhaps no accident that the factuality of the Italian Renaissance has been most vigorously questioned by those who are not obliged to take a professional interest in the aesthetic aspects of civilization—historians of economic and social developments, political and religious situations and, most particularly, natural science—but only exceptionally by students of literature, and hardly ever by historians of art." (38).

25. Michel Foucault, *The Order of Things: An Archaeology of the Human Sciences* (New York: Vintage Books, 1973).

26. Heather Dubrow and Richard Strier mention the influence of Burckhardt and Tillyard in the introduction to their edited collection, *The Historical Renaissance* (Chicago: University of Chicago Press, 1988), 2. They also caution against substituting "Foucault for Tillyard, a new Elizabethan world picture for an old one" (8). They do not, as Foucault did, object to the creation of world pictures per se but urge that "we must maintain our sense of competing and fragmentary world pictures in the period" (9).

27. The idea of the world picture reveals that the division of art from science is modern fabrication. For recent scholarly work that explores the relationship between poetics and science, see Denise Albanese, *New World, New Science* (Durham: Duke University Press, 1996) and Elizabeth Spiller, *Science, Reading, and Renaissance Literature: The Art of Making Knowledge 1580–1670* (Cambridge: Cambridge University Press, 2004). Spiller sees both literature and science as world-making practices. For a study of the conjointly literal and scientific production of knowledge in relation to print, see Adrian Johns, *The Nature of the Book: Print and Knowledge in the Making* (Chicago: University of Chicago Press, 1998).

28. Foucault, *Order of Things*, xxiv.

29. Foucault, *Order of Things*, xxii and xiv.

30. Foucault, *Order of Things*, 218.

31. Foucault, *Order of Things*, xxiii.

32. See Margreta de Grazia, "World Pictures, Modern Periods and the Early Stage." Henri Focillon's description of the framing of time suggests the extent to which the activity of framing affirms the interests of subjects: "We are exceedingly reluctant to surrender the isochronal concept of time, for we confer upon any such equal measurements not only a material value that is beyond dispute, but also a kind of organic authority. These measurements presently become frames, and the frames themselves become bodies. We personify them. Nothing, for instance, could be more curious in this respect than our concept of the century." Focillon, *The Life of Forms in Art*, trans. Charles Beecher Hogan and George Kubler (New Haven: Yale University Press, 1942), 64.

33. Michel Foucault, *The Archaeology of Knowledge*, trans. A. M. Sheridan Smith (New York: Pantheon Books, 1972), 166.

34. This has been especially true in art history. Ernst Gombrich, for example, argues that Hegel, rather than Johann Joachim Winckelmann, is the father of art history; see "The Father of Art History: A Reading of the Lectures on Aesthetics of G. W. F. Hegel (1770–1831)," in *Tributes: Interpreters of Our Cultural Tradition* (Ithaca: Cornell University Press, 1984), 51–69.

35. See, for instance, the critique of Louis Althusser in the first chapter, "On Interpretation: Literature as a Socially Symbolic Act," of Frederic Jameson's *The Political Unconscious* (Ithaca: Cornell University Press, 1981), esp. 49–50.

36. Frederic Jameson, *Political Unconscious*, 26 and 90–93.

37. Theodor W. Adorno, *Negative Dialectics*, trans. E. B. Ashton (New York: Continuum, 1994), 153.

38. Adorno, *Negative Dialectics*, 153–54.

39. Adorno, *Negative Dialectics*, 331.

40. Adorno, *Negative Dialectics*, 11.
41. Adorno, *Negative Dialectics*, 31.
42. Foucault, *The Archaeology of Knowledge*, 12.
43. Foucault, *The Archaeology of Knowledge*, 205.
44. "In order to analyse the rules for the formation of objects, one must neither, as we have seen, embody them in things, not relate them to the domain of words; in order to analyze the formation of enunciative types, one must relate them neither to the knowing subject, not to a psychological individuality. Similarly, to analyse the formation of concepts, one must relate them neither to the horizon of *ideality*, nor to the empirical progress of *ideas*." Foucault, *The Archaeology of Knowledge*, 63.
45. Foucault, *The Archaeology of Knowledge*, 231.
46. Louis Althusser, *Philosophy of the Encounter*, trans. G. M. Goshgarian (London: Verso, 2006), 190.
47. Althusser, *Philosophy of the Encounter*, 194.
48. Jameson admits in *The Political Unconscious*, to have foregrounded the "path of the subject" in his "historicizing operation" by focusing on the "interpretive codes through which we read and receive the text in question" (9). Jameson acknowledges a paradox in the Althusserian school: though it discredits Marxian versions of teleological history, it also makes the mode of production a central category for Marxism. Jameson deals with this problem of historical narrative "by relocating it within the object. . . . The idea is, in other words, that if interpretation in terms of expressive causality or of allegorical master narratives remains a constant temptation, this is because such master narratives have inscribed themselves in the texts as well as in our thinking about them" (33–34). To favor a nonidentical approach to the dialectic, according to Jameson, "often means little more than a materialist and "decentering" approach to knowledge," a "negative dialectics" that is "an essentially aesthetic ideal" (52, n. 29). But in addressing a period defined by an earlier mode of production, we may need to acknowledge that its objects are inscribed not only by master narratives, but also other modes of temporality; for these objects, an approach informed by "negative dialectics" may be crucial.

1. The Frame before the Work of Art

1. The most recent scholarship on the panel attributes it to the Venetian-Adriatic school, c. 1290–1300, though its attribution has been subject to debate: Carl Brandon Strehlke, *Italian Paintings, 1250–1450, in the John G. Johnson Collection and the Philadelphia Museum of Art* (Philadelphia: Philadelphia Museum of Art, 2004), 443–47. In Barbara Sweeney, *Catalog of Italian Painting in the John G. Johnson Collection* (Philadelphia: Philadelphia Museum of Art, 1966), catalog number 116, the attribution of the panel is listed as Sienese, c. 1340.

2. The bones and glass were added by a conservator in the twentieth century, though the presence of niches in the spandrels suggests that the panel would have been used in this way; see Strehlke, *Italian Paintings in the John G. Johnson Collection*, 443.

3. It is difficult to determine exactly what the placement and function of these painted reliquary frames might have been. Their small size suggests that they may have been cult shrines. But the pairing of the painted image with the reliquary function of the object suggests that such panels, if they were not altarpieces, bear a relation to the altarpiece as the first site of freestanding painted images. As early as 787 the General Council at Nicaea had ordained that every altar should contain at least one relic, and in 1310 the synod at Trier ordained that every altar should indicate the saint to which it was dedicated. Since celebrants had begun in the thirteenth century to conduct mass facing the altar with their backs to the congregation, thereby blocking the antependium or frontal that had been the traditional site of altar decoration, altarpieces were developed to mark saintly presence at the altar. Jill Dunkerton, Susan Foister, Dillian Gordon, and Nicholas Penny, *Giotto to Dürer: Early Renaissance Painting in the National Gallery* (London: National Gallery, 1991), 23–27. Hans Belting notices both the correspondences and overlapping of cult images and altarpieces and also the distinctions between the two. Image cults came into being outside of the liturgy, whereas the altar is the scene of the sacrificial cult of the church. The

altarpiece is for Belting a self-representation of the church and not a cult image per se. But Belting also notes: "A panel placed on the altar, no matter what image it carried or of what material it was made, was related to the cult vessels, and was thus probably confined, in the early stages, to occasions of special feasts. It might have included reliquaries hardly distinguished from its own appearance. In such cases images were the mere supplements of something else, unable to speak with a voice of their own." Hans Belting, *Likeness and Presence*, trans. Edmund Jephcott (Chicago: University of Chicago Press, 1994), 443. For a brief survey of panel painting, see Paul Mitchell and Lynn Roberts, *A History of European Picture Frames* (London: Merrell Hoberton, 1996), 10 and 15. Mitchell and Roberts also discuss the decorative shift from antipendia to altarpieces (15 and 115–17).

4. Jacob Burckhardt, *The Altarpiece in Renaissance Italy*, ed. and trans. Peter Humfrey (Oxford: Phaidon, 1988), 55. See also Belting, *Likeness and Presence*, 443; Belting's point is that the development of the altarpiece has a double root in the cult vessel and in the moveable image. His final discussion of the reframing of cult images within ecclesiastical works of art best illustrates the distinction he makes between the cult image and the art image: "The 'two kinds of images' move dramatically apart when [during the Counter-Reformation] old images are inserted into picture tabernacles on altars or when they appear within the framework of a picture that provides commentary on them. The old image was divested both of its objective character and of its historicity, exchanging the old aura of the sacred for the new aura of art" (484). This is not a simple replacement of the icon with the idea, says Belting, but a development that "cancels the claim of the particular concrete image" (488).

5. That the image functions as a frame is in keeping with the display of relics. As Patrick Geary has noted, the relic always requires "something essentially *extraneous* to the relic," an image or a text that identifies a given fragment and announces its sacred significance. Patrick Geary, *Furta Sacra: Thefts of Relics in the Central Middle Ages* (Princeton: Princeton University Press, 1990), 6. On the use of images to legitimate the relic, see Belting, *Likeness and Presence*, 432. Erik Thunø, writing about miraculously produced images, notes that the relationship between the image and the relic is reciprocal. The relic, he argues, "took presence" and made itself available to the viewer through the image; at the same time, "the sacredness of the image not made by human hands was authorized through its status as an authentic relic." Erik Thunø, *Image and Relic: Mediating the Sacred in Early Medieval Rome* (Rome: Erma di Bretschneider, 2002), 16. The reliquary frames I am speaking of are not icons in the sense that Thunø means. The Baltimore reliquaries, at the very least, are attributed to the artists Lippo Vanni and Naddo Ceccarelli, respectively. Even so, the entirety of the decorated panel, as the apparatus that supports the relic, takes its cue from the relic and derives its significance from an object whose meaning is not primarily aesthetic. The focus of these reliquaries is the presentation of spiritual matter. And though the image may not have been deemed divinely made, all of the materials that make up that image would have been.

6. Leon Battista Alberti, who says that the use of gold in images does not grant "majesty" to the image, but rather interferes with the painterly depiction of light and depth of field, does not object to the use of gold and gems in frames: "There are some who use much gold in their *istoria*. They think it gives majesty. I do not praise it. . . . In a plane panel with gold ground . . . some planes shine where they ought to be dark and are dark where they ought to be light. I say, I would not censure the other curved ornaments joined to the painting such as columns, carved bases, capitals and frontispieces even if they were of the most pure and massy gold. Even more, a well perfected *istoria* deserves ornaments of the most precious gems." Alberti, *On Painting*, trans. John R. Spencer (New Haven: Yale University Press, 1966), 85.

7. On the use of coinage for gilding, see Dunkerton et al., *Giotto to Dürer*, 129. The gilding of wood panels may have been an attempt to imitate metalwork altarpieces, which predate the painted altarpiece and often supported the crucifix or reliquary: see Dunkerton et al., *Giotto to Dürer*, 26–28; Mitchell and Roberts, *History of European Picture Frames*, 10–12; and Dominic Janes, *God and Gold in Late Antiquity* (Cambridge: Cambridge University Press, 1998), 151 and 167. David Rosand points out the correspondence between divinity and gold in " 'Divinità di cosa depinta': Pictorial Structure and the Legibility of the Altarpiece," in *The Altarpiece in the Renaissance*, ed. Peter Humfrey and Martin Kemp (Cambridge: Cambridge University Press, 1990), 143–64, at 148.

8. Bernhard Decker's "Reform within the Cult Image: The German Winged Altarpiece before the Reformation," notes that the central panel of an altarpiece was called "the corpus" and that cult images were believed to be a "surrogate for the holy person himself," in *Altarpiece in the Renaissance*, ed. Humfrey and Kemp, 90–105, at 90–92.

9. *Middle English Dictionary*, ed. Hans Kurath (Ann Arbor: University of Michigan Press, 1952).

10. Stephen Heath, tracing the history of perspectival vision from quattrocento depictions of space through photography, notes the emergence of the independent frame in the fifteenth century and identifies it as an important precursor to the interest in "composing" a cinematic frame in motion picture production. See his *Questions of Cinema* (Bloomington: Indiana University Press, 1981), 11–34. Peter Brunette and David Wills apply Jacques Derrida's argument about the submerged centrality of the frame in aesthetic discourse in *The Truth in Painting*, trans. Geoff Bennington and Ian McLeod (Chicago: University of Chicago Press, 1987) to the cinematic frame in their *Screen/play: Derrida and Film Theory* (Princeton: Princeton University Press, 1989); the result is more philosophical, and less historical and technical, than Heath's.

11. This expression is taken from E. H. Gombrich, who writes that a Neoplatonism pervaded the painting academies from the mid-sixteenth to the mid-nineteenth centuries, teaching artists to "[look] across the dross of matter to the 'essential form,' " in *Art and Illusion: A Study in the Psychology of Pictorial Representation* (London: Phaidon, 1959), 134.

12. On the question of gilding, see Jacob Simon, *The Art of the Picture Frame: Artists, Patrons and the Framing of Portraits in Britain* (London: National Portrait Gallery, 1996), 14–17; Dunkerton et al., *Giotto to Dürer*, 174–82.

13. Henry Heydenryk, *The Art and History of Frames: An Inquiry into the Enhancement of Paintings* (New York: James H. Heineman, 1963), 13.

14. Giorgio Vasari, "Life of Spinello Aretino," in *Lives of the Most Eminent Painters, Sculptors, and Architects* trans. Gaston Du C. de Vere (London: Philip Lee Warner, 1912), 2:36.

15. Pieter J. J. van Thiel and C. J. de Bruyn Kops, *Framing in the Golden Age: Picture and Frame in 17th-Century Holland*, trans. Andrew P. McCormick (Amsterdam: Rijksmuseum Amsterdam and Waanders Uitevers Zwolle, 1995), 11.

16. Mitchell and Roberts, *History of European Picture Frames*, 20–21.

17. Bram Kempers's *Painting, Power, and Patronage: The Rise of the Professional Artist in the Italian Renaissance*, trans. Beverley Jackson (London: Penguin, 1992) complements Michael Baxandall's canonical *Painting and Experience in Fifteenth-Century Italy*, 2nd ed. (Oxford: Oxford University Press, 1988), especially with its account of the shift from artists' guilds and confraternities to the founding of the academies (302–3).

18. Some would say that art not only becomes an object but that it informs the very category of objects. George Kubler ventures that art is the first category of *thing* to be regularly considered an *object* (of viewing, of study, and so forth). "The systematic study of things is less than five hundred years old, beginning with the description of works of art in the artists' biographies of the Italian Renaissance." *The Shape of Time: Remarks on the History of Things* (New Haven: Yale University Press, 1962), 1. The *OED* appears to confirm that it is not until this time that material things (as opposed to ideational objects such as a purpose or an intent) are called objects.

19. Simon, *Art of the Picture Frame*, 13.

20. Oliver Millar, *The Tudor, Stuart, and Early Georgian Pictures in the Collection of Her Majesty the Queen* (London: Phaidon, 1963), 1:12.

21. Simon, *Art of the Picture Frame*, 49.

22. For example: "Item oone table of the salvacion of o' Lady embossed upon blacke vellat garnished with sundry small peerles and counterfeit stones lacking the frame being of black ebonet garnished with silver and lacking in sundry places both leavis and scrowles" (36); "Item foure tables of parchment sett in frames of wodde with figured in them and in every oone of them a manor place videlicit in oone of them is written Hampton Courte and in another of them is written Ambroyse and in another is written Cognat End and in thother is written Gandit" (38); "10 Item thistorye of David

strickinge of Goliathes headde painted uppon tike and nailed uppon a frame of woode. 11 item a painted clothe with Tryumphe called the hurlinge of the canes sette in a frame of woode wanuttree colloure" (51). *Three Inventories of the Years 1542, 1547, and 1549–50 of Pictures in the Collections of Henry VIII and Edward VI*, ed. W. A. Shaw (London: Courtald Institute for the Study of Art History and George Allen and Unwin, 1937).

23. The entry reads: "2 Item In Addam and Eve stares roome above the doore the picture of Tichian and Peeter Arntine Both in gould cheyns painted upon cloath togeether In a Carved and guilded frame which was chaunged with my Lord of Barksheare when the Kinge was yet Prince for 2 heads One being a ffatt Vulcan with a hammer in his hand. the other a fatt Venus houlding in her hand a flameing heart Soe Bigg as the life Sett in a black and guilded quarrell manner frame uppon boards Painted by Henrie Golshees." Oliver Millar, ed., "Abraham van der Doort's Catalogue of the Collections of Charles I," in *Walpole Society* 37 (1960), 8.

24. Dunkerton et al., *Giotto to Dürer*, 128–34, point out that notaries in most parts of Italy during the fifteenth century were required to keep copies of all contracts; see also Baxandall, *Painting and Experience*, 3–23.

25. Burckhardt, *Altarpiece in Renaissance Italy*, 55.

26. At its most basic level, perspective was simply a mathematical system for approximating the appearance of objects in space. But because perspective also rationalizes visual perception, it became a suggestive model for interpreting how the image on the canvas represents meaning. One-point perspective presumably anchors the representation of space both technically and conceptually: the vanishing point, for example, is both the dot on a painted surface at which orthogonal lines converge and, as Erwin Panofsky has pointed out, the representation of the concept of infinity. Panofsky, *Perspective as Symbolic Form*, trans. Christopher S. Wood (New York: Zone Books, 1997 [1927]). Two other foundational studies on perspective are Samuel Edgerton, *The Renaissance Rediscovery of Classical Perspective* (New York: Harper and Row, 1975), and John White, *The Birth and Rebirth of Pictorial Space* (London: Faber and Faber, 1957). Other critics have sought to clarify the anachronisms that beset discussions of perspective. Those anachronisms typically conflate technical innovations with conceptual changes that seem to correlate to those techniques. On the relationship between mathematics and art, and specifically on the question of infinity, see J. V. Field, *The Invention of Infinity: Mathematics and Art in the Renaissance* (Oxford: Oxford University Press, 1997); Field makes a historical distinction between technical and conceptual innovations. For a discussion that seeks to pull away from the characterization of perspective as the synchronous innovation of a "symbolic form," see Hubert Damisch, *The Origin of Perspective*, trans. John Goodman (Cambridge: MIT Press, 1995). On the history of perspective as a metaphor, see James Elkins, *The Poetics of Perspective* (Ithaca: Cornell University Press, 1994).

27. Burckhardt, *Altarpiece in Renaissance Italy*, 64.

28. Museums frequently alter period frames, adding or subtracting molding to fit a given painting.

29. Peter Stallybrass and Ann Rosalind Jones point out that the meaning of the word *fashion* has changed over time to reflect the increasing disposability of clothing, which was once more durable and valuable than the very paintings in which it was represented: "Composing the Subject: Making Portraits," in their *Renaissance Clothing and the Materials of Memory* (Cambridge: Cambridge University Press, 2000).

30. "Once the painting was dislodged from its " 'natural' habitat, the frame was introduced in order to replace the church as the sign that contextualized the image and reminded the viewer that the image could not possibly claim any iconographic status." Alfonso Procaccini, "Alberti and the 'Framing' of Perspective," *Journal of Aesthetics and Art Criticism* 40, no. 1 (Fall 1981): 29–39, at 35. See also Belting, *Likeness and Presence*, and Joseph Leo Koerner, *The Reformation of the Image* (Chicago: University of Chicago Press, 2004).

31. Eamon Duffy, *The Stripping of the Altars: Traditional Religion in England, c. 1400–c. 1580* (New Haven: Yale University Press, 1992). Arguing that the Reformation was a radical and even violent disruption of what was in fact a fairly stable and participatory traditional Catholicism, Duffy describes in detail the injunctions and practices by which sacred objects were made profane. His evidence is a

reminder that sacred images were not singled out by the Reformation. Instead, there was a wholesale abolition and replacement of all liturgical objects, from the deconsecration of vestments to the conscription of metals allowed in chalices for the replacement of wooden tables for stone altars.

32. Eliot Rowlands writes, "The Christian's faith in relics often lapsed into the pagan's devotion to magic. The relics appeared more valuable as material objects than as what they symbolized—more treasured as talismans than as reminders of the exemplary lives of the saints" (125). The proliferation of reliquaries, Rowlands argues, was an attempt to codify the worship of relics, especially in response to excesses in the trade of relics. Eliot W. Rowlands, "Sienese Painted Reliquaries of the Trecento: Their Format and Meaning," *Konsthistorisk Tidskrift* 48 (1979): 122–38, at 125–27.

33. Altars encasing relics often had retable depictions facing the congregants. For a discussion of relics incorporated into images that are not detached or detachable from the architecture of the church, see Gregor Kalas's analysis of the apse mosaic in S. Clemente in "Vine into Visuality: The Twelfth-Century Apse Mosaic of S. Clemente in Rome" (forthcoming). Kalas shows that the mosaic appeals to the visual authority of its viewer in a way that complements and even contests the textual authority of the inscription as the means for interpreting the relics embedded within the architectural decoration of the church.

34. Caroline Walker Bynum reports: "In the twelfth and early thirteenth centuries, fragments of saints were mostly housed in beautiful caskets, which diverted attention from their exact nature. Canonists and theologians debated whether there could be private property in relics, and whether wearing them as talismans or displaying them 'naked' was acceptably devout. By the fourteenth century, however, holy bones were owned and worn by the pious as private devotional objects; they were often exhibited in reliquaries that mimicked their shape (for example, head, arm, or bust reliquaries) or in crystal containers that clearly revealed that they were bits of bodies." Caroline Walker Bynum, *Fragmentation and Redemption: Essays on Gender and the Human Body in Medieval Religion* (New York: Zone Books, 1991), 271.

35. Desiderius Erasmus, *Ten Colloquies of Erasmus*, trans. and ed. Craig R. Thompson (New York: The Liberal Arts Press, 1957), 68. The presence of these kinds of reliquaries in England is also referred to in a seventeenth-century anti-Catholic tract that lists examples of the relics once held at Canterbury; the tract claims to have copied these examples from an early fifteenth-century record called *Memorale multorum Henrici Prioris*. The listings include: "In a Glass of Crystal was this one Relique contained *viz.* One of the Thorns of Christ's Crown. . . . In a certain great Chest of Crystal, set in silver, and gilt and garnished with many goodly precious stones were these two Reliques: first our Ladies Hair, secondly a piece of her Vail. . . . In a Chest of Silver, and gilt, with a round Crystal, and a Vine graven thereon, were these Reliques contained; the bones of *St. Laurence*, and a piece of his Gridiron whereon he was broyled. . . . In a Chest of silver, and gilt, set with precious stones and a long Crystal, were contained a Tooth and Bone of *St. Bennet* the Monk. . . . In a Chest of Copper gilt, without precious stones, with a long round Crystal, were these Reliques contained; part of St John Baptist's head, and one of his bones; *Item*, a bone of St *Blase*, a bone of *St. Pantaleon*, . . . In a Coffer of silver, and gilt, having a great round Crystal at the foot thereof, were contained certain of the bones of those Innocents whom *Herod* slew. . . . In a little Chest of Silver, and gilt, set with precious stones, having in it a little long Crystal, were part of the bones of *St. Nicholas*. . . . In a Chest of Silver and gilt, having in it a long Crystal, were contained divers parts of our Ladies Cloaths. . . . In a long Crystal, with a Foot of silver, and gilt, and a round Cover set with four precious stones, were these Reliques contained. The Oyl of *St. Katherine* the Virgin." The author also mentions three standing tables of wood containing the relics of multiple martyrs and at one point wonders, "Where were all these trinkets kept the 800 years before they thus set them out to view?" Titus Oates, *The Popes Ware-house or the Merchandise of the Whore of Rome* (London, 1679), 38–41.

36. In the late fourteenth century, Bishop Brinton of Exeter preached that seeing the host could protect the congregant from physical harm. Miri Rubin, *Corpus Christi: The Eucharist in Late Medieval Culture* (Cambridge: Cambridge University Press, 1991), 63.

37. On the exposition of the host and the relic, see G. J. C. Snoek, *Medieval Piety from Relics to the*

Eucharist: A Process of Mutual Interaction (Leiden: E. J. Brill, 1995), 277–90. Snoek dates the ritual *elevatio* of the relic and host to the twelfth and thirteenth centuries (370) and notes that glass cylinders for the display of the relic or the host were in use from the fourteenth to the sixteenth centuries (289).

38. Caroline Drabik, "Pre-Renaissance Italian Frames with Glass Decorations in American Collections," MA thesis, Fashion Institute of Technology, 2001.

39. On the term "International Style," see Philippe Verdier's introduction to the catalog exhibition for *The International Style: The Arts in Europe around 1400* (Baltimore: Walters Art Gallery, 1962), x–xv.

40. Duffy, *Stripping of the Altars.* In "Pre-Renaissance Italian Frames," Drabik suggests that it is not only the shape of the altarpieces that imitates the architecture of the church but also the shape and decoration of the glass inset in these altarpieces (5). For an account of the stained glass windows in an English parish, see Judith Middleton-Stewart, *Inward Purity and Outward Splendors: Death and Remembrance in the Deanery of Dulwich, Suffolk, 1370–1547* (Woodbridge, England: Boydell Press, 2001), 234–51.

41. Erwin Panofsky, trans. and ed., *Abbot Suger on the Abbey Church of St.-Denis and Its Art Treasures* (Princeton: Princeton University Press, 1946).

42. Drabik, "Pre-Renaissance Italian Frames," points out that the folding diptych would have served as a "portable altar for private devotion" (53).

43. On English prayer books and specifically the use of rubrication in books of hours, see Kathleen Kamerick, *Popular Piety and Art in the Late Middle Ages: Image Worship and Idolatry in England, 1350–1500* (New York: Palgrave, 2002), 155–90. Kamerick cites a primer printed in 1535 by William Marshall that inveighs against books "garnyshed" with "redde letters" that deceive people by promising grace and pardon (188). She also discusses the relationship between the potency of images and the potency of the host (193).

44. For examples of the public display of text and the interchangeable use of text and image in fifteenth-century parishes, see Clive Burgess, "Educated Parishioners in London and Bristol on the Eve of the Reformation," in *The Church and Learning in Later Medieval Society: Essays in Honour of R. B. Dobson,* ed. Caroline M. Barron and Jenny Stratford (Donington, England: Shaun Tyas, 2002), 286–304.

45. Belting, *Likeness and Presence,* 443.

46. The veneration of the host, to which Reformers reacted, may in fact derive from visual adulation of the host, a practice derived from the treatment of relics. See Michael Andrieu, "Aux origines du culte du saint-sacrament: Reliquaires et monstrances eucharistiques," *Analecta Bollandiana* 68 (1950): 397–418, which traces the worship of the host to the worship of relics by cataloguing the conversion of reliquary ostensoria into monstrances.

47. See Erasmus, *Colloquies,* and Thomas More, *A Dialogue concerning hesesyes and matters of religion* (1530), in *The Complete Works of St. Thomas More,* ed. Thomas M. C. Lawler, Germain Marc'hadour, and Richard C. Marius (New Haven: Yale University Press, 1981). More's dialogue contains this response: "Syth all names spoken or wrytten be but ymages / yf ye set ought by the name of Iesus spoken or wrytten: why shold ye set nought by his ymage paynted or caruen that representeth his holy person to your rememberaunce / as moche and more to / as doth his name wrytten. Nor these two wordes *Christus crucifixus* / do not so lyuely represent vs the rememberaunce of his bytter passyon / as doth a blessyd ymage of the crucyfyx / neyther to lay man / nor vnto a lerned" (6.1.47).

48. Evelyn B. Tribble, *Margins and Marginality: The Printed Page in Early Modern England* (Charlottesville: University of Virginia Press, 1993). Tribble's study observes that margins, the place of commentary in many early modern printed texts, confer authority, and she speculates in conclusion "that the study of historical margins might lead to a more precise formulation of the conceptual margins we invoke so easily. For the premodern period marginalization is a very different process than for the Enlightenment and thereafter" (163).

49. *Certaine select prayers gathered out of S. Augustine's meditation which he called his selfe to talke with God* (London, 1574). See also Thomas Becon, *Pommaunder of Prayer* (London, 1578). Both works were printed by John Daye. *Certaine select prayers* was reprinted in 1586 and again in 1586 by John Wolfe for the assignes of Richard Day with the ornamental borders intact. By contrast, see the editions of Henry Bull, *Christian praiers and holie meditations as wel for private as publicke exercise, gathered out of the most godly*

learned in our time. The 1570 and 1574 editions have simple line borders, the 1584 edition has uniform decorative borders, and the 1996 edition has no borders.

50. Michael Baxandall, *Giotto and the Orators* (Oxford: Clarendon Press, 1971).

51. An important exception is John Hollander, *Vision and Resonance* (New Haven: Yale University Press, 1985 [1975]). Hollander understands meter in aesthetic terms, citing I. A. Richard's claim that the artificiality of meter produces a "frame" effect that differentiates poetry from the everyday; see his chapter on "The Metrical Frame" (135–54: 135). Hollander also acknowledges a strain of poetry that is "verse only to the eye" in the chapter "The Poem in the Eye" (245–87: 272).

52. Gotthold Ephrain Lessing, *Laocoön* [1766] (Baltimore: Johns Hopkins University Press, 1984).

53. Rosemond Tuve, Elizabethan and Metaphysical Imagery (Chicago: University of Chicago Press, 1947), 58.

54. Ernest Gilman, *The Curious Perspective: Literary and Pictorial Wit in the Seventeenth Century* (New Haven: Yale University Press, 1978).

55. Murray Krieger, *Ekphrasis: the Illusion of the Natural Sign* (Baltimore: Johns Hopkins University Press, 1992).

56. For a critique of Derrida's recourse to philosophy, see Pierre Bourdieu, *Distinction: A Social Critique of the Judgment of Taste*, trans. Richard Nice (Cambridge: Harvard University Press, 1984), 466–500.

57. Derrida, *Truth in Painting*, 2.

58. Derrida, *Truth in Painting*, 75.

59. Derrida, *Truth in Painting*, 70.

60. Derrida, *Truth in Painting*, 75.

61. Michael Adas, *Machines as the Measure of Men: Science, Technology, and Ideologies of Western Dominance* (Ithaca: Cornell University Press, 1989), 59–60. See also Eileen Reeves, *Painting the Heavens* (Princeton: Princeton University Press, 1997) and Martin Kemp, *The Science of Art : Optical Themes in Western Art from Brunelleschi to Seurat* (New Haven: Yale University Press, 1990).

62. See Leonard Barkan, "Making Pictures Speak: Renaissance Art, Elizabethan Literature, Modern Scholarship," *Renaissance Quarterly* 48 (1995): 326–51. Barkan notes the "utopian aspect" of approaches that seek "to demonstrate a unifying insight that transcends medium, form, and the contingencies of historical moment, while also confirming the enduring validity of these categories" (328) and states the continued need "to understand in theoretical and / or historical terms the actual point of contact between the word and the image and to face up to all the unanswered questions and unhomogenized oppositions that characterize a discourse that takes the parallels between the arts for granted and proceeds from there to do its own heuristic or hermeneutic or formalist work" (329).

63. Erwin Panofsky, *Perspective as Symbolic Form* [1927], trans. Christopher S. Wood (New York: Zone Books, 1997), 45.

64. Panofsky, *Perspective as Symbolic Form,* 66.

65. Svetlana Alpers, "Style Is What You make It: The Visual Arts Once Again," in *The Concept of Style,* ed. Berel Lang (Ithaca: Cornell University Press, 1987), 137–62.

66. Glenn Peers, *Sacred Shock: Framing Visual Experience in Byzantium* (University Park: Pennsylvania State University Press, 2004), 6.

67. S. K. Heninger, Jr., *The Subtext of Form in the English Renaissance: Proportion Poetical* (University Park: Pennsylvania State University Press, 1994), 185.

68. John Dover Wilson, *John Lyly* (New York: Haskell House, 1905), 55–58.

69. Robert Weimann proposes that sixteenth-century narrative prose is "mode of authority and authorization" that grew out of the Reformation and the Protestantisms it produced and speculates that "early modern fictional narrative can be viewed as the most experimental, least prescribed cultural space for unfolding (and retracting) self-sustained images and meaningful imaginings of a *subjectum* in a new mode of representation," in *Authority and Representation in Early Modern Discourse,* ed. David Hillman (Baltimore: Johns Hopkins University Press, 1996), 3.

70. Heninger, *Subtext of Form,* 184.

71. John Lyly, *Euphues: The Anatomy of Wit and Euphues and His England*, ed. Leah Scragg (Manchester: Manchester University Press, 2003), 332–33.

72. "The same monarch [Alexander], too, by public edict, declared that no one should paint his portrait except Apelles, and that no one should make a marble statue of him except Pyrgoteles, or a bronze one except Lysippus." Pliny the Elder, *Natural History*, trans. and ed. John Bostock and Henry Thomas Riley (London: Henry G. Bohn, 1855), 2:184.

73. Lyly, *Euphues and His England*, 332–33.

74. Lyly, *Euphues and His England*, 333.

75. Paul Oskar Kristeller, *Renaissance Thought: The Classic, Scholastic, and Humanist Strains* (New York: Harper Torchbooks, 1961), 113. Kristeller notes that, among European universities, logic and dialectic were particularly strong at Oxford and Cambridge in the fourteenth and fifteenth centuries.

2. The Craft of Poesy and the Framing of Verse

1. Stephen Booth, ed., *Shakespeare's Sonnets* (New Haven: Yale University Press, 1977), 102–3. The first lines of the sonnet read: "Like as to make our appetites more keen / With eager compounds we our palate urge—/ As to prevent our maladies unseen, / We sicken to shun sickness when we purge— / Ev'n so, being full of your ne'er-cloying sweetness, / To bitter sauces did I frame my feeding."

2. Thomas Wilson, *The Arte of Rhetorique* (London, 1560).

3. In a footnote of her own, Crane writes: " 'Gather' and 'frame' are used, throughout the sixteenth century, with such frequency that they become virtually technical terms. Part of the purpose of this book will be to trace their usage and shifts in meaning in the course of the period. Although they at first seem to be rough English equivalents for *inventio* and *dispositio*, the two parts of logic, their connotative force shifts as these discursive practices gain currency and fail to achieve humanist goals. 'Frame,' for example, begins by meaning either 'to give material form to an immaterial idea' or 'to arrange in coherent order according to some natural system.' In political and social contexts, it later comes to mean something like 'feign or 'falsify,' and eventually, under the influence of Ramism, becomes a synonym for methodical organization." Mary Thomas Crane, *Framing Authority: Sayings, Self, and Society in Sixteenth-Century England* (Princeton: Princeton University Press, 1993), 202, note 6.

4. Crane, *Framing Authority*, 3.

5. Crane, *Framing Authority*, 4.

6. "The student learned to gather what was already framed as a saying, it framed his character, and he, in turn, reframed it in his own writing as a sign that he had received the prescribed education." Crane, *Framing Authority*, 8.

7. Crane, *Framing Authority*, 55–56.

8. Crane, *Framing Authority*, 38 and 72.

9. Crane, *Framing Authority*, 52.

10. Crane, *Framing Authority*, 94.

11. Crane, *Framing Authority*, 12.

12. Roger Ascham, *The Schoolmaster* (1570), ed. Lawrence B. Ryan (Charlottesville: University Press of Virginia for the Folger Shakespeare Library, 1967), 138.

13. Philip Sidney, *A Defence of Poetry* (1595), ed. J. A. Van Dorsten (Oxford: Oxford University Press, 1966), 73.

14. William Webbe, *A Discourse of English Poetrie* (1586), in *Elizabethan Critical Essays*, ed. G. Gregory Smith, 2 vols. (Oxford: Clarendon Press, 1904), 1:247–48.

15. As cited in E. M. W. Tillyard, *The Elizabethan World Picture* (New York: Random House, [1943]), 30.

16. In "The Prose of the World," Foucault writes: "Resemblance in sixteenth century knowledge is without doubt the most universal thing there is: at the same time that which is most clearly visible, yet something that one must nevertheless search for, since it is also the most hidden; what determines the

form of knowledge (for knowledge can only follow the paths of similitude)." *The Order of Things: An Archaeology of the Human Sciences* (New York: Vintage Books, 1973), 29.

17. *Tottel's Miscellany*, ed. Hyder Edward Rollins, 2 vols. (Cambridge: Harvard University Press, 1966), 1:90.

18. Samuel Daniel, *A Defence of Rhyme*, in *Elizabethan Critical Essays*, 2:362.

19. Daniel, *Defence of Rhyme*, 2:359.

20. Daniel, *Defence of Rhyme*, 2:365.

21. Gabriel Harvey, *Pierce's Supererogation*, in *Elizabethan Critical Essays*, 2:255. Emphasis added.

22. Harvey, *Pierce's Supererogation*, 253–54.

23. Ronald B. McKerrow, ed., *The Works of Thomas Nashe*, 5 vols. (Oxford: Basil Blackwell, 1958), 3:329.

24. McKerrow, ed., *Works of Thomas Nashe*, 3:320.

25. Thomas Nashe, *The Anatomie of Absvrditie* (1589), in McKerrow, 1:9–10.

26. *Anatomie*, in McKerrow, 1:45.

27. *Anatomie*, in McKerrow, 1:26.

28. See the introduction in Arthur F. Marotti and Michael D. Bristol, eds., *Print, Manuscript, and Performance: The Changing Relations of the Media in Early Modern England* (Columbus: Ohio State University Press, 2000).

29. Thomas Nashe, *The Unfortunate Traveller*, in McKerrow, ed., 2:207.

30. Peter Holbrook, *Literature and Degree in Renaissance England: Nashe, Bourgeois Tragedy, Shakespeare* (Newark: University of Delaware Press, 1994), 85.

31. Lorna Hutson, *Thomas Nashe in Context* (Oxford: Clarendon Press, 1989), 4.

32. Jonathan Crewe, *Unredeemed Rhetoric: Thomas Nashe and the Scandal of Authorship* (Baltimore: Johns Hopkins University Press, 1982), 70.

33. Hutson, *Thomas Nashe in Context*, 11.

34. Neil Rhodes describes Harvey's attachment to the "right artificiality" of eloquence and claims that Nashe, by contrast, presents a "turbulent" satirical eloquence: "collision between rhetoric and satire is at the heart of Nashe's peculiar, if limited, literary achievement" (137). Neil Rhodes, *The Power of Eloquence and English Renaissance Literature* (New York: St. Martin's Press, 1992).

35. Thomas Nashe, *Have with you to Saffron Walden*, in *Works of Thomas Nashe*, ed. McKerrow, 3:12. Gabriel Harvey published a skeptical and rational treatise on the nature of earthquakes, and both of his brothers, John and Richard, addressed treatises to Gabriel prognosticating dire astrological cataclysms; Gabriel defended these pamphlets from widespread public ridicule even after the appointed hour came and passed without incident.

36. Nashe, *Saffron Walden*, 3:13.

37. Nashe, *Saffron Walden*, 3:22, 42.

38. Nashe, *Saffron Walden*, 3:62.

39. Nashe, *Saffron Walden*, 3:93–4.

40. Nashe, *Saffron Walden*, 3:72, 33, 35, 40.

41. Nashe, *Saffron Walden*, 3:76.

42. Nashe, *Saffron Walden*, 3:80.

43. Nashe, *Saffron Walden*, 3:5.

44. Nashe, *Saffron Walden*, 3:5–6.

45. Wendy Wall contends in *The Imprint of Gender: Authorship and Publication in the English Renaissance* (Ithaca: Cornell University Press, 1993) that "while it may seem natural to argue that print generates a realm of objectivity and thus distances the writer from his or her own work (the 'hand' of the manu-script), I suggest that print allows instead for the construction of the writing figure" (93).

46. *Framen, framien, freamien, frem(i)en, freomen* are recognized as cognates, meaning "to benefit or profit someone, to do good to someone, to strengthen or comfort someone spiritually," or lastly "to refresh someone with food and drink." *Framen* is also glossed as "to join or frame, as timber," and "to

fashion something, to compose a story, to devise an excuse." *Middle English Dictionary*, ed. Hans Kurath (Ann Arbor: University of Michigan Press, 1952). *Framian* and *fremman* are glossed as "accomplish, perpetrate, advance, benefit" in *A Guide to Old English*, ed. Bruce Mitchell and Fred C. Robinson (Oxford: Basil Blackwell, 1964). *Fremain* is glossed as "benefit"; *fromian* as "advance"; and *(ge)fremman* as "bring about, achieve; commit, perpetrate; make; provide, furnish; perform, do; carry out; wreak; and fight" in *Bright's Old English Grammar and Reader*, ed. F. G. Cassidy and Richard N. Ringler (New York: Holt, Rinehart, and Winston, 1971). It is difficult conclusively to differentiate the cognates, but one can see how different spellings might have been inflected by related words. For example, "fromian" may resonate with the "fro" prefix of "froward" (i.e., forward); "framian" may resonate with "fram" meaning (according to *Bright's*) "bold, valiant." "Fremman," which Mitchell and Robinson list separately (as they only do for verbs whose meaning changes slightly with the addition of the usually neutral prefix "ge-") from "(ge)fremman" is glossed "bring about, provide do." The *MED* cites also an adjectival meaning of "frame," derived from "fram," and meaning "of a sacrament, effective," listing as its example a passage from Robert Mannyng of Brunne's *Handlyng Synne* a 1400 (c. 1303): "Sey þan þus . . . 'I crysten þe [a child] . . .'; And 3yue . . . hyt a name And kast on water, þan ys hyt frame."

47. The expression "frame-up" and the association of "framing" with wrongful accusation are of American origin, according to both *The Oxford Dictionary of Modern Slang*, ed. John Ayto and John Simpson (Oxford: Oxford University Press, 1992) and *The Random House Historical Dictionary of American Slang*, vol. 1 (A–G), ed. Jonathan Edward Lighter (New York: Random House, 1994). In this latter dictionary, the earliest use of "frame" to mean wrongful accusation is dated 1899. The dates alone suggest to me that this meaning has something to do with the invention of photography, so it seems likely that this definition of "frame" has something to do with the use of mug shots in booking criminals. A similar speculation is offered in *Brewer's Dictionary of Phrase and Fable*, 15th ed., rev. Adrian Room (New York: Harper Collins, 1995). Used as a passive, as it so frequently is—"she was framed"—framing intimates the objectification of the subject (as criminal).

48. In Old English, there seems to have been a distinction between *framian*, which implies profit, benefit, and advancement, and *fremman*, which means simply to carry out, make, or do. There is a good deal of semantic crossover in the use of these words, but *fremman* is used in West Saxon texts to indicate the commission of both beneficent and maleficent deeds, whereas *framian* seems exclusively to imply advancement. There is, thus, as long a history of the negative notion of framing as a positive one, though the *Middle English Dictionary*, although it does identify "contrivance" with *framian*, does not record that negative sense of framing.

49. *The Riverside Shakespeare*, 2nd ed., ed. G. Blakemore Evans (Boston: Houghton Mifflin, 1997), 1.1.227.

50. Thomas Wilson, *A Christian Dictionary Opening the signification of the chiefe words dispersed generally through the Holy Scriptures of the Old and New Testament, tending to increase Christian knowledge* (London, 1616), 212.

51. Martin Heidegger, "The Age of the World Picture," in *The Question Concerning Technology*, trans. William Lovitt (New York: Harper and Row, 1977), 115–54, at 128, 132, 127.

52. Reinhart Koselleck, *Future's Past*, trans. Keith Tribe (Cambridge: MIT Press, 1985). See especially the chapter "*Begriffsgeschichte* and Social History."

53. Koselleck, *Future's Past*, 84–85.

54. Raymond Williams, *Keywords: A Vocabulary of Culture and Society*, rev. ed. (New York: Oxford University Press, 1983), 17 and 21–23.

55. Quentin Skinner has also argued that Williams is using concepts without acknowledging them, though Skinner would like Williams to embrace the concept rather than demystify or historicize it. See his "Language and Social Change" in *The State of the Language*, ed. Leonard Michaels and Christopher Ricks (Berkeley: University of California Press, 1980), 563–78.

56. Erving Goffman, *Frame Analysis: An Essay on the Organization of Experience* (Cambridge: Harvard University Press, 1974).

3. The Tempered Frame

1. All citations from Shakespeare's plays are taken from *The Riverside Shakespeare*, 2nd ed., ed. G. Blakemore Evans (Boston: Houghton Mifflin, 1997). Act, scene, and line references appear parenthetically in the text.

2. On the belief that the logic of language is located outside of the mind of the speaker or writer, see Anne Ferry, *The Art of Naming* (Chicago: University of Chicago Press, 1988), esp. 90–96.

3. Thomas Lodge, *Defence of Poetry* (1579), in *Elizabethan Critical Essays*, ed. G. Gregory Smith, 2 vols. (Oxford: Clarendon Press, 1904), 1:66. Emphasis added.

4. Charles Nicholl describes Paracelsus's medical theory this way: "For Paracelsus, Nature was active, dynamic, proffering. Its medicine 'grows unbidden from the earth even if we sow nothing. . . . The herbs and roots speak with you, and in them will be the power you need.' Cognition was an activity of the object itself—a *Zuwerffen*: the object 'throws' its meaning out, 'the tree gives the name tree without the alphabet.' " Nicholl, *The Chemical Theater* (London: Routledge and Kegan Paul, 1980), 58.

5. Edmund Spenser, *The Faerie Queene* (New York: Penguin, 1987). All citations from *The Faerie Queene* are taken from this edition; hereafter, book, canto, and stanza references appear parenthetically in the text.

6. The metaphor derives from Plato's *Phaedrus*, which begins with the comparison of the written text to a potion. Jacques Derrida's discussion of this passage in "Plato's Pharmacy" depends on the fact that *pharmakon* means both poison and medicine. See Derrida, *Dissemination*, trans. Barbara Johnson (Chicago: University of Chicago Press, 1981), esp. 65–75 and 95–155. Derrida's maintains that *pharmakon*—as the material letter, as paint, and as poison—and episteme—as law, as logic, and as dialectic—are positioned as antidotes to one another. The relation between the material text and truth is, of course, differently and variously reconfigured within the context of Christianity, but in many respects, to speak in the broadest possible terms, the classical emphasis on the relation between the particular and the universal is, in a Christian context, shifted onto the relation between imagination and truth. The late sixteenth-century poetic tracts seek to align figurative language with truth, though they often rely on disparate, and seemingly contradictory, means to effect those ends. In contrast to Lodge's noxious potion, Sidney suggests that poesy is a pleasing "medicine of cherries." Sidney writes that even Plato and Boethius "made mistress Philosophy very often borrow the masking raiment of poesy. For even those hard-hearted evil men who think virtue a school name, and know other good than *indulgere genio*, and therefore despise the austere admonitions of the philosopher, and feel not the inward reason they stand upon, yet will be content to be delighted—which is all the good-fellow poet seemeth to promise—and so steal to see the form of goodness (which seen they cannot but love) ere themselves be aware, as if they took a medicine of cherries." See Philip Sidney, *A Defence of Poetry*, ed. Jan Van Dorsten (Oxford: Oxford University Press, 1966), 41.

7. C. A. Patrides describes these two distinct but complementary schemes in Christian doctrine: "The Scale of Nature [the elaborate hierarchical system of analogies and correspondences that was thought to extend vertically] upheld a vertical unity in the universe, so the world histories affirmed a horizontal unity throughout the created order, from its inception at the act of creation to its termination upon the Last Judgement" (52). Patrides documents a persistent emphasis on teleological history in Christian doctrine, but he also notes a significant tendency, especially in the Gnostic and Arian traditions, "to shift Christianity's center of gravity from history to philosophy, from the historical Jesus to a system of abstractions" (13). See C. A. Patrides, *The Grand Design of God: The Literary Form of the Christian View of History* (London: Routledge and Kegan Paul, 1972). On the arts of memory, see Frances Yates, *The Art of Memory* (Chicago: University of Chicago Press, 1966). Yates notes that though Scholasticism, "in its devotion to the rational, the abstract, as the true pursuit of the rational soul, banned metaphor and poetry as belonging to the lower imaginative level," in the practice of artificial memory "its rules for images are letting in the metaphor and the fabulous for their moving power" (66). Yates also notes that that "the places and images of the artificial memory" borrowed out of classical texts by Aquinas were "changed by mediaeval piety" into a " 'natural' order" of "corporeal similitudes" (76). Yates's argument seems to imply that with classical spatial rules of memory transformed into "corporeal

similitudes," the pursuit of the rational soul in the medieval art of memory is more iconic than its classical model. Mary Carruthers, in her *Book of Memory: A Study of Memory in Medieval Culture* (Cambridge: Cambridge University Press, 1990), acknowledges the temporal decoding of the sign, stating that "signs make something present to the mind by acting on memory" (222). Nonetheless, the sign remains fixed whereas temporality is associated with memory.

8. On the medieval craft of contemplation, see Mary Carruthers, *The Craft of Thought: Meditation, Rhetoric, and the Making of Images, 400–1200* (Cambridge: Cambridge University Press, 1998).

9. See Heidegger's discussion of the way "causality, and with it instrumentality" have been "veiled in darkness" by modern technology. Martin Heidegger, "The Question Concerning Technology" in *The Question Concerning Technology*, trans. William Lovitt (New York: Harper and Row, 1977), 6–7.

10. Antony Munday, *The Mirrour of Mutabilitie* (London, 1579), facsim. repr. Henry Huntington Library.

11. Richard Haydocke, *A tracte containing the artes of curious paintinge caruinge buildinge written first in Italian by Io. Paul Lomatius painter of Milan and Englished by R.H. student in physik* (Oxford, 1598), 7.

12. As excerpted in James Winney, ed., *The Frame of Order: An Outline of Elizabethan Belief Taken from Treatises of the Late Sixteenth Century* (London: George Allen and Unwin, 1957), 54–72, at 56–57.

13. George Gascoigne, "Woodmanship," in *English Renaissance Poetry*, 2nd ed., ed. John Williams (Fayetteville: University of Arkansas Press, 1990), 102–6, at 105.

14. Munday, *Mirrour of Mutabilitie*, A₂r.

15. *Tottel's Miscellany*, Rev. ed., ed. Hyder Edward Rollins, 2 vols. (Cambridge: Harvard University Press, 1965), 1:250.

16. Alan Glover, ed., *Gloriana's Glasse* (London: Nonesuch Press, n.d.), 53.

17. *The Mirror of Mans Lyfe Plainely describing, what weake moulde we are made of: what miseries we are subject vnto: how vncertaine this life is: and what shal be our ende. Englished by H.K.* (London, 1576).

18. Reginald Scot, *The Discoverie of Witchcraft* (London, 1584).

19. Samuel Harsnett, *A Declaration of Egregious Popish Impostures* (London, 1603), 34–38.

20. Glover, ed., *Gloriana's Glasse*, 84.

21. Edmund Spenser, "A Hymne in Honour of Love," in *The Yale Edition of the Shorter Poems*, ed. William A. Oram et al. (New Haven: Yale University Press, 1989), 693 (7).

22. Spenser, *Yale Edition*, 726–77 (16–17).

23. Spenser, *Yale Edition*, 605.

24. Stephen Greenblatt cites the line in his introduction to *Renaissance Self-fashioning: From More to Shakespeare* (Chicago: University of Chicago Press, 1980), 2.

25. *A treatise declaryng and shewing . . .* (Strasburg, 1537).

26. *The Divine Weeks and Works of Guillaume de Saluste, Sieur du Bartas*, trans. Josuah Sylvester, ed. Susan Snyder (New York: Clarendon, 1979), 1:112–13.

27. Du Bartas, *Divine Weeks and Works*, 1:118.

28. Roger Ascham, *The Schoolmaster* (1570), ed. Lawrence Ryan (Charlottesville: University Press of Virginia, 1967), 46.

29. Ascham, *The Schoolmaster*, 17.

30. "A *Shibboleth* is untranslatable, not because of some inaccessibility of its meaning to transference, not simply because of some semantic secret, but by virtue of that in it which forms the cut of a non-signifying difference in the body of the (written or oral) mark." Jacques Derrida, "Shibboleth," in *Midrash and Literature*, ed. Geoffrey H. Hartman and Sanford Budick (New Haven: Yale University Press, 1986), 307–48, at 324. In the Bishop's and Geneva Bibles, the word *shibboleth* bears a reference mark to a notation containing the English definition, "which signifieth the fall of waters or an ear of corn." The absence of such a gloss in the King James Version furthers the interpretation of this passage, which accentuates the performative over the semantic aspects of language (we do not need the gloss to understand the passage), though paradoxically the 1611 version removes the visible evidence of translation as it offers a presumably better translation of the problem of untranslatability as it is raised by the shibboleth passage.

31. George Herbert's poem "Jordan (2)" seems to be a riff on the shibboleth passage in terms of divine versus conceited verse. The speaker attempts to "clothe the sun" with "quaint words" that are "too rich," only to realize at the end that *"There is in love a sweetness ready penned"* that needs only to be copied out. George Herbert, *The Complete English Poems*, ed. John Tobin (New York: Penguin, 1991), 94.

32. *Frame* is later removed from English language editions of the Bible that are based on the 1611 text, but not until the 1953 Revised Standard Version; the editors' notes do not mention the removal of this word, though I think it is fair to say that, by 1953, the word *frame* is sufficiently estranged from its 1611 meanings that it inhibits rather than facilitates the reading of this passage.

33. Du Bartas, *Divine Weeks and Works*, 1:276.

34. George Chapman, *Ovids Banquet of Sence*, in *Elizabethan Narrative Verse*, ed. Nigel Alexander (London: Edward Arnold, 1967), 146 (lines 316–20).

35. For a discussion of the numerology of this passage, see Alastair Fowler, *Spenser and the Numbers of Time* (London: Routledge and Kegan Paul, 1964); for a discussion of this passage in the context of the human body as a microcosm, see Leonard Barkan, *Nature's Work of Art: The Human Body as the Image of the World* (New Haven: Yale University Press, 1975).

36. *Observations on the 22. Stanza in the 9th. canto of the 2d book of Spencers Faery Queen Full of excellent notions concerning the frame of man, and his rationall soul. Written by the right noble and illustrious knight Sir Kerelme Digby, at the request of a friend* (London: Daniel Frere, 1644). Digby writes, "'Tis evident that the Authors intention in this *Canto* is to describe the bodie of a man inform'd with a rationall soul, and in prosecution of that designe he sets down particularly the severall parts of the one and of the other: But in this *Stanza* he comprehends the generall description of them both, as (being joyned together to frame a compleat Man) they make one perfect compound, which will better appear by taking a survey of every severall clause thereof by it self " (5) and "By these Figures I conceive that he means the mind and body of Man: the first being by him compared to a Circle, and the latter to a Triangle" (6).

37. Stephen Greenblatt claims that in the *Faerie Queene* Spenser creates a separate realm of art that "affirms the existence and inescapable moral power of ideology as that principle of truth toward which art forever yearns. It is art whose status is questioned in Spenser, not ideology. . . . In *The Faerie Queene* reality as given by ideology always lies safely outside the bounds of art, in a different realm, distant, infinitely powerful, perfectly good" (192). Greenblatt's reading depends on an understanding of the poem as an aesthetic object, but, as Greenblatt himself notes, it is exactly this kind of self-contained proto-aestheticism that Spenser is indicting in his depiction of the bower of blisse. Greenblatt claims that, unlike the art of the bower, which masquerades its artificiality, Spenser erects "an art that constantly calls attention to its own processes, that includes within itself framing devices and signs of its own created-ness" and "announces its status as art object at every turn" (190). Certainly Spenser calls attention to his own craft, but to presume that his allegory is an "art object" forces this poem into a modern aesthetic context that divides art from the real. Greenblatt, *Renaissance Self-fashioning*.

38. Philip Sidney, *Defence of Poesie, Astrophil and Stella, and Other Writings*, ed. Elizabeth Porges Watson (London: Everyman, 1997), 34.

39. Quilligan writes, "The 'other' named by the term *allos* in the word 'allegory' is not some other hovering above the words of the text, but the possibility of an otherness, a polysemy, inherent in the very words on the page; allegory therefore names the fact that language can signify many things at once. It does not name the many other things language means, or the disjunction between saying and meaning, but the often problematical process of meaning multiple things simultaneously with one word." Maureen Quilligan, *The Language of Allegory: Defining the Genre* (Ithaca: Cornell University Press, 1979), 26.

40. Harry Berger Jr., *The Allegorical Temper: Vision and Reality in Book II of Spenser's* Faerie Queene (New Haven: Yale University Press, 1957).

41. Northrop Frye has claimed that the unity of *The Faerie Queene* is in its imagery rather than its allegory and explains the "goodly frame of Temperance" as an image and not an "allegorical translation": "The 'frame' is built out of the characters and places that are clearly announced to be what they are, not out of their moral or historical shadows." Though he seeks to ground the poem in a structure of images rather than in concepts, by imagining the "goodly frame" as the image of the structure of the poem, I

would argue, Frye has simply replaced theological abstractions with aesthetic abstractions. Northrop Frye, "The Structure of Imagery in *The Faerie Queene*," *University of Toronto Quarterly* 30 (1961): 109–27, at 111. On the question of how the poem can make itself the body, see Elaine Scarry's discussion of voluntary and consensual materialism in her essay, "Donne: 'But yet the body is his booke,' " in *Literature and the Body: Essays on Populations and Persons*, ed. Scarry (Baltimore: Johns Hopkins University Press, 1988), 70–105.

42. Harry Berger Jr., *Revisionary Play: Studies in the Sppenserian Dynamics* (University of California Press, 1988), 23.

43. See Berger, *Allegorical Temper*, esp. 177–89.

44. On John Foxe's adherence to the tradition of the exempla, see Patrides, *Grand Design of God*, 78.

45. As Thomas Lodge writes in his *Defence of Poetry*: "Your Plato in midst of his presisnes wrought that absurdite that neuer may be redd in Poets, to make a yearthly creature to beare the person of the creator, and a corruptible substance an incomprehensible God! for, determining of the principall causes of all thinges, a made them naughte els but an Idea, which if it be conferred wyth the truth, his sentence will sauour of Inscience." In *Elizabethan Critical Essays*, 1:67. On the Renaissance conflation of the anagoge and the trope, see Berger, *Allegorical Temper*, 185–86.

46. Quilligan applies Foucault's discursive *epistemes* to the history of allegory. See *Language of Allegory*, 156–223.

47. Berger, *Allegorical Temper*, 186.

48. See David Norbrook's introduction to *The Penguin Book of Renaissance Verse 1509–1659*, ed. Norbrook and H. R. Woudhuysen (New York: Penguin, 1993), 1–67, at 51–52. Norbrook also points out that while "Acrasia's Arachne-like weaving severs the power of representation from its divine function of mirroring eternal truths," Spenser also seems to "betray a certain unease" with Guyon's violent destruction of the bower as if Spenser were "projecting onto the female figure of Acrasia his own anxiety about his role as a poet."

49. Berger argues that Spenser's historical consciousness has "two reciprocal aspects": an "objective" and "evolutionary" mode as well as a "subjective" and "retrospective" one; see his chapter "The Mutabilitie Cantos" in *Revisionary Play*, 243–73.

4. Poetic Offices and the Conceit of the Mirror

1. The mirror metaphor underwrites historical inquiry in Hardin Craig's *The Enchanted Glass: The Elizabethan Mind in Literature* (New York: Oxford University Press, 1936). The book takes its title and opening epigram from Bacon; Craig's methodology is to produce a true mirror of the "enchanted" Elizabethan mind by seeking to explain the metaphysical and philosophical beliefs underpinning the literature of the age. M. H. Abrams's *The Mirror and The Lamp: Romantic Theory and the Critical Tradition* (New York: W. W. Norton, 1958) calls attention to the way that such metaphors as the mirror and the lamp, which he calls "submerged conceptual models" or "archetypal analogies," have had a determining, if often invisible, role in how criticism chooses to "select, interpret, systematize, and evaluate the facts of art" (31). According to Murray Krieger, in *A Window to Criticism: Shakespeare's Sonnets and Modern Poetics* (Princeton: Princeton University Press, 1964), Abrams's own methodology is an application of the tradition he exposes; since Abrams begins from the assumption that language is a representation of reality, Krieger argues, Abrams himself draws on the mirror metaphor by emphasizing the mimetic function of language. Krieger suggests an approach to poetics that conjoins the mirror metaphor and the window metaphor: that, to simplify, conjoins an attention to form (language as a representation or mirror of the real) with an attention to the real (language as a passage or window into the real).

2. William Salmon gives advice on the polishing of a steel glass in his 1701 *Polygraphice*: "*If these Glasses are sullied or made dull with Air or any thick Vapour*, you must clear them by rubbing, not with Woollen or Linnen, but with a piece of Deer or Goats Skin, wiping it in an oblique line"; quoted in Geoffrey Wills, *English Looking-glasses: A Study of the Glass, Frames, and Makers (1670–1820)* (London: Country Life, 1965), 144.

3. Eleanor S. Godfrey, *The Development of English Glassmaking, 1560–1640* (Chapel Hill: University of North Carolina Press, 1975), 235, and R. W. Symonds, "English Looking-glasses," *Connoisseur* 125 (March 1950): 8–9. Godfrey says that pennyware mirrors produced a "small but well-defined image"; Symonds, on the other hand, claims that the prevalence of steel and silver mirrors was due to the poor quality of these early glass mirrors.

4. Patrick McCray, *Glassmaking in Renaissance Venice: The Fragile Craft* (Aldershot, England: Ashgate, 1999), 62 and 122–23.

5. On the production of broad or plate glass, see R. J. Charleston, *English Glass and the Glass Used in England, circa 400–1940* (London: George Allen and Unwin, 1984), 38–39 and 71–80.

6. See chap. 1 of Sabine Melchior-Bonnet, *Histoire du miroir* (Paris: Éditions Imago, 1994), translated by Katharine H. Jewett as *The Mirror: A History* (New York: Routledge, 2001), 9–34.

7. Godfrey, *Development of English Glassmaking*, 236. On the history of mirrors, see also W. A. Thorpe, *English Glass*, 2nd ed. (London: Adam and Charles Black, 1949); Geoffrey Wills, "From Polished Metal to Looking-Glass," *Country Life* (October 23, 1958), 939–43; and H. Syer Cuming, "On Mirrors," *Journal of the British Archaeological Association* 17 (1861): 279–88.

8. Herbert Grabes, *The Mutable Glass: Mirror-Imagery in Titles and Texts of the Middle Ages and the English Renaissance*, trans. Gordon Collier (Cambridge: Cambridge University Press, 1982), 71.

9. Jean Des Caurres, *Œvres Morales et Divers* (Paris, 1584; Ann Arbor: University Microfilms 3907), 603; I am grateful to Suzanne Verderber for checking my translation here.

10. Ben Jonson, *Cynthia's Revels*, in *The Oxford Ben Jonson*, ed. Ian Donaldson (Oxford: Oxford University Press, 1995), 2.3.53–55.

11. Cited in Cuming, "On Mirrors," 286–87.

12. Benjamin Goldberg, *The Mirror and Man* (Charlottesville: University Press of Virginia, 1985), 146–47; Melchior-Bonnet, *Histoire du miroir*, 12; Grabes, *Mutable Glass*, 15.

13. Debora Shuger, "The 'I' of the Beholder: Renaissance Mirrors and the Reflective Mind," in *Renaissance Culture and the Everyday*, ed. Patricia Fumerton and Simon Hunt (Philadelphia: University of Pennsylvania Press, 1999), 21–41, esp. 37.

14. On the preponderance of *speculum* titles, see Sister Ritamary Bradley, "Backgrounds of the Title *Speculum* in Mediaeval Literature," *Speculum* 29 (1954): 100–115. On mirror book titles, see Grabes's *Mutable Glass* and Melchior-Bonnet, *Histoire du miroir*, 113–15.

15. On the mind as a reflection of the divine mens, see Frances Yates, *The Art of Memory* (Chicago: University of Chicago Press, 1966), 150. On the mirror as an image of the analogic correspondence between the world and the book, see Michael Bath, *Speaking Pictures: English Emblem Books and Renaissance Culture* (London: Longman, 1994), 122–23. For an account of classical epistemology within Christianity from the patristic period through the end of the thirteenth century, see Marcia Colish, *The Mirror of Language: A Study in the Medieval Theory of Knowledge*, Rev. ed. (Lincoln: University of Nebraska Press, 1983).

16. At its most extreme, this association of the mirror with magic meant that the mirror was often depicted as "the devil's glass." Melchior-Bonnet has an excellent chapter, "Les Grimaces du Diable," in *Histoire du miroir*, 189–220.

17. Frederick Goldin traces the mirror in the writings of Augustine and, noting the ideal and material significance of the mirror, argues that medieval literature, even secular love literature, uses the mirror to join the ideal and the material. See *The Mirror of Narcissus in the Courtly Love Lyric* (Ithaca: Cornell University Press, 1967). See also Benjamin Goldberg's chapter on the medieval mirror, which charts the mirror in scholastic commentary and ends with a focus on mirrors in *The Divine Comedy*, in *The Mirror and Man*, 112–34.

18. Heinrich Schwarz, "The Mirror of the Artist and the Mirror of the Devout," in *Studies in the History of Art Dedicated to William E. Suida on his Eightieth Birthday* (New York: Phaidon, for the Samuel H. Kress Foundation, 1959), 90–105, esp. 102.

19. Mary Carruthers, *Book of Memory: A Study of Memory in Medieval Culture* (Cambridge: Cambridge University Press, 1990), 168–69, 186; see also her *Craft of Thought: Meditation, Rhetoric, and the Making of Images, 400–1200* (Cambridge: Cambridge University Press, 1998).

20. Gascoigne continued, in other writings, to see satire as the critical turning point in his personal reformation from prodigal youth to reformed maturity. In a later epistolary bid for Elizabeth's patronage, he appealed to her to "Behold here (learned pryncesse) nott *Gascoigne* the ydle poett, wryting tryfles of the green knighte, but *Gascoigne* the *Satyricall* wryter, medytating eche *Muse* that may expresse his reformacion." See the dedicatory epistle to *Hemetes the Heremyte* in *Posies* (London, 1575). For an account of the censorship of *A Hundreth Sundrie Flowres* and Gascoigne's attempts to regain a favorable "estate," see R. W. Maslen, *Elizabethan Fictions: Espionage, Counter-Espionage, and the Duplicity of Fiction in Early Elizabethan Prose Narratives* (Oxford: Clarendon Press, 1997), 114–57. On the trope of the reformed prodigal, see Richard Helgerson, *The Elizabethan Prodigals* (Berkeley: University of California Press, 1976).

21. All citations from *The Steele Glas* are taken from George Gascoigne, *Certayne Notes of Instruction in English Verse . . . The Steele Glas . . . The Complaynt of Philomene*, in *English Reprints*, vol. 3, ed. Edward Arber (1869; repr. New York: AMS Press, 1966), here 53, 42–43. Page references will subsequently appear parenthetically in the text.

22. The 1573 edition of *A Hundreth Sundrie Flowres* came before the high commission and was partially confiscated even after revisions were made in 1576. See Charles Taylor Prouty's 1942 edition of the 1573 text, George Gascoigne, *A Hundreth Sundry Flowers*, ed. Prouty (Columbia: University of Missouri Press, 1942), and Prouty's biography, *George Gascoigne: Elizabethan Courtier, Soldier, and Poet* (New York: Columbia University Press, 1942).

23. This passage is an interesting example of the hermaphroditic conjunction of Gascoigne and Satyra in the poem's speaker. Satyra, though not strictly ancient, is a classical figure insofar as she is associated with Philomel. Lamenting that "the world goeth stil awry," this voice seems to speak from the vantage point of the past. But the metaphor of cannon shot locates the speaker in the present and suggests a speaker familiar with sixteenth-century warfare, as Gascoigne would have been from his military service.

24. Thomas Starkey, *England in the Reign of Henry VIII, a dialogue between Cardinal Pole and Thomas Lupset* (London, 1538; repr., Early English Texts Society, 1878), 1.3.80.

25. See Erwin Panofsky's discussion of *concetto* in *Idea: A Concept in Art Theory*, trans. Joseph J. S. Peake (Columbia: University of South Carolina Press, 1968), 66, 82, 118–19.

26. *The Riverside Shakespeare*, 2nd ed., ed. G. Blakemore Evans (Boston: Houghton Mifflin, 1997), 1.1.33–37.

27. According to the *Oxford English Dictionary*, *incontinent*, used as an adverb, can mean immediately, suddenly, "in continuous time." An event that happens "incontinent" happens too fast to be explained causally, thus it is almost hypercontinuous in that it seems to disrupt proper temporal causation.

28. Godfrey, *Development of English Glassmaking*, 235.

29. McCray, *Glassmaking in Renaissance Venice*, 130–32.

30. Glaziers are mentioned as early as the thirteenth century, and a glaziers company was first formed in 1328 under Edward III, but in general glazing refers to the cutting, annealing, and fitting of quarrels and other cut pieces of glass into lead frames, rather than glassblowing per se. The first published manual for glaziers is Walter Gedde, *A booke of Sundrie draughtes, principaly serving for glasiers: and not impertinent for plasterers, and gardeners: be sides sundry other professions. Whereunto is annexed the manner how to anniel in glas: and also the true forme of the fornace, and the secretes thereof* (London, 1615). The book offers patterns and instructions for outfitting leaded window frames, as well as for painting and firing images onto glass, or annealing. In addition to glaziers, there was a company of glass-sellers in England, but there was no glassblower's guild.

31. McCray, *Glassmaking in Renaissance Venice*, 56.

32. The Venetian glass industry is a prime example of import substitution, whereby a locale that is involved in the transport and resale of goods assumes production of those selfsame goods, transforming an import commodity into an export commodity. Italian states also did this with the trade in textiles. See Herman van der Wee, "European Long-Distance Trade, 1350–1750," in *The Rise of Merchant Empires: Long Distance Trade in the Early Modern World, 1350–1750*, ed. James D. Tracy (Cambridge:

Cambridge University Press, 1990), 25. See also van der Wee's *The Rise and Decline of Urban Industries in Italy and in the Low Countries: Late Middle Ages–Early Modern Times* (Leuven: Leuven University Press, 1988).

33. Godfrey, *Development of English Glassmaking*, notes that "the cheapness of the ingredients, the high value of the product, and a tightly guarded monopoly of skill brought glassmakers prosperity and a high social status" (4). Members of the lesser nobility in France, Bohemia, and Italy not only owned glasshouses but worked as craftsmen at their own furnaces. Godfrey goes on to note that by 1640 the tradition of the owner-craftsman glassmaker had all but died out in England due to Sir Robert Mansell's administration of the glass monopoly (253). Still, glass was perceived as a "polite" and noble substance. Merret's translation of Neri states that "its use in drinking vessels, and other things profitable for mans service, is much more gentile, graceful, and noble then any Metall or whatsoever stone fit to make such works"; both the crafting and the use of glass objects were identified with gentlemen. Christopher Merret, *Arte of Glass* (London, 1662), A,r, translating Antonio Neri, *L'arte Vetraria* (Florence, 1612).

34. Godfrey, *Development of English Glassmaking*, 7.

35. McCray, *Glassmaking in Renaissance Venice*, 22–25, 126–32.

36. The evidence that Gutenberg was involved in mirror making stems from a lawsuit brought against the partnership. Douglas McMurtrie, *The Gutenberg Documents* (New York: Oxford University Press, 1941), 93–126. All of the known legal documents pertaining to Gutenberg have been collected and translated by McMurtrie in this collection. The proceedings that mention mirror making were the result of a suit filed by George Dritzehen on behalf of his deceased brother Andrew, who was one of four original partners (the others being Gutenberg, Heilmann, and Riffe). The suit sought either remuneration of Andrew's original investment by refund or admission into the partnership. The defense was based on a written partnership contract, which said that in the case of death all tools and implements of art and all works perfected by the instruments were to remain in the partnership. Gutenberg made two contracts with these partners. The first, in 1438, concerned "the polishing of stones and the manufacture of looking glasses." The second does not specify the product of manufacture but stipulates that it is to be in force for five years (1438–43) and that its objective, "the exploitation of other ideas," depends upon Gutenberg instructing his partners "in new arts." McMurtrie surmises that printing may be one of those arts on the grounds that one witness gave testimony that he was hired by the partners to assist in a printing operation. We can assume, because the use of lead is mentioned by one of the witnesses, that the partnership was indeed also making glass "pennyware" mirrors as planned. These partnership agreements, protecting the arts and instruments for a period of five years, seem to be more concerned with protecting trade secrets than with rights to the initial investments, since they agree that, in the case of death, the initial investment will be disbursed to the heirs of the deceased after the period of five years. The council of Strasbourg ordered Gutenberg to pay fifteen gulden (all that Andrew had paid of his promised investment of one hundred gulden) to Andrew's brothers.

37. Godfrey, *Development of English Glassmaking*, 178–79.

38. Hugh Tait, ed., *Five Thousand Years of Glass* (London: British Museum Press, 1991), 174. On the private glass industry in Tyrol, see Reino Liefkes, ed., *Glass* (London: V and A Publications, 1997), 56–57, 60.

39. See Lorna Hutson, *Thomas Nashe in Context* (Oxford: Clarendon Press, 1989), esp. 173.

40. Michael Mendle, *Dangerous Positions: Mixed Government, the Estates of the Realm, and the Making of the Answer to the XIX Propositions* (Birmingham: University of Alabama Press, 1985), 56–59.

41. I am grateful to Tyler Smith for his insight that "strange" might be a punning commentary on the oddity of foreign peasants.

42. Stephen Batman, *A christall glasse of christian reformation wherein the godly maye beholde the coloured abuses vsed in this our present tyme* (London, 1569), A₃ᵢᵢᵢr.

43. Thomas Salter, *A mirrhor mete for all mothers, matrones, and maidens, intituled the Mirrhor of Modestie* (1579), in J. P. Collier, ed., *Illustrations of Old English Literature*, ser. 4, no. 5 (London: Privately printed, 1866), 5.

44. On the presence of the memento mori tradition in this sonnet, see Stephen Booth, ed., *Shakespeare's Sonnets* (New Haven: Yale University Press, 1977), 266.

45. Carruthers, *Book of Memory*, 186.

46. *Shakespeare's Sonnets*, ed. Katherine Duncan-Jones (London: Thomas Nelson, Ltd., 1997), 264.

47. See Booth, *Shakespeare's Sonnets*, 267.

48. On contemplation as a craft in the late medieval period, see Mary Carruthers, *The Craft of Thought*. For a discussion of how the sonnets reject Christian allegory in the Pauline tradition, see Lisa Freinkel, "The Name of the Rose: Christian Figurality and Shakespeare's Sonnets" in *Shakespeare's Sonnets: Critical Essays*, ed. James Schiffer (New York: Garland, 1999), 241–61.

49. On the overlapping roles of author, reader, and scribe, see Arthur F. Marotti's chapter on "Social Textuality in the Manuscript System" in his *Manuscript, Print, and the English Renaissance Lyric* (Ithaca: Cornell University Press, 1995), 135–208.

50. Lawrence Stone mentions this practice in *The Crisis of the Aristocracy 1558–1641* (Oxford: Oxford University Press, 1967), 270. See also Gail Kern Paster, *The Body Embarrassed: Drama and the Disciplines of Shame in Early Modern England* (Ithaca: Cornell University Press, 1993), 215–33. For further references to discourses on maternal nursing, see Joan Pong Linton, "The Humanist in the Market: Gendering Exchange and Authorship in Lyly's *Euphues* Romances," in *Framing Elizabethan Fictions: Contemporary Approaches to Early Modern Narrative Prose*, ed. Constance C. Relihan (Kent, Ohio: Kent State University Press, 1996), 73–97, at 87–88.

51. Office-holding occurs as all levels of society, so there is nothing about holding an office per se that would besmirch the status of a gentleman, since even nobles at court held "offices." But, as Laura Caroline Stevenson points out, "there was, however, considerable resistance to the idea that a man could be a gentleman while engaging in trade"; see her *Praise and Paradox: Merchants and Craftsmen in Elizabethan Popular Literature* (Cambridge: Cambridge University Press, 1984), 77–106, at 87. What may be an affront about "these offices" is that it links the higher, intellectual functions of the young man's book learning with the lower bodily functions of childbirth and nursing; and since offices, as the *OED* points out, can also refer to the discharge of excrement, "these offices" may echo the "waste" of line 10. For a consideration of how the word "waste" indicates a link, in sodomitical discourse, between nonreproductive heterosexual intercourse and homosexual intercourse, see Valerie Traub, "Sex without Issue: Sodomy, Reproduction, and Signification in Shakespeare's Sonnets," in *Shakespeare's Sonnets*, ed. Schiffer, 431–52, at 435.

52. For a discussion of the way male codes of friendship and collaborative homoerotics are constitutive of both power relations and the formation of a "gentlemanly subject," see Jeffrey Masten's *Textual Intercourse: Collaboration, Authorship, and Sexualities in Renaissance Drama* (Cambridge: Cambridge University Press, 1997), 28–62, esp. 35–37 and 43.

53. Heather Dubrow's essay on the Sonnets in her *Captive Victors: Shakespeare's Narrative Poems and Sonnets* (Ithaca: Cornell University Press, 1987), 169–257, also notes the way rhetorical mastery dovetails with "the imperatives of power" inherent in the poet's relation to the young man as a patron; see esp. 205, 235–36, and 245–52.

54. On the class connotations of the word *rude*, see Patricia Parker's discussion of the "rude mechanicalls" in *Shakespeare from the Margins: Language, Culture, Context* (Chicago: University of Chicago Press, 1996), 83–115.

55. For a discussion of the way Shakespeare expresses eternity as a worldly rather than a transcendental value, see the second chapter of Lars Engle's *Shakespearean Pragmatism: Market of His Time* (Chicago: University of Chicago Press, 1993).

5. Poesy, Progress, and the Perspective Glass

1. George Herbert, *The Complete English Poems*, ed. John Tobin (New York: Penguin Books, 1991), 61.

2. Jean Hagstrum, *The Sister Arts: The Tradition of Literary Pictorialism and English Poetry from Dryden to Gray* (Chicago: University of Chicago Press, 1958), 100. Although Robert Whalen observes a "balance of word and image" in Herbert's poetry in *Poetry of Immanence: Sacrament in Donne and Herbert* (Toronto: University of Toronto Press, 2002), 131, Richard Strier notes that " 'The Windows' could have been written by an iconoclast" in *Love Known: Theology and Experience in George Herbert's Poetry* (Chicago: University of Chicago Press, 1983), 150. On the question of clarity and transparency—and specifically that the "servant of God must be a transparent vehicle of divine action"—in Herbert's Poetry, see Michael Schoenfeldt, *Prayer and Power: George Herbert and Renaissance Courtship* (Chicago: University of Chicago Press, 1991), 175–85, at 178.

3. Michel Foucault, *The Order of Things* (New York: Vintage Book, 1973), 64. Louis Marin points out that with this logic, the sign is effectively framed. See his "The Frame of Representation and Some of Its Figures," in *The Rhetoric of the Frame: Essays on the Boundaries of the Artwork*, ed. Paul Duro (Cambridge: Cambridge University Press, 1996), 79–95.

4. George Puttenham, *The Arte of English Poesie* (1589), facsimile reproduction, ed. Edward Arber, intro. Baxter Hathaway (Kent, Ohio: Kent State University Press, 1970), 34–35. The full passage from Puttenham says of the imagination: "that part being well affected, not onely nothing disorderly or confused with any monstrous imaginations or conceits, but very formall, and in his much multiformitie *uniforme*, that is well proportioned, and so passing cleare, that by it as by a glasse or mirrour, are represented vnto the soule all manner of bewtifull visions, whereby the inuentiue parte of the mynde is so much holpen, as without it no man could devise any new or rare thing: and where it is not excellent in his kind, there could be no politique Captaine, nor witty enginer or cunning artificer, nor yet any law maker or counsellor of deepe discourse. . . . And this phantasie may be resembled to a glasse as hath bene sayd, whereof there be many tempers and manner of makinges, as the *perspectiues* doe acknowledge, for some be false glasses and shew thinges otherwise than they be in deede, and others right as they be in deede, neither fairer nor fouler, nor greater nor smaller. There be againe of these glasses that shew things exceedingly faire and comely, others that shew figures very monstrous and illfauored. Euen so is the phantasticall part of man (if it be not disordered) a representer of the best, most comely and bewtifull images or apparances of thinges to the soule and according to their very truth." Puttenham's notion that the imagination represents the truth of things to the soul reveals the influence of Neoplatonism on this understanding of the imagination. Yet Puttenham's insistence on the materiality of the imagination marks a clear distinction from the Platonic understanding of truth and knowledge. For an account of classical epistemology as it was inflected by Christianity from the patristic period through the end of the thirteenth century, see Marcia L. Colish, *The Mirror of Language: A Study in the Medieval Theory of Knowledge* (Lincoln: University of Nebraska Press, 1983).

5. On the metaphor of truth as insight, see Hans Blumenberg, "Light as a Metaphor for Truth: At the Preliminary Stage of Philosophical Concept Formation," in *Modernity and the Hegemony of Vision*, ed. David Michael Levin (Berkeley: University of California Press, 1993), 30–62.

6. In her discussion of Puttenham's anomalous definitions of *enargeia* and *energeia*, Linda Galyon notes that Puttenham privileges the aural over the visual in these rhetorical terms. Galyon concludes that "the importance of sound in poetry, with its accompanying strange classificational scheme, far from driving the wedge between form and content, which one might at first glance expect, actually leads toward a union of content with all aspects of figurative language other than sound" (38). Key to this argument is Galyon's observation that, for Puttenham, "at the cognitive level, when language has passed the ear and reached the mind, *res* and *verba* are inextricably woven together" (37). Galyon identifies this union of things and words with Italian humanists such as Benedetto Varchi whom she quotes as follows: "Because words cannot be separated from things . . . and things cannot be expressed without words, it comes to pass that the soul as well as the body, at the very same time, are delighted by words through things and by things through words" (37). Linda Galyon, "Puttenham's *Enargeia* and *Energeia*: New Twists for Old Terms," *Philological Quarterly* 60, no. 1 (Winter 1981): 29–40. Puttenham's strange revision of the traditional notion of *enargeia* as the capacity of language to conjure images and his insistence on the imagination as glass suggests to me the extent to which Puttenham sought to articulate an

understanding of poetic vision without relying on the kind of picturing that does, to use Galyon's terms, drive "the wedge between form and content."

7. On the question of social mobility and courtliness in Puttenham, see Rosemary Kegl, *The Rhetoric of Concealment: Figuring Gender and Class in Renaissance Literature* (Ithaca: Cornell University Press, 1994), esp. 29–42.

8. Puttenham, *Arte of English Poesie*, 305.

9. According to the *OED*, before the sixteenth century the word *profession* was used exclusively to refer to religious vocations or to knighthood and that during the sixteenth century the word gained a more general application, though it retained an emphasis on avowal to or declaration of a vocation. Margaret Pelling explains that *profession* implies membership in a community and knowledge of a trade, rather than the manual practice of that trade (citing Bacon's comment that physicians are "more professed than laboured"), in the essay "Trade or Profession? Medical Practice in Early Modern England," from her collection, *The Common Lot: Sickness, Medical Occupations and the Urban Poor in Early Modern England* (New York: Longman, 1998), 230–58. I am grateful to Tyler Smith for directing me to Pelling's book.

10. Puttenham, *Arte of English Poesie*, 196.

11. Puttenham, *Arte of English Poesie*, 21.

12. Puttenham, *Arte of English Poesie*, 312.

13. Puttenham, *Arte of English Poesie*, 309 and 313.

14. For a discussion of the way "mechanical" labor factors into sixteenth-century rhetorical discourse, see Patricia Parker's chapter on the "Rude Mechanicals" in Parker, *Shakespeare from the Margins: Language, Culture, Context* (Chicago: University of Chicago Press, 1996), 83–115.

15. Philip Sidney, *A Defence of Poetry*, ed. Jan Van Dorsten (Oxford: Oxford University Press, 1966), 51–58.

16. Puttenham, *Arte of English Poesie*, 34.

17. Laura Caroline Stevenson, in her *Praise and Paradox: Merchants and Craftsmen in Elizabethan Popular Literature* (Cambridge: Cambridge University Press, 1984), 79, notes that in 1581 Richard Mulcaster distinguishes handicraftsmen from laborers as those whose work requires "cunning." On the hierarchy of mind and body, see S. K. Heninger, *The Cosmographical Glass: Renaissance Diagrams of the Universe* (San Marino, Calif.: Huntington Library, 1977), esp. fig. 84 (145).

18. Puttenham, *Arte of English Poesie*, 19.

19. Sidney, *Defence of Poetry*, 24.

20. Roland Greene differentiates Puttenham's "fictions of immanence" from Sidney's "fictions of embassy" on the grounds that immanence presents "fiction as located not parallel and adjacent to actuality but deep within it" (177). That view, including the argument that fictions of embassy depend to a greater extent on perspectivism, is close to my own. But I am disinclined to see Puttenham's immanence as "magical or liturgical" (182), as Greene does. As I see it, what is unique about Puttenham's view that poesy is a crafted inversion of innate sensory perception, with its emphasis on the artisanal and technical character of poetic invention, is that it presents human ingenuity as neither magical nor aesthetic, and yet no less imaginative for its instrumentality. Roland Greene, "Fictions of Immanence, Fictions of Embassy," in *The Project of Prose in Early Modern Europe and the New World*, ed. Elizabeth Fowler and Greene (Cambridge: Cambridge University Press, 1997), 176–202. Whereas Greene examines the interarticulation of the fictive and the actual in Puttenham, David Hillman imagines a "dialectical interpenetration of social and psychical aspects of language" (74) in the terms "decorum" and "discretion," noting that Puttenham's work expresses a "struggle to find a universal standard for the correspondence of 'the mynde' and its 'objects'" (77); David Hillman, "Puttenham, Shakespeare and the Abuse of Rhetoric," *Studies in English Literature* 36 (1996): 72–90.

21. Sidney, *Defence of Poetry*, 24.

22. Sidney, *Defence of Poetry*, 48.

23. Puttenham, *Arte of English Poesie*, 313.

24. Panofsky, tracing the classical *Idea* in art theory through the Renaissance, has argued that whereas for classical thinkers the *Idea* "guarantees that the mind is independent of nature," the reinterpretation of

the classical *Idea* in the high Renaissance, poised between the Renaissance and mannerism, did not hold the mind and nature in opposition, but rather transformed the *Idea* into the notion of the ideal and brought it into "a beautiful and almost organic conformity with nature." For Panofsky, it was mannerism that first addressed the *Idea* in terms of subjects and objects. Before that "Renaissance thinkers [had] understood the *idea* concept in light of a fundamentally novel attitude toward art which identified the world of ideas with a world of heightened realities" (64–65). For Panofsky, "phantasy" is characteristic of the high Renaissance and expresses the notion that artists could alter appearances and supersede nature through artistic intellect in a way that mannerism offset with the belief that the artist's ideal was prefigured in the object (49, 58, and 63). And while Panofsky's description of the high Renaissance applies aptly to Sidney, it does not describe Puttenham's articulation of the material character of the phantasy, an articulation that does not even name or identify a division between "idea" and "nature." Erwin Panofsky, *Idea: A Concept in Art Theory*, trans. Joseph J. S. Peake (Columbia: University of South Carolina Press, 1968).

25. Puttenham, *Arte of English Poesie*, 161.

26. Puttenham, *Arte of English Poesie*, 310–11.

27. I am assuming that Puttenham's reference to "ennealed glooves" refers to a fancy item of clothing, though I cannot say for sure. Annealing can refer to any process of fusion that uses heat, but commonly refers to the process of fusing pigment to glass through firing or enameling. "Ennealed glooves," I am guessing, were gloves that had glass baubles fused to them, giving the appearance of being covered with jewels. Perhaps such gloves were meant to be the sign of someone whose hands are not engaged in manual labor, whose hands are protected, delicate, and capable of fine sensation; but this is purely speculation.

28. Puttenham, *Arte of English Poesie*, 311.

29. Puttenham, *Arte of English Poesie*, 311–12.

30. Puttenham, *Arte of English Poesie*, 150.

31. For a discussion of reminiscence as artificial memory in Aristotle, see Frances Yates, *The Art of Memory* (Chicago: University of Chicago Press, 1966), 63–92.

32. See *Hero and Leander* (bk. 3, lines 235–38) in Christopher Marlowe, *Complete Poems and Translations*, ed. Stephen Orgel (Middlesex: Penguin, 1971), 49–50.

33. Francis Bacon, *The New Organon and Related Writings* [Library of Liberal Arts repr. of *The Works*, vol. 8, trans. James Spedding, Robert Leslie Ellis, and Douglas Denon (Boston: Taggard and Thompson, 1863)], ed. and intro. Fulton H. Anderson (New York: The Liberal Arts Press, 1960), "Preparative Toward a Natural and Experimental History," 3:274; here Bacon warns against getting caught up in the opinions of other authors "and for all that concerns ornaments of speech, similitudes, treasury of eloquence, and such like emptinesses, let it be utterly dismissed. Also let those things which are admitted be themselves set down briefly and concisely, so that they may be nothing less than words."

34. Bacon, *New Organon*, proem, "The Great Instauration" (3).

35. Bacon, *New Organon*, 2:28 (73).

36. Bacon, *New Organon*, 1:130 (119).

37. See Walter E. Houghton Jr., "The History of Trades: Its Relation to Seventeenth-Century Thought as Seen in Bacon, Petty, Evelyn, and Boyle," *Journal of the History of Ideas* 2 (1941): 33–60.

38. On the reception of Puttenham, see Derek Attridge, "Puttenham's Perplexity: Nature, Art, and the Supplement in Renaissance Poetic Theory," in *Literary Theory/Renaissance Texts*, ed. Patricia Parker and David Quint (Baltimore: Johns Hopkins University Press, 1986), 257–79. Attridge believes that Puttenham maintains a sharp divide between nature and artifice. On Bacon, see Charles Whitney, *Francis Bacon and Modernity* (New Haven: Yale University Press, 1986); John C. Briggs, *Francis Bacon and the Rhetoric of Nature* (Cambridge: Harvard University Press, 1989); and Lisa Jardine, *Francis Bacon: Discovery and the Art of Discourse* (Cambridge: Cambridge University Press, 1974).

39. Mary Carruthers discusses meditation as a craft within the medieval monastic tradition in *The Craft of Thought: Meditation, Rhetoric, and the Making of Images 400–1200* (Cambridge: Cambridge

University Press, 1998). In her introduction, she explains that "the main emphasis in literary studies for the past twenty-five years has been on this matter [hermeneutics, the validity or legitimacy of an interpretation], while the basic craft involved in making thoughts, including thoughts about the significance of texts, has been treated as though it were in itself unproblematical, even straightforward. It is neither. In the idiom of medieval monasticism, people do not 'have' ideas, they 'make' them" (4–5).

40. Francis Bacon, *Advancement of Learning*, in *Selected Writings of Francis Bacon*, ed. Hugh G. Dick (New York: Random House, 1955), 1:120.

41. Bacon, *Advancement of Learning*, 2:233–34.

42. Bacon, *New Organon*, "Preparative Toward a Natural and Experimental History," 5:278.

43. Antonio Neri, *L'Arte Vetraria* (1612), trans. Christopher Merret, *The Art of Glass* (London, 1662), 208–10.

44. Neri, *Arte Vetraria*, 209; Bacon, *New Organon*, 2:31 (182).

45. William S. Ellis, *Glass: From the First Mirror to Fiber Optics; The Story of the Substance That Changed the World* (New York: Avon Books, 1998), 6–7 and 75–77.

46. Thorpe links the invention of lead crystal to the experimental movement of the seventeenth century: " 'Experiment' was the word of the moment. Glassmaking was one of the first trades to benefit by the mood of critical investigation." W. A. Thorpe, *English Glass*, 2nd ed. (London: Adam and Charles Black, 1949), 141–43.

47. Bacon, *New Organon*, 2:39 (205).

48. Bacon, *Advancement of Learning*, 1:161–62.

49. Bacon, *Advancement of Learning*, 2:361.

50. Bacon, *New Organon*, 1:23 (44).

51. Bacon, *New Organon*, 1:41 (48).

52. Bacon, *New Organon*, 2:4 (122–23).

53. Bacon, *Advancement of Learning*, 2:295.

54. Bacon, *Advancement of Learning*, 2:308.

55. Bacon, *New Organon*, 1:42 (49).

56. Bacon, *Advancement of Learning*, 2:243.

57. Erwin Panofsky, *Perspective as Symbolic Form*, trans. Christopher S. Wood (New York: Zone Books, 1997), 27.

58. Leon Battista Alberti, *On Painting*, trans. John R. Spencer (New Haven: Yale University Press, 1966), 56.

59. Panofsky, *Perspective as Symbolic Form*, 66.

60. "To a remarkable extent the study of art and its history has been determined by the art of Italy and its study. . . . In referring to the notion of art in the Italian Renaissance, I have in mind the Albertian definition of the picture: a framed surface or pane situated at a certain distance from a viewer who looks through it at a second or substitute world. In the Renaissance this world was a stage on which human figures performed significant actions based on the texts of the poets. It is a narrative art. And the ubiquitous doctrine *ut pictura poesis* was invoked in order to explain and legitimize images through their relationship to prior and hallowed texts" (xix). Alpers proposes that, by contrast, "the Dutch present their pictures as describing the world seen rather than as imitations of significant human actions" and that Dutch images are characterized by "the frequent absence of a positioned viewer . . . ; a play with great contrasts in scale . . . ; the absence of a prior frame . . . ; a formidable sense of the picture as a surface (like a mirror or a map, but not a window) . . . ; an insistence on the craft of representation" (xxv). Alpers also addresses the considerable impact of Kepler's optical theories and optical devices on the visual culture of seventeenth-century Dutch art. Svetlana Alpers, *The Art of Describing: Dutch Art in the Seventeenth Century* (Chicago: University of Chicago Press, 1983).

61. Celeste Brusati, *Artifice and Illusion: The Art and Writing of Samuel van Hoogstraten* (Chicago: University of Chicago Press, 1995), 86.

62. Brusati, *Artifice and Illusion*, 186 and 196.

63. James Elkins, *The Poetics of Perspective* (Ithaca: Cornell University Press, 1994), 41. Harry Berger Jr. has also observed that "perspective anticipates and crudely exemplifies the more modern ideas of co-ordinate systems and superimposed frames of reference" (18) and also traces, though in more positive terms, a movement from "empirical" to "hypothetical" consciousness: "Naïve Consciousness and Culture Change: An Essay in Historical Structuralism," in *Second World and Green World: Studies in Renaissance Fiction Making*, 63–107 (Berkeley: University of California Press, 1988).

64. Elkins, *Poetics of Perspective*, 79.

65. Elkins, *Poetics of Perspective*, 49.

66. Claudio Guillén, *Literature as System: Essays toward the Theory of a Literary History* (Princeton: Princeton University Press, 1971), 300.

67. Guillén, *Literature as System*, 301–2.

68. Bushy's lines appear at 2.2.17–18 and Richard's speech as he shatters the mirror is at 4.1.273–91 in *The Riverside Shakespeare*, 2nd ed., ed. G. Blakemore Evans (Boston: Houghton Mifflin, 1997).

69. Martin Kemp, *The Science of Art: Optical Themes in Western Art from Brunelleschi to Seurat* (New Haven: Yale University Press, 1990), 22–26.

70. Alberti writes, "Nor is this the place to discuss whether vision, as it is called, resides at the juncture of the inner nerve or whether images are formed on the surface of the eye as on a living mirror. The function of the eyes in vision need not be considered in this place. It will be enough in this commentary to demonstrate briefly things that are essential." *On Painting*, 47.

71. John White, *The Birth and Rebirth of Pictorial Space*, 3rd ed. (Cambridge: Harvard University Press, Belknap Press, 1987), 126–30.

72. As quoted in Kemp, *Science of Art*, 51. It is tempting to suggest that Leonardo encrypted his manuscripts with particular notions about the imagination as an active mirror—encryption that also reflects the centrality of glass to his theories of perspective and proportion—by writing them backward, from right to left, prompting at least one transcriber to experiment with using a mirror to read them. See Jean Paul Richter's introduction in *The Notebooks of Leonardo da Vinci*, ed. Richter (New York: Dover, 1970). Alpers describes Leonardo's comparison of the mirror to the imagination as "selective or rational" mirroring and says that Leonardo's theories of picturing combine notions of artificial construction with those of natural perception; see *Art of Describing*, 47–49. Harry Berger Jr. observes several diversified "modes of seeing" in Leonardo's painting and poetry in his "Leonardo da Vinci: The Influence of World View on Artistic Style," in *Second World and Green World*, 409–40.

73. Egnatio Danti, *La Prospettiua di Euclide* (Florence, 1573). This seemingly inverted lineage actually makes sense if one considers artificial perspective as classical rather than modern and natural perspective as medieval.

74. Kemp, *Science of Art*, 61.

75. Eileen Reeves discusses painterly and scientific understandings of second light and mirror refraction in *Painting the Heavens: Art and Science in the Age of Galileo* (Princeton: Princeton University Press, 1997).

76. John Bates, *Mysteryes of Nature and Art* (London, 1634), 109.

77. Salomon de Caus, *La Perspective Avec la Raison des Ombres et Miroirs* (London, 1612), a_{iiv}.

78. Francisci Mavrolyci, *Photismi de Lvmine & vmbra ad perspetiuam & radiorum incidentiam facientes* (1521) (Naples, 1611), 80. English translation by Henry Crew, *Photismi de Lumine of Maurolycus: A Chapter in the Late Medieval Optics* (New York: Macmillan, 1940), 120.

79. Porta actually compares the hole in the window to a table, so that the eye itself is like a surface of representation. See also Girolamo Cardano's in *De Subtilitate* (1550) and Daniele Barbaro in *La Pratica della Perspettiva* (Venice, 1569), who makes a more direct and material comparison between the camera obscura and vision by suggesting that a glass lens be placed in the window to imitate the function of the eye as one of the methods listed under the section heading "*Modi Naturale di mettere in Perspettiva*," Barbaro, 192 (Aa_2v).

80. *Notebooks of Leonardo da Vinci*, ed. Richter, 1:53.

81. Joseph Moxon, *Practical Perspective; or, Perspective Made Easy* (London, 1670), D_2v. Moxon says

that "Lady perspective" is dressed "so curiously" by her handmaidens (Ichnographie, Orthographie, and Scenographie) that "he who is ever admitted her presence, shall see a Person beautiful enough to commit a rape upon his Ey. But she has a Language by her self, which is one reason she is no better understood; and yet it is very easie to learn, and to make it appear so" (C_2r). Moxon's manual further suggests, beyond its need to characterize Lady Perspective as a language rather than a ravishing sight, an increasing rationalization of perspective, for though he says that the practice of perspective is a manual art (B2v), he also defines it as "a Mathematical Science, that Speculates, and Contemplates, the manner and properties of all Radiations, Direct, Reflected, and Broken" (B_2r).

6. "Shakes-speare's Sonnets" and the Properties of Glass

1. All citations from the Sonnets are taken from Stephen Booth, *Shakespeare's Sonnets* (New Haven: Yale University Press, 1977). Citations follow Booth's modernizations of the 1609 quarto edition, unless otherwise stated; sonnet numbers, when not clearly stated in the discussion, will appear parenthetically in the text.

2. As Margreta de Grazia shows in her chapter on the Sonnets, "Individuating Shakespeare's Experience: Biography, Chronology, and the Sonnets," in *Shakespeare Verbatim: The Reproduction of Authenticity and the 1790 Apparatus* (Oxford: Clarendon Press, 1991), 132–76, biographers and editors shaped a narrative of Shakespeare's identity and emphasized the Sonnets as an expression of his interiority. Elsewhere de Grazia has argued that editors and critics have invented a scandal out of the homoeroticism of the Sonnets and buried the scandal of miscegenation that is in fact present in the poems; "The Scandal of Shakespeare's Sonnets," *Shakespeare Survey* 46 (1993): 35–49.

3. Joel Fineman, *Shakespeare's Perjured Eye: The Invention of Poetic Subjectivity in the Sonnets* (Berkeley: University of California Press, 1986).

4. Stephen Booth, *An Essay on Shakespeare's Sonnets* (New Haven: Yale University Press, 1969). See also the preface to Booth's edition of *Shakespeare's Sonnets*.

5. Murray Krieger, *A Window to Criticism: Shakespeare's Sonnets and Modern Poetics* (Princeton: Princeton University Press, 1964).

6. John Kerrigan discusses the articulations of time in relation to the novelty of timepieces in his introduction to the Penguin edition of the *Sonnets* (New York: Penguin, 1986).

7. On the distinction between the emblem and the impresa, see Michael Bath, *Speaking Pictures: English Emblem Books and Renaissance Culture* (London: Longman, 1994), 1–27. Bath points out that in the emblem the motto tends to explain the image through the conventions of Christian allegoresis, whereas the connection between the word and image in the impresa was held to be the expression of the author's wit.

8. Murray Krieger characterizes the Renaissance interest in poetry as images this way: "Under the influence of the Neo-Platonic mind, the concept of poetry as 'speaking picture' received a radically different cast: instead of trying vainly to be like a picture in reflecting sensible reality, the verbal object, as its own emblem, accepts its independent—indeed superior—function of speaking and picturing intelligible reality"; *Ekphrasis: The Illusion of the Natural Sign* (Baltimore: Johns Hopkins University Press, 1992), 141.

9. For an account of the mirror metaphor that refers back to a classical source, see M. H. Abrams's *The Mirror and The Lamp: Romantic Theory and the Critical Tradition* (New York: W. W. Norton, 1958) and also my discussion of this text in chapter 4.

10. Fineman, *Shakespeare's Perjured Eye*, 15.

11. Fineman, *Shakespeare's Perjured Eye*, 46.

12. Fineman, *Shakespeare's Perjured Eye*, 12.

13. See, for instance, Gordon Braden, "Shakespeare's Petrarchism," in *Shakespeare's Sonnets: Critical Essays*, ed. James Schiffer (New York: Garland, 1999), 163–83.

14. Fineman, *Shakespeare's Perjured Eye*, 249–50.

15. Fineman, *Shakespeare's Perjured Eye*, 238–41.

16. On glass as a symbol of the Virgin's purity, see Heinrich Schwarz, "The Mirror of the Artist and the Mirror of the Devout," in *Studies in the History of Art Dedicated to William E. Suida on His Eightieth Birthday* (New York: Phaideon for the Samuel H. Kress Foundation, 1959), 90–105 at 98. Margreta de Grazia has noted that the Sonnets repeatedly compare the womb to a glass vial in "The Scandal of Shakespeare's Sonnets," 47.

17. I am grateful to Margreta de Grazia for calling my attention to the homophonic wordplay on pent/penned here.

18. William Shakespeare, *Pericles* (1.1.31–32). All citations from Shakespeare's plays are taken from *The Riverside Shakespeare*, 2nd ed., ed. G. Blakemore Evans (Boston: Houghton Mifflin, 1997).

19. Francis Bacon, *Essays and New Atlantis*, ed. Gordon S. Haight (New York: Walter J. Black, 1942), 180–81.

20. Bacon, *Essays and New Atlantis*, 216.

21. The "liquid pris'ner pent in walls of glass" might equally be, as Margreta de Grazia has suggested to me, an ink well. Olga L. Valbuena distinguishes between ink and distilled essence in her discussion of this line: see her " 'The dyer's hand': The Reproduction of Coercion and Blot in Shakespeare's Sonnets," in *Shakespeare's Sonnets*, ed. Schiffer, 325–45, at 329. My own reading of the materiality of the Sonnets is closer to that of Joyce Sutphen, who suggests that materiality functions in these poems to store or keep what time will waste, although I believe the Sonnets express time not only as mutability but also as advancement. Joyce Sutphen, " 'A dateless lively heat': Storing Loss in the Sonnets," in *Shakespeare's Sonnets*, ed. Schiffer, 199–217.

22. Richard Halpern charts a relation between homoeroticism and sublimation in the Sonnets and describes the "liquid pris'ner" as a perfume extracted by sublimation in *Shakespeare's Perfume: Sodomy and Sublimity in the Sonnets, Wilde, Freud, and Lacan* (Philadelphia: University of Pennsylvania Press, 2002).

23. For accounts of medicinal distillation and of the craft of tempering in various trade practices, see Margaret Pelling, *The Common Lot: Sickness, Medical Occupations, and the Urban Poor in Early Modern England* (New York: Longman, 1998).

24. On the romantic poetics of transcendence, see Abrams, *Mirror and the Lamp*.

25. Ben Jonson, *The Complete Poems*, ed. George Parfitt (New York: Penguin, 1975), 335.

26. Leon Battista Alberti, *On Painting*, trans. John R. Spencer (New Haven: Yale University Press, 1966), 85.

27. Booth, *Shakespeare's Sonnets*, says of the word *perspective* that it is difficult to discern what form of speech it is (173).

28. Erwin Panofsky, *Perspective as Symbolic Form*, trans. Christopher S. Wood (New York: Zone Books, 1991), 27.

29. On the use of *stilus* for pen and on the relation between *stilus* and style, see Booth, *Shakespeare's Sonnets*, 269–70.

30. Jill Dunkerton, Susan Foister, Dillian Gordon, and Nicholas Penny, *Giotto to Dürer: Early Renaissance Painting in the National Gallery* (London: National Gallery, 1991), 171.

31. For a summary of arguments concerning the emendation of the word, see *Sonnets*, ed. W. G. Ingram and Theodore Redpath (London: University of London Press, 1964).

32. Fineman, *Shakespeare's Perjured Eye*, 138.

33. Helge Kökeritz, *Shakespeare's Pronunciation* (New Haven: Yale University Press, 1953).

34. Edmund Spenser, *The Faerie Queene*, ed. Thomas P. Roche Jr., bk. 3, canto 10 (New York: Penguin, 1987).

35. Krieger, *Window to Criticism*, 3.

36. Krieger, *Window to Criticism*, 96.

37. Krieger, *Window to Criticism*, 57–8.

38. Krieger, *Window to Criticism*, 64–5.

39. Margreta de Grazia, "The Ideology of Superfluous Things: King Lear as Period Piece," in

Subject and Object in Renaissance Culture (Cambridge: Cambridge University Press, 1996). See also the introduction to this collection.

40. Simon Thurley, *The Royal Palaces of Tudor England: Architecture and Court Life, 1460–1547* (New Haven: Yale University Press, 1993), 225–27. For an example of a heraldic roundel inset in a window, see the Portrait of William Style of Langley, R. J. Charleston, *English Glass and the Glass Used in England circa 400–1940* (London: George Allen and Unwin, 1984), plate 16.

41. Eleanor S. Godfrey, *The Development of English Glassmaking, 1560–1640* (Chapel Hill: University of North Carolina Press, 1975), 207. The technique for producing large rectangular sheet glass for windows was first developed in France in the fifteenth century. Though the technique for producing broad or muff glass, in which a cylinder of glass is blown and then cut lengthwise and laid flat to harden as a rectangle, is an ancient one, it was not until French glassmakers of the fifteenth century perfected the technique that large plates of high-quality broad glass, or great glass, were produced. Before the production of great glass, stained glass and other leaded windows primarily contained crown glass. Crown glass—produced by blowing a small globe of molten glass, which is then cut from the pipe, flattened, and spun to produce a small roundel—has a high polish because it is fired in its final stages. Until great glass was perfected, crown glass was generally considered of higher quality. "When the cylinder method was established the provision of rectangular panels became easier. These could be leaded or, if large enough, secured by wooden glazing-bars, thus ultimately making possible the sash window." R. J. Charleston, *English Glass and the Glass Used in England,* 80 (see also 38–39 and 71 for the distinction between broad and crown glass). Godfrey reports that glass windows were considered a luxury until the final decade of the sixteenth century, when broad glass was reintroduced into England by alien glassmakers. The innovations in mirrors are not unrelated to these techniques of glassmaking. Convex mirrors are related to crown glass in that they are made from blown spheres of glass, whereas crystal glass mirrors are produced by cutting and silvering sites from a sheet of cristallo blown according to the broad glass method. Sabine Melchior-Bonnet points out that advances in the technique of broad glass are one factor in the innovation of crystal glass mirrors: *Histoire du miroir* (Paris: Éditions Imago, 1994), 25. Geoffrey Wills notes that Murano glassmakers, who traditionally made vessel glass only, had to pick up the technique of broad glass in order to produce cristallo sites for mirrors; see his "From Polished Metal to Looking-Glass," *Country Life* (October 23, 1958): 939–43, at 940. The crystal glass mirror, then, was a European invention, combining the technique of broad glass from Normandy and Lorraine, the technique of silvering from Flanders, and the cristallo of Venice.

42. Godfrey, *Development of English Glassmaking,* 13 and 251. D. W. Crossley suggests that the industry never died out, but accedes that it was "widely scattered and perhaps occasional": "The Performance of the Glass Industry in Sixteenth-Century England," *Economic History Review* 25, no. 3 (August 1972): 421–33, at 426–27.

43. William Harrison, *Elizabethan England,* ed. Lothrop Withington (London: Walter Scott, 1876), 116–17.

44. Godfrey, *Development of English Glassmaking,* 200–236. According to Godfrey, clocks were an expensive luxury item, but nearly every household inventory lists an hourglass, even those households, she says, that list no other glassware. On the use of glass windows in farmhouses, see Crossley, "Performance of the Glass Industry," 425.

45. Lena Cowen Orlin, "Things with Little Social Life: Henslowe's Properties," in *Staged Properties in Early Modern English Drama,* ed. Jonathan Gil Harris and Natasha Korda (Cambridge: Cambridge University Press, 2002), 99–128, at 107.

46. Godfrey, *Development of English Glassmaking,* 207.

47. Amy Louise Erickson, *Women and Property in Early Modern England* (London: Routledge, 1993). Erickson even maintains that, because of the value of moveable property, the inheritances of sons and daughters may in practice have been more equitable than the law would have it appear; see esp. 64–67. Constance Jordan draws the following conclusion from studies of female inheritance, in this instance from Italy: "Women who had property to bequeath commonly did so on the basis of affection rather than strict kinship, and more often in favor of female than male relatives. The pattern of inheritance

from women therefore tended to undermine the wealth of patrilinear families. To the extent that women could independently hold and pass on property, they represented a potential perturbation to patrilineage and finally to patriarchy." *Renaissance Feminism: Literary Texts and Political Modes* (Ithaca: Cornell University Press, 1990), 42.

48. Orlin, "Things with Little Social Life," 109.

49. Orlin, "Things with Little Social Life," 108, 118.

50. Booth, *Shakespeare's Sonnets*, 138.

51. Margreta de Grazia differentiates between the "sense-making function of language" that attends modern definitions of the word and the signifying practice that we now refer to as a pun that makes sense "by drawing together semantic pieces and making them coherent." "Homonyms before and after Lexical Standardization," *Deutsche Shakespeare-Gesellschaft West: Jahrbuch* (1990): 143–56, at 143.

52. I am indebted to conversations with Lynn Festa about the correspondence between property and properties.

53. Though Panofsky suggests that conceit or *concetto* in art theory is interchangeable with "idea," he also notes: "Michelangelo himself, who seems to have avoided the expression 'idea' on principle, consistently used the word *concetto* as an equivalent of 'idea' and differentiated it sharply from the related word, *immagine* . . . [which] reproduces an already existing object. *Concetto*, on the other hand, when it does not simply stand for 'thought,' 'concept,' or 'plan,' means the free, creative notion that constitutes its own object, so that it in turn can become the model for external shaping" (Erwin Panofsky, *Idea: A Concept in Art Theory*, trans. Joseph Peake [Columbia: University of South Carolina Press, 1968], 119). It is the "in turn" that seems problematic here, for Michelangelo's avoidance "on principle" of the term "idea" suggests a refusal utterly to deliver the idea from matter by granting it absolute priority—*concetto* indicating not the pure idea, but the active formation of a uniquely crafted object that is conditioned by the physical nature of the object. A striking illustration that the *concetto* does not impose itself on or reduce itself to matter, but is animated in its integration with matter, can be found in Michelangelo's *Prigoni* (Slaves) in the Accademia dell Belle Arti in Florence and in the Louvre: in these sculptures, the partially carved figures seem to wrest themselves out of rough-hewn rock. Michelangelo's Sonnet 124, to Vittoria Colonna, offers a literal expression of this theory: "Da che concecto a l'arte intera e uiua." "Yet the work which best illustrates his *concetto* theory is the *San Matteo*, whose unfinished appearance gives the illusion that the artist was interrupted in his work of chipping away the superfluous marble just as the inner form was beginning to 'grow.' " Robert J. Clements, *Michelangelo's Theory of Art* (New York: New York University Press, 1963), 23–25.

54. Fineman, *Shakespeare's Perjured Eye*, 250.

55. Lisa Freinkel, *Reading Shakespeare's Will: The Theology of Figure from Augustine to the Sonnets* (New York: Columbia University Press, 2002), 216–21, 208, and 232–36.

56. See de Grazia, *Shakespeare Verbatim*, 159–60 and "Scandal," 42.

57. Bruce Smith, "I, You, He, She, and We: On the Sexual Politics of Shakespeare's Sonnets," in *Shakespeare's Sonnets: Critical Essays*, ed. James Schiffer (New York: Garland, 1999), 411–29 at 414.

Coda: The Material Sign and the Transparency of Language

1. John Donne, *Complete English Poems*, ed. C. A. Patrides (London: J. M. Dent, 1994), 22–24.

2. Arthur Marotti, *John Donne: Coterie Poet* (Madison: University of Wisconsin Press, 1986).

3. R. C. Bald, *John Donne: A Life* (Oxford: Clarendon Press, 1970), 94.

4. Donne, *Complete English Poems*, 314.

Index